FRANZ BOAS

PRIMITIVE ART

NEW YORK

DOVER PUBLICATIONS, INC.

Published in Canada by General Publishing Company, Ltd., 30 Lesmill Road, Don Mills, Toronto, Ontario.
Published in the United Kingdom by Constable and Company, Ltd., 10 Orange Street, London WC 2.

This Dover edition, first published in 1955, is an unabridged republication of the work originally published in 1927 by H. Aschehoug and Co., Oslo, for the Oslo Institute for Comparative Research in Human Culture, and in 1928 by Harvard University Press.
An Index of Names has been prepared for this Dover edition.

Standard Book Number: 486-20025-6
Library of Congress Catalog Card Number: 55-12840

**Manufactured in the United States of America
Dover Publications, Inc.
180 Varick Street
New York, N.Y. 10014**

TABLE OF CONTENTS

Table of contents

PREFACE

This book is an attempt to give an analytical description of the fundamental traits of primitive art. The treatment given to the subject is based on two principles that, I believe, should guide all investigations into the manifestations of life among primitive people: the one the fundamental sameness of mental processes in all races and in all cultural forms of the present day; the other, the consideration of every cultural phenomenon as the result of historical happenings.

There must have been a time when man's mental equipment was different from what it is now, when it was evolving from a condition similar to that found among the higher apes. That period lies far behind us and no trace of a lower mental organization is found in any of the extant races of man. So far as my personal experience goes and so far as I feel competent to judge ethnographical data on the basis of this experience, the mental processes of man are the same everywhere, regardless of race and culture, and regardless of the apparent absurdity of beliefs and customs.

Some theorists assume a mental equipment of primitive man distinct from that of civilized man. I have never seen a person in primitive life to whom this theory would apply. There are slavish believers in the teachings of the past and there are scoffers and unbelievers; there are clear thinkers and muddleheaded bunglers; there are strong characters and weaklings.

The behavior of everybody, no matter to what culture he may belong, is determined by the traditional material he handles, and man, the world over, handles the material transmitted to him according to the same methods.

Our traditional experience has taught us to consider the course of objective events as the result of definite, objective causation. Inexorable causality governs here and the outer world cannot be

influenced by mental conditions. Hence our hesitating wonder at the phenomena of hypnotism and suggestion in which these lines seem no longer sharply drawn. Our cultural environment has impressed this view upon our minds so deeply that we assume as a fundamental fact that material phenomena, particularly outside of the field of human behavior, can never be influenced by mental, subjective processes. Still, every ardent wish implies the possibility of fulfilment and prayers for objective benefits or for help do not differ in principle from the attempts of primitive man to interfere with the uncontrollable course of nature. The credulity with which fantastic theories bearing upon health are accepted, the constant rise of religious sects with abstruse dogmatic tenets, as well as the fashions in scientific and philosophic theory prove the weakness of our claim to a rational view of the world.

Anyone who has lived with primitive tribes, who has shared their joys and sorrows, their privations and their luxuries, who sees in them not solely subjects of study to be examined like a cell under the microscope, but feeling and thinking human beings, will agree that there is no such thing as a "primitive mind", a "magical" or "prelogical" way of thinking, but that each individual in "primitive" society is a man, a woman, a child of the same kind, of the same way of thinking, feeling and acting as man, woman or child in our own society.

Investigators are too apt to forget that the logics of science,— that unattainable ideal of the discovery of pure relations of cause and effect, uncontaminated by any kind of emotional bias as well as of unproved opinion,— are not the logics of life. The feelings underlying taboo are everpresent among us. I remember that as a boy, when receiving instruction in religion,— that is in dogma,— I had an insuperable inhibition against uttering the word "God", and I could not be brought to answer a question that required the answer "God". If I had been older I should have searched for and found a personally satisfying explanation for this inhibition. Everyone knows by experience that there are actions he will not perform,

lines of thought that he will not follow, and words that he will not utter, because the actions are emotionally objectionable, or the thoughts find strong resistances and involve our innermost life so deeply that they cannot be expressed in words. We are right in calling these social taboos. It requires only a dogmatic standardization to transform them into true taboos.

And magic? I believe if a boy should observe someone spitting on his photograph and cutting it to pieces he would feel duely outraged. I know if this should have happened to me when I was a student, the result would have been a duel and I should have done my level best to do to my adversary *in natura* what he had done to me *in effigie* and I should have considered my success as a compensation for the harm done me;— all this without any psycho-analytic meaning. I do not believe that my feelings would have differed much from those of other young men. Again a standardization and dogmatization would bring us right back to "magical" attitudes.

Dr. Tozzer's [1] collection of superstitions of College students with the enlightning remarks by those who hold the beliefs will be read with profit by all those who are convinced of our mental superiority and the lack of ability of clear thinking among the primitives.

Still other considerations should caution us against the assumption of a radical difference between primitive and civilized mentality. We like to see this distinction in greater individual mental freedom from social bondage expressed in a free critical attitude that makes possible individual creativeness.

Our much admired scientific training has never proved a safeguard against the seductiveness of emotional appeals, just as little as it has prevented the acceptance as gospel truth of the grossest absurdities, if presented with sufficient energy, self assertion and authority. If anything, the late war with its organized governmental and private propaganda should make us understand this truth. Opinions ener-

[1] A. M. Tozzer, Social Origins and Social Continuities, New York, 1925, pp. 242 et seq.

getically propagated and spurious facts diligently disseminated color the thinking of the people, and not only of the uneducated. The intellectual is deceived as easily as the untutored by sanctimonious professions that conform to the moral code of time and place and flatter the feeling of selfrighteousness. They gloss over the conflict of deed and word and, when uttered by those in authority, make criminals appear like saints.

Our advantage over primitive people is one of greater knowledge of the objective world, painfully gained by the labor of many generations, a knowledge which we apply rather badly and which we, or at least most of us, discard just as soon as a strong emotional urge impels us to do so, and for which we substitute forms quite analogous to those of primitive thought.

The much maligned introspective psychology proves to the unbiased observer that the causes that make primitive man think as he does, are equally present in our minds. The particular behavior in each case is determined by the traditional knowledge at the disposal of the individual.

The second fundamental point to be borne in mind is that each culture can be understood only as an historical growth determined by the social and geographical environment in which each people is placed and by the way in which it develops the cultural material that comes into its possession from the outside or through its own creativeness. For the purpose of an historical analysis we treat each particular problem first of all as a unit, and we attempt to unravel the threads that may be traced in the development of its present form. For this reason we may not start our inquiries and interpretations, as though the fundamental thesis of a single unilineal development of cultural traits the world over, of a development that follows everywhere the same lines, had been definitely proven. If it is claimed that culture has run such a course, the assertion must be proven on the basis of detailed studies of the historical changes in single cultures and by the demonstration of analogies in their development.

It is safe to say that the critical study of recent years has definitely disproved the existence of far reaching homologies which would permit us to arrange all the manifold cultural lines in an ascending scale in which to each can be assigned its proper place.

On the other hand dynamic conditions exist, based on environment, physiological, psychological, and social factors, that may bring forth similar cultural processes in different parts of the world, so that it is probable that some of the historical happenings may be viewed under more general dynamic viewpoints.

But historical data are not available and when prehistoric research does not reveal sequences of cultural changes, the only available method of study is the geographical one, the study of distribution. This has been emphasized in the last third of the past century by Friedrich Ratzel. It has probably been most rigidly developed in the United States. I illustrated this method in 1891 by a study of the distribution of folk tales in North America [1] and it has become more and more the method of analytical study of cultural forms.

Its very fruitfulness, however, has led to extremes in its application that should be guarded against. I pointed out, in print in 1911 and often before and since that time in speaking, that there is a certain homology between universal distribution of cultural facts and their antiquity. The fundamental principle involved in this assumption was fully discussed by Georg Gerland in 1875, [2] although we are hardly ready to accept his conclusions. The data of prehistoric archaeology prove that some of these universal achievements go back to paleolithic times. Stone implements, fire and ornaments are found in that period. Pottery and agriculture, which are less universally distributed, appear later. Metals, the use of which is still more limited in space, are found still later.

Recent attempts have been made to raise to a general principle this point of view which, with due caution, may be applied here

[1] Journal of American Folk-Lore, Vol. IV, pp. 13—20; also Science, Vol. XII (1888), pp. 194—196.

[2] Anthropologische Beiträge, Halle a/S, pp. 401 et seq.

and there. Herbert Spinden in his reconstruction of American prehistoric chronology, Alfred Kroeber in his analysis of cultural forms of the Pacific Coast, and quite recently Clark Wissler have built up, founded on this principle a system of historic sequences that apppear to me as quite untenable. That widely distributed cultural traits develop special forms in each particular area is a truism that does not require any proof. That these local developments may be arranged in a chronological series, that those of the most limited distribution are the youngest, is only partially true. It is not difficult to find phenomena that center in a certain region and dwindle down at the outskirts, but it is not true that these invariably arise on an ancient substratum. The converse is often true, that an idea emanating from a center is diffused over a wide area. Neither may the origin always be looked for in the area of the strongest development. In the same way as we find animals surviving and flourishing in regions far distant from the locality in which they developed, so cultural traits may be transferred and find their highest expression in regions far away from their origin. The bronze castings of Benin; the wood carvings of New Zealand; the bronze work of ancient Scandinavia; the giant stone work of Easter Island; the early cultural development of Ireland and its influences over Europe are examples of this kind.

Equally unsafe are the methods used by Fritz Graebner and Pater W. Schmidt who claim the stability of certain very old and, as I fear, fictitious correlations between cultural traits.

It is probably not necessary to point out the utter inadequacy of Elliott Smith's attempt to reduce all ethnological phenomena to a single and anthropologically speaking, late source and to assume a permanence of cultural forms that exists nowhere.

It has often been observed that cultural traits are exceedingly tenacious and that features of hoary antiquity survive until the present day. This has led to the impression that primitive culture is almost stable and has remained what it is for many centuries. This does not correspond to the facts. Wherever we have detailed

information we see forms of objects and customs in constant flux, sometimes stable for a period, then undergoing rapid changes. Through this process elements that at one time belonged together as cultural units are torn apart. Some survive, others die, and so far as objective traits are concerned, the cultural form may become a kaleidoscopic picture of miscellaneous traits that, however, are remodelled according to the changing spiritual background that pervades the culture and that transforms the mosaic into an organic whole. The better the integration of the elements the more valuable appears to us the culture. I believe that it may be said that the coherent survival of cultural features that are not organically connected is exceedingly rare, while single detached elements may possess marvellous longevity.

In the present book the problem of growth of individual art styles will be touched upon only incidentally. Our object is rather an attempt to determine the dynamic conditions under which art styles grow up. The specific historical problem requires much fuller material than what we now possess. There are very few parts of the world in which we can trace, by archaeological or comparative geographical study, the growth of art styles. Prehistoric archaeology in Europe, Asia, and America shows, however, that, as general cultural traits are in a constant state of flux, so also do art styles change and the breaks in the artistic life of the people are often surprisingly sudden. It remains to be seen whether it is possible to derive generally valid laws that control the growth of specific art styles, such as Adama van Scheltema has tried to derive for North European art.[1] With increasing technical skill and perfection of tools, changes are bound to occur. Their course is determined by the general cultural history of the people. We are not in a position to say that the same tendencies, modified by local historical happenings, reappear in the course of art development everywhere.

[1] Die altnordische Kunst, Berlin, 1923.

I wish to express my thanks to those who have assisted me in gathering the illustrative material for this volume. I am indebted to the American Museum of Natural History, especially to Dr. Pliny E. Goddard for permission to have drawings made of specimens, for liberal help in their selection and also for the use of illustrative material from the Museum publications. I am also indebted to the Field Museum, Chicago; the United States National Museum, Washington; the University Museum of the University of Pennsylvania at Philadelphia, the Free Public Museum of the City of Milwaukee and to the Linden Museum at Stuttgart for illustrations of specimens. The drawings were made by Mr. W. Baake, Miss M. Franziska Boas and Miss Lillian Sternberg.

INTRODUCTION

No people known to us, however hard their lives may be, spend all their time, all their energies in the acquisition of food and shelter, nor do those who live under more favorable conditions and who are free to devote to other pursuits the time not needed for securing their sustenance occupy themselves with purely industrial work or idle away the days in indolence. Even the poorest tribes have produced work that gives to them esthetic pleasure, and those whom a bountiful nature or a greater wealth of inventions has granted freedom from care, devote much of their energy to the creation of works of beauty.

In one way or another esthetic pleasure is felt by all members of mankind. No matter how diverse the ideals of beauty may be, the general character of the enjoyment of beauty is of the same order everywhere; the crude song of the Siberians, the dance of the African Negroes, the pantomime of the Californian Indians, the stone work of the New Zealanders, the carvings of the Melanesians, the sculpture of the Alaskans appeal to them in a manner not different from that felt by us when we hear a song, when we see an artistic dance, or when we admire ornamental work, painting or sculpture. The very existence of song, dance, painting and sculpture among all the tribes known to us is proof of the craving to produce things that are felt as satisfying through their form, and of the capability of man to enjoy them.

All human activities may assume forms that give them esthetic values. The mere cry, or the word does not necessarily possess the elements of beauty. If it does so it is merely a matter of accident. Violent, unrestrained movements induced by excitement; the exertions of the chase and the movements required by daily occupations are partly reflexes of passion, partly practically determined. They have no immediate esthetic appeal. The same is

true of all products of industrial activity. The daubing of paint, the whittling of wood or bone, the flaking of stone do not necessarily lead to results that compel our admiration on account of their beauty.

Nevertheless, all of them may assume esthetic values. Rhythmical movements of the body or of objects, forms that appeal to the eye, sequences of tones and forms of speech which please the ear, produce artistic effects. Muscular, visual and auditory sensations are the materials that give us esthetic pleasure and that are used in art.

We may also speak of impressions that appeal to the senses of smell, taste and touch. A composition of scents, a gastronomical repast may be called works of art provided they excite pleasurable sensations.

What then gives to the sensation an esthetic value? When the technical treatment has attained a certain standard of excellence, when the control of the processes involved is such that certain typical forms are produced, we call the process an art, and however simple the forms may be, they may be judged from the point of view of formal perfection; industrial pursuits such as cutting, carving, moulding, weaving; as well as singing, dancing and cooking are capable of attaining technical excellence and fixed forms. The judgment of perfection of technical form is essentially an esthetic judgment. It is hardly possible to state objectively just where the line between artistic and pre-artistic forms should be drawn, because we cannot determine just where the esthetic attitude sets in. It seems certain, however, that wherever a definite type of movement, a definite sequence of tones or a fixed form has developed it must become a standard by which its perfection, that is, its beauty, is measured.

Such types exist among mankind the world over, and we must assume that if an unstandardized form should prove to possess an esthetic appeal for a community it would readily be adopted. Fixity of form seems to be most intimately connected with our ideas of beauty.

Since a perfect standard of form can be attained only in a highly developed and perfectly controlled technique there must be an intimate relation between technique and a feeling for beauty.

It might be said that achievement is irrelevant as long as the ideal of beauty for which the would-be artist strives is in existence, although on account of imperfect technique he may be unable to attain it. Alois Riegl expresses this idea by saying that the will to produce an esthetic result is the essence of artistic work. The truth of this assertion may be admitted and undoubtedly many individuals strive for expression of an esthetic impulse without being able to realize it. What they are striving for presupposes the existence of an ideal form which the unskilled muscles are unable to express adequately. The intuitive feeling for form must be present. So far as our knowledge of the works of art of primitive people extends the feeling for form is inextricably bound up with technical experience. Nature does not seem to present formal ideals,—that is fixed types that are imitated,—except when a natural object is used in daily life; when it is handled, perhaps modified, by technical processes. It would seem that only in this way form impresses itself upon the human mind. The very fact that the manufactures of man in each and every part of the world have pronounced style proves that a feeling for form develops with technical activities. There is nothing to show that the mere contemplation of nature or of natural objects develops a sense of fixed form. Neither have we any proof that a definite stylistic form develops as a product purely of the power of the imagination of the workman, unguided by his technical experience which brings the form into his consciousness. It is conceivable that elementary esthetic forms like symmetry and rhythm, are not entirely dependent upon technical activities; but these are common to all art styles; they are not specifically characteristic of any particular region. Without stability of form of objects, manufactured or in common use, there is no style; and stability of form depends upon the development of a high technique, or in a few cases on the constant use of the same kind of natural products.

When stable forms have been attained, imaginative development of form in an imperfect technique may set in and in this case the will to produce an esthetic result may outrun the ability of the would-be artist. The same consideration holds good in regard to the esthetic value of muscular movements used in song and dance.

The manufactures of man the world over prove that the ideal forms are based essentially on standards developed by expert technicians. They may also be imaginative developments of ·older standardized forms. Without a formal basis the will to create something that appeals to the sense of beauty can hardly exist.

Many works of art affect us in another way. The emotions may be stimulated not by the form alone, but also by close associations that exist between the form and ideas held by the people. In other words, when the forms convey a meaning, because they recall past experiences or because they act as symbols, a new element is added to the enjoyment. The form and its meaning combine to elevate the mind above the indifferent emotional state of every-day life. Beautiful sculpture or painting, a musical composition, dramatic art, a pantomime, may so affect us. This is no less true of primitive art than of our own.

Sometimes esthetic pleasure is released by natural forms. The song of a bird may be beautiful; we may experience pleasure in viewing the form of a landscape or in viewing the movements of an animal; we may enjoy a natural taste or smell, or a pleasant feeling; grandeur of nature may give us an emotional thrill and the actions of animals may have a dramatic effect; all of these have esthetic values but they are not art. On the other hand, a melody, a carving, a painting, a dance, a pantomime are esthetic productions, because they have been created by our own activities.

Form, and creation by our own activities are essential features of art. The pleasure or elevation of the mind must be brought about by a particular form of sense impression, but this sense impression must be made by some kind of human activity or by some product of human activity.

It is essential to bear in mind the twofold source of artistic effect, the one based on form alone, the other on ideas associated with form. Otherwise the theory of art will be one-sided. Since the art of man, the world over, among primitive tribes as well as among civilized nations, contains both elements, the purely formal and the significant, it is not admissible to base all discussions of the manifestations of the art impulse upon the assumption that the expression of emotional states by significant forms must be the beginning of art, or that, like language, art is a form of expression. In modern times this opinion is based in part on the often observed fact that in primitive art even simple geometrical forms may possess a meaning that adds to their emotional value, and that dance, music and poetry almost always have definite meaning. However, significance of artistic form is neither universal nor can it be shown that it is necessarily older than the form.

I do not intend to enter into a discussion of the philosophical theories of esthetics, but will confine myself to a few remarks on the views of a number of recent authors who have treated art on the basis of ethnological material, and only in so far as the question is concerned whether primitive art is expressive of definite ideas.

Our views agree fundamentally with those of Fechner [1] who recognizes the "direct" appeal of the work of art on the one side and the associated elements that give a specific tone to the esthetic effects on the other.

Wundt [2] restricts the dicussion of art to those forms in which the artistic work expresses some thought or emotion. He says, "For the psychological study art stands in a position intermediate between language and myth. . . . Thus the creative artistic work appears to us as a peculiar development of the expressive movements of the body. Gesture and language pass in a fleeting moment. In art they are sometimes given a higher significance; sometimes the

[1] G. T. Fechner, Vorschule der Aesthetik.
[2] Wilhelm Wundt, Völkerpsychologie, Vol. 3, Die Kunst; third edition, Leipzig, 1919, p. 5.

fleeting movement is given a permanent form . . . All these rela-
tions are manifested principally in the relatively early, although not
in the very earliest stages of artistic work in which the momentary
needs of expression of thought dominate art as well as language."

Max Verworn[1] says: "Art is the faculty to express conscious
processes by means created by the artist himself in such a manner
that they may be perceived by our sense organs. In this general
sense language, song, music and dance are art, just as well as paint-
ing, sculpture and ornamentation. The graphic and plastic arts in
the narrow sense of the term result from the ability of making
conscious processes visible in permanent materials."

Richard Thurnwald[2] accepts the view-point of Wundt when he
says, "Art, however inadequate its means may be, is a means of ex-
pression that belongs to mankind. The means employed are distinct
from those used in gesture, language and writing. Even when the
artist is intent only upon the repetition of what he has in mind he
does so with at least the subconscious purpose of communicating
his ideas, of influencing others."

The same onesidedness may be recognized in Yrjö Hirn's[3] opinion,
who says: "In order to understand the art impulse as a tendency
to esthetic production we must bring it into connection with some
function from the nature of which the specifically artistic qualities
may be derived. Such a function is to be found, we believe, in the
activities of emotional expression."

It will be seen that all these authors confine their definition of
art to those forms which are expressions of emotional states or of
ideas, while they do not include in art the pleasure conveyed by
purely formal elements that are not primarily expressive.

Ernst Grosse[4] expresses similar views in somewhat different form.

[1] Die Anfänge der Kunst. Jena, 1920, p. 8. "Kunst im allgemeinsten Sinne ist,
wie das Wort schon sagt, ein 'Können'."

[2] Richard Thurnwald, Handbuch der vergleichenden Psychologie, herausgegeben
von Gustav Kafka, Vol. I, pag. 211.

[3] Yrjö Hirn, The Origins of Art, London, 1900, p. 29.

[4] Ernst Grosse, Die Anfänge der Kunst, 1894, p. 292.

He stresses the practical purpose of artistic forms which appears to him as primary. However, he assumes that these forms, while devoted first of all to practical purposes, are intended at the same time to serve an esthetic need that is felt by the people. Thus, he says, that primitive ornament is by origin and by its fundamental nature not intended as decorative but as a practically significant mark or symbol, that is to say as expressive. If I understand him correctly this practical significance implies some kind of meaning inherent in the form.

Emil Stephan [1] concludes from his detailed discussion of Melanesian art that technical motives offer no sufficient explanation for the origin of artistic forms (pp. 52 et seq.). He considers all ornament as representative and sees the origin of art in that unconscious mental process by which the form appears as distinct from the content of the visual impression, and in the desire to give permanence to the form (p. 51). For this reason he considers the artistic forms also as equivalents of the way in which the form appears to the primitive artist.

Alfred C. Haddon [2] and W. H. Holmes [3] seek the origin of all decorative art in realism. They discuss the transfer of technical forms to ornament but they see in these also results of the endeavor to reproduce realistic form, namely; technical details. Henry Balfour [4] agrees, on the whole, with this position but he stresses also the development of decorative motives from the actual use of technical processes.

Gottfried Semper [5] emphasizes the importance of the form as determined by the manner of use. He also stresses the influence of designs developed in weaving and of their transfer upon other forms of technique, particularly upon architectural forms.

[1] Emil Stephan, Südseekunst, Berlin, 1907.

[2] Alfred C. Haddon, Evolution in Art, London 1895.

[3] W. H. Holmes, Origin and Development of Form in Ceramic Art, Annual Report Bureau of Ethnology, Vol. 4, 1886, pp. 443 et seq.

[4] Henry Balfour, The Evolution of Decorative Art, London 1893.

[5] Gottfried Semper, Der Stil in den Technischen und Tektonischen Künsten, 1860.

Alois Riegl [1] is also inclined to stress the representative character of the most ancient art forms, basing his argument essentially upon the realistic paleolithic carvings and paintings. He sees the most important step forward in the attempt to show the animals in outline, on a two-dimensional surface which necessitates the substitution of an ideal line for the three-dimensional form that is given to us by every day experience. He assumes that geometric ornament developed from the treatment of the line, obtained by the process just mentioned, according to formal principles.

Setting aside the assumed sequence of these two aspects, his viewpoint is distinguished from that of the authors referred to before, by the recognition of the principle of form as against that of content.

The principle of form is still more energetically defended by van Scheltema, who tries to prove definite developmental processes through which the formal treatment of North European art has passed, first in the Neolithic period, then in the bronze age and finally in the iron age. [2]

Alfred Vierkandt [3] also emphasizes the fundamental importance of the formal element in the esthetic effect of all manifestations of art.

[1] Alois Riegl, Stilfragen, 2nd edition, Berlin, 1923, pp. 2 et seq.

[2] F. Adama van Scheltema, Die altnordische Kunst, Berlin, 1923. For a comprehensive review of works on primitive art up to 1914, see Martin Heydrich, Afrikanische Ornamentik, Internationales Archiv für Ethnographie, Supplement to Volume XXII, Leyden, 1914; also the bibliography in Eckert von Sydow, Die Kunst der Naturvölker und der Vorzeit, Berlin, 1923; and Herbert Kühn, Die Kunst der Primitiven, München, 1923. An excellent review of the subject has been given by Elizabeth Wilson, Das Ornament (Dissertation, University of Leipzig).

[3] Prinzipienfragen der ethnologischen Kunstforschung, Zeitschrift für Aesthetik und allgemeine Kunstwissenschaft, Vol. XIX, Berlin, 1925, pp. 338 et seq. See also Jahrbuch für historische Volkskunde, Vol. II; Vom Wesen der Volkskunst, Berlin 1926; Rafael Karsten, Civilization of South American Indians, New York, 1926.

GRAPHIC AND PLASTIC ARTS
THE FORMAL ELEMENT IN ART

An examination of the material on which our studies of the artistic value of objects of primitive manufacture are founded shows that in most cases we are dealing with products of an industry in which a high degree of mechanical skill has been attained. Ivory carvings of the Eskimo; fur clothing of the Chukchee; wood carving of the northwest coast of America, of New Zealand, the Marquesas, or central Africa; metal work of Africa: appliqué work and embroidery of the Amur River; pottery of the North American Pueblos; bronze work of ancient Scandinavia are examples of this kind.

The close relation between technical virtuosity and the fullness of artistic development may easily be demonstrated by an examination of the art of tribes with onesided industries. While people like the African negroes or the Malay are in possession of many industries, such as basketry, carving, weaving, metal work and pottery, we find others among whom the range of industrial activities is so narrow that almost all the utensils for their manifold needs are made by the same process.

The Californian Indians present an excellent example of this kind. Their chief industry is basketry. Almost all their household goods, receptacles for storage, cooking vessels, mortars for preparing food, children's cradles, receptacles for carrying loads, are made of basketry. As compared to this industry others employed for the manufacture of weapons and tools are insignificant. The building of houses, of canoes, woodcarving, and painting are only slightly developed. The only other occupation in which an unusual degree of skill has been attained is featherwork. A great deal of time is therefore given to the manufacture of baskets and an unusual degree of virtuosity is found among the basketmakers. The beauty of form, the evenness of texture of the Californian baskets are well known and highly prized by collectors. At the same

time the baskets are elaborately decorated with a variety of geometrical designs or by the addition of shells and feathers. (Plate I.) Basketmaking is an occupation of women and thus it happens that among the Californian Indians only women are creative artists. They are virtuosos in their technique and on account of their virtuosity productive. The works of art made by the men are, as compared to theirs, insignificant.

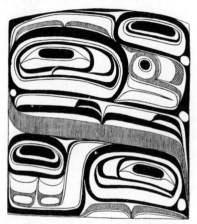

Fig. 1. Front of painted box, Tlingit, Alaska.

It so happens that conditions among the northern neighbors of the Californians are reversed. From Puget Sound northward the household goods and implements of the Indians are made of wood, and much of the time of the men is spent in woodworking. They are skilled joiners and carvers who through constant practice have acquired virtuosity in the handling of wood. The exactness of their work rivals that of our very best craftsmen. Their boxes, buckets, kettles, cradles, and dishes are all made of wood, as those of the Californians are made of basketry. In their lives basketry plays a relatively unimportant part. The industry in which they have attained greatest proficiency, is, at the same time, the one in which their decorative art is most fully developed. It finds expression, not only in the beauty of form of the woodwork, but also in elaborate decoration. Among these people all other aspects of decorative art are weak as compared to their artistic expression in woodwork or in art forms derived from woodwork (fig. 1). All this work is done by men and hence it follows that the men are the creative artists while the women seem to be lacking in inventiveness and artistic sense. Here also virtuosity in technique and artistic productivity go hand in hand.

PLATE I.

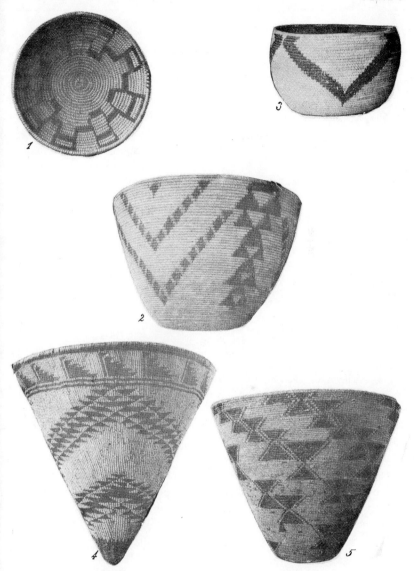

Maidu Baskets. 1—2. Butterfly design. 3. Raccoon design.
4. Rim: mountains; body: flying geese. 5. Moth-miller.

As a third example we might mention the Pueblo Indians of the Southern United States. In many villages of this region pottery is the dominant industry and in pottery is found the highest expression of art. The form of the clay vessel is characterized by great regularity and it becomes the substratum for decoration. Since pottery is a woman's art, women are the most productive artists among the Pueblos (fig. 2). However, the industrial activities of the Pueblos are not quite so one-sided as those of California and British Columbia. Therefore the men who are experienced in industrial work devoted to ceremonial purposes are not lacking in the ability of artistic expression.

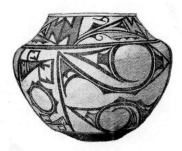

Fig. 2. Jar from Zuni.

I believe these examples demonstrate that there is a close connection between the development of skill in an industry and artistic activity. Ornamental art has developed in those industries in which the greatest skill is attained. Artistic productivity and skill are closely correlated. Productive artists are found among those who have mastered a technique, among men when the industries are in their hands, among women when they are devoted to industrial activities.

It will be admitted that aside from all adventitious form elements, the product of an experienced worker in any handicraft has an artistic value. A child learning to make a basket or a pot cannot attain the regularity of outline that is achieved by the master.

The appreciation of the esthetic value of technical perfection is not confined to civilized man. It is manifested in the forms of manufactured objects of all primitive people that are not contaminated by the pernicious effects of our civilization and its machine-made wares. In the household of the natives we do not find slovenly work, except when a rapid makeshift has to be made. Patience and careful execution characterize most of their products. Direct

questioning of natives and their criticism of their own work shows also their appreciation of technical perfection. Virtuosity, complete control of technical processes, however, means an automatic regularity of movement. The basketmaker who manufactures a coiled basket, handles the fibres composing the coil in such a way that the greatest evenness of coil diameter results (fig. 3). In making her stitches the automatic control of the left hand that lays down the coil, and of the right that pulls the binding stitches over the

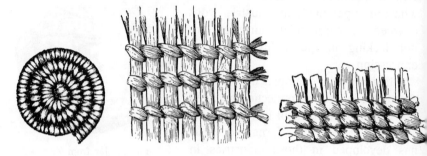

Fig. 3. Coiled basketry. Fig. 4. Twined basketry.

coil brings it about that the distances between the stitches and the strength of the pull are absolutely even so that the surface will be smooth and evenly rounded and that the stitches show a perfectly regular pattern, — in the same way as an experienced seamstress will make her stitches at regular intervals and with even pull, so that they lie like beads on a string. The same observation may be made in twined basketry (fig. 4). In the handiwork of an expert the pull of the woof string will be so even that there is no distortion of the warp strings and the twisted woof will lie in regularly arranged loops. Any lack of automatic control will bring about irregularities of surface pattern.

A pot of well-rounded form results also from complete control of a technique. Primitive tribes make their pottery without the aid of the potter's wheel, and in most cases the potter builds up his

vessel by the process of coiling, analogous to the coiling of a
basket. Long round strips of clay are laid down spirally beginning
at the bottom. By continued turning and gradual laying on of
more and more strips in a continued spiral the pot is built up.
Complete control of the technique will result in a perfectly round
cross section and in smooth curvatures of the sides. Lack of skill
will bring about lack of symmetry and
of smoothness of curvature. Virtuosity
and regularity of surface and form
are here also intimately related.

A similar correlation is found in
the manufacture of chipped stone
implements. After the brittle stone
has been roughly shaped it is given
its final form either by pressure
with an implement that squeezes
off long, thin flakes or by indirect
chipping. In the former case the
flaking implement is held in the right
hand and by sudden pressure with
the point of the flaker long flakes
or small bits are removed from
the surface. When the worker has

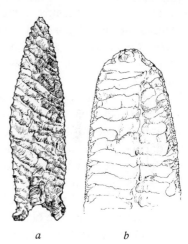

a *b*

Fig. 5. Chipped flint implements:
a North America; *b* Egypt.

attained complete control of this technique his pressure will be
even and executed with equal rapidity; the distances between the
points of attack will be the same and he will move his flaker
in regular lines. The result is a chipped implement of regular form
and surface pattern in which the long, conchoidal depressions caused
by the flaking off of thin chips are of equal size and regularly
arranged (fig. 5).

When indirect chipping is applied the thin part of the object
which is to be worked is placed on a hard, sharp edge and by a
smart blow on the body of the flint a strong vibration is produced
which results in a break just over the sharp edge. In this way,

place and size of the flake are perfectly controlled by the expert craftsman.

Quite similar are the conditions in woodwork. The smoothing of large surfaces is generally done with the adze. A skilled worker handles his adze automatically. The strength of the stroke and the depth to which it enters the surface of the wood are always the same and the chips removed have always the same size and form. The workman will also move the adze in even lines and strike the surface at even distances. The result of automatic action is here, also, evenness of surface and regularity of surface pattern (fig. 6).

These conditions are well-described by Sophus Müller, who says,[1] "A great part of the work on flint must be designated as luxury, and was done with the sole intent of producing a masterpiece of handiwork. When making an adze blade all that is needed for practical purposes is a good cutting edge. Smoothness of face, back and sides is not necessary, particularly since a large portion of these were covered by the attachment to the handle. With coarse and conchoidal chipping the blade would be equally serviceable. However, the maker wanted to produce excellent stone work, to the making of which he devoted all the care, taste and skill at his command and by this the manufactured objects undoubtedly increased in value. These objects might be called therefore, in the strict sense of the term, works of artistic industry."

All these examples show that complete automatic control of a technique, and regularity of form and surface pattern are intimately correlated.

However, besides these, attempts at decoration occur in which a mastery of technique has not been attained. Among a few tribes almost all artistic work is of this character. Among the inhabitants of Tierra del Fuego are found only meagre examples of painting, lacking in skill (fig. 7). The patterns are simply dots and

[1] Sophus Müller, Nordische Altertumskunde, Strassburg 1897, Vol. I, p. 190.

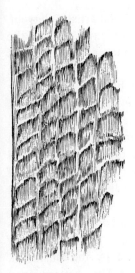

Fig. 6. Part of surface of wooden sail, Vancouver Island.

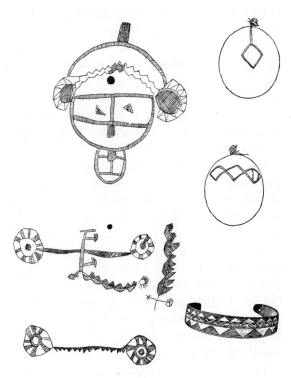

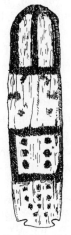

Fig. 7. Painted board, Tierra del Fuego.

Fig. 8. Bushman designs from ostrich eggs and from horn bracelet.

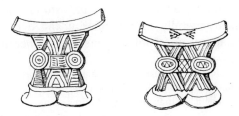

Fig. 9. Kaffer headrests.

coarse lines in which the arrangement is the essential artistic element. It is intelligible that a feeling for symmetry may exist without the ability of perfect execution. The modern Bushmen scratch patterns on ostrich eggs which serve as receptacles for water (fig. 8). Here we find the intent to give expression to form but with inadequate means. It is important to note that the same motive, two circles connected by a narrow band, occurs several times in these etchings. The circle might be suggested to the workman by the perforation of the shell of the ostrich egg through which the water is poured out, but the combination can hardly be derived on the basis of Bushman industries. Shall we consider the pattern as the result of the play of their imagination or as an attempt at representation? It seems to me important to note that the neighbors of the Bushmen, the negroes of the Zambezi, use the same pattern and that rows of triangles and diamonds, such as are used by the Bushmen, are found on their implements also (fig. 9). The pattern may therefore have come from an outside source.[1] Perhaps the decoration on ostrich eggs is poor only on account of the difficulties of handling the material. At least the zigzag patterns (fig. 8), found on a bracelet, show a much greater technical perfection than those found on the ostrich eggs.

Here may also be mentioned the painting and carving of the Melanesians. We see among them a wealth of forms in carvings of excellent technique. In some specimens, particularly from western New Guinea, we find complete mastery of the art. In the majority of cases, however, there is an imperfect control of technique, while there is an astounding multiplicity of forms. The lines generally lack regularity and evenness (fig. 10 *a, b*). There is no clear proof of a general degeneration of the art and we may

[1] F. von Luschan, Buschmann-Einritzungen auf Strausseneiern, Zeitschrift für Ethnologie, Vol. 55 (1923), pp. 31 et seq. — Hendrik P. M. Muller et John F. Snelleman, L'Industrie des Caffres dans le sud-est de l'Afrique. (Pl. XIV, Figs. 2—5). See also P. C. Lepage, La décoration primitive; Afrique, Paris, Librairie des arts décoratifs, Plate 5, where similar designs are shown on pottery vessels.

perhaps assume that in this case the development of a keen sense for form among all the carvers and painters of the tribe did not go hand in hand with a corresponding mastery of technique. It is not unlikely that foreign influence has led here to an exuberant form perception.

Setting aside any esthetic consideration, we recognize that in cases in which a perfect technique has developed, the consciousness of the artist of having mastered great difficulties, in other words the satisfaction of the virtuoso is a source of genuine pleasure.

I do not propose to enter into a discussion of the ultimate sources of all esthetic judgments. It is sufficient for an inductive study of the forms of primitive art to recognize that regularity of form and evenness of surface are essential elements of decorative effect, and that these are intimately associated with the feeling of mastery over difficulties; with the pleasure felt by the virtuoso on account of his own powers.

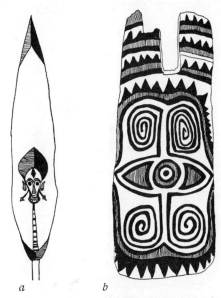

Fig. 10. Paddle and shield, New Ireland.

I can give at least a few examples which illustrate that the artist has not in mind the visual effect of his work, but that he is stimulated by the pleasure of making a complex form.

The raw hide boxes of the Sauk and Fox Indians are made of a large piece of hide which is carefully ornamented according to a definite plan (fig. 11). The boxes are made by folding the hide. There are five sides of approximately equal width (1—5). These are the four sides of the box: front (5), bottom (4), back (3), top (2), and a flap (1) covering the front. A strip on each side *(a—e)* is

folded over and the marginal piece *(d)* belonging to the bottom seg-
ment is folded in along diagonal lines as we fold in the ends of a
paper wrapper, so that the marginal strips, *e* and *c*, form the sides
of the box. Another similar fold is made in *b* when the top is folded

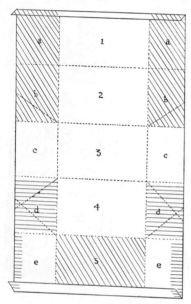

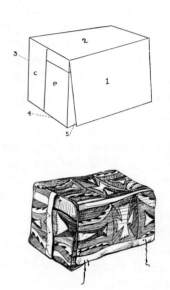

Fig. 11. Plan of rawhide box,
Sauk and Fox Indians.

Fig. 12. Rawhide box,
Sauk and Fox Indians.

over the top opening of the box. The folds at the bottom are sewed
in firmly, while the fold on top remains open. The resulting form
is shown in fig. 12. Those parts of the surface that are entirely
invisible are indicated by horizontal shading (fig. 11). These are
folded in and sewed in on the inside of the box. Those parts that
may be seen when the box is opened are indicated by diagonal
shading; while the white area is that part of the surface that is
visible when the box is closed and tied up. It will be noticed that
the fields *c* and *e* overlap on the short sides of the finished box.

The decoration of these boxes is carefully laid out on a flat piece of rawhide. Corresponding to the five faces of the box most of the designs are divided into five equal fields and corresponding to the folded margins two marginal fields are set off from the central

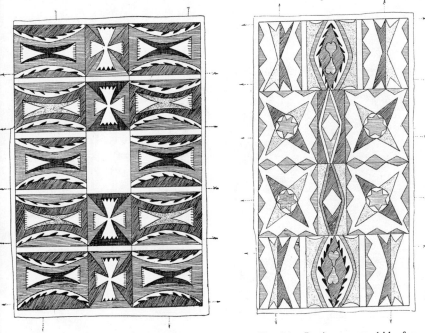

Fig. 13. Design on rawhide for a box, Sauk and Fox Indians.

Fig. 14. Design on rawhide for a box, Sauk and Fox Indians.

field. This, however, is so narrow that in folding part of the lateral design is turned over so that it becomes invisible. When the boxes are folded the cohesion of the pattern is completely lost. Not only do the folds fail to agree with the divisions, but owing to the method of folding and the complete covering of the field *d* and of part of *e*, the whole pattern is broken up and on the short sides we find only fragments adjoining in the most irregular way (fig. 12). When the box is closed field *e* adjoins field 1, and the overlapping

section *c* adjoins it in the middle of the narrow side. On top it adjoins field 2 and at the bottom field 4. The whole formal idea of the carefully planned pattern is lost in the completed box. We find even patterns laid out in four strips instead of five, so that the funda-

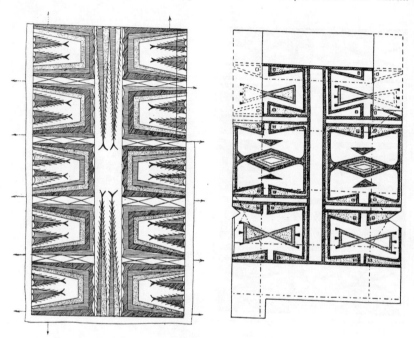

Fig. 15. Designs on rawhide boxes, Sauk and Fox Indians.

mental pattern and the sides do not coincide (fig. 14). It will be seen, therefore, that the artist spends his ingenuity in decorating the rawhide but that in the box the fundamental ideas of his carefully planned decoration are lost.

The disregard of the original pattern is such that in some specimens (fig. 15) part of the design has been cut off in order to make the sides fit together. In our illustration the parts cut off,—the right upper corners,—have been reconstructed.

It might be said that similar conditions prevail in modern, patterned fabrics that are made into garments. In this case the manufacturer tries to attain a pleasing effect for the fabric as a whole. If economy of material did not interfere, the tailor would fit the pattern together, but we always feel the conflict between the pattern and the requirements of the finished garment.

As another example I mention a legging made by an Indian woman from the interior of British Columbia. It bears the usual decoration,—a long fringe along the outer seam. The fringe consists of a long piece of curried skin cut in narrow strips. These strips are decorated in rhythmic order (fig. 16), a string decorated by one glass bead and two bone beads in alternating order is followed by a plain string, next by one decorated with single alternating glass and bone beads,

Fig. 16. Fringe from legging, Thompson Indians.

then a plain one and finally one like the first. When we indicate the plain and decorated strips by letters, we find the arrangement

· · · | A B C B A | A B C B A | · · ·

repeated over and over again.[1] The important point to be noted is, that when in use, the fringe hangs down without order along the outer side of the leg so that the elaborate rhythmic pattern cannot be seen. The only way in which the maker can get any satisfaction from her work is while making it or when exhibiting it to her friends. When it is in use there is no esthetic effect.

[1] James Teit, The Thompson Indians of British Columbia, Publications of the Jesup North Pacific Expedition, New York 1900, Vol. I, p. 382; see also Gladys A. Reichard, The Complexity of Rhythm in Decorative Art, American Anthropologist N. S., Vol. 24 (1922), p. 198.

Other cases occur in which motives are applied that are practically invisible. Thus in mattings from Vancouver Island, the weaver will alternate the direction of the strands in squares without any attempt

Fig. 17. Twilled weaving showing alternation of patterns.

to set off the surface in colors (fig. 17). When the matting is new these patterns may be seen in reflected light, but after a very short time they disappear almost completely.

Similarly the woven patterns on arm rings from the Ucayali are practically invisible.[1]

To sum up: Objectively the excellence of workmanship results in regularity of form and evenness of surface which are characteristic of most uncontaminated primitive manufactures, so much so that most objects of every day use must be considered as works of art. The handles of implements, stone blades, receptacles, clothing, permanent houses, canoes are finished off in such a way that their forms have artistic value.

Expert workmanship in the treatment of the surface may lead not only to evenness but also to the development of patterns. In adzing the form of the object to be smoothed will determine the most advantageous direction of the lines in which the adze has to be carried. In a large Bella Bella canoe, the

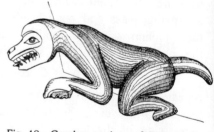

Fig. 18. Carving on bow of Bella Bella canoe, British Columbia.

body of the canoe is adzed in horizontal lines, while prow and stern show vertical lines. The wolf carved on the bow of the same canoe shows surface patterns on its body and limbs (fig. 18). Decorative

[1] Max Schmidt, Besondere Geflechtsart der Indianer im Ucayaliegebiete, Archiv für Anthropologie, N. S., Vol. VI (1907), p. 270.

use of adzed lines, is also found on a rattle (fig. 19). In this specimen there is no technical need for the alternation in the direction of the groves, and the fields on the top of the rattle can the explained only as determined by the pleasure felt by the variation of the simple activity in novel and more complicated ways.[1]

In chipping of flint zigzag lines are produced by the meeting of two lines on a ridge (fig. 20).

Technical experience and the acquisition of virtuosity have probably led to the general prevalence of the plane, the straight line and regular

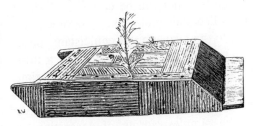

Fig. 19. Rattle, Kwakiutl Indians, British Columbia.

Fig. 20. Base of flint knife, Scandinavia.

curves such as the circle and the spiral, for all of these are of rare occurrence in nature, so rare indeed, that they had hardly ever a chance to impress themselves upon the mind.

Plain surfaces are represented by crystals, by the cleavage of some kinds of rock, or by the surface of water during a calm. Straight lines by the shoots and stems of plants or by the sharp edges of crystals; regular curved lines by the shells of snails, by vines, bubbles on water or by smooth pebbles, but there is no obvious motive that would induce man to imitate these particular abstract forms, except perhaps in those cases in which regularly curved shells are worn as ornaments or employed as utensils.

On the other hand, the straight line develops constantly in technical work. It is a characteristic form of the stretched thong or cord and its importance cannot be ignored by the hunter who hurls a lance or flies an arrow. The technical use of the straight shoot may well have

[1] See also page 41.

been important in its derivation. Plants like the bamboo or the reed may thus have helped man to discover the value of the straight line.

More essential than this seems to be the possession of a perfect technique, which involves great accuracy and steadiness of movement. These in themselves must lead necessarily to regular lines.

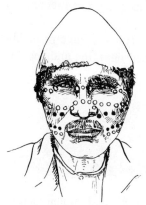

When the uncertain wobbling of the cutting tool is eliminated, smooth curves will result. When the potter turns the pot he is making and his movements are quite regular the pot will be circular. Perfectly controlled coiling of basketry or of wire will lead to the formation of equidistant spirals.

A number of other characteristic features may be observed in the art of all times and all peoples. One of these is symmetry. Symmetrical forms are found even in the simplest forms of decorative art. The tribes of Tierra del Fuego [1] decorate their faces and bodies with designs, many of which are symmetrical. Vertical lines on both sides of the body or a series of symmetrically arranged dots running from ear to ear across the nose are of this kind (fig. 21). They also use symmetrically decorated boards with which they adorn their huts (see fig. 7, page 23). The Andaman Islanders like to decorate their bodies with symmetrical patterns (Plate II). Many of the designs of the Australians are symmetrical (fig. 22) and in paleolithic painting geometrical forms occur that exhibit bilateral symmetry (fig. 23). In a few cases the elements arranged symmetrically are so complex that the symmetry can have been attained only by careful planning. Examples of this kind are necklaces of Indians in British Columbia in which we find as many as eighteen beads of different colors irregularly arranged, but repeated in equal order right and left. [2]

Fig. 21. Face painting, Tierra del Fuego.

[1] W. Koppers, Unter Feuerland-Indianern, p. 48, Pl. 7.
[2] See Gladys A. Reichard, American Anthropologist, N. S., Vol. 24 (1922) p. 191.

PLATE II.

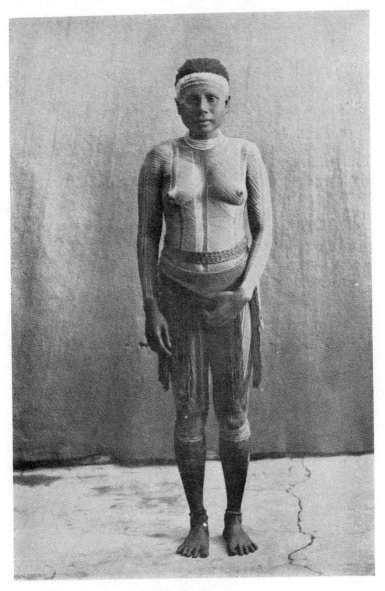

Andaman Islander.

The causes that have led to the widespread use of symmetrical forms are difficult to understand. Symmetrical motions of the arms and hands are physiologically determined. The right and left are apt to move symmetrically and the motions of the same arm or of both arms are often performed rhythmically and symmetrically from right to left and from left to right. I am inclined to consider this condition as one of the fundamental determinants, in importance equal to the view of the symmetry of the human body and of that of animals; not that the designs are made by right and left hand, rather that the sensation of the motions of right and left lead to the feeling of symmetry.

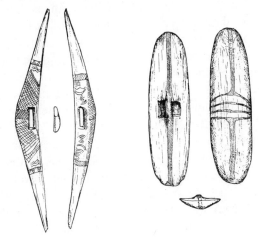

Fig. 22. Australian shields.

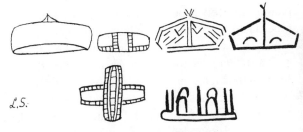

L.S.

Fig. 23. Paleolithic paintings.

In by far the greatest number of cases symmetrical arrangements are to the right and left of a vertical axis, much more rarely above and below a horizontal one.

The prevalence of horizontal and the rarity of vertical symmetry is presumably due to the absence of vertically symmetrical movements,—except in those rhythmic movements in which the arms are

alternately raised and lowered,—and in the rarity of natural forms that are vertically symmetrical.

In nature we see generally more fundamental differences in vertical direction than in horizontal layers. In animals, legs, body and head are on different levels. In landscapes, earth, trees, mountains and sky follow one another in vertical succession. On the other hand, we are liable to find in horizontal sequence sameness or variations of analagous form. This may be one of the reasons why there are found in ornamental art frequent arrangements in a series of horizontal bands that differ fundamentally in pattern, while in each horizontal band we find either symmetry, rhythmic repetition, or variations of similar forms (figs. 24, 25, 26). Exceptions however, occur, for instance in the decorations of Melanesian houses (Plate III).

Other causes may contribute to the development of symmetrical patterns. In the making of coiled pottery or coiled basketry symmetry results from the process of manufacture. By regular turning of the pot or basket a circular form is produced. The process of winding twine around a holder may have the same effect. In two-handed implements, such as the bow of the bowdrill, symmetrical forms also develop, but implements of this type are not by any means numerous and their occurrence is no adequate explanation of the general occurrence of symmetry.

We must leave it undecided whether the circumstances here referred to are adequate to account for the symmetry of form of such implements as lance heads, arrowheads, baskets and boxes. We must be satisfied with the establishment of their general occurence and the knowledge that they have an esthetic value wherever they are found. Examples of symmetrical arrangements are very numerous. The boxes from British Columbia (fig. 274, p. 263), neckrests of the Kaffers (fig. 9, p. 23), Melanesian shields and paddles (fig. 10, p. 25), and the painted rawhides of the Sauk and Fox (figs. 13—15, pp. 27, 28) may serve as exemples. A special type of symmetrical design is found in our heraldic style with its animals rampant on each side of a central field. It is interesting to note that the same arrangement is very ancient. It occurs on the Lions' Gate of Mycenae. It has also developed independently in prehistoric Peru (fig. 27).

PLATE III.

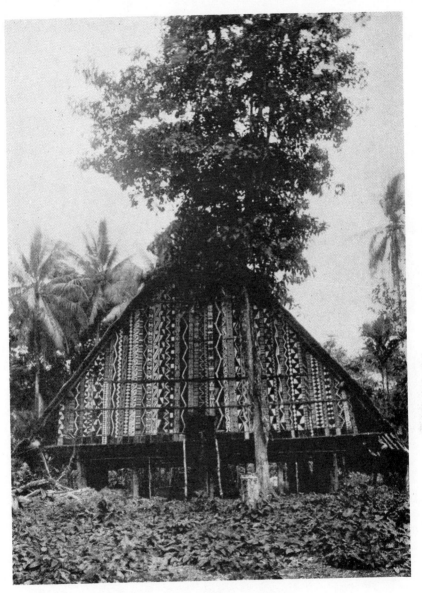

Decorated House, Northern New Guinea.

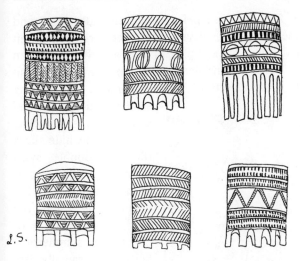

Fig. 24. Patterns from bamboo combs, Malay Peninsula

Fig. 25.
Design from
bamboo spear,
New Guinea.

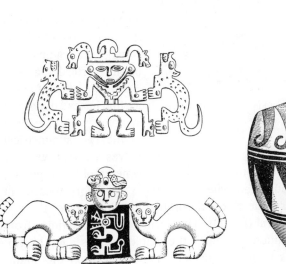

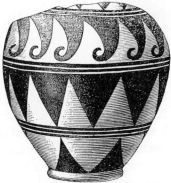

Fig. 27. Peruvian designs.

Fig. 26. Etruscan vase.

On objects that are frequently seen from different sides are found forms that are symmetrical both ways, when seen right and left and when seen up and down. Examples of this are the Australian shield fig. 22 (p. 33), and the parfleches of the North American Indians (fig. 89, p. 97). On objects of similar character made by the same technical processes and by the same tribe, such as rawhide bags (fig. 28) double symmetry may also occur

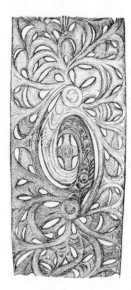

In circular forms the diameter is often the axis of symmetry. In other cases symmetrical fields are radially arranged and there may be a number of repetitions. The circumference takes the place of the horizontal, the radius that of the vertical (fig. 29).

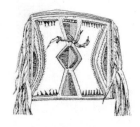

Fig. 28. Painted rawhide bags, Shuswap, British Columbia.

Fig. 30. Carved board Kaiserin Augusta Fluss, New Guinea.

In a number of cases we find instead of normal symmetry an inversion of the two symmetrical halves so that what is above to the right, is below to the left. Arrangements of this type are, however, less numerous than true symmetry. Such forms occur in New Guinea. They are due to the decorative development of the two branches of a double spiral (fig. 30). This form results sometimes from circular rhythmic repetitions in which the whole circle is filled by two or more units. This is found for instance, in pottery from the southwestern Pueblos (fig. 31) and also quite commonly in Central-America.[1]

[1] See, for instance S. K. Lothrop, Pottery of Costa Rica and Nicaragua, New York, 1926, Plates 39, 46, fig. 195.

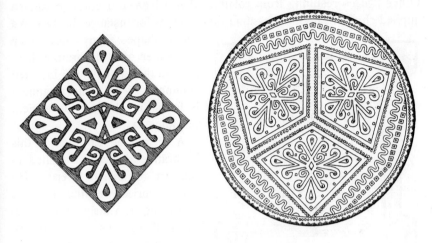

Fig. 29. Designs of the Dayak.

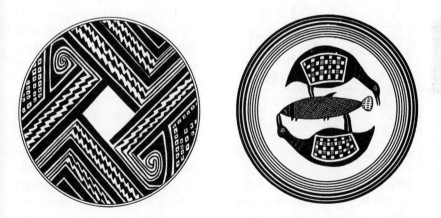

Fig. 31. Designs from pottery of the ancient Pueblos.

Other figures resulting from rotation, that is from a decorative pattern applied rhythmically in the same direction, as for instance the swastika and S shaped figures occupying the center of a decorative field, present the same type of inverted symmetry. The same treatment is found in the art of ancient Scandinavia (fig. 32).

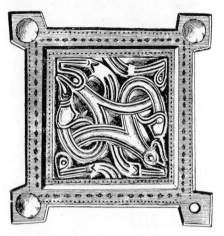

Fig. 32. Bronze ornament, Sweden, 7the Century A. D.

A curious development of this decorative device is applied in the art of ancient Peru. On many fabrics we find patterns consisting of a diagonal arrangement of squares or rectangles. In each diagonal the same design is repeated, while the next diagonal has another type. In each diagonal line the design is shown in varying positions. If the one faces the right, the next faces the left. At the same time there is an alternation of colors, so that even when the form is the same, the tints and the color values will not be the same. A characteristic specimen of this type will be described later on (p. 47).

The plan of one of these designs is illustrated in fig. 33.[1]

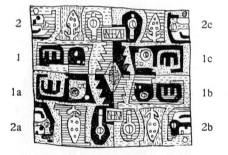

Fig. 33. Design from Peruvian textile.

There are eight rectangular fields with two designs (1 and 2); those right and left of the middle line and those above and below the horizontal middle line are symmetrical in regard to form. In color, 1 corresponds to 1b and 1a to 1c; also 2 corresponds in color to 2b and

[1] Walter Lehmann, Kunstgeschichte des alten Peru, Berlin 1924, Plates 3 and 4.

2a to 2c. The colors being in all these cases, on the whole, reversed. 1, 2, and 1b, 2b have a yellowish background and a red field sur-

rounding the tree shaped design; 1a, 2a and 1c, 2c have a light red background and a greenish field surrounding the tree shaped figure. The whole field, consisting of four sections, is followed in the whole decorated stripe by another set of four sections in form like the preceding one. In this the background of 1 and 2, 1b and 2b is blue, of 1a, 2a and 1c, 2c yellowish. The field surrounding the tree shaped figure is yellowish in 1 and 1b, greenish in 1a, and 1c. Taken as a whole, the right side is practically the same as the left, turned upside down. The order of fields on the left from the top downward and for the right side from below upward, is according to the color of the background, abbreviating, r red, y yellow, b blue:

r r y y / y y b b / r r y y / y y
b b / r r y y / y y b b / r r y y /.

A second example is shown in fig. 34. In this specimen the diagonally arranged fields marked 1, a, 2, b[1] have the same color scheme.

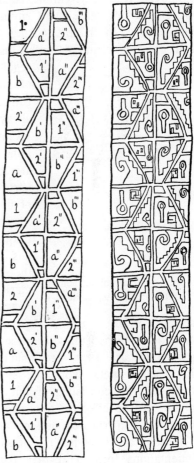

Fig. 34. Designs from Peruvian textile.

The larger fields in 1 are yellow, the lesser black. The larger fields in 2 are pink, the lesser grey. The background in b is grey, the scroll purple. The background in a is dark grey, the scroll light purple.

[1] These remarks refer also to the fields marked as 1′, 1″ etc.

Another fundamental element of decorative form is rhythmic repetition. Technical activities in which regularly repeated movements are employed lead to rhythmic repetition in the direction in which the movement proceeds. The rhythm of time appears here translated into space. In flaking, adzing, hammering. in the regular turning and pressing required in the making of coiled pottery, in weaving,

regularity of form and rhythmic repetition of the same movement are necessarily connected. These rhythmic movements always produce the same series of forms. Examples of rhythmic surface forms determined by perfect control of a technique are found in many industries and in all parts of the world. Exquisite regularity of flaking is found in the Egyptian flint knives (see fig. 5, p. 21). It is not so frequent in the flaking of American Indians. The adzed boards of the Indians of the North Pacific Coast bear chipping marks of great regularity that give the appearance of a pattern (figs. 6, p. 23

Fig. 35. Pot of coilled pottery, Prehistoric Pueblo Indians.

and 18, p. 30). On surfaces that are to be painted these marks are often polished off with grit-stone or shark skin, while on unpainted parts they are kept, presumably on account of their artistic effect. In Oriental metal work the strokes of the hammer are so regular that patterns consisting of flat surfaces originate. Other examples of the artistic effect of the regularity of movement are found in the prehistoric corrugated pottery of the North American South West. The coils are indented by pressure of the fingers and a series of indentations form a regular pattern on the surface (fig. 35). The effect of automatic control is seen nowhere more clearly than in basketry, matting and weaving. It has been pointed out before (p. 20) that evenness of surface results from regularity of movement. The rhythmic repetition of the movement leads also to

rhythmic repetition of pattern. This is most beautifully illustrated by the best examples of California basketry.

The virtuoso who varies the monotony of his movements and enjoys his ability to perform a more complex action, produces at the same time a more complex rhythm. This happens particularly in weaving and related industries such as braiding and wrapping with twine. Skipping of strands,— that is twilling (see fig. 17, p. 30) is the source of many rhythmic forms and twilling is undertaken by the virtuoso who plays with his technique and enjoys the overcoming of increased difficulties.

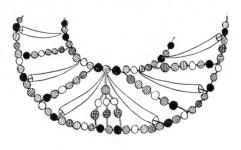

Fig. 36. Necklace of Thompson Indians.

In many cases rhythmic complexity is clearly the result of careful planning. I have referred before to the rhythmical arrangement on fringes of the Thompson Indians of British Columbia, (p. 29).

Another good example (fig. 36) is a double necklace in which the rhythmic series is—

<div align="center">black, red, yellow, green, blue, green,</div>

both in the inner and outer lines while the connecting links have the order black, red, yellow, green, red, blue.[1]

Dr. Reichard [2] has discussed a number of other examples from the same region which have similar characteristics. In one example

[1] In this specimen (see American Anthropologist, N. S., Volume 24, 1922, p. 188), the connecting links between the two strings have been misplaced, the inner string of beads being shifted three units to the right, i. e. the central connecting link is attached to the first yellow bead to the left of the red center; the others being shifted correspondingly. They have been corrected here so as to bring out the arrangement which was evidently planned.

[2] American Anthropologist l. c., pages 198—199.

the arrangement of the fringe elements is more complex than in the one previously described. Designating different colors by numbers and dentalia shells by D, we find the order

$$1 \ 2 \ 3 \ D \ 2 \ 1 \ 2 \ 3 \ 2 \ 1 \ 2 \ D \ 3 \ 2 \ 1 \ [1]$$

Other examples of complex rhythms from this region have been given by Dr. Reichard in the essay previously referred to.

In some instances the rhythms are not so distinct, but nevertheless discernible. As an example may serve a neckband consisting of a double string in which beads of various colors are interspersed among red beads in the following order

$$-r-r--r---r-\ -\ -\ -\ r----r---r--r-$$
$$\diagup\ \diagup\ \diagup\ \ \diagup\ \ \ |\ \ \diagdown\ \ \ \diagdown\ \ \ \diagdown\ \ \diagdown$$
$$-r--r--r-\ -\ r---rrr---r----r---r--r-$$

In Eastern Siberia similar conditions occur.[2]

A fairly simple sequence is shown on an embroidered strip (fig. 37 a) consisting in regular sequence of squares followed by three narrow strips; the middle strip is a little wider than the two lateral strips.

A more complex rhythm is shown in figure 37 b. The long fringe which is caught in the seam near the upper border of the embroidery is repeated at regular intervals. An embroidered strip near the upper part of the design is interrupted and the black bars on the central white strip are omitted at these places. A division of the upper row of embroidery, between the sets of fringes, into three parts of unequal length will be noticed. Just under the breaks in this row are two groups of tufts of seal fur, a little wider below

[1] Owing to a probable error the arrangement of the beads, the order of the last five beads to the right is

D 2 3 2 1 instead of 2 D 3 2 1.

The change of D and 2 makes the arrangement symmetrical. The same result might be obtained by changing the first five beads from 1 2 3 D 2 to 1 2 3 2 D and leaving the right end undisturbed.

[2] See W. Jochelson, The Koryak, Publications of the Jesup North Pacific Expedition, Vol. VI, pp. 688 et seq.; and in the publication previously referred to by Dr. Reichard.

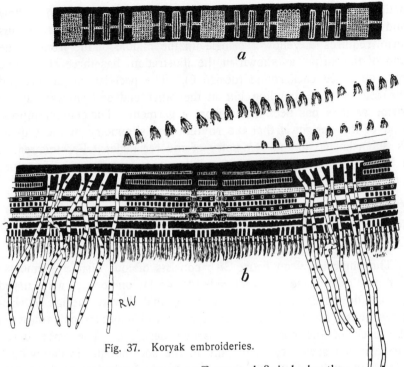

Fig. 37. Koryak embroideries.

than on top, and these are set off more definitely by the arrangement of groups of white lines on the lower two rows.

Still more complex are a number of borders embroidered in colored yarn. In these we may distinguish between the rhythm of form and of color (fig. 38). The arrangement is one combining symmetry with rhythmic complexity. On one of these strips (fig. 38 a) some of the rectangles with rhombic checkerwork have a white background; in these there are two rows of blue or purple diamonds at each end and two rows of red diamonds in the centre (design 1). Other rectangles have a yellow background with red diamonds at the sides and blue ones in the middle (design 2). Besides these there is one with red background and black diamonds (design 3). The colors of the crosses are irregularly arranged. There are four with predomi-

nating red and white (design 4) and others with predominating yellow and blue (design 5). The most symmetrical arrangement of this strip requires a yellow rectangle in the middle of the front. One end of the stripe, as shown in the illustration, has three short blue bars on a red background (design 6). The peculiar cut at this end fits into a corresponding cut at the other end and shows that the stripe as it is has been taken from a garment. The general impression of the design is that the rhythm and symmetry of the crosses is subordinated to the symmetry of the rectangles. For this reason I have placed the crosses in the following arrangement in the upper line, the rectangles in the lower line.

Crosses	4	5	5	5	4	5	4	4		5	4	6
Rectangles		2	1	1	2	1	1	2		1	3	1

<div align="center">Front Back</div>

The embroidery on figure 38 b consists of four distinct elements; a flower with leaves on each side (design 1); one branch with curved leaves (design 2); one branch with terminal flowers (design 3). Besides these there is one other element which occurs only once on the back of the coat. It is marked design 4. The embroidered stripe is not sewed symmetrically to the coat but has evidently been placed in such a way that the arrangement in the front of the coat corresponds to the sequence:—

<div align="center">2 3 2 1 *3* 1 2 3 2</div>

while the back is occupied by three designs (3). The small design (4) is found on the back. The whole arrangement of the small designs on the back being

<div align="center">2 2 4 2</div>

Another specimen (fig. 38 c) consists of a double leaf design on a plain background alternating with another design consisting of three crosses. This pair of designs occurs in regular succession five times, but under the left arm it is interrupted by the two patterns shown on the right hand side of the figure.

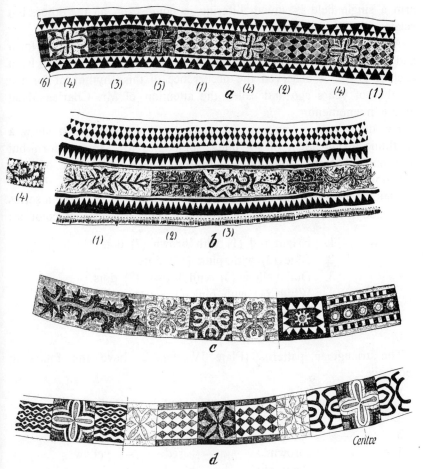

Fig. 38. Koryak embroideries.

In still another coat (fig. 38 d) we find the same series of designs in symmetrical arrangement on the front and back. The middle is occupied by a cross and the other designs follow as indicated. Under the right arm appears an additional design, consisting of a central cross and rhomboidal fields with central dots; while under the left

arm a single field is added differing in color from all the others but related to them in form.

An interesting feature in this series is the overlapping of form and color. This condition appears even more clearly in designs from ancient Peru. I observed the occurrence of this rhythmical form a number of years ago and called the attention of Mr. Charles Mead to the phenomenon.

He described[1] a number of designs of this type which show a rhythmic arrangement of six units, sometimes the same in form but different in color. Sometimes with a double rhythm, one of form and one of color.

Plate IV, fig.1 represents a border of vicuna wool, consisting of a series of diagonal bars all of the same pattern. The sequence of color is:

1. Bright red (1) with brown (7) dots.
2. Blue (2) with pink (1*) dots.
3. Dull yellow (3) with brown (7) dots.
4. White (4) with pink (1*) & brown (7) dots.
5. Dark green (5) with red (1) dots.
6. Red (1) with green (2) dots.

The triangular patterns (Plate IV, fig. 2) have the following sequence:

1.	Background	white	figures	red	spots	dark blue.
2.	—	dark blue	—	red	—	dark yellow.
3.	—	yellow	—	red	—	dark blue.
4.	—	brown	—	red	—	yellow.
5.	—	light blue	—	red	—	dark yellow.
6.	—	dark yellow	—	red	—	light blue.

The quadruple bird head pattern (Plate IV, fig 3) has the following colors for the background, bird, and bird's eye:

[1] Charles W. Mead, Six-Unit design in Ancient Peruvian Cloth, Boas Anniversary Volume, New York 1906, pp. 193 et seq.

PLATE IV.

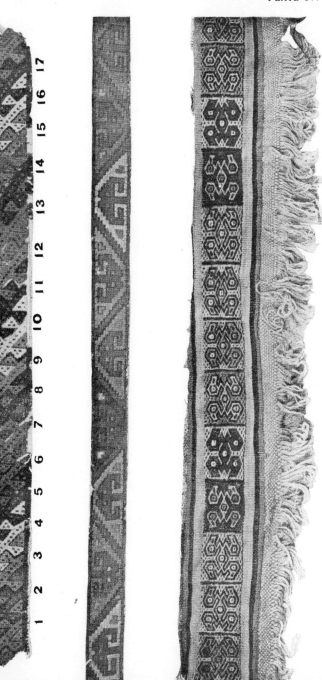

Peruvian Textiles.

1. Background pink	1 bird: yellow	eye: pink.
2. — yellow	2 — red	— yellow.
3. — dark yellow	3 — light yellow	— yellow.
4. — dark red	1ᵃ — yellow	— pink.
5. — yellow	2ᵃ — dark red	— yellow.
6. — dark yellow	3ᵃ — light yellow	— light yellow.

A large cloak from Ica is embroidered with designs representing a man with a bow and head dress (fig. 39). The figures are the same all over, except that the position and the objects they hold alternate right and left. The color scheme, however, varies: there are six distinctive types. Considering only the colors of coat, legs and face we may arrange them in the following order:

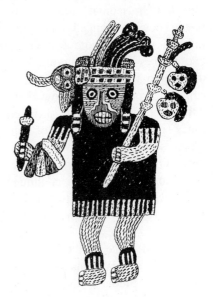

	Coat.	Legs.
1.	Yellow	dark blue
2.	purple	red
3.	red	dark blue
4.	blue	dark yellow
5.	black	dark blue
6.	dark blue	black

	Face, above.	Face, below.
1.	dark yellow	black
2.	yellow	white
3.	brown	dark yellow
4.	blue	red
5.	brown	dark yellow
6.	dark yellow	light yellow

Fig. 39. Peruvian embroidery from Ica.

The fifth and sixth type correspond in the rest of their color schemes to the third and second types.

The general arrangement of these types is as follows:

1	2	3	4	1	2	3a	4	1	6	5a	4	1	
3	4	1	2	3	4	1	6	5	4	1	2	3	4
2	3	4	1	2	3	4	1	6	5	4	1	2	3
4	1	2	3	4	1	6	5	4	1	2	3	4	1
3	4	1	2	3	4	1	6	5	4	1	2	3	4
1	2	3	4	1	6b	5	4	1	2	3	4	1	2
4	1	2	3	4	1	6	5	4	1	2	3	4	1
2	3	4	1	6	5c	4	1	2b	3c	4	1	2	3
1	2	3	4	1	6	5	4	1	2	3	4	1	

In the actual arrangement there are apparently three mistakes. In the first horizontal line, the two figures marked with the note *a* have been exchanged. In line six and line eight the two figures marked with the note *b* have been transposed and in line eight the two figures with the note *c* have been exchanged. It will be seen that when these transpositions have been effected the diagonal lines running from the first row down to the left, follow a regular alternation of types. Type 6 is clearly related to 2, and type 5 to 3. Since in quite a number of woven garments regular diagonal sequences may be observed, it seems likely that these were particular determinants of the style. There are in all, six different types, but if we imagine the lines continued, it would be found that the same order will occur after twelve lines. The embroidery does not represent a regular six unit design but is rather a four unit design of two distinct types—1 2 3 4 and 1 6 5 4,—in which the former type is repeated twice and the latter once.

Similar observations may be made on the fabrics illustrated in Reiss and Stübel's "Necropolis of Ancon". I have selected a few specimens that illustrate the rhythmic repetition of color. Figure 40 [1] represents a band with red background on which are animal figures in the following sequence:

purple, yellow, *green*, yellow, *white*, yellow, *green*, yellow

[1] Reiss and Stübel, Necropolis of Ancon, p. 67 b, fig. 3.

in other words a sequence of eight units consisting of one purple and one white design interrupted by the symmetrical color sequence yellow, green, yellow. The yellow designs are surrounded by a heavy black border.

In figure 41 [1] we have another band which consists of diagonal patterns framed by red lines except in one place where a black

Fig. 40. Peruvian fabric.

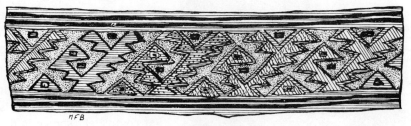

Fig. 41. Peruvian fabric.

frame is found. As on the preceding specimen the black serves to separate the red and yellow. The design is the same all through, and the order of the elements as follows:

yellow red yellow brown yellow
 black frame black zig-zag red frame red zig-zag red frame

 blue-green yellow purple
 red zig-zag red frame red zig-zag

In other words the essential sequence is yellow, red, yellow, brown, yellow, blue-green, yellow, purple; a series of eight elements.

[1] Ibid, p. 67, fig. 6.

4 — Kulturforskning. B. VIII.

In figure 42 we find a border of simple interlocking S shaped designs in the order, white, dark blue, light blue, yellow, brown; a series

of five elements which are repeated regularly.

Fig. 42. Peruvian fabric.

Figure 43 represents a part of a design on a poncho in which, from above downward we have a series of six pairs of a fret design in the following arrangement:

Fig. 43. Peruvian fabric.

green, red
yellow, blue
white, purple
yellow, brown
ligt red, black

the sixth line repeats the color sequence of the first.

Figure 44 is a somewhat complicated design which is not completely shown in the section here represented. The principle of the pattern is illustrated in figure 44 *b.* The sequence of color of the S shaped head design is purple, yellow, green, on a red background.

In figure 45 we have a decorative band with the color sequence yellow, green, yellow, green, light yellow, white, yellow, green, yellow; obviously a series of six units. The designs on the background of these colors are all in red.

In figure 46 a border is shown which has the color arrangement, from left to right:

Fig. 44. Peruvian fabric.

Fig. 45. Peruvian fabric.

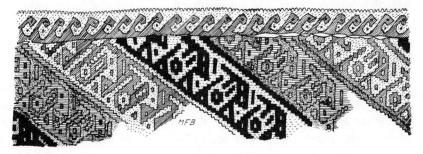

Fig. 46. Peruvian fabric.

> pink—black,
> red—yellow,
> light gray—dark gray,
> black—pink,
> yellow—red,
> dark gray—light gray.

In this specimen there is a systematic inversion of color values; what is light in the first set of three is dark in the second three. This tendency is quite marked in a considerable number of cases. We have for instance, a series of

> white, red, yellow;—gray, pink, yellow,

where the white corresponds to the dark gray and the red to the light pink.

The tendency to this repetition of colors is shown very clearly in Mexican codices. For example in the Codex Nuttall, p. 82 (fig. 47), we find in the figure in the left hand lower corner a base in which stepped triangles are used with the sequence: yellow, red, black, yellow, purple, reddish brown. On the same page, the feather fringes on the coats of the figures represented are in the same order. Quite a number of feather dresses may be found in which the same order is preserved, as for instance on page 81 of the same Codex. The order in which these colors are given runs sometimes from left to right; sometimes from right to left, as for instance in the feather dress of the lowest left hand figure, page 81. Sometimes a different set of colors is used. On the feather head dress of a figure, page 75, we find the order:

> white, red, yellow, blue, purple, brown,
> white, purple, yellow, blue, red, brown (twice),

and the latter order is repeated in figures found on page 67 in the left hand lower corner on a base; in reverse order on page 67 on a feather coat and also on page 62 in stripes on the figures in the lower right hand corner. It seems that in this codex the order of colors is quite definitely fixed.

Remarkable rhythmic repetitions are found also on bead work from the Zambesi. On quite a number of specimens the following order of colors is regularly repeated:

Black white red yellow *green* yellow red white. Or written in another way: *Green* yellow red white *black* white red yellow.

Fig. 47. Patterns from Mexican Codex.

These occur on a belt, a woman's apron, a necklace, and on two mats[1]. In a number of places blue is substituted for green, and brown for red.

The rhythmic repetition and symmetry appears most clearly when we substitute numbers for colors. I designate

White 1, Red 2, Yellow 3, Brown 3′, Blue 4, Green 4′, Black 5.

[1] Muller et Snelleman, L'industrie des Caffres dans le sud-est de l'Afrique. Pl. XIX figs. 3, 5, 7. Pl. XXIV figs. 1, 2.

According to the description of the belt first mentioned, as given by the authors, there is a regular repetition in the following order:

1 2 3 | 4 | 3' 2 1 | 5 | 1 2 3 | 4' | 3 2 1 | 5 |
1 2 3 | 4' |

The same order is found on the handle of an axe which is decorated with colored zigzag lines [1].

On a pouch [2] there is a lower field arranged in rows of diamonds, followed by a middle field consisting of zigzag bands, and an upper field consisting again of diamonds.

In this the order is from below upward

2 1 5 1 2 3 4 3 2 | 4 3 5 1 5 3 5 1 |
 diamonds zigzags
 2 3 4 3 2
 diamonds.

Like symmetry, rhythmic repetition runs generally on horizontal levels, right and left, although not quite as preponderantly as symmetry.

Piling up of identical or similar forms occurs in nature as often as lateral symmetry. Plants with their vertical succession of leaves, branches of trees, piles of stones, ranges of mountains rising behind one another, may suggest vertical arrangements of similar elements. However, much more common are repetitions in horizontal bands; of simple arrangements of single strokes in rows; and of complicated successions of series of varied figures that recur in regular order (fig. 48, Plate V).

It follows from what has been said before that the forms here discussed are not expressive of specific emotional states and in this sense significant.

This conclusion may be corroborated by a further examination of decorative forms.

We have already indicated that the artistic value of an object is not due to the form alone, but that the method of manufacture

[1] *Ibid.* plate XI, fig. 1.
[2] *Ibid.*, plate XXIV, fig. 3.

PLATE V.

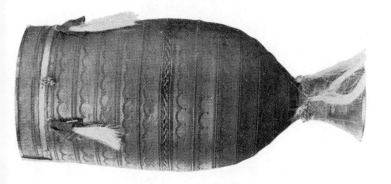

Kumiss Goblets of the Yakut.

gives to the surface an artistic quality, either through its smoothness or through a patterning that results from the technical processes employed. However, the treatment of the surface is not controlled solely by technical processes. We may observe that in the art products of people the world over other elements occur that are due to the attempt to emphasize the form.

The application of marginal patterns is one of the most common methods employed for this purpose. In many cases these are technically determined. When, for instance, a woven basket is finished off, it is necessary to fasten the loose strands and this leads generally to a change of form and surface pattern in the rim. The strands may be turned down, wrapped and sewed together, they may be braided, or woven together and left

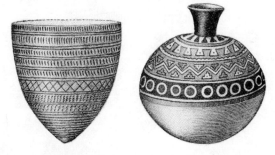

Fig. 48. Pottery vessels: *a* Finland; *b* Ica, Peru.

standing as a fringe. In a bark basket the rim must be strengthened by a band, to prevent splitting of the bark, and the band and the sewing set off the rim from the body. A thin·metal disk may have to be strengthened by rolling in the outer rim.

The birchbark basketry of western North America and of Siberia presents an excellent example of a marginal pattern originating through technical necessity and regularity of motor habits. Necessary protection of the rim is obtained by sewing on a hoop. The grain of the bark runs parallel to the rim and if the stitches were all passing through the same grain the whole rim of the basket would tear off. It is therefore necessary to make the holding stitches of different lengths. This is done in the most effective way by beginning with a short stitch which passes through the bark immediately under the strengthening hoop, by making the next stitch a

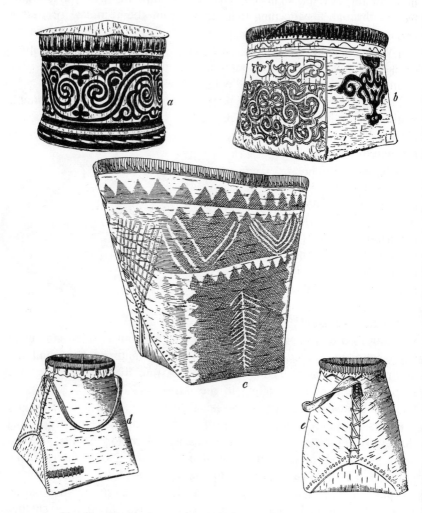

Fig. 49. Birchbark vessels; *a, b*, Amur River; *c*, Shuswap;
d, e, Alaska.

little longer and the following still longer. In this way the distance from the first short stitch has become long enough to permit a repetition of the new short stitch and by continuing in this way a marginal pattern of right triangles develops. The same result may be attained by alternating a few short stitches with a few long ones. From this results a different type of pattern. The same method is used by the Golds of southeastern Siberia (fig. 49 [1]).

In woodwork, pottery and in most kinds of metal work these technical motives are not present. Nevertheless marginal patterns are widely distributed, although they cannot be explained on the basis of technical considerations. It would be quite arbitrary to claim that all these marginal patterns were primarily suggested in those types of technique in which a distinctive treatment of the margin is a necessity, for these are relatively few in number and of highly specialized character, while rim patterns are well nigh universal. It is instructive to observe that in coiled pottery the whole body of the vessel is generally polished off and that sometimes the impressions of the modelling fingers are left on the rim. There is no technical, compelling reason that requires this mode of treatment, but it is intelligible as an attempt to emphasize the form. Examples of this mode of treatment are very numerous. Rows of small pellets,

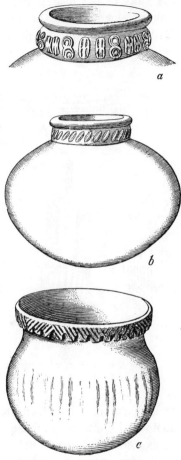

Fig. 50. Pottery vessels; *a, b,* Chiriqui, Costa Rica; *c* Ontario.

[1] See for a fuller description the remarks by F. Boas in James Teit "The Shuswap", Publications of the Jesup North Pacific expedition, Volume II, page 478—487.

moulded rims or incised lines along the rim of pots (fig. 50), small
marginal curves along the rim of bronze disks, lines accompanying
the rims of flat dishes and spoons such as are used by the Alaskan
Eskimo, incised lines on the rim of a soapstone pot of the Hudson
Bay Eskimo, and on their ivory combs (fig. 51), the spur line
decoration of all the Eskimo tribes (see fig. 78, p. 86), the jutting

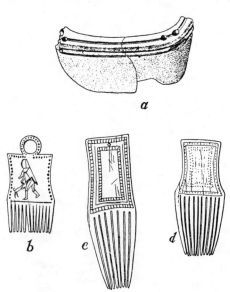

Fig. 51. *a,* Part of soapstone kettle;
b, c, d, Ivory combs, Eskimo.

out of the rims of dishes
from Oceania, or on pots
from ancient Europe are of
this kind. As F. Adama van
Scheltema has justly pointed
out, we cannot reduce
this world-wide tendency
to any other ultimate cause
than to a feeling for form,
in other words, to an esthetic
impulse that prompts man
to emphasize the form of
the object that he has made.

In a number of cases the
form is not so much ac-
centuated as rather set off,
closed in and separated from
the surrounding space by a
formal limitation, a marginal
line, thickening of the rim

or a sharp crest, by which means the individualization of the object is
attained. Quite often these limiting bands develop into decorative
fields and serve the double purpose of limitation and of decoration.
They may attain an individuality of their own.

When the surface itself is decorated, these lines or ornamental
bands serve the additional purpose of limiting and closing the decora-
tive field. Examples of this kind are very numerous. We find
them in borders of our rugs, in architectural decoration, when the

corners and roof lines of a building are formed by ornamental stone work, in book binding,—in short in practically all forms of modern decorative art, but no less in primitive art. Blankets of the Alaskan Indians (see figs 269 et seq., pp. 259 et seq.), bronze work of ancient Scandinavia, prehistoric pottery of Europe and of Central America, gable boards of New Zealand houses, belts from New Guinea, baskets from British Guinea (fig. 81, p. 90) and wooden cups from the Congo region illustrate this tendency (fig. 52).

Fig. 52. Wood carving, Bambala, Congo.

There are, however, many cases in which the decoration is so closely adapted to the form of the object that the stimulus for developing a closing outline is not felt. The decoration of the field appears as a picture fitted into the object. In still other cases the smooth, undecorated marginal field serves as a border setting off the central ornamented area. In basketry with radial decoration, we find often a lack of border designs and a tendency to let the ornament run right up to the rim where it seems cut off.

Another characteristic trait of decorative art must be mentioned. Not only is the general form emphasized and limited, but its natural divisions are determining elements in the application of decorative patterns and bring it about that the decoration is arranged in distinct fields. This is very apparent in pottery in which a neck is set off from a body or in which the body is divided by a sharp angle into an upper and a lower part. Such types are found in prehistoric European art as well as in America (fig. 53).

On pouches of American Indians (fig. 54) body and flap are treated as separate units. In moccasins, the uppers form a field separate from the rim (fig. 55). In clothing, the patterns on collars, pockets or sleeves are often considered as separate units. Wissler has called attention to the influence of the structure of garments upon their decoration [1].

The tripartite division of the decorative field of Alaskan woven blankets is determined by the position of the blanket. The wider

Fig. 53. Pottery vessel,
Molkenberg type,
Megalithic period.

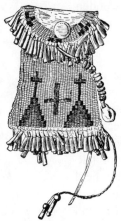

Fig. 55. Embroid-
ered moccasin,
Apache.

Fig. 54. Pouch, Arapaho.

middle field is on the back of the wearer, the narrower, lateral fields are in front of the body (see figs. 269 et seq., pp. 259 et seq.).

In garments made of single pieces of fabric, or in sewed basketry (fig. 56) we find the seams sometimes decorated so that the seam becomes a decorative element. In other cases seams are accompanied by decorative bands. In leggings and shirts of American Indians the seams are often emphasized by the attachment of fringes.

In other objects prominent places are elaborated by the addition of decorative elements.

In clay pots, the handles are so treated (fig. 57). On shields the

[1] Clark Wissler, Structural Basis to the Decoration of Costumes among the Plains Indians, Anthrop. Papers Am. Mus. Nat. Hist., Vol. 17, pp. 93 et seq.

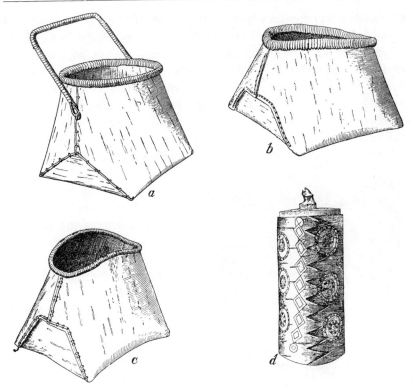

Fig. 56. Birchbark vessels; *a*, *b*, *c*, Eastern Indians; *d*, Koryak.

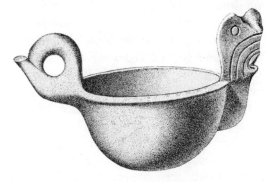

Fig. 57. Pottery vessel, Arkansas.

central knob becomes an object of decoration. The handles of canes or other knob-like terminations are often elaborated as decorative elements.

Sometimes fields without natural breaks, such as wall surfaces, are treated as units. Examples of this kind are our modern wall papers, or the painted walls of ancient Egyptian buildings. Often the tendency to break up the decorative field is so strong, that even where a natural division is not given it may be broken up into smaller parts. We may notice particularly that the marginal lines which emphasize or limit the form, develop exuberantly and thus encroach more and more upon the body of the object. In baskets from the interior of British Columbia the marginal pattern has grown to such an extent that it occupies the whole upper half or even more of the basket and is itself sub-divided into a number of fields that follow the outline of the margin (fig. 58). Similar conditions are found on the margins of blankets of the New Zealanders

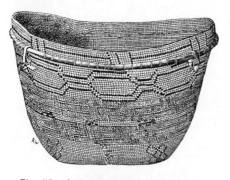

Fig. 58. Imbricated basket, Chilcotin, British Columbia.

(see Plate VIII, p. 182) and on the bronze work of ancient Scandinavia.

Thus we reach the conclusion that a number of purely formal elements, some of which are more or less closely connected with technical motives, others with physiological conditions of the body and still others with the general character of sense experience are determinants of ornamental art. From this we conclude that a fundamental, esthetic, formal interest is essential; and also that art, in its simple forms, is not necessarily expressive of purposive action, but is rather based upon our reactions to forms that develop through mastery of technique. The same elements play also an important role in highly developed art forms. If it is true that these elements **are** in part not purposive, then it must be admitted that our relation

to them is not essentially different from those we have towards esthetically valuable phenomena of nature. The formal interest is directly due to the impression derived from the form. It is not expressive in the sense that it conveys a definite meaning or expresses an esthetic emotion.

It might be thought that this condition prevails only in the domain of decorative art, and that representative art, dance, music, and poetry must always be expressive. This is to a great extent true so far as representative art is concerned, for the term itself implies that the art product represents a thought or an idea. It is also necessarily true in poetry, in so far as its materials are words that convey ideas. Nevertheless a formal element may be recognized in these also, a form element quite analagous to the one we found in decorative art. It determines certain aspects of the characteristic style. So far as representative art is ornamental, the formal principles of decorative art enter into the composition and influence the representative form. In dance, music and poetry, rhythm and thematic forms follow stylistic principles that are not necessarily expressive but that have objectively an esthetic value. We shall discuss these questions more fully at another place [1].

[1] See p. 301.

REPRESENTATIVE ART

While the formal elements which we have previously discussed are fundamentally void of definite meaning, conditions are quite different in representative art. The term itself implies that the work does not affect us by its form alone, but also, sometimes even primarily, by its content. The combination of form and content gives to representative art an emotional value entirely apart from the purely formal esthetic effect.

If has been customary to begin the discussion of representative art with a consideration of the simple attempts of primitive people or of children to draw objects that interest them. I believe that the art problem is obscured by this procedure. The mere attempt to represent something, perhaps to communicate an idea graphically, cannot be claimed to be an art; just as little as the spoken word or the gesture by means of which an idea is communicated, or an object,—perhaps a spear, a shield or a box,—in which an idea of usefulness is incorporated, is in itself a work of art. It is likely that an artistic concept may sometimes be present in the mind of the maker or speaker, but is becomes a work of art only when it is technically perfect, or when it shows striving after a formal pattern. Gestures that have rhythmical structure, words that have rhythmic and tonal beauty are works of art; the implement of perfect form lays claim to beauty; and the graphic or sculptural representation has an esthetic, an artistic value, when the technique of representation has been mastered. When a tyro attempts to create a work of art, we may recognize and study the impulse, but the finished product teaches only his vain efforts to master a difficult task. When man is confronted with a new problem like the building of a house of new, unfamiliar material, he is apt to find a solution, but this achievement is not art, it is a work adapted to a practical end. It may be that the solution is intuitive, that is, that it has not been found by an intellectual process, but after having been solved it is subject to a rational explanation.

Just so when man has to represent an object, he is confronted with a problem that demands a solution. The first solution is not an artistic but a practical achievement. We are dealing with a work of art only when the solution is endowed with formal beauty or strives for it. The artistic work begins after the technical problem has been mastered.

When primitive man is given a pencil and paper and asked to draw an object in nature, he has to use tools unfamiliar to him, and a technique that he has never tried. He must break away from his ordinary methods of work and solve a new problem. The result cannot be a work of art, — except perhaps under very unusual circumstances. Just like the child, the would-be artist is confronted with a task for which he lacks technical preparation, and many of the difficulties that beset the child beset him also. Hence the apparent similarity between children's drawings and

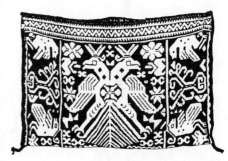

Fig. 59 *a*. Embroidery, Huichol Indians, Mexico.

those of primitive man. The attempt of both are made in similar situations. A most characteristic case of this kind was told to me by Mr. Birket-Smith. He asked an Eskimo of Iglulik to draw with a pencil on a piece of paper a walrus hunt. The native was unable to accomplish this task and after several attempts he took a walrus tusk and carved the whole scene in ivory, a technique with which he was familiar.

The contrast between representation for the sake of representation and representation as a work of art appears clearly in many cases. I select a few examples. The Indians of the mountains of north-western Mexico wear beautifully embroidered or woven clothing, the designs of which are largely based on Spanish motives. Heraldic patterns and isolated animal figures combined with geometrical forms are the constituent elements (fig. 59 *a*). Besides these embroidered

and woven fabrics, which are of excellent workmanship, we find small embroidered rags (fig. 59 *b*), which are attached to arrows and serve the purpose of representing a prayer to a deity. A roughly

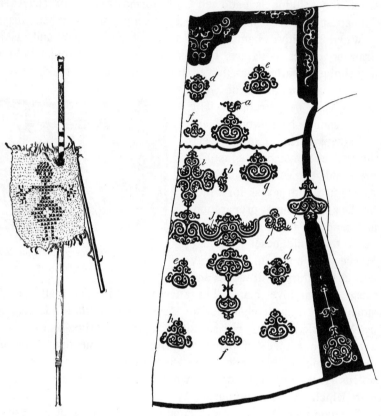

Fig. 59 *b*. Embroidery, Huichol
Indians, Mexico.

Fig. 60. Decorated fishskin garment,
Amur River.

outlined figure of a child expresses a prayer for the health of the child; that of a deer, a prayer for success in hunting. The arrows with the attached rags are stuck into the thatched roof of a temple where they are allowed to decay. They are not intended as works

PLATE VI.

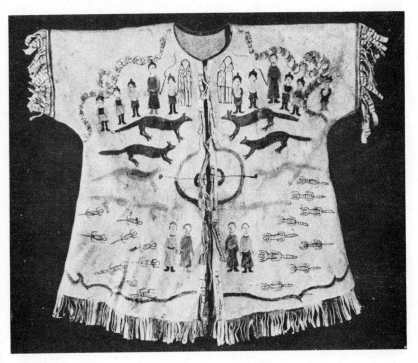

Shaman's Dress, Amur River.

of art but only as representations that serve a temporary purpose; hence the disregard of form and of exactness of workmanship.

Quite similar observations may be made on the clothing of the Amur tribes. The skin clothing worn by the people, particularly on festive occasions, is beautifully ornamented in appliqué, or by painting. The ornaments are in part geometrical, in part representative. Figures of birds and fish abound (fig. 60). On the other hand the painted dresses of shamans are roughly executed (Plate VI). They represent

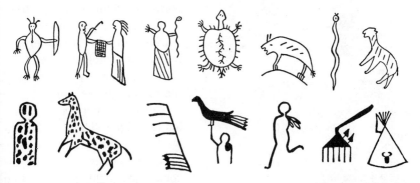

Fig. 61. Upper row, pictographs of Ojibwa Indians; lower row, of Dakota Indians.

mythological concepts and have a value solely on account of their meaning. The interest does not center in the form. As compared to wearing apparel they are crudely done, for the beauty of execution is of minor importance.

A third example is found among the North American Indians of the Great Plains. Their representative art, in the strict sense of the term, is almost entirely confined to a crude form of picture writing. They have not developed a high technique of painting and the forms of horses, men, buffaloes and tents are merely reminders of incidents in the life of the people. The figures (fig. 61) are in no way ornamental and bear no relation to the object on which they are depicted. They are made for the purpose of representation only. They are not art in the rigid sense of the term. Judging from the character

of the figures and their use we may safely say that the artistic interest is entirely absent. We may even apply this observation to the picture writing of the ancient Mexicans (fig. 62), which, as compared to their sculpture, is of inferior value. The importance of communicating ideas outweighs the artistic interest. We shall see later on that nevertheless there is a definite relation between artistic style and the forms of inartistic painting (see p. 164).

Incidentally it may be remarked here that the difference in interest sometimes leads to contrasting art styles, provided the representative work is also executed in a perfectly controlled technique. Thus the Northwest Americans who have a very characteristic style of art sometimes make carvings that are intended to deceive by their realism. In one of their ceremonies a person is apparently decapitated and after the decapitation the head is shown held by the hair. This head is carved in wood and done with great care in a most realistic fashion. It is entirely free of the stylistic characteristics of Northwest coast carving and painting (see fig. 156, p. 185).

Fig. 62. Mexican painting from Codex Borbonicus.

We revert now to a consideration of the simple, crude representative drawings. The most important inference that may be drawn from the study of such representations, graphic as well as plastic, is that the problem of representation is first of all solved by the use of symbolic forms. There is no attempt at accurate delineation.

Neither primitive man nor the child believes that the design or the figure he produces is actually an accurate picture of the object to be represented. A round knob on an elongated cylinder may represent head and body; two pairs of thin, straight strips of rounded cross section, arms and legs; or in a drawing a circle over a rectangle may suggest head and body; straight lines, arms and legs; short diverging lines at the ends of arms and legs, hand and feet.

The break between symbolic representation and realism may occur in one of two ways. The artist may endeavor to render the form of the object to be represented in forceful outline and subordinate all consideration of detail under the concept of the mass as a whole. He may even discard all details and cover the form with more or less fanciful decoration without losing the effect of realism of the general outline and of the distribution of surfaces and of masses. On the other hand, he may endeavor to give a realistic representation of details and his work may consist of an assembly of these, with little regard to the form as a whole.

a *b*

Fig. 63. *a*, Carved figure, Philippine Islands; *b*, Marble figure represending harpist, Thera.

An excellent example of the former method is the Filipino wood carving, fig. 63 *a*. Head and chest show the concentration of the artist upon the delimiting surfaces and an utter disregard of detail. The same method is used in the figure of a harpist belonging to the ancient art of the Cyclades (fig. 63 *b*).

In fig. 64, an African mask, the surfaces of forehead, eyes, cheeks and nose are the determinants of the form which has been treated decoratively with the greatest freedom. There are no ears; the eyes are slits with geometrical ornaments; the mouth a circle emclosing

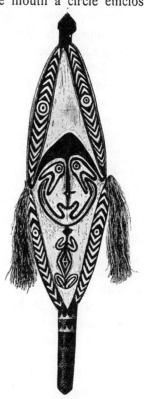

Fig. 64. Wooden mask,
Urua, Congo.

Fig. 65. Carved board,
Papua Gulf, New Guinea.

a cross. In fig. 65, representing a painted carving from New Guinea, the outline of the face, emphasized by the hair line, eyes, and mouth, is easily recognized, but all the other parts are treated purely decoratively.

The opposite method is found, for instance, in Egyptian paintings and reliefs in which eyes, nose, hands, and feet are shown with a

fair degree of realism, but composed in ways that distort the natural form and which are perspectively impossible (fig. 66). A still better example is the drawing, fig. 67, an attempt of one of the best Haida artists from Northern British Columbia to illustrate the story of an eagle carrying away a woman. The face of the woman is evidently intended as a three-quarter view. Facial painting will be noticed on the left cheek; the left ear only is shown as seen in profile; the mouth with teeth is placed under the nose in mixed full profile and front view, and has been

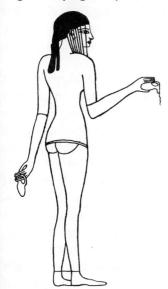

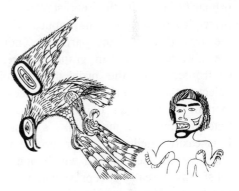

Fig. 66.
Egyptian painting.

Fig. 67. Haida drawing representing eagle carrying away a woman.

moved to the right side of the face. In the lower lip is a large labret shown *en face*, for only in this view was the artist able to show the labret with its characteristic oval surface. The nose seems to be drawn in profile although the nostrils appear *en face*.

In a graphic representation of objects one of two points of view may be taken: it may be considered as essential that all the characteristic features be shown, or the object may be drawn as it appears at any given moment. In the former case our attention is directed primarily towards those permanent traits that are most striking and

by which we recognize the object, while others that are not characteristic, or at least less characteristic, are considered as irrelevant. In the latter case we are interested solely in the visual picture that we receive at any given moment, and the salient features of which attract our attention.

This method is more realistic than the other only if we claim that the essence of realism is the reproduction of a single momentary visual image and if the selection of what appears a salient feature to us is given a paramount value.

In sculpture or modelling in the round these problems do not appear in the same form. Here also attention may be directed primarily towards the representation of the essential, and the same principles of selection may appear that are found in graphic art, but the arrangement of the parts does not offer the same difficulties that are always present in graphic representation. As soon as man is confronted with the problem of representing a three-dimensional object on a two-dimensional surface and showing in a single, permanent position an object that changes its visual appearance from time to time, he must make a choice between these two methods. It is easily intelligible that a profile view of an animal in which only one eye is seen and in which one whole side disappears may not satisfy as a realistic representation. The animal *has two* eyes and *two* sides. When it turns I see the other side; it exists and should be part of a satisfying picture. In a front view the animal appears foreshortened. The tail is invisible and so are the flanks; but the animal has tail and flanks and they ought to be there. We are confronted with the same problem in our representations of maps of the whole world. In a map on Mercator projection, or in our planiglobes, we distort the surface of the globe in such a way that all parts are visible. We are interested only in showing, in a manner as satisfactory as possible, the interrelations between the parts of the globe. We combine in one picture aspects that could never be seen at one glance. The same is true in orthogonal architectural drawings, particularly when two adjoining views taken at right angles to each

other, are brought into contact, or in copies of designs in which the scenes or designs depicted on a cylinder, a vase, or a spherical pot are developed on a flat surface in order to show at a single glance the interrelations of the decorative forms. In drawings of objects for scientific study we may also sometime adopt a similar viewpoint, and in order to elucidate important relations, draw as though we were able to look around the corner or through the object. Different moments are represented in diagrams in which mechanical movements are illustrated and in which, in order to explain the operation of a device, various positions of moving parts are shown.

In primitive art both solutions have been attempted: the perspective as well as that showing the essential parts in combination. Since the essential parts are symbols of the object, we may call this method the symbolic one. I repeat that in the symbolic method those features are represented that are considered as permanent and essential, and that there is no attempt on the part of the draftsman to confine himself to a reproduction of what he actually sees at a given moment.

It is easy to show that these points of view are not by any means absent in European art. The combination of different moments in one painting appears commonly in earlier art,— for instance when in Michel Angelo's painting Adam and Eve appear on one side of the tree of knowledge in Paradise and on the other side of the tree as being driven out by the angel. As a matter of fact, every large canvass contains a combination of distinct views. When we direct our eyes upon a scene we see only a small limited area distinctly, the points farther away appear the more blurred and indistinct the farther removed they are from the center. Nevertheless most of the older paintings of large scenes represent all parts with equal distinctness, as they appear to our eyes when they wander about and take in all the different parts one by one. Rembrandt forced the attention of the spectator upon his main figures by strong lights, as upon the swords in the great scene of the conspiracy of Claudius Civilis and his Batavians against the Romans, but the distant figures

are distinct in outline, although in dark colors. On the other hand, Hodler, in his painting of a duel draws compelling attention to the points of the swords which are painted in sharp outline while everything else is the more indistinct the farther removed it is from the point on which the interest of the artist centers.

Traits considered as permanent characteristics play a rôle even in modern art. Until very recent times the complexion of man was conceived as essentially permanent. At least the strong changes that actually occur in different positions have not been painted until very recent times. A person of fair complexion standing between a green bush and a red brick wall has certainly a face green on one side and red on the other, and if the sun shines on his forehead it may be at times intensely yellow. Still we are, or at least were, not accustomed to depict these eminently realistic traits. We rather concentrate our attention upon what is permanent in the individual complexion as seen in ordinary diffuse daylight. We are accustomed to see the accidental momentary lights weakened in favor of the permanent impression.

In primitive, symbolic representations these permanent traits appear in the same way, sometimes strongly emphasized. It will be readily seen that children's drawings are essentially of the character here described. They are not memory images, as Wundt claims, except in so far as the symbols are remembered and reminders, but compositions of what to the child's mind appears essential, perhaps also as feasible. A person has two eyes which have their most characteristic form in front view, a prominent nose which is most striking in profile; hands with fingers which are best seen when the palms are turned forward; feet the form of which is clear only in profile. The body is essential and so is the clothing, hence the so-called Röntgen pictures in which covered parts are drawn. These drawings are a collection of symbols held together more or less satisfactorily by a general outline, although single traits may be misplaced. The same traits prevail commonly in primitive drawings. When Karl von den Steinen had the South American Indians draw a white man, they

placed the moustache as a characteristic symbol on the forehead, for it sufficed to place it as a symbol on the most available space. The Egyptian paintings with their mixture of profile and front views and transparent objects through which hidden parts may be seen (fig. 68) must be viewed in the same manner. They are not by any means proof of an inability to see and draw perspectively; they merely show that the interest of the people centered in the full re-presentation of the symbols.

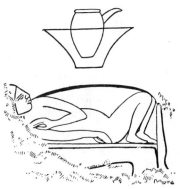

Fig. 68. Egyptian drawings; above: bowl and pitcher; below: sleeping person covered by blanket.

When exceptionally great weight is attached to the symbol, so that it entirely outweighs the interest in the outline, the general form may be dwarfed and forms originate that, from our perspective point of view, lose all semblance of realism. The most characteristic case of this kind is found in the art of the Northwest coast of America, in which the whole animal form is reduced to an assembly of disconnected symbols. A beaver is adequately represented by a large head with two pairs of large incisors and a squamous tail (see pp. 186 et seq.). However, in this case we are no longer dealing with crude representations, but with a highly developed art. Its form proves that in its development symbolic representation has been of fundamental importance.

The second form of representation is by means of perspective drawing, in which the momentary visual impression regardless of the presence or absence of characteristic symbols, is utilized. This method is not by any means absent in the drawings of primitive man as well as in those of children, but it is not as common as symbolic representation. In a way most crude symbolic forms contain a per-spective element, although it does not extend over the whole figure, but only over parts which are more or less skilfully put together,

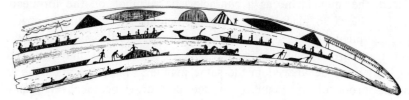

Fig. 69. Eskimo etching on walrus tusk, Alaska.

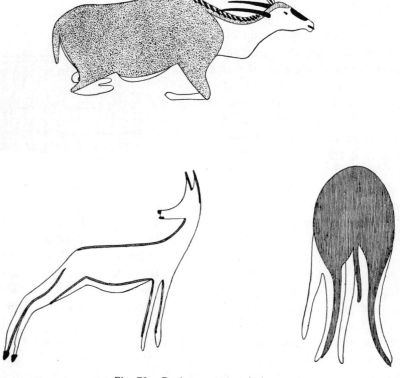

Fig. 70. Bushman rock paintings.

so that a semblance of the general outline is maintained. This is
the case in Egyptian paintings, in those of Australians and in North
American picture writing (see figs. 61, 62). In other cases the art
of perspective drawing rises to real excellence. The silhouettes of
the Eskimo may be mentioned as a case in point (fig. 69). Their

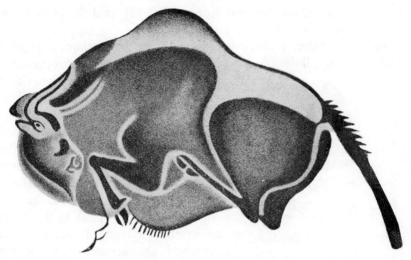

Fig. 71. Paleolithic painting representing bison.

figures are always small, scratched into ivory, antler or bone, and
filled with hachure or with black pigment. Form and pose are well-
done. Although there is generally no perspective arrangement of
groups, each figure is well executed and renders a single visual im-
pression. We find perspective of groups in the rock paintings of
South Africa (fig. 70), not perfect, but indicated by the overcutting
of figures and by the relative sizes of objects near by and of those
seen at a distance. Perspective realism of single figures is even
more fully developed in the paintings of later paleolithic man, found
in the caves of southern France and of Spain (fig. 71). Less skilful
efforts at perspective representation are not rare. On mattings from

the Congo region, on basketry hats from Vancouver Island (fig. 72) rather clumpsy attempts have been made. In those from the former region there are animals in profile in the latter whaling scenes: men going out in a canoe and hauling in a harpooned whale.

Much more common are carvings in wood, bone or stone, or pottery objects that are not symbolic but true to nature. Ivory carvings of the Eskimo, Chukchee and Koryak (fig. 73), prehistoric carvings, pottery from North America are examples.

As stated before, a sharp line between the two methods of graphic representation cannot be drawn. In most cases symbolic representa-

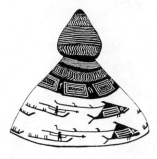

tions are at least in part perspective, either in so far as the general form is maintained, or as parts are shown in perspective form; while perspective representations may contain symbolic elements. When the Pueblo Indian paints the form of a deer with a fair degree of perspective accuracy (see fig. 142, p. 167), but adds to it a line running from the mouth to the heart

Fig. 72. Hat of the Nootka Indians. as an essential symbol of life; or when

the symbols are arranged with a fair degree of correspondence to perspective order we have forms in which both tendencies may be observed. Indeed, some degree of conventional symbolism is found in every drawing or painting, the more so, the more sketchy it is; in other words, the more the representation is confined to salient traits. This is particularly true in all forms of caricature.

If representative art did develop into absolute realism, stereoscopic color photography would be the highest type of art, but this is obviously not the case. Setting aside the emotional appeal of the object itself, an accurate copy of a natural object, such as a glass flower, a painted carving, an imitation of natural sounds or a pantomime may attain an intense emotional appeal, they may excite our admiration on account of the skill of execution; their artistic value

will always depend upon the presence of a formal element that is not identical with the form found in nature.

Stress must be laid upon the distinctive points of view from which the two methods of graphic representation develop, because the development of perspective drawing is often represented as growing

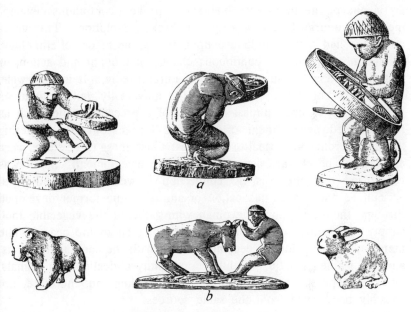

Fig. 73. Koryak carvings.

out of the cruder symbolic method. As a matter of fact the two have distinct psychologial sources which remain active in the early, as well as in the late history of art. Vierkandt[1] designates the various methods of representation as suggestive (andeutend), descriptive (beschreibend), and perspective (anschaulich). Of these the former two correspond to what I have called here symbolic. They

[1] Das Zeichnen der Naturvölker, Zeitschrift für angewandte Psychologie, Vol. 6, (1912), pp. 347 et seq.

differ only in the more or less fragmentary character of the symbols. The perspective type does not develop from the former two as the result of an evolution; it is based on a distinct mental attitude, the early presence of which is manifested by the realistic, perspective paintings of a number of primitive tribes.

The theory of a continuous development from symbolic to realistic art is one of the numerous attempts to prove a continuous development of cultural forms, a steady, unbroken evolution. This viewpoint has had a deep influence upon the whole theory of ethnology. Evolution, meaning the continuous change of thought and action, or historic continuity, must be accepted unreservedly. It is otherwise, when it is conceived as meaning the universally valid continuous development of one cultural form out of a preceding type, such as the assumed development of economic forms from food gathering through herding to agriculture. In past times these three stages were assumed to be characteristic of all human development, until it was recognized that there is no connection between the invention of agriculture and the domestication of animals,—the former developed through the occupation of woman who gathered the vegetable food supply, the latter through the devotion of men to the chase. The men had no occasion to become familiar with the handling of plants, and the women had just as little opportunity of dealing with animals. The development of agriculture and of herding can, therefore, not possibly be derived from the same sources.

It is no less arbitrary to assume that social forms must have developed in regular universally valid sequence, one certain stage always being based on the same preceding one in all parts of the world. There is no evidence that would compel us to assume that matrilineal organizations always preceded patrilineal or bilateral ones. On the contrary, it seems much more likely that the life of hunters in single family units, or that of larger groups in more fertile areas has led to entirely different results. We may expect continuous evolution only in those cases in which the social and psychological conditions are continuous.

After this brief excurse, let us revert to our subject. Representations become works of art only when the technique of their manufacture is perfectly controlled, at least by a number of individuals; in other words, when they are executed by one of the processes, that are industrially in common use. Where carving is practiced, we may expect artistic form in carvings; where painting, pottery, or metal work prevail, artistic form is found in the products of those industries in which the highest degree of technical skill is attained. The Eskimo carves in ivory, antler or bone, of which he makes his harpoons and many other utensils; his best representative work is made with the knife and consists of small carvings and etchings in which he applies the same methods that he employs every day. The New Zealander carves in wood, makes delicate stonework, and paints; his best representative work is made by these methods. Metal work and ivory carvings from Benin (fig. 74), headmasks from the Cameroons (fig. 75, p. 82), wood carvings from the Northwest coast of America (see figs. 154—156, pp. 184, 185), pottery from Peru, from the Yoruba country (fig. 76, p. 82), Central America and Arkansas (fig. 77, p. 85), basketry of the Pima, embroideries (see

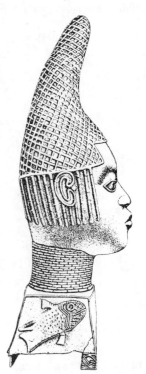

Fig. 74. Bronze casting, Benin.

fig. 39, p. 47) and woven fabrics of the Peruvians are other examples.

Since representations that are intended to have artistic value are made in the most highly developed technique it is not surprising that the formal style of the technique gains an influence over the form of the representation. The angular lines of weaving with coarse materials and the steplike forms of diagonals which are

determined by this technique impress themselves often upon representations and become part and parcel of a local style. There develops an intimate relation between the formal and representative elements that brings it about that representation receives a formal value entirely apart from its significance. The deeper the influence

Fig. 75. Headmask, Cross River, Cameroon.

Fig. 76. Terra cotta head from Ife, Yoruba country.

of the formal, decorative element upon the method of representation, the more probable it becomes that formal elements attain an emotional value. An association between these two forms of art is established which leads, on the one hand to the conventionalization of representative design, on the other to the imputation of significance into formal elements. It is quite arbitrary to assume a one-sided development from the representative to the formal or *vice versa*, or even to speak of a gradual transformation of a representative form into a conventional one, because the artistic presentation

itself can proceed only on the basis of the technically developed forms. At another place we shall discuss this subject more fully (see pp. 118 et seq.).

In all aspects of life may be observed the controlling influence of pattern, that is of some typical form of behaviour. As we think in a pattern of objective, material causality, primitive man thinks in a pattern in which subjective causality is an important element. As our personal relations to blood relatives are determined by the pattern of our family, so the corresponding relations in other societies are governed by their social patterns. The interpretation of the pattern may change, but its form is apt to continue over long periods.

The same stability of pattern may be observed in the art products of man. When a definite type has once been established, it exerts a compelling influence over new artistic attempts. When its control continues over a long period it may happen that representations are cast in an iron mould and that the most diverse subjects take similar forms. It appears then as though the old pattern had been misunderstood and new forms had developed from it. Thus, according to Von den Steinen, the figurines on carvings from the Marquesas, which originally represented two figures back to back, have determined the type of entirely new representations, or, as he prefers to put it, they have been misunderstood and developed in new ways. I do not doubt that in some cases this process of misinterpretation occurs, but it is not the one that interests us at this place. Striking examples of the overmastering influence of a pattern may be found in many parts of the world. The style of the Northwest coast of America is so rigid that all animal figures represented on plain surfaces are cast in the same mould (see pp. 185 et seq.); the overwhelming frequency of the spiral in New Zealand is another example; the interwoven animal figures of early medieval Germanic art; the angular patterns of the North American Indians (see p. 176); all these illustrate the same condition. In an art, the technique of which does not admit the use of curved lines and in which decorative patterns have developed, there is no room for curved lines, and the

curved outlines of objects are broken up into angular forms. The patterns, or as we usually say, the style, dominates the formal as well as the representative art.

However, the style is not by any means completely determined by the general formal tendencies which we have discussed, nor by the relations between these elements and the decorative field, but it depends upon many other conditions.

One more point must be discussed here. Attention has been called to the apparent absence of purely formal elements in the art of those tribes that are from an economical and industrial point of view most primitive, namely the modern Bushmen of South Africa, the Eskimo of Arctic North America, the Australians, and in remote times, the paleolithic hunters. The statement is not quite correct, as has already been pointed out by Vierkandt, because other tribes that live on the same industrial level, do not share these characteristics; particularly the Veddah and the Andaman Islanders. Furthermore, it is not by any means certain that the South African rock sculptures were made by the Bushmen. It seems fairly certain that the best ones of those recorded were made in early times and that the living Bushmen know little about their origin. In the South African paintings and petroglyphs and in the art works of the other tribes mentioned before, we find a highly developed realistic art which exhibits an astonishing truth of perspective perception, in rest as well as in motion. Verworn has based on this observation a distinction of what he calls the physioplastic and ideoplastic art; the former containing truthful, momentary visual images, the latter representing nature remodeled by thought and therefore, in a conventional style.

I do not believe that the assignment of these styles to distinct levels of culture is tenable, for physioplastic representations are not by any means confined to the tribes of simplest economic structure, nor, as indicated just now, are they common to all of them. We must avoid in these matters, as well as in all other ethnic questions, treating tribes too much as standardized units. Individual variation

in physical appearance as well as in mental life is as important in primitive society as in our own. There are artists and craftsmen in all forms of society, as there are believers and unbelievers; there are creative artists who rise above the level of the skilful artisan and tradesmen who are satisfied with a slavish, though accurate adhesion to existing patterns.

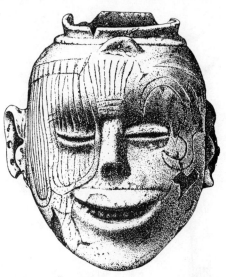

Fig. 77. Pottery head from Arkansas.

Where representative art has fallen under the rigid control of technique, there is little opportunity for the development of a naturalistic style; where the technique is free, there we may also expect free forms. This condition is realized in two ways, namely, in those cases in which representative art is not enslaved by a one-sided technique, and under conditions in which a high degree of freedom in the use of a variety of technical processes has been attained. A study of the whole range of art products shows that where a technique is practised that gives free range to the development of form, naturalistic forms, that is forms relatively free of stylistic mannerisms, although sometimes of bold generalization, occur. Carving in wood, bone, ivory or stone, and modelling in clay are the principal arts that give this freedom which is not so easily found in graphic representation. Therefore we find in many cultures that are otherwise under the strict control of conventional style, at least occasionally figures in the round that are naturalistic. Examples are found in the art of the North Pacific Coast; in bronze castings, wood carvings and clay figures of Africa (figs. 74—76); in pottery of the ancient inhabitants of Arkansas (fig. 77); and in

stone work from Mexico, as well as in Peruvian pottery. On the other hand, our modern realism is based on the emancipation from a single rigid style that controls all art production. Such freedom is not found to the same extent in primitive art with its more limited number of technical processes.

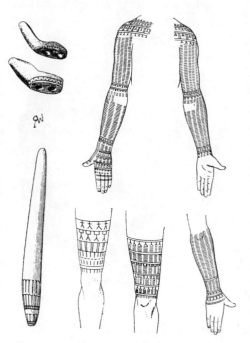

Fig. 78. Ivory and bone carvings, and tattooing of eastern Eskimo.

Another error seems to me to underly the theory propounded by Max Verworn. It is not only incorrect to assume that representations true to nature are confined to tribes on the lowest economic and industrial level, it can also be shown that at least those living at the present time have ideoplastic art as well as physioplastic art. This is particularly true of the Eskimo. While they do produce a remarkable number of realistic carvings and etchings, they also have a number of conventional, geometric designs which are of regular occurrence. Most prominent among these are the alternating spurline and the sequence of Y shaped figures (fig.78). The latter has sometimes a symbolic meaning, just as other conventional geometric designs among other groups of people. With small circles at the end of the bifurcated Y it is interpreted as a flower. Furthermore, the clothing of men and women is always decorated with motives that indicate or emphasize the parts of the body they cover, as the shoulderblades or the breastbone. Particularly among the Alaskan is this conventional art ideoplastic in the meaning of Verworn.

We have also shown examples of the geometric, ornamental art of the Bushmen (fig 8, p. 23); however, we do not know whether it has a symbolic meaning. Their ornamental art is very meagre because they have so little that can become the subject of ornamentation.

It seems more than likely that man of later paleolithic time whose implements are quite on the same level as those of modern primitive tribes, who adorned his body and who used geometrical ornaments on his bone implements, decorated also his clothing and other perishable possessions of which no trace remains. If we imagine the remains of the modern Indians of the plains, or those of Australians exposed for thousands of years to the wet climate of Europe, nothing would remain to give us an insight into the complexity of their culture and into the existence of their symbolic, that is, ideoplastic art.

SYMBOLISM

We have seen that in the art of primitive people two elements may be distinguished; a purely formal one in which enjoyment is based on form alone, and another one in which the form is filled with meaning. In the latter case the significance creates an enhanced esthetic value, on account of the associative connections of the art product or of the artistic act. Since these forms are significant they must be representative, not necessarily representative of tangible objects, but sometimes of more or less abstract ideas.

In our previous discussion we have also shown that representative art may be, and generally is, strongly influenced by technical form, so much so, that in many cases the natural prototype is not readily recognized.

It is remarkable that in the art of many tribes the world over, ornament that appears to us as purely formal, is associated with meanings, that it is interpreted. Karl von den Steinen found that the geometrical patterns of the Brazilian Indians represented fish, bats, bees, and other animals, although the triangles and diamonds of which they consist bear no apparent relation to these animal forms. The design on top in figure 79 represents bats, indicated by the black triangles. The figure below it represents the uluri, a small object of clay used by women in place of a breech clout. The third figure represents a fish, the large scales of which are indicated by diamonds. The fourth and fifth figures also represent fish, while the last one is called young bees.

A number af clay dishes that were said to represent animals were in part characterized by distinct heads, limbs, and tails, while others bore no resemblance to the forms that they were claimed by the natives to represent. A general similarity of form, however, exists between the purely conventional and the realistic forms, which suggested to Von den Steinen the conclusion that the former developed from the latter. Later on Ehrenreich corroborated these

observations both in South and North America. A small number
of designs with names are shown in fig. 80. The diamonds in the
first figure on top, represents wasps nests and may be compared to

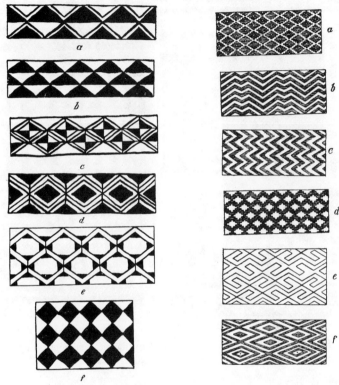

Fig. 79. Ornaments of the Auetö Brazil. Fig. 80. Ornaments of the Karayá.

the young bees in fig. 79. The zigzag band in the second figure, which
is symmetrically arranged and has rhythmically repeated elements of
unequal lengths, represents bats. In form these are identical with the
frigate bird of New Ireland (see fig. 101, p. 107). The third figure
from the top represents the marking on the skin of the rattlesnake,
and the remaining figures also are marks on the skin of various snakes.

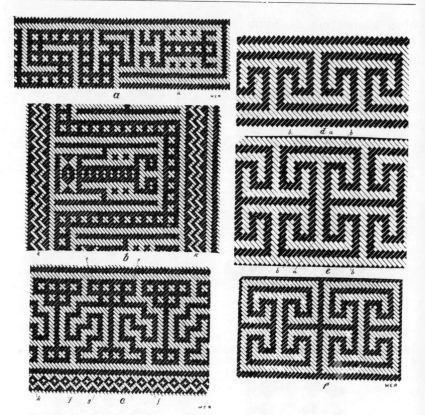

Fig. 81. Basketry patterns from British Guyana; *a*, snake pursuing frog; *b*, man; *c*, dog; *d—f*, wild nutmeg.

W. E. Roth has recorded the significance of basketry designs of the Indians of British Guiana.[1] Some of these designs contain realistic figures, but many of them are geometrical derivatives of zigzag bands and meandric forms such as occur on coarse twined basketry in many parts of the world. Most of these forms are

[1] W. E. Roth "Introductory Study of Arts, Crafts, and Customs of the Guiana Indians" 38th Annual Report, Bureau of American Ethnology, Washington 1924, pp. 354 et seq.

explained as animals; some identified by their form, others imitating the pattern of the skin or being suggestive of parts of the body. There are also a number of plant representations (figs. 81, 82). In some of these the meaning of the form is readily recognized as in the snake pursuing a frog (fig. 81 *a*) or in the human form (fig. 81 *b*). The body of the snake is represented by a broad meander, its head by a triangle. To the right of the head is the frog. Less evident is the dog shown in fig. 81 *c*. The interpretation of the designs in figs. 81 *d*, *e* and *f* and 82 seems quite arbitrary. The meanders fig. 81 *d—f* represent the wild nutmeg. In *e* the vertical connecting bar of the double T represents the main branches, the horizontal one the secondary branches.

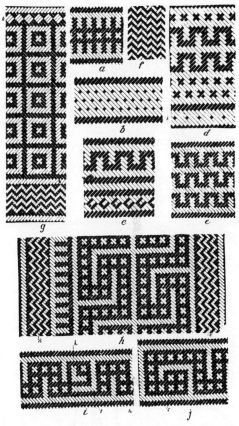

Fig. 82. Basketry patterns from British Guyana; *a*, Centiped; *b*, Savannah grass; *c—f*, Periwinkles; *g*, Butterflies; *h—j*, Snakes.

Fig 82 *a* is called the centipede, *b* savanna grass, *c—f* periwinkles, *g* butterflies, and the three designs *h—j* represent snakes. The square in the pattern in the left hand lower corner of *j* is the head of the snake.

Ehrenreich was the first to observe the highly developed symbolism of the North American Indians and his observation gave the impetus to the studies of North American art which were largely

instituted by the American Museum of Natural History in New York. His observations were made among the Cheyenne, and on account of their importance, they may be quoted here;[1] "Representations of heavenly phenomena are found in their highest development among the agricultural Pueblo tribes, whose whole cult consists essentially in

Fig. 83. Designs of the Cheyenne Indians.

magic performances intended to secure rain. Besides this, geographical motives are used, such as mountains, rivers, trails, camping sites, which are important to the Indians who inhabit the endless prairies. A typical example is found on the ornament taken from a moccasin (fig. 83 *a*) in which a dark blue series of triangles represent mountains, a light blue stripe a river, a red one a trail. A second ornament, also taken, from a moccasin (Fig. 83 *b*) shows a series of tents. Red dots in the triangular tents represent fire.

"The hoods of cradle boards are generally richly ornamented. The design of a specimen purchased by me is of peculiar interest on account of the representation of abstract ideas (Fig. 83 *c, d*). As usual, the upper surface of the hood is white, which color, in the

[1] Ethnologisches Notizblatt, vol. II, 1, pp. 27 et seq. (1899).

symbolism of the Indians designates the sky and life. The margin is formed by a green line and the whole surface is divided into three fields by two convergent blue lines. The large lateral fields are strictly symmetrical. They contain three groups of stars represented by rectangles. The lowest line,—four red rectangles with enclosed green centers,—represent large, bright stars; and the top row, red without centers, are the children of the stars. It is uncertain whether by this term the smallest stars or falling stars are meant.

"The middle field, bounded by blue lines, represents the path of life of the child. In this field are found peculiar green figures which terminate above and below in T shaped ends. They are diamond shaped and enclose a red and yellow checkerwork. They designate the child's good luck or the success that he will have in life. In this case green symbolizes growth and development; yellow, maturity and perfection; red, blood, life and good-fortune; all of which are related to the deities. The lower rim of the hood is interrupted on both sides by small white and blue squares. These are said to represent the child's age. I did not learn what was meant by this expression. Probably the change of seasons was meant, since the alternation of blue and white signifies the change of winter and summer.

"The hood ends in a square flap which bears in its center a green diamond terminating in cross bars, but smaller and simpler than the corresponding figures of the central field. It represents the heart. The blue lines and angles in the corners of the flap are continued in the same way on the opposite side. They represent the unexpected events of life. Attachments on each side are the child's ears; the short lines of beads embroidered on the back of the flap represents the hair of the child."

Based on these results a somewhat extended study of the symbolism of American Indian art was undertaken, in the course of which A. L. Kroeber investigated the art of the Arapaho; Roland B. Dixon, that of the Californian tribes; Clark Wissler, that of the

Sioux and Blackfeet, and H. H. St. Clair that of the Shoshone. Later on the study was extended over other adjacent areas.

The results obtained by Kroeber indicate a close similarity between the symbolism of the Arapaho and that of the Cheyenne. Here also abstract ideas appear in considerable number. It will suffice here to give a few examples. On a moccasin[1] (fig 84) "the longi-

Fig. 84. Moccasin, Arapaho. Fig. 85. Knife case, Arapaho.

tudinal stripe signifies the path to destination. A small stripe at the heel of the moccasin (not shown in the figure) signifies the opposite idea, the place whence one has come. The variety of color in the larger stripe represents a variety of things (which naturally are of many different colors) that one desires to possess. The small dark-blue rectangles are symbols that are called 'hiiteni'[2]. The white

[1] A. L. Kroeber, The Arapho, Bulletin American Museum of Natural History, Vol. XVIII, pp. 39, 40.

[2] *Hiiteni* is explained as meaning life, abundance, food, prosperity, temporal blessings, desire or hope for food, prayer for abundance, or the things wished for (A. L. Kroeber, *ibid.*, p. 40).

border of this moccasin, on account of its color, represents snow. The figures in it represent hills with upright trees. The stripe over the instep signifies 'up hill and down again' (its middle portion being elevated above the ends by the instep of the foot). The dots in this stripe represent places left bare by the melting snow." The knife-scabbard [1] represented in fig 85 "has at the top a cross signifying a person. The triangles above and below it are mountains. On the lower part, on the middle line, are three green squares, symbols of life or abundance. Red slanting lines pointing towards the squares are thoughts or wishes directed towards the desired objects, represented by the life symbols."

Fig. 86. Legging, Sioux Indians.

Observations among the Sioux Indians made by Clark Wissler have given similar results. The design on a legging (fig. 86) may serve as an example. It represents a battle.[2] The diamond-shaped center is here the body of a man. The large triangles are the tents of the village in which the battle took place. The pronged figures represent wounds and blood; the straight lines supporting them, the flight of arrows. The crossed lines are said to represent arrows and lances.

The Assiniboine, a closely related branch of the Sioux, did not yield much information in regard to the meaning of designs, but the few fragments collected by Robert H. Lowie [3] show that the principles found among other tribes are or were not unknown to them. The designs found on a drum illustrate this (fig. 87).

"The gray central field is itself a drum; the concentric rings around it are rainbow symbols, and the four sets of slanting lines

[1] l. c. p. 88.

[2] Clark Wissler, Decorative art of the Sioux Indians, Bulletin American Museum of Natural History, Vol. XVIII, p. 253.

[3] Robert H. Lowie, The Assiniboine, Anthropological Papers American Museum of Natural History, Vol. IV, p. 26.

(yellow, black and whitish) represent the sunshine. The green color between these lines denotes clouds; the four following rings the rainbow, and the external ring has no ascertainable meaning. On

the other side there is a star in the center; the black circle stands for night, the blue color at the circumference for twilight, and the oblique red, yellow and white lines for the sunshine."

Some Arapho designs are interpreted as representing geographical features or a village in its geographical environment. In the specimen shown in (fig. 88) "the two large triangles at the end represent tents; the center diamond two tents; between them a white stripe with black dots in it represents a buffalo path with buffalo tracks in it. The four red obtuse triangles along the sides are mountains; small yellow triangles enclosed by them are tents; the double blue lines surrounding the entire pattern represent mountain ranges. Small rectangles in this border, colored red and yellow, represent lakes."

Fig. 87. Drum of the Assiniboine.

Geographical interpretations are quite common among most of the Indian tribes of the Great Plains. Mountains, caves, trees, streams, lakes, trails, and tents are commonly symbolized in the angular forms of their paintings and embroideries. As compared to these the association between abstract ideas and geometric form is rater rare.

A few examples may also illustrate the explanations given by Shoshone Indians.[1] The interpretations are largely geographic. In fig. 89 the red central rectangle represents the ground, the green background trees. On this green ground is a lake, indicated by the blue area in the center, the yellow line dividing the central field, is an inlet of the lake. The obtuse blue triangle on the sides of the

Fig. 88. Rawhide bag, Arapaho. Fig. 89. Design from parfleche, Shoshone.

central rectangle represents mountains with timber. The triangles on the short sides are also mountains. The yellow apex is the sun shining on the mountains, the red middle part of the triangle the ground, the green area at the base, grass at the foot of the mountains. In the corners we find small triangles representing sand and over them the yellow sun light.

On a second Shoshone parfleche obtuse triangles in the central rectangle and smaller triangles in the longitudinal borderstrips represent mountains, a red line in the center stands for a river, and right-angle triangles are tipis.

[1] These are taken from observations by H. H. St. Clair at Wind River Reservation. Lowie did not succeed in obtaining any explanations at the Lemhi Agency, Idaho.

Another Shoshone parfleche of similar pattern, was explained as follows: a blue line enclosing an inner rectangle is a fort or enclosure surrounded by the enemy, represented by red and green squares of the border. A yellow and red line passing through the center is the pass by which the people escape.

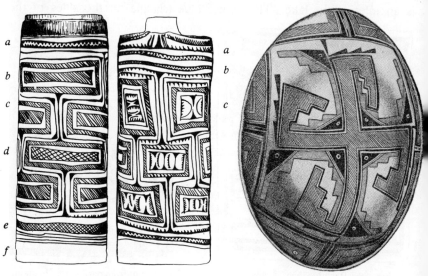

Fig. 90. Bamboo case, Melanesia.

Fig. 91. Zuni bowl, broken and edges ground down.

A consistent geographically explained ornament has also been described by Stephan (fig. 90). The upper zig-zag line (*a*) represents a snake; the rectangular fields under it (*b*), the sea moved by the wind. The dark corners of the rectangle (*c*) indicate calm on deep water. The central field with cross hachure (*d*), rain on the sea or ripples on the water. The lowest bands (*e*, *f*) and the top band (*a*) do not belong to the sea picture. (*e*) is explained as the veins of the cocanut leaf, (*f*) as a kind of grass.

In the opposite end (*a*) is not explained, (*b*) is a snake. The rest of the design fits in with the geographical pattern, (*c*) being rocks beaten by breakers.

I am indebted to Miss Ruth L. Bunzel for the following consistent interpretation of a Zuni bowl, — part of a deep bowl the upper part of which has been broken off. Her informant explained it as follows (fig. 91): "We call the whole design 'cloud all alone'. When a person does not go to the dances when they dance for rain, after her death she goes to the Sacred Lake and when all the spirits of the other dead people come back to Zuni to make rain, she cannot go, but must wait there all alone, like a single little cloud left in the sky after the storm clouds have blown over. She just sits and waits all alone, always looking and looking in all directions, waiting for somebody to come. That is why we put eyes looking out in all directions."

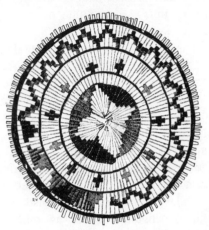

Fig. 92. Ceremonial object, Huichol Indians, Mexico.

Consistent symbolic interpretations have also been given for ceremonial objects of the Huichol Indians.[1]

On a "front shield", a sacred object (fig. 92) fertility symbols are represented by geometrical figures: "The cross in the center represents four clouds on the horizon, the colored segments completing the inner circle represent red and blue birds (swifts) soaring above the clouds. In the second circle are shown crosses representing red, yellow and blue corn. In the outer zone is a zigzag line in red and blue representing Mother East-water, a Deity. Nine triangles between head and tail of the serpent, crowded together, represent mescal (a narcotic cactus) which is considered related to corn and is held as a prayer for rain and for health."

[1] Carl Lumholtz, Symbolism of the Huichol Indians, Memoirs American Museum of Natural History, Vol. III, page 125, fig. 133.

Another example is a sacrificial back shield (fig. 93),[1] in which the symbol (*a*) represents a serpent, (*b*) white clouds, (*c*) black clouds, (*d*) rain, (yellow and white stripes); (*e*) three flowers, (*f*) a squash vine, these two representing vegetation, springing up after rain; and (*g*) the earth with its hills.

Similar representations are found in embroideries in woven garments, thus a zigzag line on a pouch [2] (fig. 94) represents lightning, the crosses the Pleiades.

Turning to Polynesia, von den Steinen [3] has given us a full description of tattooing of the Marquesans, from which it appears that in the minds of the natives the designs have definite significance. I mention a series of black triangles on rectangular bases, called the Fanaua, women who died in child birth (fig. 95 *a*); the cumulus clouds of the northwind (fig. 95 *b*). In fig. 95 *c* the upper row was called by one informant, "the fellow with the step of the rooster", the lower one "the hero Pohu and his house". Another informant from another village, designated the figures with raised arms as legendary miscarriages consisting of a chest, the low semicircular and rectangular figures as others consisting of ribs only. Of the two analogous figures, 95 *d* and *e*, the former is called a crab, the latter a turtle, while 95 *f* is called the bath of the hero Kena.

We find in our civilization cases in which form or color composition possess symbolic significance entirely apart of their form values. The most obvious case is that of the national flags. They are not only ornamental, but possess a strong emotional appeal. They call forth the feeling of national allegiance and their values cannot be understood on a purely formal basis, but are founded upon the association of the form with definite fields of our emotional life. The same is true of certain symbols. In Germany, at the

[1] Page 146, fig. 173.

[2] Carl Lumholtz, Decorative Art of the Huichol Indians, Memoirs American Museum of Natural History, Vol. III, p. 325, fig. 257.

[3] Karl von den Steinen, Die Marquesaner und ihre Kunst, Berlin 1925; also W. C. Handy, Tattooing in the Marquesas, Bernice P. Bishop Museum, Bulletin 7, Honolulu 1922.

a

b

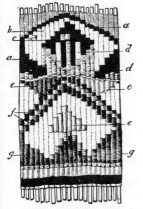

Fig. 93. Woven ceremonial object, Huichol Indians, Mexico.

c

d

e

f

Fig. 95. Tattooing designs, Marquesans.

Fig. 94. Design from a pouch, Huichol Indians.

present time, the swastika as the symbol of antisemitism, and the David's star as the Jewish symbol have very definite political significance and are apt to excite the most violent passions when used for decorative purposes, — not on account of their form, but because of the emotional reaction to the ideas they represent. Military insignia, emblems of secret societies, students' emblems and other regalia exert the same influence through their associations. Owing to the strong emotional value of these patterns and the specific character of the associations, the use of the ornament may be restricted to special classes of objects, or reserved for privileged classes or individuals. Thus, among ourselves, the cross, or the

flag, cannot appropriately be used at all places and at all times, and insignia of rank are confined to those who have the right to wear them. Just so, totemic devices may be used only by the privileged, not by those who belong to another totem. Strong emotional values are commonly associated with all forms that are used in important rituals. The simple ornaments of cedarbark dyed red wich are used by the Indians of British Columbia have such an appeal, because the ornamental attachments symbolize the gifts that the wearer has received from his supernatural protector.

It is readily recognized that these conditions can prevail only when the interpretation of the ornament, and with it its emotional significance are firmly established in the minds of the people; if all react without fail, without hesitation to the same pattern. This is not by any means the case everywhere. On the contrary, many cases are known in which there is considerable wavering in regard to the meaning of the symbol. One person may interpret it one way, another another way. For instance, in the designs of the Californian Indians, the same form will be called by different people, or even by the same person at different times, now a lizard's foot, then a mountain covered with trees, then again an owl's claw. It is conceivable that an individual may feel a strong emotional value of a design, but in a case of variable associations the symbol has no binding emotional value for the whole tribe. It will be the less relevant the more variable the individual and tribal associations. I believe this is also the reason why among ourselves an expressionistic art is impossible, or why at least it cannot appeal to the people as a whole. It is possible for an artist to train a group of followers and admirers in the symbolism that he cultivates, but it is exceedingly unlikely that such symbolism should develop in such a way that it would be felt automatically by all of us. In music a few associations of this type exist. We feel, for instance, the difference of mood in the major and minor keys; the former mood joyful and energetic; the latter gentle, moody or even sad. It is well to remember that these emotional tones are not by any

means everywhere connected with these two forms, but that in the music of other people that have something comparable to our major or minor, the relations may be quite different. We also feel a certain energy connected with the major key of E flat, but undoubtedly this is due to very specific associations that are not valid in other cultural areas.

Expressionistic art requires a very firm and uniform cultural background, such as is possessed by many peoples of simple social structure, but that cannot exist in our complex society with its manifold, intercrossing interests and its great variety of situations that create different emotional centers for each of its numerous strata.

It is, therefore, important to know whether there exist firm associations between form and significance, and whether these

Fig. 96. Patterns representing the star, Arapaho.

associations are accompanied by strong emotional reactions.

The former question may be investigated in two ways: By studying the variety of forms which are used to represent the same objects, and conversely by illustrating the variety of explanations given to the same form. Arapho designs collected by Kroeber offer a favourable field for this study. The range of forms interpreted as the star (fig. 96) is based on the tendency in the art of the Plains Indians to use triangular and quadrangular figures and narrow lines, and on the scarcity of polygons. We find, therefore, as representations of stars, crosses, groups of squares, diamonds and a cross with triangular wings. In the last quite exceptional figure of this series the star is represented by a hexagon. In some cases the association between the form and its meaning becomes more

intelligible through the general setting in which the design element is found, as for instance, through the color contrast between design and background.[1]

The variety of forms which are used to represent a person may serve as another example (fig. 97). Some of these are similar to the forms used to represent the star.

Still another example is the representation of the butterfly (fig. 98). In this series one of the designs representing the star will be found.

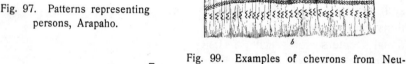

Fig. 97. Patterns representing persons, Arapaho.

Fig. 99. Examples of chevrons from Neu-Mecklenburg; *a*, Carved bamboo; *b*, Embroidered mat. The chevron to the left on the bamboo represents a palm leaf, an armring or a worm; the same design on the mat, tracks of a crustacean.

Fig. 98. Patterns representing butterfly, Arapaho.

Conversely a diamond is explained as a person, a turtle, the navel, a mountain, a lake, a star, an eye. The setting of the design does not by any means explain sufficiently why these varying interpretations should be used.

A rectangle represents a camp circle, brush hut, a mountain, the earth, a buffalo or life; a triangle with an enclosed rectangular or pentagonal figure (see fig. 117, p. 120) is explained as a mountain with trees, a cave in the mountain, a brush hut or a tent.

The second form in fig. 98 is explained as a butterfly or the morning-star.

[1] See A. L. Kroeber "The Arapaho", Bulletin of the American Museum of Natural History, Vol. 17.

In bead embroidery we find frequently a central design in the form of a diamond, from the acute angles of which, extend straight lines. To the ends of these triangular designs or other small forms are attached. In fig. 152 (p. 178) some of these designs are shown. The first one is taken from a pouch (*j*); the central diamond represents a person. the triangular designs at the ends of the lines, buffalo hoofs. A similar design (*k*) from a moccasin represents the navel and arrows; the background is snow. In a third example (*q*) the central diamond represents a turtle, the lines its claws and the small patterns at the ends of these lines, eggs.

Another example of the variation of explanation of the same design is found in designs from New Ireland[1] (fig. 99). The chevron represents the leaf of a palm, an armring, a worm, the foot of a bird, tracks of a crustacean, or fish bones.

The great variety of these interpretations of the same figure and of the many forms by means of which the same ideas find expression, show clearly that the terms by which designs are described must not be conceived simply as names, but that rather a certain association exists between the general artistic pattern and a number of ideas which are selected according to tribal usage, and also in accordance with the momentary interest of the person who gives the explanation.

Often the range of ideas associated with forms follows a fairly definite pattern in each tribe. We may compare this condition with attitudes which we assume in regard to forms that may have varying types of symbolic connotation. To a Canadian, a British flag surmounted by maple leaves would be closely associated with patriotic feeling, and in this connection the maple leaf has a definite significance; in other combinations it may appear with quite a different meaning. A red maple leaf may be symbolic of the fall of the year.

[1] Stephan, Neu-Mecklenburg, p. 114, fig. 120. The same figure is found in the same author's "Südseekunst", p. 15, fig. 19, with somewhat different explanations, presumably due to an oversight.

During the World War the bloody hand was used on posters to excite the populace to hatred, because it was symbolic of the imaginary cruelty of the German soldier and this association was assiduously cultivated by word and letter. In another setting a bloody hand may be a symbol of suffering or of sacrifice, as the red hand impressed on church walls or sanctuaries.

A white rose may be a symbol of death or innocence. A crescent may bring up a thought of Turkey, a beautiful summer night, or it may be conceived purely as form.

Not only is the significance of designs variable, the explanations of forms found on the same object seem often quite incoherent. The cases are not very numerous in which we find a clearly defined, consistent symbolism extending over the whole pattern.

Judging from information given by Stephan in regard to paintings and carvings from Melanesia,[1] the explanations, varied and incoherent as they may be, are given without hesitation and although the same pattern elements are not given every time the same interpretation, the whole grouping, expressed at any given time, seems to be clear in the mind of the person who gives the explanation.

In by far the majority of cases the interpretation appears to us as entirely incoherent. The terms by which the same forms are designated by different individuals and at different times are so varied that it is difficult to assume that we are merely dealing with names of design elements.

As a typical example of lack of relation between the symbols composing the ornament may be mentioned an Arapho knife-scabbard[2] (fig. 100). "The green lines forming a square at the top represent rivers. The figure within is an eagle. The two larger dark portions of this figure are also cattle-tracks. The two rows of triangles on the body of the scabbard represent arrow-points. The squares in the middle are boxes, and the lines between them are the conventional morning-star cross. The small squares on the pendant attached to the point of the scabbard are cattle-tracks."

[1] Emil Stephan, Südseekunst, p. 86.
[2] Kroeber, The Arapaho, Bull. Am. Mus. Nat. Hist., Vol. 18, p. 87.

As another example I select a decorated object from New Ireland described by Stephan. In fig. 101 (*a*) represents a frigate bird, (*b*) fish bones, (*c*) buttons for strings of shell money, (*d*) men's arms, and (*e*) a fish head. On a paddle (fig. 102) the spirals represent the opercula of a snail; the connected triangles, the wings of the frigate bird. On other specimens the spirals represent young fern fronds.

d

e

c

b

a

Fig. 100.
Embroidered knife
sheath, Arapaho.

Fig. 101.
Painted board,
Neu-Mecklenburg.

Fig. 102.
Decorated paddle,
Neu-Mecklenburg.

In the art of the North Pacific coast a definite totemic meaning is given to conventional figures. There is no general agreement as to their significance, but to many forms is assigned a meaning according to the totemic affiliation of the owner for whom it thus attains a value based on its meaning. Explanations of a blanket design (fig. 103) obtained by G. T. Emmons and John R. Swanton, may serve as an example. According to Emmons the design represents a whale

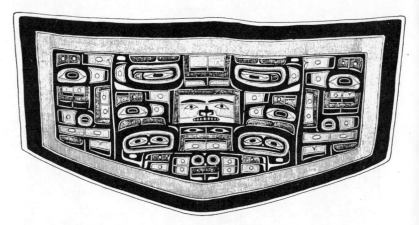

Fig. 103. Blanket of mountain goat wool, Tlingit. Alaska.

diving, in the lateral fields are ravens sitting. The head with nostrils and mouth is shown below. The central face represents the body, the inverted eyes along the upper border, the tail. According to Swanton the design represents a wolf with young. The head is shown below. The hind legs and hip-joints are represented by the two large inverted eyes and the adjoining ornament along the upper border. The two dark segments just above the eyes are explained as the feet. The face in the middle of the design represents, as usual, the body of the animal. The small eye designs, with adjoining ear and wing-feathers, in the middle on each side of the body, are interpreted as forelegs and feet. The designs in the lateral pannels are explained as young wolves sitting.

It seems likely that wherever varied interpretations of the same form, or of closely allied forms occur within the same social unit, conditions of this kind prevail.

We have no information whatever that would enable us to decide whether the ideas expressed are entirely incoherent. It is conceivable that there may be associations that are unknown to us and that create a greater unity than appears on the surface. I am under

Fig. 104. Basketry patterns of the Pomo Indians, California.

the impression that connected with the interpretation there exists a certain emotional tone that may be weak, but that is, nevertheless, not negligible in the esthetic effect of the whole object.

It would seem that in a considerable number of cases ornamental patterns have definite names that are always applied, no matter in what combination the design may occur. Many Californian basketry patterns are of this kind. Barrett[1] gives the names of decorative patterns used by the Pomo Indians, from which I select a few as an illustration (fig. 104). The northern and eastern Pomo call fig. 104 *a*, *b* butterflies; the central Pomo call them arrowheads; the designation for *c* is sharp arrow-heads. The northern Pomo call *d*, pointed broad band, deer back, or darts for a game;

[1] S. A. Barrett, Pomo Indian Basketry, Univ. of California Publications in Am. Arch. and Ethn. Vol. VII, No. 3.

the central Pomo call them crow-foot or crow-track; the eastern Pomo, zigzag or marks of the east. The design *e* is called quail-plumes; *f* and *h,* by the northern Pomo, "sharp points and in the middle striped water snake"; the central Pomo call them "similar

Fig. 105. Drawn work, Mexico.

to slender arrow heads", and the single triangles, turtle-neck. The eastern Pomo call the designs butterfly and "in the middle (gaya) striped water snake". The design *g* is called by the northern Pomo, empty spaces and quail tip patterns; by the eastern Pomo, butterfly and quail plumes; *i* by the central Pomo quail plumes arrowhead.

This usage corresponds to our terms when we speak, for instance, of the "egg and dart" design. Among the Shetland Islanders patterns

on knit stockings are called "flowers", flowers serving as a synonym for pattern. The drawn work of Mexico bears also names.[1] Here we find names as for instance, "Little Jesus", "Beehive" (*a*) (fig. 105), "Partridge's Eye" (*b*), "Tomato Seed and Peel" (*c*), liana (*d*), "Spider Net" (*e*). The same is true of the embroidery of Paraguay.[2]

Named designs among more primitive people are particularly common in Africa, where, according to all investigators, the complex designs are conceived as compounds of single elements which bear names.

Czekanowski[3] says in discussing the ornaments found in Ruanda (fig. 106): "On account of the simplicity of the Ruanda ornament its elements are easily determined. We shall enumerate them here according to their names: quiver (*a*); shield (*b*); millet (*c*); knife (*d*); arrowhead (*e*); kindly person (*f*); ferrule of a spear (*g*); wings of a swallow (*h*); large tail (*i, j*); arrows (*k*).

Fig. 106. Designs of the Ruanda.

The three last patterns may be considered as compound forms. The pentagon occupies an exceptional position. All these elements consist of straight lines. Curves occur as segments, crescents, spirals and circles. Wide-lined circles are called arm rings (*m*); narrow ones, bracelets (*n*)." The general ornamentation consists of horizontal rows of black triangles or diamonds on a plain background or a white triangle on a black background. The arrowhead design (*e*) appears in long rows, the point of one head touching the

[1] Journal American Folk-Lore Vol. 33, 1920, pp. 73 et seq.

[2] E. Roquette-Pinto, On the Nandutí of Paraguay. Proceedings of the Congress of Americanists, Gotenburg, 1925, pp. 103 et seq.

[3] Jan Czekanowski, Wissenschaftliche Ergebnisse der Deutschen Zentral-Afrika Expedition, 1907—1908, Vol. VI, Part 1. pp. 329 et seq.

112 *Symbolism*

notch of the other. Zigzag bands in diagonal or vertical rows of the pattern *i* and *j* occur also. The characteristic point seems to be that only the elements of the whole pattern bear names.

I infer from Tessmann's [1] description that among the Pangwe of West Africa also the single pattern elements bear names while the multifarious combinations lack explanations such as we find in America or in Melanesia. In fig. 107 patterns in woodcarving are

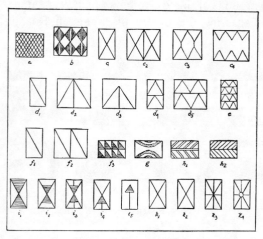

Fig. 107. Designs of the Pangwe.

represented which are named as follows: (*a*) file; (*b*) string of cowrie shells; (*c, d*) triangular leaf used for feathering arrows for the cross bow (triangle with wide base); point of iron money, spear point (triangle with narrow base); (*e*) tail of armadillo; (*f*) kerf; (*g*) rainbow; (*h*) fish bone; (*i*) triangular spear; (*k*) spider net.

Of the Bushongo Torday [2] says that the nomenclature is not certain (p. 216). "The Bushongo do not consider the design as a whole, but they divide it into various elementary patterns. They take one of these elements as characteristic of the whole figure and call the whole design by this term. The motives obtained by interrupting woven patterns [3] at regular intervals are built up of

[1] Günter Tessmann, Die Pangwe, Berlin 1913, Vol. 1, p. 243 et seq.

[2] E. Torday and T. A. Joyce, Notes etnographiques sur les peuples communément appelés Bakuba, etc. Les Bushongo, Documents ethnographiques concernant les populations du Congo Belge, Vol. II, number 1, Brussels, 1910, pp. 217, 219.

[3] i. e. the element consisting of a single warp strand showing between two woof strands and the adjoining similar elements, formed in simple up and down weaving.

small details which are found variously combined in other motives. Therefore, owing to the analytical mind of the natives, the curious phenomenon results that the same name may be given to two designs, apparently quite dissimilar, at least so far as the general impression is concerned, and that the natives of opposite sex will

give to the same design different names because either considers a particular element as the principal part." The closely related patterns fig. 108 *b* and *d* are derived from interwoven strands (fig. 108 *a*). The form *b* is called imbolo (interwoven?); *c* is called the xylophone and *d* the foot of Matarma. The Bangayo call the same pattern in carving (*e*, *f*) back and head of the python. The patterns 108 *g*, *h* are called the knee and *i* the knot.

The significance of primitive ornament has also been studied in another way. In a number of cases it has been shown that

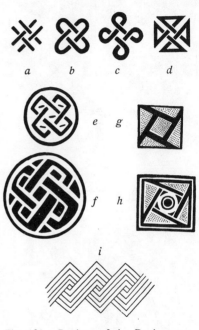

Fig. 108. Designs of the Bushongo.

series can be arranged in which we may place at one end a realistic representation of an object. By degrees we may pass to more and more conventional forms that show each a distinct similarity to the preceding one, but end in a purely conventional, geometric design in which the initial stage can hardly, if at all, be recognized. I believe the first to discover this phenomenon was Frederic Ward Putnam, who described the development, as he called it, of the hollow, slit feet of Chiriquian (Costa Rican) pottery from a

fish form to a purely conventional design (fig. 109). He was fol-
lowed by others who made studies of similar transitions in other
parts of the world. William H. Holmes described the so-called

Fig. 109. Feet of pottery dishes, Chiriqui, Costa Rica.

alligator vases of Chiriqui, showing the relations between the alligator
design and curious irregular painted forms (see fig. 129, p. 137).
Hjalmar Stolpe, and about the same time, Charles H. Read
(fig. 110) discussed the relations of human figures and geometrical

Fig. 110. Polynesian ornaments.

designs in Polynesian ornaments; Haddon studied the so-called
crocodile arrows (fig. 111) and the frigate bird (fig. 112) designs of
New Guinea in their gradual transition from fairly realistic forms in
which the crocodile and the bird are easily recognized, to geometrical
types in which the prototype is entirely obscured. Similar relations are

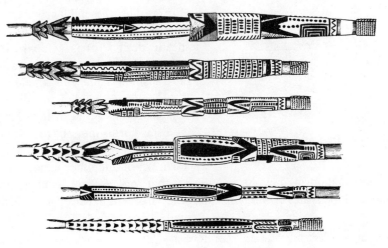

Fig. 111. Crocodile arrows, New Guinea.

○ **found** in the facial urns of prehistoric times, (fig. 113) in some of which we find a perfectly plain and distinct face, while in others there are only a few knobs that, on account of their position, recall

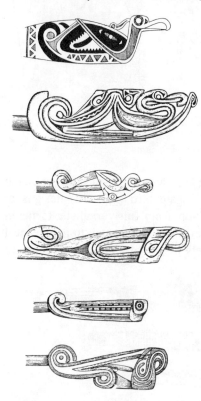

the face. George Grant MacCurdy takes us back to Chiriqui where he collected from museum collections series of types beginning with the form of the armadillo and ending with small decorative points (fig. 114). Von den Steinen forms out similar phenomena in the tattooings of the Marquesans.

In a few cases the striking similarity of the patterns which contradicts the diversity of names suggests an historical relation between the forms. This is the case, for instance, with the Bushongo antelope and beetle patterns (fig. 115). The resemblance between the realistic antelope head (*a*) and beetle design (*d*) is evident. It is, however, not necessary to assume a transition from the antelope to the beetle design, but the question has to be answered in how far the stylistic form may have moulded the two representations in the same form or, on the other hand, why an

Fig. 112. Designs representing frigate bird and crocodile.

ornamental form may have outlines that, on the one hand, express an antelope's head and, on the other hand, the body of a beetle. [1]

[1] E. Torday and T. A. Joyce, Notes ethnographiques sur les peuples communément appelés Bakuba, etc. Les Bushongo, Documents ethnographiques concernant les populations du Congo Belge, Vol. II, number 1, Brussels, 1910, p. 212.

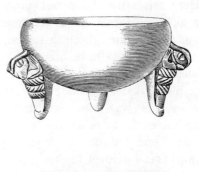

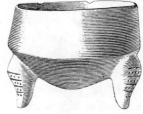

Fig. 114. Armadillo designs, Chiriqui.

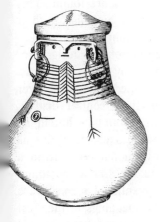

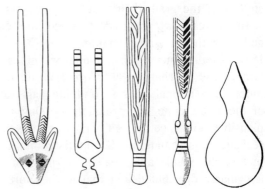

Fig. 113. Facial urns.

Fig. 115. Designs of the Bushongo representing the head of the antelope and the beetle.

Here arises the important problem whether we are to assume that all these forms are developments from realism to conventionalism, as has often been assumed, or whether the converse process may not also have occurred, namely that a geometrical design existed and that a gradual development towards a realistic form took place, that a meaning was read into the geometric pattern and that in this way the significant forms originated. Unfortunately historical evidence is hardly ever available and we are compelled to rely upon indirect evidence. We cannot follow the excellent example set by Riegl in his detailed study of the history of the introduction of curved lines in Mediterranean art.

However, we can apply the geographical method, the only one that has made it possible to unravel part of the historical development of people that do not possess written records, and for cultures the development of which cannot be traced by archaeological evidence. It is possible to establish with a high degree of probability the relationship of cultural forms and their gradual spread by means of a study of the distribution of ethnic phenomena and their variations in the sections of the area in which they are found. This method is strictly analogous to the one applied by biologists in their studies of the gradual distribution of plants and animals.

In our case we must try to trace the distribution of designs together with the interpretations given to them by different tribes. If we should find consistent interpretations of the same form over large areas, perhaps even more realistic forms in a central district, more conventional ones in outlying parts of the country, but in all of them the same interpretation, we should have to consider this as plausible evidence of an origin of the conventional types from a realistic representation. If, on the other hand, it should be found that in the whole area realistic forms and conventional forms were irregularly distributed and that furthermore the meanings of identical or similar forms did not agree, then the origin of conventional forms from realistic ones would seem to be quite unlikely. Then we should have to assume one of two possibilities; either the form must have

spread gradually over the whole area and must have been given a meaning independently by each people, — in other words the meaning must have been read into the pattern, — or it may have been that a dominating style has forced a diversity of realistic representations into the same geometric patterns.

In the latter case we should have to consider the processes by which realistic forms should gradually change into unrecognizable conventional ones; in the former the processes by which from a conventional form a representative one develops.

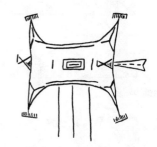

That both ways are possible is easily shown. When the Plains Indians represent a buffalo in a stiff angular form, like a hide spread out provided with legs, head and tail (fig. 116); and if also a rectangle without these attachments is called a buffalo, it may be as well the buffalo hide that has been abbreviated, so to speak, as that the hide has been read into the rectangle. The process of reading in is not at all unfamiliar

Fig. 116. Design representing the buffalo, Arapaho.

to us. We see realistic forms in the shapes of mountains and clouds and in marks on rocks, and we enjoy the play of fancy that endows natural forms with new meanings. There is no·reason to doubt that the same tendency prevails among primitive peoples. Koch-Grünberg's[1] observations among the natives of South America prove this point. He tells us that the Indians, when camping at a portage and waiting for the rivers to become navigable, take up accidental marks on the rocks and by pecking develop them into forms suggested by the natural outlines, or that they take up the lines left by a preceding party who amused themselves in the same way and whose play was interrupted when they were able to resume their journey. We have also ample evidence to show that curiously formed rocks are not only compared with animate beings, but that they are actually

[1] Th. Koch-Grünberg, Südamerikanische Felszeichnungen. Berlin, 1907.

considered as men or beasts transformed into stone. Thus the Pueblo Indians tell in their migration legend that a person or an animal became tired on account of the fatigue of the long travel, sat down and was transformed into stone. The forms of a hawk,

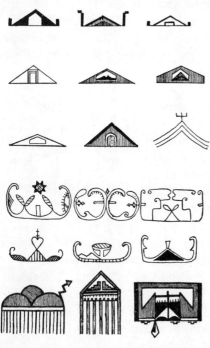

man, bear, and of a woman carrying a basket are still pointed out. On Vancouver Island are shown the tracks of the culture hero, where he stepped on a rock. In the interior of British Columbia a large boulder is said to be Coyote's basket. [1]

I shall illustrate this point by the discussion of a design found widely spread among the Indians of North America. Their decorative art is characterized by the use of straight lines, triangles and rectangles that appear in manifold combinations. One of the most typical forms is that of an isosceles triangle with enclosed rectangle, sometimes provided with spurs at the base (fig 117). This design is found in an extended area. It occurs most frequently on the great plains but also on part of the western

Fig. 117. Designs of North American Indians; the first nine Arapaho, the next six Eastern Algonquin; the last line; first Hopi; then archaeological specimens, Pueblo region.

plateaus and among the Pueblo Indians (fig. 118). To the west it is found among the tribes of the woodlands and certain peculiar patterns of New England and the interior of Labrador are strongly reminiscent

of it. The stylistic similarity, or better, identity of the pattern on the plains is so great that it cannot possibly have developed from several independant sources. It is part and parcel of the general art style of the area that has developed either in one spot, or what seems more probable, by the conflux of artistic activities of a number of tribes. Thirty or forty years ago, under the strong influence of the evolutionary theory, the psychologising ethnologist might have interpreted this similarity as due to the sameness of the reaction of the human mind to the same or similar environmental causes, — as Daniel G. Brinton explained the similarity of Algonquin and Iroquois mythologies. However, the development of our science since that time has so firmly established the fact that even the most primitive cultures must be considered as having had a historical development no less complex than that of civilization, that the theory of independent origin of almost identical phenomena in contiguous areas can no longer be maintained and has been given up by all serious students.

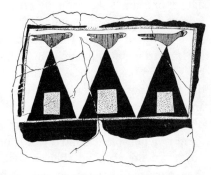

Fig. 118. Triangular design, prehistoric Pueblo.

When we study the significance of the pattern we find the greatest possible divergence of meaning. As pointed out before, different individuals in one tribe, do not all assign to it the same meaning, but more or less decided tendencies to certain interpretations are found in each tribe. The design is sometimes drawn steeply and the sides of the triangle extend slightly beyond the apex. Thus the form of a tent with tent poles, doorway and pegs for pinning down the tent cover is expressed. At other times the triangle is more obtuse and represents a hill. It may be placed on a white background which signifies snow or sand; blue lines extending downward from the base indicate springs of water and

small triangles may be placed in the inner triangle. Thus it becomes the mythical mountain in which, at the beginning of time, the buffaloes were kept and which is located on a snowcovered plain. On the slopes of the mountain grow trees. Again, quite different, is the interpretation given by the Pueblo Indians. In their arid country the greatest need is rain without which their crops wither and starvation stares at the people. The communal life centers around the idea of fertility to be attained by an abundance of rain. Accordingly they interpret the symbol as a cloud from which the rain falls. Since their art is far less angular in style than that of the Plains Indians, they often substitute a semicircle for the triangle and attain a greater realistic resemblance to clouds by superimposing three of these semicircles, from which flow down the rain lines. When we turn to the western plateaus, we find among the Shoshone the regular design of the obtuse triangle applied and explained on the basis of geographical features; it suggests to them montain-passes and a fort protected by palisades. Further to the north we do not find the enclosed rectangle, but the triangle and the spurs at the base persist. These are explained as paws of a bear, the triangle being the sole of the foot, the spurs the claws. In the eastern woodlands new developments occur. The triangle now is exceedingly narrow, so that there is no room for the enclosed rectangle which is reduced to a triangle. The sides of the triangle are produced beyond the apex, even more so than among the Sioux Indians, and a considerable number of almost straight vertical lines are added to the sides. The form bears now a certain resemblance to a fish tail and is so interpreted. Still more curious are the developments in New England. The triangle and the enclosed rectangle are still unmistakably present, although curved lines, characteristic of eastern American art, are added on. The interpretation has changed again. The pattern is a symbol of the town or of the tribe and its chief.

Among none of these tribes do we find any indication of the existence of more realistic forms from which the conventional tri-

angle might have been derived. The realistic forms of the western tribes are almost exclusively crudely pictographic and no transition from the pictograph to ornamental, geometric patterns can be traced. The realistic forms of the eastern tribes are found particularly in mattings and weaving. These also show no relation to the triangular forms that we are discussing. The theory that the pattern has developed under the stress of a compelling style that cast a variety of realistic forms into the same mould does not find support in the facts, because transitional forms are lacking. We conclude, therefore, that the sameness of form and the difference of meaning are not due to a geometrisation of realistic forms but to a reading in of significance into old conventional patterns. This view is corroborated by the prevailing uncertainty in regard to many of the meanings. The Blackfeet, according to Clark Wissler, [1] have practically no feeling whatever for the significance of these designs. The Arapaho behave somewhat differently on different occasions. Ceremonial paraphernalia may have fairly definite meaning, while clothing, bags and other objects are given interpretations that are quite subjective and which show therefore great individual differences.

The importance of the social position, or perhaps better, of the social interests of the owner of an object, in determining the meaning of ornaments has been demonstrated most clearly among the Sioux Indians. In former times their ornamentation was made in porcupine quill embroidery, but at present beads have taken place of the quills. Men and women use to a considerable extent the same ornamental designs, but with distinctive meaning. A diamond-shaped pattern with attached double triangular appendages, when found on a cradle, or a woman's legging, is interpreted as a turtle, the turtle being a symbol closely associated with birth and maturity of the woman. When found on a man's legging it represents a slain enemy.[2]

[1] Bulletin of the American Museum of Natural History, Vol. 18, p. 276.
[2] Clark Wissler, Decorative Art of the Sioux Indians, Bull. Am. Mus. Nat. Hist., Vol. 18, pp. 253, 273.

I will mention one more case in which the actual process of reading in has been observed. At one time, when I visited British Columbia, I purchased a woven bag from an elderly woman. It was decorated with a series of diamonds and small embroidered cross-like figures. Upon inquiry I learned that the bag had been purchased from a neighboring tribe and that the new owner did not know anything about the original significance of the pattern,— if such a significance existed which is doubtful, because the tribe in question is not given to interpretations. It appeared to the new owner that the diamonds looked like a series of lakes connected by a river. The different colors of the diamonds appeared to her to suggest the colors of the lakes; — a green border, the vegetation of the shore, a yellow area inside the shallow water, and a blue center the deep water. The interpretation did not seem to her sufficiently clear, and in order to emphasize it she added, in embroidery, figures of birds flying towards the lakes. Thus she gave greater realism to her conception and made it more intelligible to her friends (Plate VII).

The needle cases of the Alaskan Eskimo offer an excellent example of an elaboration of geometrical into realistic forms. It must be remembered that all the Eskimo tribes, east and west, are very fond of carving and that they produce many small animal figures that serve no practical purpose but which are made for the pleasure of artistic creation, and that many of their small implements are given animal forms. The mind of the worker in ivory is imbued with the idea of animal representation. The Alaskan needle cases have a stereotyped form to which the bulk of the specimens conform (fig. 119). The type consists of a tube slightly bulging in the middle, with flanges at the upper end, with lateral knobs under the flanges on opposite sides. On the body of the tubing, between the flanges, is a long narrow concave face, set off from the flanges and the body of the tube by parallel lines with small forks at the lower ends. Lines border the sides and ends of the flanges and the upper end of the concave face, and an alternate-spur band is found at the lower end

PLATE VII.

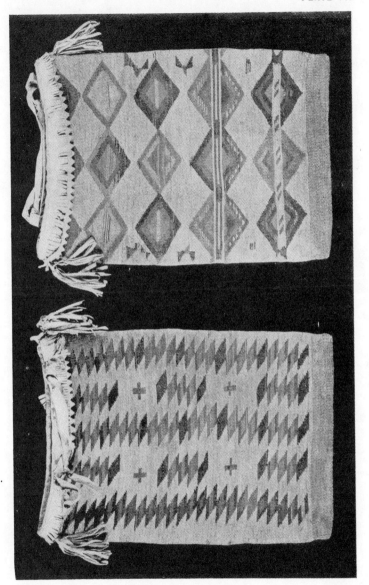

Woven Pouch, British Columbia.

of the tube. This type is presumably related to the ancient type of needle case from Hudson Bay, which is characterized by a tubular form, flanges at the upper end and a pair of large wings in the middle part of the tube. These, I believe are the prototypes of the small knobs at the sides of the Alaskan type. These are sometimes so small that they can hardly be seen, although they may be felt when the fingers glide lightly over the surface of the tube. However this may be, the majority of Alaskan specimens are of the type here described. The variations in geometrical form are very slight.[1]

In a number of cases part of the needle case or the whole object is elaborated in representative forms. In a few specimens the knobs have been given the form of seal heads. A slight enlargement, and the addition of eyes and

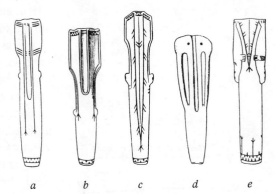

a b c d e

Fig. 119. Alaskan needle cases.

mouth are sufficient to bring about this effect (fig. 119 *c*). In other cases the flanges have been developed into walrus heads (fig. 119 *d*) or into other animal forms that fit the form of the flange (fig. 119 *e*). By adding a point for the eye and by cutting out the inner part of the flange the outer form is essentially preserved and the form of the bulky walrus head with its large tusks is successfully attained; or the walrus motive may be repeated so that the original form of the needle case is considerably obscured. By adding a seal's head at the lower end the lower part of the object receives more or less the form of a seal.

It is important to note that in all specimens of this type the double

[1] See Franz Boas, Decorative Designs on Alaskan Needlecases, Proceedings of the United States National Museum, Volume XXXIV, (1908), pages 321—344, Washington, D. C.

spur ornament persists, although it interferes with the seal's head that is often added at the lower end. It seems very unlikely that the many animal forms attached to the needlecases were the primary forms from which the geometrical form developed. On the contrary, the wide distribution and the great frequency of the geometrical

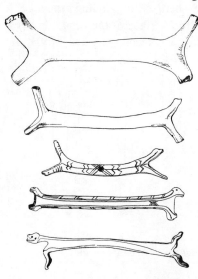

Fig. 120. Reels of Alaskan Eskimo.

forms, their agreement with Eskimo geometrical style and the occurrence of this geometric style on specimens that do not imitate animal forms are entirely in favor of the assumption that the earlier form is geometrical, whatever the origin of the flanges and knobs may have been. Presumably the habit of carving animal forms has induced the artist to produce the variants described here.

Equally interesting are the reels used by the Alaskan Eskimo. Their prototype is a piece of caribou antler cut as shown in fig. 120. This, however has been developed into animal forms. One specimen has a geometrical decoration on the body, while three of the ends are elaborated as animal heads. In another one the two prongs on one side are given the form of seal heads which are connected by a long line with the flippers which are shown on the opposite side. Still another specimen has been treated like a much distorted form of a wolf. The head is at the prong of one end, the forelegs at the other prong of the same end; the two hind legs are carved on the two prongs at the opposite end.

Similar observations may be made on arrow shaft straighteners and snow knives of the Alaskan Eskimo.[1]

[1] E. W. Nelson, The Eskimo about Bering Strait, Annual Report Bureau of American Ethnology, Volume XVIII, pl. 40, 48, 94.

The examples which I have given demonstrate beyond cavil that the process of reading in exists and accounts for the significance of many geometrical forms; that it is not necessary to assume in each and every case that geometrical ornament is derived from realistic represen-

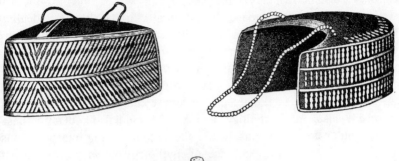

Fig. 121. Eye shades and vessel, Ammassalik.

tations. Hjalmar Stolpe to whose researches on primitive art we owe so much had an exaggerated opinion of the importance of realistic designs, for he believed that every geometric form must have been derived from a representation. Stephan expresses the same opinion. I may perhaps illustrate Stolpe's point of view by one example. Among the Eskimo of East Greenland is found an eye-shade decoration consisting of notched pieces of ivory placed side by side. Stolpe explained this form as a derivation from carvings representing seals, abbreviated due to the rhythmic repetition of the seal design (fig. 121). However, we know that the Eskimo when

making small blocks of ivory, such as are used for the manufacture of toggles or other similar objects, cut the walrus tusk just in this manner, so that through a technical process they have become familiar with the ornamental form. Therefore it is not indispensable to assume a realistic origin for the design.

It is interesting to compare the process with which we are dealing with other ethnic phenomena of similar import. The essential conclusion drawn from our observations is that the same form may be given different meanings, that the form is constant, the interpretation variable, not only tribally but also individually. It can be shown that this tendency is not by any means confined to art, but that it is present also in mythology and in ceremonialism, that in these also the outer form remains, while the accompanying interpretations are widely different. In the case of mythology we may observe that in the same way as patterns have a wide distribution, so also motives of myths, or even whole plots are found over extended areas. For example, the well-known tale of the magic flight, which is one of the most widely distributed fairy tales, occurs in a number of North American localities. Among the Eskimo it is given as accounting for the origin of fog; in British Columbia it is made to account for the origin of certain cannibalistic ceremonials. Another example is the so-called star husband story, a tale of two girls who were taken up to the sky by the stars. The story is widely spread and is told as the explanation of a great variety of phenomena. The child of one of the women becomes the culture hero and destroys the monsters infesting the world. Customs, ceremonials, and prerogatives of clans are explained by this tale, in accordance with the chief interests of the tribes concerned. The nature myths collected from all parts of the world by Dähnhardt [1] are full of examples of this kind: the most diverse features are explained by the same tales. This shows that it is quite untenable to assume that the tales developed through the immediate effect of viewing natural phenomena, that much rather the tales preexisted and the explanatory part was tacked on at a

[1] Oskar Dähnhardt, Natursagen, Vol. 4. Leipzig 1912.

later time, precisely as the art forms preexisted and their meaning was tacked on according to the peculiar mental disposition of the individual or the tribe.

The same observation has been made in regard to ceremonials. The so-called sun dance is performed by almost all the tribes of the great plains. The general run of the ceremonial is essentially the same everywhere, although different tribes have added on special characteristic details. The meaning, on the other hand, presents far greater variations. In one case the performance is made in fulfilment of a vow made when supernatural aid is invoked in time of distress; in another case it is undertaken to purchase the right of ownership in a sacred bundle, and then again it is a tribal, seasonal ceremonial.[1]

These three examples illustrate that the psychological explanation of a custom and its historical development are not by any means the same; on the contrary, owing to secondary interpretations that in course of time set in and the general character of which depends upon the cultural interest of the people, the psychological explanation is much more likely to be quite independent of the actual historical happenings. The mere fact that a tribe explains forms according to a certain pattern does not prove, that they have developed from actual representations of the objects they now represent.

It might perhaps be admitted that in the special case of the North American triangle which we have discussed the argument is convincing because no transitional forms exist, that, however, when an almost continuous series of forms is found, beginning with the most realistic and ending with a purely geometrical one, the conclusion cannot be avoided that the development has been in the direction from realism to conventionalism. I have already indicated that as long as there is no historic proof, the sequence might as well be reversed. In all the cases that have been described and that are based on direct inquiry among primitive people regarding the meaning of designs, realistic and conventional forms have been found to occur

[1] Leslie Spier, Anthropological Papers of the American Museum of Natural History, Vol. XVI, (1921), pp. 457 et seq.

at the same time. It would therefore be necessary to give a reason why some excellent artists should use the one style, others, equally good ones the other; or why even the same artist should combine the two styles.

It is generally claimed that slovenly execution brings about deterioration of pattern and through this, causes misunderstandings. I do not consider this explanation as tenable under the conditions of life prevailing among primitive people, because there is no slovenly execution among natives who make utensils for their own use. The pottery and paintings of the South American Indians, observed by Von den Steinen, the crocodile arrows of New Guinea, the frigate bird carvings, are all carefully made. We find often that people will use inferior wares for exchange with neighboring tribes, while they keep the good material for themselves. The natives of Vancouver Island for instance, adulterate with elderberries berry cakes that are made for trade, while those made for home consumption are made of the more valuable berries, such as blueberries or salmonberries without the addition of other material of inferior value. This tendency, particularly when combined with the desire to manufacture quickly large masses of material, leads to poor work. The question then arises, what happens in cases of this kind. Does slovenly work lead to misunderstandings and to conventionalism? Balfour has tried to make the process clear. He let an individual copy a design and used the first reproduction as original for a second copy. By continuing in this way he received the most astonishing transformations. Such results may occur when work executed in a highly developed technique is imitated by people of lesser accomplishments. The standard example is that of the degeneration of Greek coins when copied by Keltic imitators [1] which led to a complete disruption of the original design. However, this example is not to the point, because we are ordinarily not dealing with copies of designs borrowed from people of higher technical development, but with those belonging to a single tribe.

[1] See Max Ebert, Reallexikon der Vorgeschichte, Vol. 6, pp. 301 et seq.

I have had occasion to observe the effect of factory production
and of slovenly execution in some Mexican material. In western
Mexico dishes are made of tree calabashes which are covered with
an orange laquer. By the lost-color process these are overlaid with
designs in green laquer. The industry is probably of Spanish origin.
Old specimens made of wood are of excellent workmanship. These
are decorated mostly with animal forms, deer, fish, and so on. At
present the work is of much poorer execution and the ware is sold
in market places, as in Oaxaca (fig. 122). On some specimens the
fish designs of ancient type are still used, but we find also, even

Fig. 122. Designs from vessels made of tree calabashes, Oxaca.

more frequently, leaf patterns and we may here apparently observe
just that kind of misunderstanding described by Balfour. The gill
region becomes the base of the leaf. The head of the fish corre-
sponds to the base of the leaf; the fins to the marginal indentations,
and the ribs of the fish to the veins of the leaf. Since both the
fish and the leaf occur in modern types it may be doubted whether
we are dealing with an actual transformation, with a real misunder-
standing. It might be as well that the psychological process involved
has been rather the substitution of new subject matter for the old,
in which process the new subject was rigidly controlled by the old,
stereotyped form. We shall see that conditions of this kind are
often very potent.

Another good example is the pottery made for sale by the ancient
inhabitants of the Valley of Mexico. Pottery was made here in great

masses and, as described by Sahagun,[1] sold in the market places. The vessels show plainly the effect of factory production and of the resultant slurring. The Aztec pottery is fundamentally of uniform type. In Culhuacan, a small village at the foot of the Sierra de la Estrella, a coarse kind of this ware was made. Great masses

Fig. 123. Fragments of pottery
vessels, Texcoco.

Fig. 124. Designs from pottery
vessels, Culhuacan.

of potsherds are found in the swampy soil which was used in early times as garden beds. The pottery is thick, dark orange, painted black. It is a pronounced local form, darker than the light ware of Texcoco (fig. 123); the painted lines are broad and coarse, while those of Texcoco are very delicate. The patterns are fixed, but the rapidity of manufacture has developed a definite style, analogous to the styles of handwriting. Each painter had his own method

[1] Bernardino de Sahagun, Historia general de las cosas de Nueva España, ed. C. M. de Bustamante, México, 1830, Vol. 3, p. 56.

of handling the brush, with the result that his individuality may easily be recognized.[1] I select a few examples here in order to show the effect of slurring upon design. It is essential to note that on the same specimen the lines are always drawn in the same way; that is, that the hand of the painter followed very definite motor habits.

One of the simplest designs is instructive in regard to the effect of slurring and the development of individual style. One of the decorative elements consists of a series of S shaped, interlocking figures (fig. 124). It will be noticed that, in fig. 124 *b* the lines which seem to have developed from the S shaped forms, are degenerating into simple curves, while in *c* the lines are drawn more carefully. Fig. 124 *d* represents the decoration from the outer side of a vessel and here the S shaped curves have been carefully connected and are developing into a new pattern.

Fig. 125. Designs from pottery vessels, Culhuacan.

Another simple pattern which illustrates the effect of rapid production consists of a regular repetition of a curve and two vertical strokes. It seems likely that the form is derived from a circle followed by vertical strokes such as are also found in the finely painted pottery of Texcoco (Fig. 125 *a*). The corresponding Culhuacan specimens are shown in fig. 125 *b, c*. While in a few cases the curve is a more or less carefully drawn circle *(b, c)*, it has generally the shape of a spiral. One of the most striking characteristics of the development of this pattern is the tendency to change the direction of the vertical strokes to an inclined position (fig. 126). According to the tendency of the painter the strokes incline either strongly from right above to left below (*a, b* inside, *c, d* outside), while in *e* and *f* the strokes run from the left to right. In the rapid creation of these forms the vertical lines are transformed

[1] See, Franz Boas y Manuel Gamio, Album de collecciones arqueológicas, México 1912.

into hooks. They are so characteristic that it seems perfectly feasible to recognize the same hand in these specimens.

There is still another way the design is treated. In fig. 127 *a* the spiral lies in the direction opposite to the one usually given to it and a single dividing vertical line is placed between the two spirals; the end of the first spiral taking the place of the second vertical line. Here again the method of treatment is consistent. In a few cases the spiral line instead of terminating abruptly is continued under the vertical strokes (*b*). In still another case, a separate single or double horizontal line is placed under the spiral (*c*).

A frequent design of which many specimens have been collected consists of a spiral with attached curves. Presumably it is derived from a circle and straight lines (fig. 128 *a*). In rapid execution, the center of the circle is connected with the circumference so that the whole line is transformed into a spiral. Sometimes the spirals develop into a simple hook *(b)*, and the lowest point of the circumference of the circle is continued into the adjoining horizontal line. In by far the majority of specimens the distinction between the circle and the adjoining line may be recognized by a sudden turn, or at least an indention in the lowest horizontal line *(c)*. The form developing from the original pattern depends entirely upon the peculiar turn of the brush used by the artist. In many cases *(b, c)* the spiral, continuing into the lowest horizontal line and turning back into the central horizontal line, is made in one stroke and the upper horizontal line is added on by a separate movement, adjoining the middle and forming a hook. In other cases *(d, e)*, the spiral and lowest horizontal are drawn in the same way. The horizontal lines, however, are made separately by drawing a right angle, probably from the top downward and adding a central line. In these cases, the horizontal ends at the far side in a sharp angle. In fig. 128 *f*, the two horizontal lines are separated from the curve; in *g*, they are made very long and apparently the middle one is made in one stroke with the spiral. The method of producing *h* is the same as that applied in *b* and *c* but the upper horizontal line is very much reduced in size.

Fig. 126.

Fig. 127.

Fig. 128.

Designs from pottery vessels, Culhuacan.

The same method is applied in *i* with the difference that the lower horizontal is turned up and ends rather abruptly, and that the upper and middle horizontals are made in the form of a single horseshoe curve. In *j* and *k* quite a different method is applied, the spiral remains as before but the horizontal lines are made separately in

the form of a 3. In *l* and *m* the whole curve is made in one continuous line which has led to the doubling of the middle horizontal in the form of a loop. In *n* the three horizontals are treated quite differently; the long S shaped figure starting above on the left being substituted for the lines attached to the lowest horizontal. A similar principle, but beginning on the opposite side, is applied in *o*, in which specimen the three horizontals have taken the form of a spiral ending below in an almost vertical spur. In *p* we recognize a form in which the S shaped curve is made separately; in the middle an additional horizontal line is added and furthermore, the lowest part of the S shaped curve is connected with the lower horizontal. The form *q* is reversed and by attaching the S shaped curve to the center of the spiral, a divergent form is developed.

I believe that many of the highly irregular forms that occur in painted pottery must be explained in the same way. Another instance of this kind is represented by the so-called alligator ware of the Chiriqui (fig. 129) on which W. H. Holmes based his arguments of gradual degeneration of realistic forms into conventional forms. Although the pot itself is well made, the painting is almost always slovenly; evidently the result of mass production. The most characteristic trait of decoration of this ware is line and dot work. All the designs are characterized by the use of black and red lines interspersed with dots. The geometrical designs, as well as the animal forms are crudely executed. Professor Holmes has called attention to the fact that the dots are used to indicate the scales of the alligators, but this fact does not prove that all the dots are derived from alligator scales. Forms like those shown in fig. 129 to the right above may well be understood as attempts in general decoration in black and red lines and dots, badly executed. This seems more probable since the dotted triangle has a much wider distribution than the alligator motives. A representation of the alligator might then be explained as executed in accordance with the technique applied to geometrical motives. Owing to slovenly execution the animal form may degenerate according to the motor habits of the individual artist.

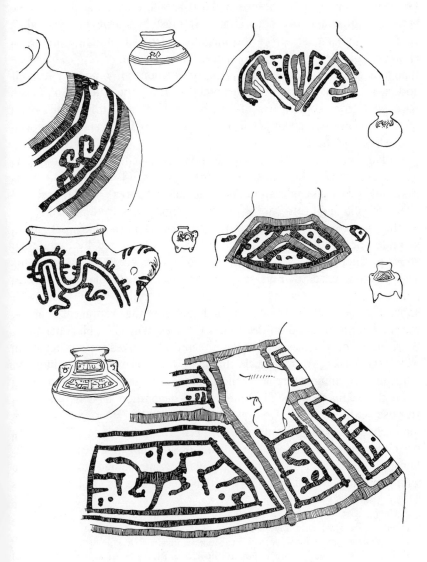

Fig. 129. Alligator designs from Chiriqui pottery.

However, this would not prove that the alligator, as such, is older than the line and dot decoration. It must be borne in mind also, that the upturned snout of the alligator, of which much is made as a means of identification, is a character of much wider distribution than the alligator motive itself. Representations of monkeys have it and we find it also in representations from the interior of Costa Rica and from some parts of South America. All this is also true of the curious nuchal appendage which occurs in Costa Rica as well as in South America.

Equally instructive is the application of small nodes and fillets to pottery which has been explained by Dr. G. G. MacCurdy as resulting from degeneration of armadillo figures.[1] The essential characteristic of all this ware is the use of small nodes and fillets applied to the surface of the vessel or to some of its parts, like feet, neck, shoulder or handle. These attachements are decorated by a series of short parallel impressions. An oval node with single medial line or lines is often used to indicate an eye; a similar nodule with several parallel lines indicates the foot; a series of parallel, short fillets with short parallel crosslines, are applied to forms that represent animals, but they are also found on the bodies of vases. Dr. C. V. Hartman[2] and S. K. Lothrop[3] describe the same technical motives from other parts of Costa Rica. In technical character these are so much like the Chiriqui specimens that we can hardly doubt that they are derived from the same device. This method of decoration is widely spread. Its use extends over Central America and the West Indies. It is most characteristic of archaic ware, particularly figurines of this early period are always modelled by means of attaching nodules and fillets. During this period the eye is regularly represented by a nodule with one or several incisions. This technique is also found in

[1] George Grant MacCurdy, A Study of Chiriquian Antiquities, Memoirs Connecticut Academy of Arts and Sciences, Vol. 3 (1911), pp. 48 et seq.

[2] C. V. Hartman, Archaeological Researchers in Costa Rica, Stockholm, 1901.

[3] Samuel Kirkland Lothrop. Pottery of Costa Rica and Nicaragua, New York, Museum of the American Indian, Heye Foundation, 1926.

Ecuador[1] up to more recent times. In the Toltec period the adornment of vessels by attached nodule decoration reached its highest development. In North America it is not common. Incised fillets occur in remains from the middle Mississippi region but even here they are not one of the pronounced features. In contrast with its frequency in the highly developed pottery of early Central America its rarity may be noted in Africa, where highly developed forms are by no means absent, and where lids with animal figures might seem to suggest readily the application of the device.[2] This is true also of the prehistoric pottery of Europe. The nodule appears in the pottery of Michelsberg, in Jaispitz (Moravia) and in a few other late localities. Only in the slip (barbotine) decorations of the terra sigillata do we find anything resembling the American appliqué ornamentation, but since the material is applied in a semifluid state, it does not attain the same freedom of treatment. Nodes that do occur in European prehistoric pottery were apparently made rather in imitation of punched bronze decorations and belong to a late period. Attached animal figures, made in clay, like those found at Gemeinlebarn, also seem to be imitations of metal work and have never reached that development which is so characteristic of Central American ceramic art.

The characteristic slit rattle feet of Chiriqui pottery prove even more conclusively than the application of fillets and nodes, that the art forms of this province must be considered as a special development of forms characteristic of a much wider area. This type of foot is widely spread beyond the territory in which the fish forms prevailed.[3]

We are thus led to the conclusion that the use of the nodes and fillets for building up armadillo motives, are historically related to

[1] Marshall H. Saville, The Antiquities of Manabi, Ecuador, New York, 1910.

[2] See a relief ornament on a red ware vessel from Banana, Belgian Congo, Annales du Musée du Congo; Notes analytiques sur les collections ethnographiques, Vol. 2, Brussels, 1907, Les industries indigènes, Pl. III, fig. 34.

[3] See Franz Boas y Manuel Gamio, Album de colecciones arqueológicas, México, 1912, Plates 36, 42, 51.

the method of decorating vessels by means of the attachment of separate pieces. The armadillo motive can then be only a specialized application of building up animal motives from the elements in question. The elements themselves must not be considered primarily as symbols of the armadillo, nor can all the animals built up of these elements be interpreted as armadillos.

The essential point of this consideration lies in the wide distribution of technical and formal motives over large areas, although differing in details in various localities. These technical and formal motives are the materials with which the artist operates and they determine the particular form which a geometrical motive or a life motive takes. If the notched fillet and node are the material with which the hand and the mind of the artist operate, they will occur in all his representations.

The investigators who have tried to prove that conventionalized forms originate through a process of degeneration from representations, have generally overlooked the strong influence of motor habits and of formal arrangements upon the resultant style. In those cases in which there is a tendency to organize decorative motives in rectangular panels, in circular areas, or in fields defined in other ways, the result must be quite different from others in which the artist habitually arranges his material in large fields or in continuous bands. The habit of decorating pottery by moulding and by adding on relief forms, must lead to results different from those which are obtained by painting or engraving. The use of lines and the habit of using dots or circles will also effect the resultant style. I think there can be very little doubt that if an artist is in the habit of using dot designs combined with lines and if, later on, he tries to represent an animal, this particular method will be applied in the representation. The origin of the motor habits must probably be looked for in technical processes, that of arrangement in the same processes and in the forms of familiar utensils.

Our examination of the factory-made material shows that the process of slurring, or slovenly execution leads first of all to the

development of individual characteristics that can best be compared with handwriting. Pronounced mannerisms permit us to recognize the hand of the artisan. It is only when an unusually careful and ingenious person operates with this traditional material that new forms develop, analogous to those described by Balfour. It will readily be seen that these conditions are not often realized in primitive society.

I believe another cause is more potent in bringing about a modification of design. Ornamental patterns must be adjusted to the decorative field to which they are applied. It is not often that the artist is satisfied with representing part of his subject and cutting it

Fig. 130. Chinese embroidery representing bats.

off where the decorative field ends. He will much rather distort and adjust the parts in such a way that they all fit in the field that he has at his disposal. When a bird is represented with outspread wings, which would occupy approximately a square field, and the space to be decorated is long and narrow, the artist may twist body and tail about, and draw out the wings and thus squeeze the design into the available space. Henry Balfour[1] gives as an instance the adjustment of Chinese figures of bats to an ornamental band (fig. 130).

The northwest coast Indians, who always take the greatest liberties with the outer forms of animals, do not hesitate to distort them in a way that allows the artist to adjust the animal to the decorative field. Their method will be discussed in greater detail at another place (see pp. 183 et seq.).

On shell discs from the mounds of Tennessee the rattlesnake is so represented (fig 131). The head of the rattlesnake with upturned upper

[1] The Evolution of Art, 1893, p. 50.

jaw is readily recognized in fig. 131 *a*. Behind the mouth, the eye represented by a number of circles, will be seen. The body continues along the lower rim towards the right and terminates on the left, in a rattle. The analogy between fig. *b* and *a* is easily recognized; the essential difference consists in the fact that the body in *b* is undecorated; the rattle lies just over and behind the eye. Figure *c* still preserves the same form, but added to the decorations found in the preceding specimens, is the long loop with small circles surrounding the eye. The position in *d* is slightly changed; the eye will be easily recognized and just to the right of it, more upright than in the preceding specimens, is the mouth with a fang. The body is in the same position as before, following the rim of the disk and ending in a rattle. In *e* the mouth is very much shortened and the eye is reduced to a single small circle, while the body and tail retain their characteristic features.

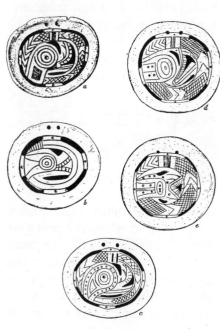

Fig. 131. Shell with representation of rattle snake.

The formal elements which were discussed in the beginning of this book exert a farreaching influence upon decorative forms. The exigencies of symmetry within a decorative field require adjustments which may modify the representative form considerably. A peculiar effect of inverted symmetry may be seen in those Borneo shields in which the whole shield represents the face of a demon; one half to the left of the vertical middle line right side up, the other half upside down.[1]

[1] A. R. Hein, Die bildende Künste bei den Dayaks of Borneo, figs. 48, 49, 51.

Much more potent than the necessities of formal adjustment is the symbolic tendency which is liable to lead to abbreviations in which the representation is reduced to the slightest indications. In our former discussions we have seen that symbolic representations are very common and that it happens in many cases that the symbol itself is represented in a more or less perspective way. Wherever the art of the people wavers between the symbolic and representative modes of delineation, opportunity arises for the occurrence of realistic and abbreviated forms, side by side. To this class belong the face urns, the prehistoric representations of human figures in stone, and even our busts and portraits may be considered as continuing this practice, for they are fragmentary in so far as they show only that part of the body in which we find the character of the individual most clearly expressed; in part, because the rest of the body is always covered by inexpressive clothing which hides whatever individuality may exist. The principal character of forms of this type will be the tendency to suggest an object by the indication of a few of the most characteristic traits. It would probably be erroneous to speak in these cases of a gradual breaking up of the realistic form and the development from it of a conventional form, for this is not what actually happens. The two types occur side by side.

STYLE

We have to take up now the problem of individual art styles. The general formal elements of which we spoke before, namely symmetry, rhythm, and emphasis or delimitation of form, do not describe adequately a specific style, for they underlie all forms of ornamental art. Representative art is more apt to develop differential features, for in each area symbolic, perspective and wavering representations have peculiar, pronounced characteristics. The principles of symbolic selection and the method of composition help to individualize representative art forms; but, besides these, many formal elements are integral parts of every art style and these give it its most specific character. The New Zealander, the Melanesian, the African, the Northwest American, the Eskimo,— all are in the habit of carving human figures in the round. They are all representative, and still the provenience of each is easily determined on account of very definite formal characteristics.

We shall direct our attention to an elucidation of the principles by which art styles may be described. We shall also ask ourselves, in how far the historical and psychological conditions under which art styles grow up and flourish may be understood.

It will be well to begin with a simple problem. We have seen that we may consider as works of art undecorated implements made by a perfectly controlled technique,—in other words made by a virtuoso. Such are polished stone axes, chipped arrow or lance heads, iron spear heads, spoons, boxes; in short, any object of daily use, provided only the form which we may recognize as conceived in crude specimens, is worked out in a perfect technique. Objects of this kind, used for the same purposes, have not by any means the same form everywhere. The specimens accumulated in ethnological museums prove that, until very recent times, before contamination by European wares, each locality, and also each cultural period had developed fixed types that were rigidly adhered to.

This observation is illustrated by the utensils of prehistoric times as well as by those collected among the primitive tribes of our times. The throwing sticks of the Eskimo may serve as an example. They are used to give greater impetus to the hand-thrown weapon. The principle of their use is the same among all the Eskimo tribes, but

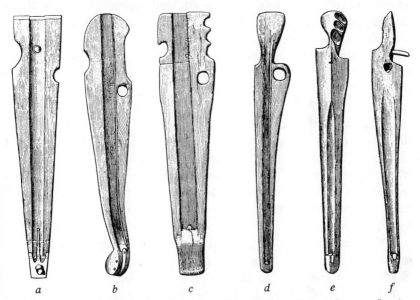

a *b* *c* *d* *e* *f*

Fig. 132. Throwing sticks of the Eskimo; *a*, Greenland; *b*, Ungava Bay; *c*, Cumberland Sound; *d*, Point Barrow; *e*, Alaska (exact location doubtful); *f*, Cape Nome.

they present highly specialized local forms, so distinct in appearance that each type may with certainty be assigned to the region from which it comes (fig. 132).

For the purpose of our inquiry it is important to understand the reasons that bring about this fixity of type. In a tool like the throwing stick it is obviously related to the manner of its use. The clumsy board of Baffinland must feel unwieldy to the hand of a native who has learned to handle the narrow, pegged stick from Bering Sea. The adaptation of the hand to the handle does not

permit the use of forms that require unusual muscular movements which would lessen the accuracy and ease of use. Therefore the variations of form are confined within the limits established by the fixed motor habits of the people. Even if a variation of form should appeal to the eye, it will not be adopted if it should require a new adjustment of the hands. The more fundamental the motor habits that determine the form of the implement, the less likely will be a deviation from the customary type.

The motor habits which find expression in the forms of utensils are in part highly specialized,—like those required for the effective use of the throwing sticks just referred to,—but others are much more general in character, and it would seem as though large divisions of mankind were characterised by habits of this kind which influence the forms of their implements and household goods. The restriction to the islands of the Pacific Ocean of the process of producing fire by ploughing; the areas of different types of arrow release described by Edward S. Morse; the extended use of throwing clubs in Africa and their relative insignificance in many parts of America are other examples of this kind.

A curious instance of the stability of motor habits is found among the Eskimo; notwithstanding their great inventiveness the ancient Eskimo does not seem to have used the saw for cutting large bones. The cutting was always done by drilling holes close together along the line on which the bone was to be divided. When enough holes had been drilled the parts were separated by a blow of a hammer or by means of a wedge; it seems that saws of flaked stone were entirely unknown to these people.

Another instance may be cited; the Indians of the North Pacific Coast, from southern Alaska to central Vancouver Island, do not practice the art of stone chipping and flaking. All their stone work was made either in tough stones that are handled by sawing, battering, pecking and polishing, or in soft stones that can be cut with a knife and rubbed down with polishing materials. The beautiful chipped blades, characteristic of their Eskimo neighbors in the north and

their Indian neighbors on the interior plateaus and of the southern coast tribes, are missing here entirely.

Similar observations may be made in regard to the handling of the knife. The North American woodcarver of modern times uses principally the crooked knife, the blade of which forms part of a spiral surface. Archaeological specimens of this type are rare[1] so that it is not certain whether this method of cutting was extensively used in olden times. At present it is undoubtedly distributed over the whole continent.[2] The knife is used like a spoke-shave, being drawn towards the body. In Africa, on the other hand, carving is done with a rasp and a straight[3] double-bladed knife. I find the use of a crooked, sickle shaped knife mentioned only once, as being applied to the shaving down of an arrow shaft and, presumably, to similar purposes. Schweinfurth[4] mentions that the Mangbattu are the only people in the regions he visited,—including even Egyptians—, who are familiar with the use of the single-edged carving knife, while all the others use the double-edged knife. Of the Ila speaking people it is also said that they use a spear blade for carving[5].

Another example illustrating our point is presented by the hammers used by the Indians of the northwest coast of North America. The coast tribes of Washington use a hand hammer made of a single bowlder with a lateral striking head, the tribes of Vancouver Island, a hand hammer also made of a single bowlder, with a cylindrical

[1] Harlan I. Smith, Archaeology of the Thompson River Region, Publ. Jesup North Pacific Expedition, Vol. I, fig. 352 *d*, p. 418; James Teit, The Thompson Indians, *ibid.* figs. 125, 126. p. 184; perhaps also the beaver tooth knife, *ibid.* fig. 49, p. 144.

[2] Otis T. Mason, Report U. S. National Museum, 1897, pt. 1, pp. 725 et seq.

[3] M. Weiss, Die Völkerstämme im Norden Deutsch-Ostafrikas, p. 421 et seq.; also G. Tessmann, Die Pangwe, p. 222; Jan Czekanowsky (Ruanda) l. c. (see p. 111) p. 155.

[4] G. Schweinfurth, Im Herzen von Afrika, 3d ed. p. 349.

[5] E. W. Smith and A. M. Dale, The Ila-speaking Peoples of Northern Rhodesia, Vol. I, p. 199.

shaft and a flat striking head at the lower end[1]; those of northern British Columbia a heavy hammerstone lashed to a large wooden handle.

In another way habits of movement or position find expression in household furniture and dress. Tribes among which squatting on the ground is habitual do not use stools or chairs. Those in the habit of lying on their sides do not use neck rests which are found among people with elaborate hair dress that lie on their backs.

The clothing of women is adapted to the manner in which they carry their children. The hood of the Eskimo woman of Baffinland accommodates the child that is carried on the back. The wide boot of the women of Southampton Island and of the ancient styles of Hudson Strait served to protect the child that was carried on the hip.

It is hardly likely that the habits of the people originated from forms of the household goods they used. It is much more probable that the inventions were determined by older habits. In later times the relation may have been reversed, in so far as each generation stabilizes its habits in accordance with the objects to which it is accustomed.

A similar permanence of form of utensils which are adjusted to definite motor habits exists in modern times, as is illustrated by the rigidity of form of many tradesmen's tools or the permanence of the keyboard of the piano.

The same conservatism, although based on the training of another sense organ, is found in the stability of the forms of the letters of our alphabet. In writing, both the firmly established motor habits and the fixity of the associations between visual image and form, help to stabilize old forms and to make difficult innovations.

The stability of language is another phenomenon of the same kind, The fundamental phonetic characteristics of a language are based on motor habits; the use of vocabulary and of grammatical forms partly on auditory associations. In all these cases; in the use of tools, forms and language the mind becomes so thoroughly adjusted to the use

[1] Franz Boas, The Kwakiutl of Vancouver Island, Publications of the Jesup North Pacific-Expedition, Vol. 5, pp. 314 et seq.

of definite motor habits, and to certain types of association between sense impressions and definite activities, that a resistance to change appears as the most natural mental attitude; if for no other reason, because it requires the effort of unlearning and relearning. It must be understood that this does not imply an absolute stability, which does not exist, but merely the individual resistance to sudden changes.

In another way this resistance is expressed through an emotional attachment to customary forms. In the domain of tools it is perhaps not so much the pleasure of play that induces man to bestow much labor upon the manufacture of his utensils, as rather the love of the special tool that he is using, a love that implies pleasure in the customary movements as well as in the form of the implement. This mental attitude is one of the most important sources of the conservatism in the form of objects of use, and of the tendency to give to them the greatest possible technical excellence. The intensity of the emotional relation between a person and his tool is naturally greatest when maker and user are the same person; it must decay with the ease with which substitutes are obtained. Here is one of the causes of the rapid decay in the beauty of form of native utensils as soon as European tools and manufactures are introduced.

While the lack of variation in the forms of utensils, and their regional characterisation are often expressions of definite motor habits, or of other sensory reactions that are firmly associated with useful activities which have become culturally fixed, there are other cases in which conservative retention of form may not be thus explained. This is true particularly when the use of an object does not depend to any considerable extent upon its form. Whether a basket is round or oblong, angular or without corners does not influence the mode of its use, unless it serves as a carrying basket. Still, in many cases the familiarity established through long use of the objects may readily lead to an emotional attachment that finds expression in permanence of form, and in the refusal to accept new, unfamiliar shapes for everyday use, an emotional resistance to change that may be variously expressed,— as a feeling of impropriety of certain

forms; of a particular social or religious value, or of superstitious fear of change. Permanence of form is also favored by the participation of many individuals in the manufacture of objects. In most cases every person supplies his own needs. The number of original minds is certainly no larger in primitive society than in our own, although I do not believe that it is any smaller. The bulk of the makers of objects of everyday use are, therefore, imitators, not originators, and the mass of uniform material that is in use and constantly seen will restrict the free play of imagination of the original minds. The desire for deliberate attempts to create something novel, that characterises the industries of our times, is not present, just as little as it is present among our peasants, so far as they are uncontaminated by city influences. I do not mean to imply that primitive forms are absolutely stable. Nothing could be farther from the truth; but the conscious striving for change that characterizes our fashions, is rare. We are also conservative in forms, a modification of which would require fundamental changes of habits.

The stability of the inner arrangements of houses, notwithstanding all variations in detail; the adherence to types of windows used in different countries; the forms of churches, our localized food habits are all examples of a considerable degree of conservatism. This prevails also at least in part, in the fundamental patterns of male and female attire.

Conservatism of form makes itself felt in many cases in which an object is made of new material. The relinquishment of the old material may be due to lack of an adequate supply of the old material, or it may be an innovation due to an inner creative impulse. It constitutes a break with the past. The old forms, however, are often retained. Such substitutions are the more liable to occur the more plastic the new material. Pottery, to a lesser extent wood, and also stone are the principal materials in which forms can be imitated in the round. Particularly pottery lends itself readily to the manufacture of a great variety of forms. When the necessary skill in tempering the clay, in modeling and firing has been attained; the opportunity is presented

for copying a great variety of forms. Thus we find shell dishes and spoons, gourd vessels and basket forms imitated in pottery. We still continue doing so. We have in our China ware innumerable instances of copies of even the finest fabrics. In Africa we find clay lamps which are evidently derived from the forms of bronze lamps of antiquity in which the complicated feet are imitations of wire work, and many pottery vessels seem to be copies of baskets. For instance, the handled ceremonial clay dishes of the Pueblo Indians look more like baskets than like pottery forms.

On account of the great frequency of imitative forms in pottery the theory has been advanced, that all pottery forms must have originated from prototypes that were first made in some other technique. Professor Schuchardt[1] assumes that the first neolithic forms which are pointed at the base, must be copies of bottles made of hide. Cushing and Holmes[2] have advocated the theory that pottery and pottery designs developed from basketry, that pots were first of all modeled over a basket and that the basket with its clay cover was then fired. The basket was thus burnt and the clay vessel remained in the form of the basket. In corroboration of this theory it has been pointed out that actually clay covered baskets have been found, on the surface of which the ornamental pattern that is usually found on the basket is painted on the clay. These attempts do not seem to me convincing. The oldest pottery that we know is very crude and does not recall any other technical form. The Eskimo made clay lamps of unbaked clay that seems to be merely squeezed into shape. It seems much more likely that the firing of clay was discovered when foods were cooked on clayey soil or in pits in clayey ground, than that baskets should be made watertight by an application of clay and that the basket, the making

[1] Carl Schuchardt, Alteuropa, Berlin 1919, p. 44.

[2] W. H. Holmes, Origin and Development of Form and Ornament in Ceramic Art Frank Hamilton Cushing, A Study of Pueblo Pottery; Fourth Annual Report Bureau of Ethnology, Washington, 1886. There is, however, evidence tha pots were moulded on baskets, then removed and fired.

of which is a laborious process, should then have been intentionally destroyed. However, I do not wish to introduce a new unproven theory in place of others. For our purpose it is sufficient to recognize the frequent copies of natural and technical forms in pottery.

The same happens, although not quite so extensively in wood carving and even in stone work, particularly in soft stones that may be worked with a knife. Wooden copies of objects made of buffalo horn occur in Africa. Many of the beautifully carved wooden goblets from the Congo region look to me like pottery vessels, held in place by stone supports. Carvings in wood imitate forms made by joining pieces together. In some regions we find stone vessels of the same form that is usually used for wooden ones. Best known among imitative stone forms are the prehistoric European stone axes which are copies of the forms of bronze weapons that were in use in more southern regions, or the stone settees of ancient South America, copies of wooden seats.

We have spoken so far only of the general forms of the objects, not of decoration or ornament. We have seen in our discussion of the purely formal elements that the technique will sometimes bring about patterns on the surfaces of the manufactured objects. We mentioned the patterns produced by flaking of stone, by adzing and by weaving with coarse material. The importance of these surface patterns for the development or ornament can hardly be overstated. When a large board is adzed, the workman must shift his position in order to cover the whole board. According to the way he moves, different patterns of adjoining surfaces may develop. Much more important are the patterns that naturally develop when a weaver plays with his technique, that is when he or she is no longer satisfied with the simple weaving up and down, but begins to skip strands and thus introduces more complex rhythms of movement. The solidity of the fabric requires alternations of skipping and thus the twilling leads immediately to diagonal surface patterns. The more complex the rhythmic movements, the more complex will also be the patterns. The attempt has been made to trace the

origin of all important decorative patterns to this source. I presume this is an exaggeration, because other conditions may as well lead to the discovery of designs. I say advisedly discovery, not invention, for I believe, with those investigators who would derive all patterns from weaving, that intentional invention is less important than the discovery of possibilities which come to be observed as an effect of the play, particularly the rhythmic play with technical processes.

I presume that the occurrence of a number of simple ornamental elements may be explained as technically determined. We have seen before that the straight line and the regular curve such as circle and spiral presuppose an accurate technique, that they are too rare in nature to be considered as representative in character. The straight line may be the result of cutting, folding or splitting some kinds of wood, of the use of reeds or similar materials, of stretching fibres and of many other processes. Circles may originate by the regular turning of coiled basketry and of coiled pottery: spirals by the laying of coarse coils. Weaving in coarse material leads to rectangular figures, to checker patterns, steplike diagonals and to many other complicated forms. Tying with cord produces straight lines intersecting at various angles and also parallel, circular and spiral forms. We may confidently claim independent origin in separate areas for the triangular design in basketry (fig. 104 *a*, *b*, p. 109); for simple radial forms in coiled basketry placques; for the swastika cross, the meander and for many other simple forms, like the spirals of prehistoric Bohemia; of eastern Siberia; of Melanesia and of ancient New Mexico; in the sameness of design elements from Africa and America; in the occurrence of the circle and central dot in prehistoric Europe and among the Eskimo. The principle of symmetry, of balance, of rhythmic repetition and of emphasis laid upon prominent points or lines apply to all kinds of technique and many lead to parallel developments.

We have seen that in some cases, simple elements which develop independently, possess stylistic pecularities that differentiate one locality from another. But even if the forms are identical, the arrangement

in the decorative field is liable to give a specific form to the art of each locality.

The negroes of the Congo present an excellent example of the transfer of design from one technique to another. Their woven patterns consist largely of intersecting bands, imitating the interweaving

Fig. 133. Pile cloth, Congo.

of broad bands. These motives appear in most of the decorative work of these tribes. Their embroidered pile cloth (fig. 133) imitates the interwoven patterns; they reappear on their wood carvings, particularly on their goblets (see fig. 52, p. 59), and on carvings on buffalo horns.

Interwoven bands that look like imitations of coarse weaving are also very common in American art. They are found in many parts of South America and among the Pueblo Indians. Some of the wood carving of Tonga is evidently influenced in style by the artistic methods of tying, which are highly developed in the islands of the Pacific Ocean.

Granting all this, it still remains obscure why there should be that degree of individualization of style that is actually observed even where similar technical processes prevail. The Indians of Guiana and the Indonesians use the same methods of weaving in rather broad, stiff materials. The technical conditions controlling their basketry work are practically the same. Nevertheless the styles of art they use are quite distinctive.

We conclude from this that besides the influence of the technique there must be some other causes that determine the individual style of each area. I doubt very much that it will ever be possible to give a satisfactory explanation of the origin of these styles, just as little as we can discover all the psychological and historical conditions that determine the development of language, social structure, mythology or religion. All these are so exceedingly complex in their growth that even at best we can do no more than hope to unravel some of the threads that are woven into the present fabric and determine some of the lines of behavior that may help us to realize what is happening in the minds of the people.

We have to turn our attention first of all to the artist himself. Heretofore we have considered only the work of art without any reference to the maker. Only in the case of slovenly work have we referred to the artisan. It has appeared that his behavior as revealed in his work helped us to understand the fate of the designs. We may hope, therefore, that in the broader question also knowledge of the attitude and actions of the artist will contribute to a clearer understanding of the history of art styles. Unfortunately, observations on this subject are very rare and unsatisfactory, for it requires an intimate knowledge of the people to understand the innermost thoughts and feelings of the artist. Even with thorough knowledge the problem is exceedingly difficult, for the mental processes of artistic production do not take place in the full light of consciousness. The highest type of artistic production is there, and its creator does not know whence it comes. It would be an error to assume that this attitude is absent among tribes whose artistic

productions seem to us so much bound by a hard and fast style that there is little room for the expression of individual feeling and for the freedom of the creative genius. I recall the instance of an Indian from Vancouver Island who was suffering of a lingering malady that confined him to his bed. He had been a good painter but his productions did not differ stylistically in any way from those of his tribe. During his long illness he would sit on his bed, holding his brush between his lips, silent and apparently oblivious of his surroundings. He could hardly be induced to speak, but when he spoke he dilated upon his visions of designs that he could no longer execute. Undoubtedly his was the mind and the attitude of a true, inspired artist.

The general character of the artistic productions of man, the world over, shows that the style has the power of limiting the inventiveness of the productive artist; for, if we grant that potential genius like the one just described is born in all cultures, then the uniformity of art forms in a given tribe can be understood only by these limitations.

The restriction of inventiveness is not due, as might perhaps be supposed, to the habit of copying old designs and to a sluggishness of the imagination of the artisan who finds it easier to copy than to invent. On the contrary, primitive artists hardly ever copy. Only in very exceptional cases are found working designs such as we employ in embroidery, dressmaking, woodcarving and architecture. The work is laid out in the mind of the maker before he begins and is a direct realization of the mental image. In the process of carrying out such a plan technical difficulties may arise that compel him to alter his intentions. Such instances can easily be discovered in the finished product and are highly instructive, because they throw a strong light upon the mental processes of the workman. We may see particularly in richly decorated basketry how such difficulties arise and what influence they exert upon the development of the design.

Even in the making of mass products, like the pottery which we described before, (pp. 132 et seq.) copying is evidently not practised. The patterns are so simple and require only a small number of

standardized movements which are combined in a variety of ways. The method of work corresponds strictly to our method of writing in which also a number of standardized movements occur in a multitude of combinations.

Although the artisan works without copying, his imagination never rises beyond the level of the copyist, for he merely uses familiar motives composed in customary ways. It does not require much practice to learn how to carry out such simple work without patterns. The method of procedure is the same as that followed in European folk art. The embroidered or woven patterns, the wood carvings of European peasants are not copies of patterns but the results of individual composition. Pattern books appear only at a time when the folk art is decadent. Therefore, notwithstanding the rigidity of style it would be difficult to find two objects that have identical ornamentation.

When designs are very complex, and rigid symmetry or accurate rhythmic repetitions are required, we find sometimes the use of stencils. It does also happen, that one person plans a design and another executes it. In these cases actual copying may occur; both of these instances are rare in primitive culture and do not modify the general picture as here outlined.

It is interesting to hear the opinions of individuals who create new designs. We have already seen that the novelty consists generally in the combination of old pattern elements in new ways. Nevertheless, the authors of these designs are convinced that they have created something new. I have information on the attitude of these artists only from the North American Indians. They call designs of this kind "dream designs", and claim that the new pattern actually appeared to them in a dream. This explanation of the origin of the new form is remarkably uniform over the whole continent. It has been recorded on the Great Plains, on the north western Plateaus and among the Pueblo Indians. There is little doubt but that this is merely another term for invention. It expresses a strong power of visualization which manifests itself when the person is alone and at rest, when he can give free play to the

imagination. Perhaps the artists have greater eidetic power than most adults among ourselves. The few individuals who create new forms in this manner have probably a good control over the technique and wide command over a multitude of current forms. In the one case which has been investigated with some care by James Teit the woman who created new basketry patterns was also one of the best technicians and had full command over the greatest variety of forms.

When the patterns made by individual artists are compared, it is seen that the number of designs made by different individuals differs very considerably. Some have command of the full range of forms, while others are satisfied with a small number which they repeat over and over again.

The controlling power of a strong, traditional style is surprising. The Northwest coast people have characteristic methods of representing heads, eyes, eyebrows and joints; fig. 67 (p. 71) shows the attempt of an excellent Haida artist who tried to illustrate the tale of an eagle who carried away a woman.

The general form of the eagle is quite realistic, but the artist could not avoid placing the characteristic eye design in the wing joint of the eagle, and to render the head in the conventional style in which the eagle is shown. The woman whom the eagle carries has the typical eyebrow and cheek patterns. The style has penetrated the picture which was planned as a realistic representation.

Similar observations may be made in regard to the Wasgo, the fabulous sea monster with a wolf's body and large ears. In fig. 134 it is shown carrying a whale between its ears, another one in its tail, and a person in the mouth. It has the characteristic high nose of the wolf, the ears turned back (here shown as transparent). The large shoulder and hip joints and the hands and feet in form of eyes are features of Northwest coast art. The whale with its round eyes, blowhole, and characteristic tail conforms also to the local art style. Still the artist attempted to give a realistic painting.

Quite analagous is another painting by the same Haida artist, Charles Edensaw (fig. 135) who tried to illustrate for me a Haida

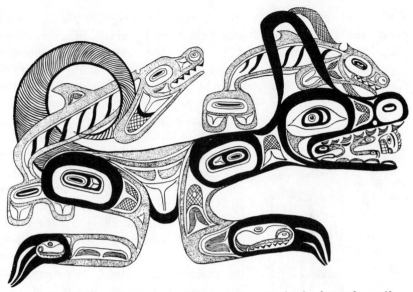

Fig. 134. Haida painting representing a sea-monster in the form of a wolf, carrying two whales.

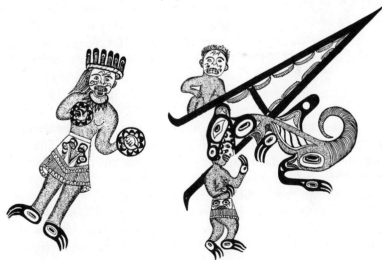

Fig. 135. Haida drawing representing the story of a young man who caught a sea monster.

story of a man who caught the sea monster Wasgo by placing a split cedar tree under water. It was held open by means of a spreading-stick. A child was placed in it as bait and when the monster appeared to devour the child, the youth knocked out the spreading-stick ; the tree closed and caught the monster. In this sketch the tree is shown by the black, sharp angle, set on the inside with teeth that killed the monster. The spreading-stick, which holds the split tree apart is indicated by the black crossbar. The Wasgo in the form of a wolf with large dorsal fin is shown biting the head of the child, while the youth sits on the tree. The story continues telling that the youth dons the Wasgo skin and goes every night to hunt sea game which he deposits on the beach of the village. His mother-in-law claims shamanistic power and pretends to have obtained the game. When the youth makes known that he has killed it, his mother-in-law falls down being shamed by the young man. She is shown on the left in shamanistic dress with shell rattles, shamanistic apron, neck ring of bone ornaments and the shamanistic crown. Her position indicates that she is falling. It will be noticed that here also every figure shows characteristic traits of the northwest coast ornamental style.

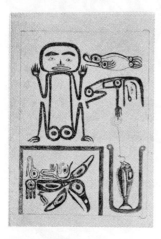

Fig. 136. Haida drawing representing part of the raven story.

In fig. 136 part of the raven story is represented. The human figure in the left hand upper corner presumably represents the owner of the halibut hook. Under it is shown the raven flying and carrying on his back the owner of the halibut hook. According to this story he throws him into the sea, takes the halibut hook and begins to fish. This incident is shown on the right hand side of the sketch. The meaning of the seal in the upper right hand corner is not clear.

We have seen that in representative art the particular type of perspective or symbolic form or the combination of the two determines in part the local style. We have to turn now to a consideration of the purely formal elements that characterize style. We may distinguish here between the forms of ornamentation and their composition. A general survey of the field of primitive art convinces us at once of the great variety of elementary forms and of their sharp localization. As an instance of the importance of fundamental forms I choose the occurrence of the spiral. It is characteristic of the art of New Zealand, of Melanesia, and of the Amur tribes,— to select only a few typical examples. And still, how great are the differences, how sharply specialized the spiral of each of these districts! Practically all the spirals in primitive art are equidistant. It can easily be shown that spirals develop in many different ways.

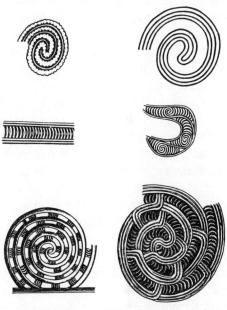

Fig. 137. Types of New Zealand spirals.

As has been pointed out by Semper, the coiling of wire or the making of coiled basketry or pottery must lead to the discovery of the ornamental spiral. Wrapping with twine may have a similar result. In other cases the spiral develops without technical motives from natural forms. This is exemplified, for instance, by the spirals used for expressing the nostrils of the beaver, bear and dragonfly in northwest coast art (see figs. 157 p. 186, 175 p. 193). It is, however, doubtful whether the spiral has ever become in this manner a dominant motive of local art.

The New Zealand carved spiral (fig. 137) is generally double;

one arm running in, the other out, and the two clasping each other in the center. The spirals are so placed that their general contours harmonize with the decorative field, although their outer turns often cut into its borders. The appearance of the spiral is strongly influenced by the application of a common pattern of carving, which consists of a long lineal field with crosshatching limited by two or more equidistant lines. The two arms of the spiral are connected at regular intervals by small bars having crossline decoration. In other cases the spirals themselves are decorated with crosslines, while the surrounding lines are smooth. Sometimes the spirals are given a notched outline. Single spirals consisting of a number of equidistant lines, occur in tattooing and in wood carving representing tattooed faces. Spirals are often connected and form S shaped figures and when placed serially in a narrow field, they are accompanied by a series of equidistant lines,— fragments of the outer turns that would have shown if the spiral had been able to develop freely.

The spiral of eastern New Guinea is in some ways similar to the one of New Zealand. The double spiral appears commonly in both areas, also the notches or scallops on the spiral and the filling in of the gore with curved lines accompanying the outer turns of the spiral (fig. 138). The lack of connecting bars, of the crossline decoration and the fundamentally different design arrangement, as well as the treatment in black and white differentiate the New Guinea spiral from that of New Zealand. The curves are fitted much more rigorously in the decorative field. The great freedom of the New Zealand forms, the delicate accuracy of all the constituent elements, and the multiplicity of forms connected with the spiral, are absent.

The third area, the Amur region, in which the spiral is used extensively, represents fundamentally different forms, (fig. 139). While the spirals of New Zealand and those of New Guinea are equally wide through the whole distance of their course, those of the Amur region show peculiar lateral developments. The spirals of this area are generally single, and broad; or double, but the spirals do not clasp each other. The outlines of the spiral bands

are varied by strictures. Where the general course of these spirals leaves fields that would remain undecorated, they are filled in by broad tendrils, leaf like projections or by independent circular ornaments that help to keep the background broken up in bands that

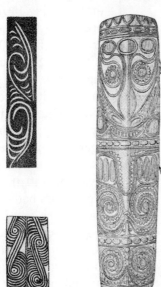

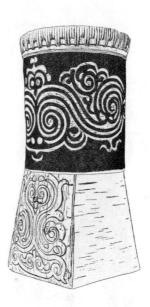

Fig. 138. Types of spirals from eastern New Guinea.

Fig. 139. Spirals from the Amur River.

retain throughout approximately the same width. Often the variations in the lines of spirals form animal figures, particularly birds and fishes; sometimes of fairly realistic form.

Fixity of form occurs even in crude representative drawings made without such technical skill as is developed in industrial occupations. This is strikingly illustrated by certain forms used by the Algonquin tribes of the woodlands around the western Great Lakes and also by the neighboring Siouan tribes. In their pictographs the human

figures appear regularly with broad shoulders, tapering down in straight lines to the waist. Sometimes the figure is cut off at this place; sometimes it ex-

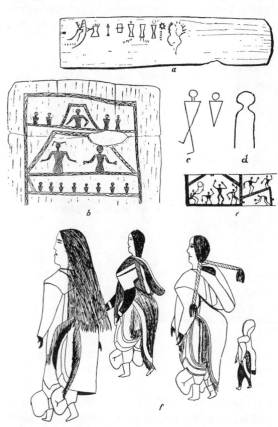

pands downward from the waist. Fig. 140 *a* represents a Potawatomi drawing; fig. 140 *b* a Wahpeton Sioux drawing of the same type. In the winter counts of the Sioux published by Mallory, the human figure is represented in quite a different style, (fig. 140 *d*). This type occurs both in the La Flamme and Lone-Dog winter counts. We may compare these forms with the typical symbol used by the Blackfeet to represent a slain enemy, which, according to Wissler, has always the form given in *c*. On the reproductions of pictographs the same form appears, often with only one leg. Quite distinct from these Plains

Fig. 140. Pictographs representing human beings:
a, Potawatomi; *b*, Wahpaton Sioux; *c*, Blackfoot;
d, Dakota; *e*, Alaskan Eskimo; *f*, Pencil sketches by
Eskimo from the west coast of Hudson Bay.

Indians types are the forms used by the Alaskan Eskimos in their etchings on bone, antler, and ivory (*e*). The forms are always small silhouettes in lively motion and the realism of form and movement

of the Eskimo etchings forms a strong contrast when compared to the conventional style of the Plains and Woodlands Indians. Even the pictographic representations of men in motion, which do occur in other types of Plains Indian drawings, differ entirely in style from

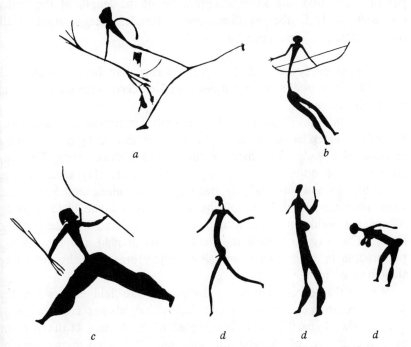

Fig. 141. Pictographs; *a, b, c,* from the Cueva de los Caballos; *d,* Bushman.

those of the Eskimo. The style of the eastern Eskimos representation of the human form differs considerably from that of the Alaskan Eskimo. They do not use silhouettes but draw their forms true to life with particular attention to the details of the clothing (fig. 140 *f*).

Quite distinct from these forms are the representations of the human form made by the Bushman and by paleolithic man. They are always silhouettes of large size with strong exaggerations of characteristic forms and movements of the body, (fig. 141). Obermaier has

described these in detail.[1] Some of the figures in lively motion are represented with thread-like legs and body, while in other cases the calves of the legs are shown in exaggerated sizes. The Bushman paintings are somewhat similar in type to those of the paleolithic period. We find the same exaggeration of the length of the limbs and particularly in the representation of females, exaggeration of all the characteristic features of the body.

In almost every art definite stylistic forms may be recognized. I will add a few additional examples based on certain classes of objects which illustrate this.

Miss Ruth Bunzel has given to me a full description of the decoration of the water jar of the Zuni. "It is characterized by great stability in decorative style. The form of the jar itself shows very slight variations. The outer surface is slipped with white clay which serves as a background for painted decorations in black and red. The most characteristic feature of the decorative scheme is the boxing off of the field into clearly defined areas outlined by heavy black lines. The ways in which the field is thus divided and the designs permissible in each section are all definitely prescribed by prevailing standards of taste.

"Essential on every jar is the division of the field into two zones known as neck and body. Neck designs are always used in pairs, four or six alternating units being used on each jar. At the present time the choice of designs for the neck is limited to two sets of designs, the way in which they are combined being absolutely fixed. Alternating diamond and triangular patterns, both highly elaborated, are used together, and, on the other hand a scroll and conventionalized prayer-stick are used together on other jars.

"For the body there is a greater choice of design, but the choice is between certain well known patterns, and the ways in which each

[1] H. Obermaier, P. Wernert, Las Pinturas Rupestres del Barranco de Valletorta. (Castellon) Comisión de investigaciones paleontológicas y prehistóricas, Mem. No. 23. Museo Nacional de ciencias naturales, Madrid 1919.

may be used are definitely fixed. The most characteristic and, at the present time, the most popular type is the deer-sunflower pattern (fig. 142). Two large medallions representing sunflowers are painted on opposite sides of the jar. Three such medallions are sometimes used, but two is the preferred number. The space between the medallions is divided horizontally by a narrow band. The band may be filled with small conventionalized birds or with an interlocking scroll figure.

In each of the spaces formed by this band are painted two deer, each surrounded by graceful scroll work, called in Zuni terminology 'the deer's house'. In all, eight deer are used, two in each of the four fields. The deer are always painted in exactly the same way, in profile with the head to the right, and with certain

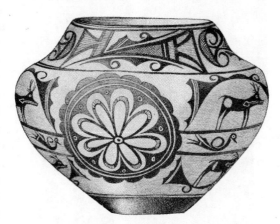

Fig. 142. Zuni pot.

of the internal organs indicated. There is no variation even in the ornamental scrolls surrounding the representation. In small jars it is permitted to substitute for the deer on the lower and smaller part of the jar one of several well defined crook or scroll patterns, but any other departures from the established scheme are severely criticised. The first of the two rim designs referred to above is always used with the deer pattern. The whole composition in precisely the combination described appears over and over again in water jars now in use at Zuni as well as older specimens now in our museums, and the fixity of the type is clearly recognized by native artists.

"This is only one of a number of equally fixed types of decoration at present in favor at Zuni. There is, for instance, one very

elaborate terraced figure repeated in literally hundreds of specimens of water jars, and always without the slightest variation either in the figure itself or in its application to the jar. It is always used in threes

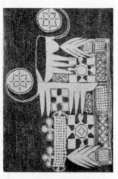

and with the second of the two rim designs. There are other types also, any one of which is known to and can be described by any well informed Zuni potter. Although the invention of new designs is considered eminently desirable among them, the actual number of Zuni pots that do not belong to one or the other of these recognized types is exceedingly small."

As another example I choose the style of embroidery on Haussa shirts (fig. 143). Felix von Luschan has called attention to the rigidity of the general pattern.[1] A narrow elongated field in the left hand upper corner of the

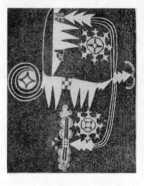
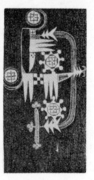

Fig. 143. Haussa embroideries.

design surrounded on the left by a thin white line, on the right by a white field with long pointed triangles, limits the hole through which the head passes. The white disk to the left of it rests, therefore on the right side of the chest, the upper disk on the right shoulder blade. The line dividing the design into an upper and lower

[1] Felix von Luschan, Beiträge zur Völkerkunde, p. 50. Patterns of the same kind have been figured by Leo Frobenius in "Das sterbende Afrika," Pls. 58—60.

part, beginning just at the lower end of the slit through which the head passes, sets off the embroidery on the body of the shirt from that on the large pocket below. The upper rim of the pocket is always decorated with a central design, consisting of a square field with checkered figures, to the left of which are two triangles, to the right, three. In many specimens there is, on the right border of the field, a looped band. The design on the lower part of the pocket and the one on the body of the shirt are, in the main, symmetrical. The three-barbed arrow pattern of the lower border reappears on top followed inside by the same type of rosette. The two designs differ, however, in so far as the three-pointed pattern with the connected loop band is repeated to the right of the slit for the head, turned at right angles to the corresponding portion on the pocket border. This pattern disturbs the symmetry of the upper and lower designs and produces a distortion of the upper one which, however, does not influence the pattern elements. On the pocket below and to the left, is a rectangular band with a leaf design forming an inner border.

Great fixity of design appears also in the rawhide boxes of the Sauk and Fox Indians, to which I referred before (p. 25 et seq.). The characteristic feature is the division of the rectangular hide that is to form the box, into three fields lengthwise, five fields crosswise. The five fields are determined by the way in which the box is folded; four sides forming front, bottom, back and top, and the fifth a flap covering the front. The lengthwise division is not so determined, for the width of the box differs considerably from that of the central field. The design elements are based on common patterns of the Indians of the northern part of North America: rectangles divided by central longitudinal lines and obtuse triangles on each side of it. It should be noticed that the design unit is not the diamond but the rectangle with two obtuse triangles that have the apex near the central dividing line. This appears clearly in the specimen shown in fig. 144 *b* in which every design begins at the margin with at triangle pointing inward towards the opposite triangle and also in the other figures in which, in accordance with the

art style of the eastern woodlands, a segment is substituted for the acute triangle. A second element in these designs is the acute triangle with lines, or a single line, extending from the apex; a form which is also common to all the woodland and plains Indians.

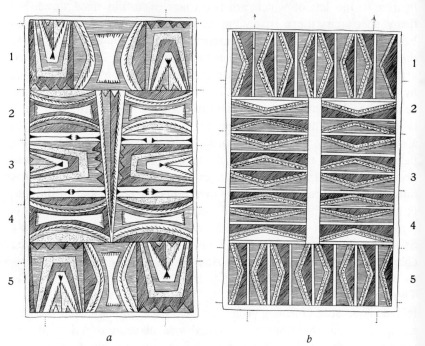

Fig. 144. Painted rawhides, Sauk and Fox.

Two styles of these paintings may be distinguished; one in which the five crosswise fields are so treated that the patterns on the three central rectangular fields (2, 3, 4) are at right angles to those in the two extreme fields (1, 5). In the central fields the long sides of the rectangles run parallel to the narrow side of the hide and in the outer ones, the rectangles are turned so that the long sides are parallel to the long side of the hide. The central lengthwise field extends only over the three middle fields and is very narrow

(figs. 14, 144, *a*, *b*). The only ornament on fig. 144 *b* is the rectangle with two obtuse triangles facing at the apex. To the four rectangles on 2, 3, 4 correspond four corresponding ones in the fields 1 and 5. In fig. 144 *a* there is an alternation of two designs in these fields. There

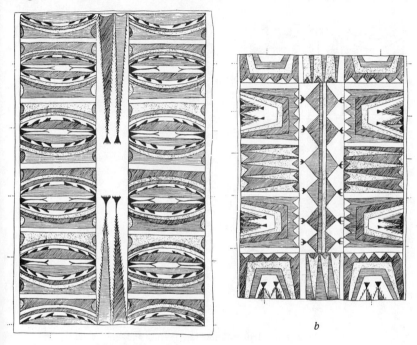

a

b

Fig. 145. Painted rawhides, Sauk and Fox.

are two triangles with protruding lines with complex frames, and rectangles with the obtuse triangles transformed into segments. The central dividing line in these rectangles is missing. It will be noticed that here also the number of rectangles in the three inner fields (2, 3, 4) corresponds to the number in the outer fields (1 and 5), but their order is reversed. Left and right triangles in the outer fields (1 and 5) are also in reverse positions. The narrow central field is occupied by a single acute triangle. In fig. 145 *b* we have a similar

arrangement, but in place of the rectangle with obtuse triangles, we find a new arrangement of acute triangles. Fig. 14 (p. 27) differs from those just described in that the central field is divided into two divisions instead of four. The obtuse triangles in the four corners

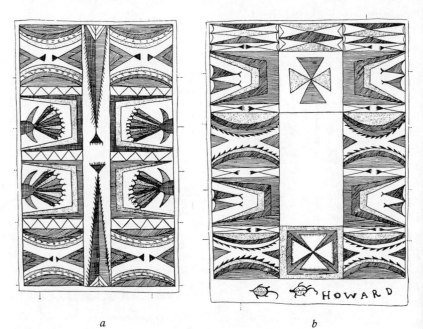

a *b*

Fig. 146. Painted rawhides, Sauk and Fox.

are treated somewhat differently and the figure between them in the middle of the short side is treated as though the essential design were the diamond, not the obtuse triangle. The heart shaped design and the star like figures give the impression of a new development of older patterns.

In figures 13, 15, 145 *a* and 146 the rectangles are all placed in the same direction; the long side parallel to the short side of the hide. Fig 145 *a* consists throughout of curved segments corresponding to the obtuse triangles. At the apices of these segments the

rectangles are divided by central lines. The fields separating the rectangles bear each an acute triangle with prolonged apex. In the narrow central field we find also the acute triangle with extending lines. Fig 15 consists of the acute triangle with the usual frame but with scolloped edges instead of the angular figures of fig. 145 *b*. The central field is treated in the same way as in fig. 145 *a*. Fig. 13 corresponds nearly to fig. 145 *a*, except that the rectangular fields are not divided by a central line, but have a central figure somewhat hour-glass shaped enclosing an acute triangle at each end. The crosses in the middle field are also derived from the acute triangles. The three central fields of the long side of fig. 146 *b* correspond to fig. 144 *a*. Since the rectangles in the marginal field on the short side are not turned, the acute triangle design did not fit and we find, therefore, instead the cross design. The lack of symmetry between the extreme upper and lower fields is quite unusual. In fig. 146 *a* we find, as in fig. 14, only four fields. The designs are similar in character to those of fig. 146 *b*, except that the acute triangle design is developed in a peculiar manner.

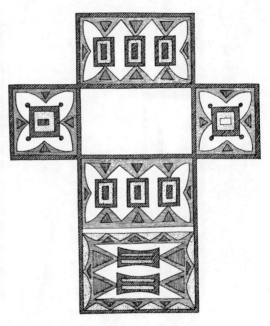

Fig. 147. Painted rawhide, Ioway.

The Ojibwa and Ioway use another method of building up their boxes. The short sides are made of separate flaps and there is no flap covering the front. The bottom is not decorated and the hide

is folded over simply in box form and sewed together (fig. 147). The method used by the Otoe and sometimes by the Ioway, is still different. There is a short flap covering part of the front; the sides are folded in, somewhat in the same manner as done by the Fox

a *b*

Fig. 148. Painted rawhides; *a*, Ioway; *b*, Otoe.

and there is also a complete lack of coherence between the design as laid out on the hide and as it appears in the completed box (fig. 148).

Still another example of fixity of type is presented in the woven bags of the Ojibwa and Potawatomi (figs. 149, 150). The two opposite sides have always distinct patterns. The purely geometrical patterns are always laid out symmetrically. There is a broad central figure bordered by a number of narrow stripes. These are followed, above and below by a wide stripe of a pattern different from the central one. Sometimes the colors above and below are inverted.

The dividing line runs all around the bag, but the patterns in the broad bands change. On the one side there are often representative figures above, and in this case there is no correspondence between the upper and lower designs. Similar bags are used by other

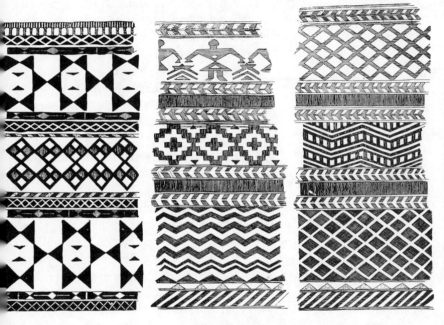

Fig. 149. Design from
pouch, Ojibwa.

Fig. 150. Design from two sides of pouch,
Potawatomi.

neighboring tribes. The Potawatomi use the same decorative arrangements, except that the central band often remains undecorated.[1]

For a clear understanding of the character of a local style a comparison with related forms in contiguous areas is indispensable. Historical conditions like those that may be traced in the development of art forms in prehistoric and historic times in Europe and in Asia

[1] See Alanson Skinner, The Mascontens or Prairie Potawatomi Indians, Bull. Public Museum of the City of Milwaukee, Vol. 6, No. 2, Plate 21.

have been determinants in forming the art of primitive people also. There is probably not a single region in existence in which the art style may be understood entirely as an inner growth and an expression of cultural life of a single tribe. Wherever a sufficient amount of material is available, we can trace the influence of neighboring tribes upon one another, often extending over vast distances. Dissemination of cultural traits that has made the social structures, the ceremonials and the tales of tribes what they are today, has also

Fig. 151 *a.* Type of parfleche and pouch painting, Arapaho.

been a most important element in shaping the forms of their art. The local distribution of technical processes, of form elements, and of systems of arrangement contribute to the character of each art style. In another place we have discussed the distribution of pottery decorated by means of applied pellets and fillets (see p. 138), and it appeared that the technical process covers a wide continuous area and that it is applied in different ways by each cultural group. We have also seen that the characteristic triangular design with

enclosed rectangle, often with spur lines along the base, is widely disseminated over the North American continent. We found that this form is common to the Pueblos, the Indians of the northwestern plateaus and of the plains, and that the fundamental pattern may be recognized in New England and Labrador. Patterns composed of lines, triangles and rectangles are characteristic of the art of the North American Indian. Notwithstanding their simplicity, these forms are practically confined to North America. Their strong individuality proves that their present distribution must be due to mutual influence among various North American cultures. We cannot determine where the pattern originated but it is quite certain that its present distribution is due to cultural contact; its occurrence is

probably related to the use of stiff rawhide for receptacles, to the method of painting used by the Indians, and to the old method of decorating with porcupine quill weaving and embroidery. I have called attention to the difference in arrangement of these patterns among a number of tribes and A. L. Kroeber, R. H. Lowie, and Leslie Spier [1] have discussed these questions in greater detail (fig. 151).

Fig. 151 *b, c*. Types of parfleche and pouch painting, Shoshone.

The parallel stripe arrangement is characteristic of the Arapaho; a central field surrounded by a square, of the northern Shoshone. Owing to the close contact in which these two tribes live at the present time, which favors intertribal trade, the distribution is not quite so clear as it has probably been in earlier times.

Certain differences may also be observed in the arrangement of bead embroidery the forms of which are very uniform over an extended area of the western prairies. A characteristic form of this

[1] Leslie Spier, An Analysis of Plains Indian Parfleche Decoration, University of Washington Publications in Anthropology, Vol. I, pp. 89 et seq. where the earlier literature has been quoted.

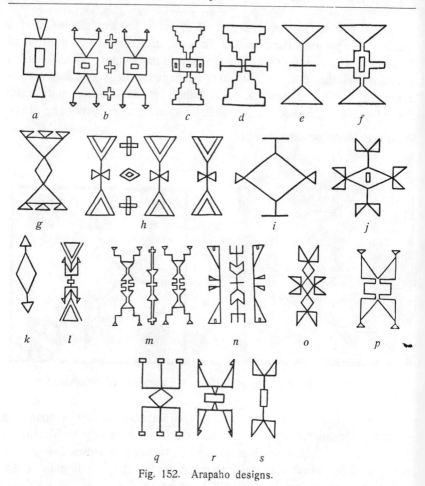

Fig. 152. Arapaho designs.

design consists of a central diamond or rectangle, from the corners of which emanate lines that terminate in triangles facing the central field either with the apex or with the base; sometimes a cross-bar with prongs is found at the end of these lines. Among the Arapaho (fig. 152) these patterns appear singly on a plain background; among the Sioux (fig. 153) the central square is seldom

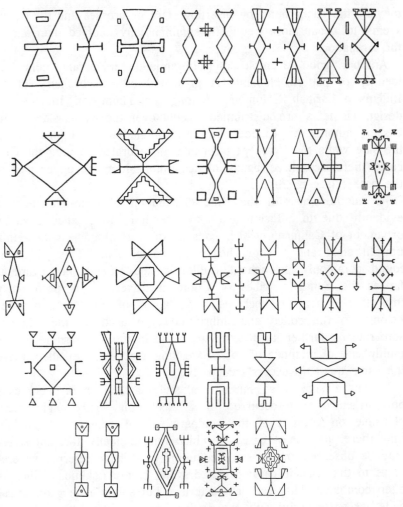

Fig. 153. Sioux designs.

used. While among the Arapaho the lines are usually attached to only two opposite ends, the Sioux almost always attach them to the four corners of the central diamond. Furthermore, the Sioux like

PLATE II.

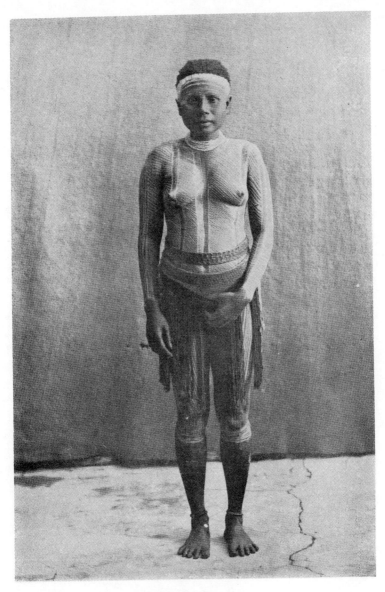

Andaman Islander.

to vary the background by inserting stars or crosses and the design seems to occur more frequently symmetrically doubled than among the Arapaho.

Another good example of differentiation in arrangement and identity of pattern elements is presented by the basketry of the Indians of British Columbia. Among the Thompson Indians the design elements are distributed evenly over the whole side of the basket; among the Lillooet they are confined to the upper part of the side while the lower part remains undecorated; among the Chicotin there are three bands of decoration along the upper part of the basket (see p. 297).

As another case of the wide distribution of a design element, evidently due to diffusion, we may mention the socalled quail tip ornament of California which consists of a right angle with a thin upright stem and a short heavy horizontal arm. This pattern is found commonly throughout California and extends northward as far as the Sahaptin tribes of Columbia River. It is particularly important to note that technically the basket of the Sahaptin tribes belongs to the coiled and imbricated type used by the Thompson Indians farther to the north; while in the southern regions a multiplicity of methods of basket weaving are used. In all of these the same quail tip occurs (see p. 109).

We have spoken so far of local styles as though in every case only a single style occurred in a tribal unit. This might seem plausible on account of the comparative uniformity of tribal life. Still there are many cases in which fundamentally different styles may be observed in the same community. I have referred several times to the realistic carving and drawing of the Eskimos, which is often combined with very characteristic but subordinate geometrical patterns, particularly with the double line with alternating spurs, a series of "Y" shaped figures, arranged on a continuous line; and circles and dots (see fig. 78, p. 86). In certain cases realistic forms are used for the purpose of ornamentation. On some modern specimens from the west coast of Hudson Bay, the representations

of human beings or animals are found (see fig. 51 *b*, p. 58). In Greenland wooden vessels are ornamented by attached ivory carvings representing seals, which are nailed on to the surface (fig. 121, p. 127). Pieces of skin in which needles are kept, are ornamented with appliqué figures.[1] On the east coast of Greenland similar decorative motives are in use.

The style of ornamenting cloth is quite different. There is no realism and the formal patterns which are used are broad bands, accompanying the borders of the garments and long lines of fringes. The basis of this ornamentation is a feeling for color contrast and a tendency to emphasize outlines. The representative tendency is entirely absent. In a single specimen in which it appears as a representation of a human hand, it looks strangely out of place.[2] This decorative type is fully developed in Greenland where checker work is applied to garments, buckets, and also to wooden goggles.

I presume the principal cause for the difference of these styles is found in the difference of the technical processes, but perhaps even more in the circumstance that the realistic work is made by the men, the clothing and sewed leather work by the women.

Two fundamentally distinct styles occur also among the Indians of the North Pacific coast. I have referred a number of times to their symbolic representations of animals with the curious disregard of natural relations between the parts of the body. This style of art is confined primarily to woodwork and to other industries allied to woodwork. It occurs also in appliqué and in embroidery in porcupine quill,— probably copied from painted designs,— so that it is practiced by both men and women. It is, however, entirely absent in modern basketry made for home use, and in matting. The decorative patterns in these types of technique are always geometrical and bear no relation to the art of carving. Only in the woven

[1] Kaj Birket-Smith, Ethnography of the Egedesminde District, Meddelelser om Grønland, Vol. 66, (1924), pp. 522, 550.

[2] Franz Boas, The Eskimo of Baffinland and Hudson Bay, Bulletin American Museum of Natural History, Vol. 15, (1907), Plate 9.

blankets of the Tlingit which are copied by the women from pattern boards made by the men do we find the typical symbolic style.

I might also refer to the contrast between the pictographic representations of the Indians of the Plains and their ornamental art, if it were not for the fact that their pictography never rises to the dignity of an art.

The cases might be considerably increased in which a difference of style is found in different types of technique, or in different parts of the population. Birchbark baskets of the interior of British Columbia have their own style of border decoration and their sides are often covered with pictographic designs. Coiled baskets from the same district have geometrical surface patterns. Central American painted pottery differs in style from other types in which painting is not used, but in which plastic ornamentation is applied. New Zealand borders of woven mattings have geometric style and lack patterns that might be considered derived from the elaborate spiral decoration that characterizes Maori carving (Plate VIII).

Such differences in style are, however, not by any means the rule. As has been stated before, we find much more commonly (p. 154) that the most highly developed art is liable to impose its style upon other industries and that mat weaving and basketry have been particularly influential in developing new forms and powerful in imposing them upon other fields.

PLATE VIII.

Woven Blanket, New Zealand.

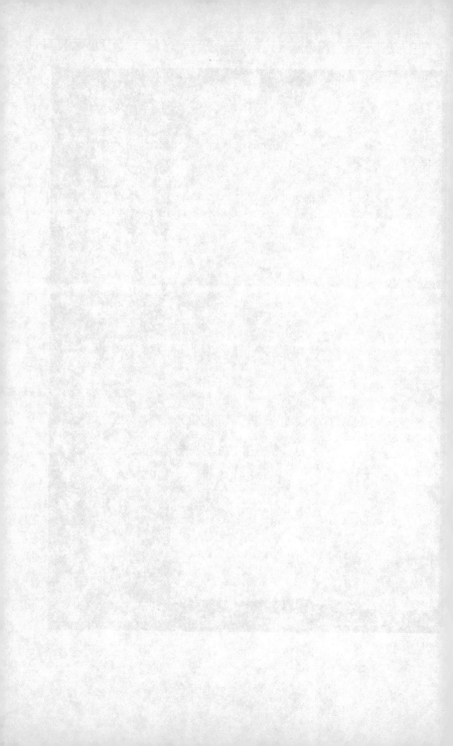

ART OF THE NORTH PACIFIC COAST OF NORTH AMERICA[1]

The general principles discussed in the preceding chapters, may now be elucidated by a discussion of the style of the decorative art of the Indians of the North Pacific Coast of North America.

Two styles may be distinguished: the man's style expressed in the art of wood carving and painting and their derivatives; and the woman's style which finds expression in weaving, basketry, and embroidery.

The two styles are fundamentally distinct. The former is symbolic, the latter formal. The symbolic art has a certain degree of realism and is full of meaning. The formal art has, at most, pattern names and no especially marked significance.

We shall discuss the symbolic art first. Its essential characteristics are an almost absolute disregard of the principles of perspective, emphasis of significant symbols and an arrangement dictated by the form of the decorative field.

While the Eskimo of Arctic America, the Chukchee and Koryak of Siberia, the Negroes and many other people use carvings in the round which serve no practical ends, but are made for the sake of representing a figure,— man, animal, or supernatural being,— almost all the work of the Indian artist of the region that we are considering serves at the same time a useful end. When making simple totemic figures, the artist is free to shape his subjects without adapting them to the forms of utensils, but owing to their large size, he is limited by the cylindrical form of the trunk of the tree from which they are carved. The native artist is almost always restrained by the shape of the object to which the decoration is applied.

The technical perfection of carvings and paintings, the exactness and daring of composition and lines prove that realistic representa-

[1] The present chapter is a revised edition of my essay, "The Decorative Art of the Indians of the North Pacific Coast of America" (Bulletin American Museum of Natural History, Vol. IX, pp. 123—176, 1897).

tions are not beyond the powers of the artist. This may also be demonstrated by a few exquisite examples of realistic carvings. The helmet shown in fig. 154 is decorated with the head of an old man affected with partial paralysis. Undoubtedly this specimen must be considered a portrait head. Nose, eyes, mouth and the general expression, are highly characteristic. In a mask (fig. 155) representing a dying warrior, the artist has shown faithfully the wide

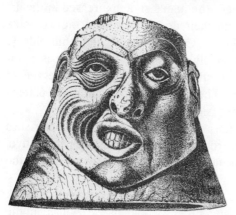

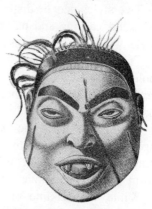

Fig. 154. Tlingit helmet.

Fig. 155. Mask representing dying warrior, Tlingit.

lower jaw, the pentagonal face, and the strong nose of the Indian. The relaxing muscles of mouth and tongue, the drooping eyelids, and the motionless eyeballs, mark the agonies of death. Plate IX represents a recent carving, a human figure of rare excellence. Posture and drapery are free of all the formal characteristics of North West coast style. Only the treatment of the eye and the facial painting betray its ethnic origin. Here belongs also the realistic head previously referred to, made by the Kwakiutl Indians of Vancouver Island (fig. 156), which is used in a ceremony and intended to deceive the spectators who are made to believe that it is the head of a decapitated dancer.[1]

[1] The selection of North West Coast art given by Herbert Kühn (Die Kunst der Primitiven, pp. 100, 104, Plates 48, 50, 51 are characteristic only of realistic representations. Only Plates 47, 49 and part of 52 are stylistically typical).

PLATE IX.

Carved Figure, British Columbia.

When the artist desires realistic truth he is quite able to attain it. This is not often the case; generally the object of artistic work is decorative and the representation follows the principles developed in decorative art.

When the form of the decorative field permits, the outline of the animal form is retained. The size of the head is generally stressed as against that of the body and of the limbs. Eyes and eyebrows, mouth and nose are given great prominence. In almost all cases the eyebrows have a standardized form, analogous to that in which the Indian likes to trim his own eyebrows,— with a sharp edge on the rim of the orbits, and a sharp angle in the upper border, the brows being widest at a point a little outward from the center, tapering to the outer and inner angles and ending quite abruptly at both ends. The eye is also standardized. In many cases it consists of two outer curves which indicate the borders of the upper and lower eyelids. A large inner circle represents the eyeball.

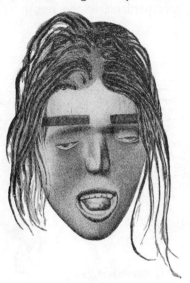

Fig. 156. Carved head used in ceremonial, Kwakiutl Indians.

The lip lines are always distinct and border a mouth which is given an extraordinary width. Generally the lips are opened wide enough to show the teeth or the tongue. Cheeks and forehead are much restricted in size. The trunk is not elaborated. The ears of animals rise over the forehead (fig. 157). These are almost always applied in reproductions of mammals and birds, while they are generally missing in those of the whale, killer-whale, shark and often also of the sculpin. The human ear is represented in its characteristic form, on a level with the eye (figs. 207 and 209, pp. 217, 218). Whales and fish often have round eyes, but exceptions occur (figs. 233, 234, 235, pp. 229—231).

For clear presentation of the principles of this art it seems advantage-
ous to treat the symbolism and the adjustment of the animal form
to the decorative field before taking up the purely formal elements.

Fig. 157 *a* is a figure from the model of a totem pole, which re-
presents the beaver. Its face is treated somewhat like a human
face, particularly the region around eyes and nose. The position of

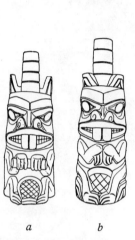

a *b*

Fig.157. Carvings repres-
enting the beaver from
models of Haida totem
poles carved in slate.

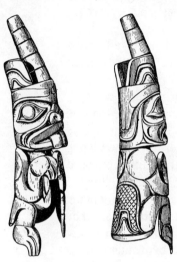

Fig. 158. Carving from handle
of spoon representing beaver,
Tlingit.

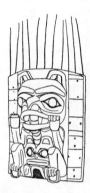

Fig. 159. Headdress
representing beaver;
a dragonfly is shown
on the chest of the
beaver, Haida.

the ears, however, indicates an animal head. The two large incisors
serve to identify the rodent par excellence,—the beaver. The tail
is turned up in front of the body. It is ornamented by cross-
hatchings which represent the scales on the beaver's tail. In its
forepaws it holds a stick. The nose is short and forms a sharp
angle with the forehead. The nostrils are large and indicated by
spirals. The large incisors, the tail with cross-hatchings, the stick,
and the form of the nose are symbols of the beaver and the first
two of these are sufficient characteristics of the animal.

Fig. 157 *b* is another representation of a beaver from the model of a totem pole. It resembles the former one in all details, except that the stick is missing. The beaver is merely holding its three-toed forepaws raised to the chin. In other carvings the beaver is shown with four or five toes, but the symbols described here never vary.

On the handle of a spoon (fig. 158), the head and forepaws of the beaver are shown; and in its mouth are indicated an upper pair of incisors, all the other teeth being omitted. The scaly tail is shown on the back of the spoon. The nose differs from the one previously described only in the absence of the spiral development of the nostril. Its form and size agree with the preceding specimens.

In the centre of the front of a dancing head-dress (fig. 159), a beaver is represented in squatting position. The symbols mentioned before will be recognized here. The face is human, but the ears, which rise over the forehead, indicate that an animal is meant. Two large pairs of incisors occupy the center of the open mouth. The tail, with cross-hatchings, is turned up in front of the body, and appears between the two hind legs. The forepaws are raised to the height of the mouth, but they do not hold a stick.[1] The nose is short, with large round nostrils and turns abruptly into the forehead. On the chest of the beaver another head is represented over which a number of small rings stretch upward. This animal represents the dragon-fly, which is symbolized by a large head and a slender seg-mented body.[2] Its feet extend from the corners of its mouth towards the haunches of the beaver. Its face resembles a human face; but the two ears, which rise over the eyebrows, indicate that an animal is meant. In many representations of the dragon-fly there are two pairs of wings attached to the head. Combinations of two animals similar to the present one are found frequently, as in figs. 165, 170 and 235.

[1] For additional representations of the beaver see figs. 216, 225, 228, 229, 230, 255, 283.

[2] See p. 192.

In a painting from a Kwakiutl housefront (fig. 160), which was made for me by an Indian from Fort Rupert, the large head with the incisors will be recognized. The scaly tail appears under the mouth. The broken lines (1) around the eyes, indicate the hair of

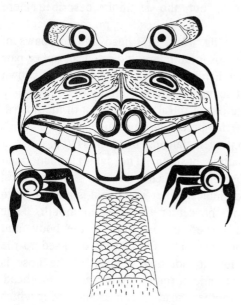

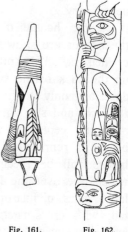

Fig. 161. Fig. 162.

Fig. 161. Halibut hook with design representing a sculpin swallowing a fish, Tlingit.

Fig. 162. Part of a totem pole with design representing a sculpin, Tsimshian.

Fig. 160. Painting for a housefront placed over the door, representing the beaver, Kwakiutl Indians.

the beaver. The design on each cheek (3) the bones of the face, the high point of the nose (2) its sudden turn. The nostrils are large and round as in the specimens described before. Under the corners of the mouth are the feet. The meaning of the two ornaments over the head is doubtful.

A carved halibut-hook (fig. 161) is decorated with the design of the sculpin. The symbols of the fish are fins and tail, those of the sculpin, two spines rising over its mouth, and a joined dorsal fin. The sculpin is represented swallowing a fish, the tail of which pro-

trudes from its mouth. The two spines appear immediately over the lips, their points being between the two eyes which are represented by two circles with small projections. The two pectoral fins are indicated over the eyes. The joined dorsal fin extends from the eyes upward toward the narrowest part of the body. The tail of the animal extends toward the place where point and shank of the hook are bound together by means of a strip of spruce root.

The same animal is represented in a slightly different way on the lower portion of a totem pole (fig. 162). The lowest figure is probably the sun, or perhaps a starfish. Its arms extend upward, and are held in the mouth by a sculpin, standing head downward, back forward, and tail extending upward. Two crescent-shaped ornaments above the corners of the mouth represent the gills of the fish. Above these are

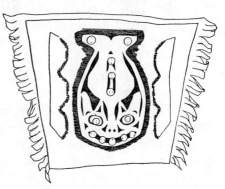

Fig. 163. Woolen legging with appliqué designs representing sculpin, Haida.

the pectoral fins. On the level of the pectoral fins towards the middle appear the symbols of the sculpin, two spines, the lower portions of which are decorated with small human faces. The round eyes are placed just under the spines. The dorsal fin commences at the height of the eyes, and merges into the tail which is clasped by a human figure cut in two by the fish tail. This carving is also characterized by two symbols,——the two spines and the joined dorsal fin.

On a legging made of blue cloth (fig. 163) the sculpin is shown in red cloth appliqué. Its teeth, eyes, and dorsal fin are represented by buttons of abalone shell. Two small triangles cut out to the right and left of the mouth represent the gills. Immediately over the eyes, and extending toward the middle of the back, are the two spines, indicated by two slender triangular pieces of red cloth cut out in

their middle parts. The pectoral fins are indicated by two broader pieces of red cloth extending from the eyes outward and upward toward the margin of the body of the fish, the dorsal fin by the long slits along the back of the animal. The species is characterized by the two spines which appear over the eyes.[1]

In facial paintings the sculpin is generally indicated by the two spines which are painted just over the lips (fig. 164).

Figs. 165—168 represent the hawk which is symbolized by an enormous hooked beak, curved backward so that its slender point touches the chin. In many cases the face of the bird is that of a human being, the nose being given the shape of the symbol of the hawk. It is extended in the form of a beak, and drawn back into the mouth, or merged into the face below the lower lip.

On the head-dress, fig. 165, the upper, larger face is that of the hawk. The face in human; but the ears, which rise over the forehead, indicate that an animal is meant. The body is small, and is hidden behind the face of a seamonster with bear's head and flippers. The wings of the hawk are grasped by the arms of the seamonster whose flippers may be seen over the arms.

Fig. 166 is the handle of a spoon on which is represented the head of a hawk, symbolized by its beak. The top of the spoon represents a man who is holding a small animal with a segmented body, which may represent the dragon-fly, although the head seems rather smaller than usual. [2]

In figs. 167 and 168 the same symbols of the hawk will be recognized. It is worth remarking that in most of these specimens the mouth is entirely separated from the beak and has the form of the toothed mouth of a mammal. A characteristic form of the hawk's beak is shown in the facial painting fig. 169.

Fig. 170, the front of a head-dress representing the eagle, is quite similar to the forms of preceding series; but it differs from them in that the beak of the bird is not turned back so as to touch the face,

[1] For additional representations of the sculpin see figs. 206, 219, 224, 262.
[2] See also figs. 207, 243, 257.

Fig. 164. Fig. 165. Fig. 166. Fig. 167.

Fig. 164. Facial painting representing the sculpin, Haida.
Fig. 165. Headdress representing a hawk, Tsimshian.
Fig. 166. Handle of a spoon made of mountain-goat horn; lowest figure representing
a hawk; upper figure representing a man holding a dragon-fly, probably Tsimshian.
Fig. 167. Rattle with design of a hawk, Tlingit.

Fig. 168. Fig. 169. Fig. 170.

Fig. 168. Dish made of horn of bighorn sheep, Tlingit.
Fig. 169. Facial painting representing hawk, Haida.
Fig. 170. Headdress representing an eagle bearing a frog on its chest, Tsimshian.

but ends in a sharp point extending downward, and that there is no mammal mouth indicated. The wings of the eagle are shown extending from the border of its body inward. The shoulder joint is indicated by the head of a human figure which is ornamentally carved on the wings. The feet are seen at the sides of the lower border of the carving, under the wings. On the body of the eagle is a rather realistic carving of a toad. An eagle is also shown on top of the Haida house post (fig. 171). The wings are turned in in front of the body and the curves of the lower figures fit into the curved side. [1]

Fig. 171. Housepost representing eagle above, cormorant below, Haida.

In figs. 172 and 173 I give two representations of the hawk (or fish hawk) made by the Kwakiutl. The treatment is different from that of the Haida, but the sharply curved beak is found here also. On the paddle (fig. 172), (1) represents the eyebrow and ear, (2) the cheek, (3) the wing, (4) the beak. Fig. 173 is taken from a painting on a settee. On the back is shown a man with ears (4) over the head, like those of the Haida animals. (1) is the navel, (2) the wrinkles running down from the nose to the corners of the mouth, (3) is painting on the cheeks. The head of the hawk is placed on each side of the human figure. On the lower border of the settee is the lower jaw (5), over the eyes the feathers on the head (6), the eye next to the head on the side wing of the settee, is the shoulder joint. The bone of the wing is shown in (7), the long wing feather in (8), the feathers of the body in (9).

The dragonfly is represented with a large head, a long segmented body and two pairs of wings. The representation on the headdress,

[1] See also fig. 215.

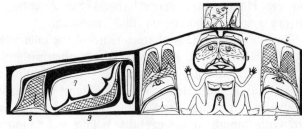

Fig. 173.

Fig. 172. Painting on paddle representing hawk. Kwakiutl.
Fig. 173. Painting on back and one end of a settee representing man and hawk, Kwakiutl.

Fig. 172.

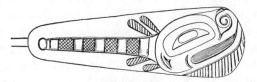

Fig. 175.

Fig. 174. Handle of spoon of mountain-goat horn representing dragon-fly.
Fig. 175. Berry spoon with engraving representing dragon-fly.

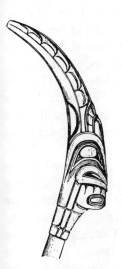

Fig. 174.

fig. 159, has been referred to before. The head is human but provided with animal ears. It has also been mentioned that the animal with segmented body in fig. 166 may be a dragonfly, although it is lacking the wings. According to Edensaw, the spoon handle (fig. 174) also represents the dragonfly. It has a strongly curved beak; wings are placed under the lower jaw and the segmented body forms the tip of the handle. A particularly good representation of a dragonfly is found

on the Haida berry spoon [1] (fig. 175). Attention should be called to the spiral proboscis on this specimen.

The most important characteristic of the killerwhale as represented by the Haida is the long dorsal fin,—often with white circle or white stripe in the middle, and a face or eye indicating a joint at the base. The head is elongated, the mouth long and square in front. The nostril is large, high, and at the same time elongated. The distance from the mouth to the eyebrow is long and on totem poles and spoon handles the head is always so placed that the long snout points downward. When seen in profile the front of the face is square on account of the forward extension of the nose over the front part of the mouth. The eye is generally round but sometimes surrounded by elongated lid lines with sharp inner and outer corners. Sometimes the blow-hole is shown by a circular spot over the forehead. In fig. 176 are shown a few representations of the killer-whale as found on handles of spoons made of mountain goat horn. In *(a)* and *(b)* the dorsal fin rises immidiately over the head of the animal. The inverted face in *(b)* probably represents the blow-hole. In *(a)* and *(c)* the fins are folded forward; in the latter specimen the tail is turned up in front on the body. On the rattle (fig. 177) the characteristic large head with steep face appears. The mouth is set with large teeth; the eye is round. In front of the dorsal fin is a blow-hole. The Haida float (fig. 178) is abnormal in so far as it has a very small dorsal fin (see also fig. 182 *d*),

A number of Kwakiutl masks and dishes representing the killer-whale are shown in fig. 179. Although there are some differences in the treatment of the animal, the main features are common to both tribes. All these specimens, except *h*, have the dorsal fin; the last named specimen shows the head only. The long, high nose is found in all except in *c, d, e*. The high, steep face is common to all of them. Fig. *e*, a large house dish,[2] is said to represent the

[1] These flat,wooden spoons are used for eating soapberries which are beaten to a foam.

[2] These dishes are used in great feasts. Some of them are of enormous size. They are emblems of the family of the houseowner.

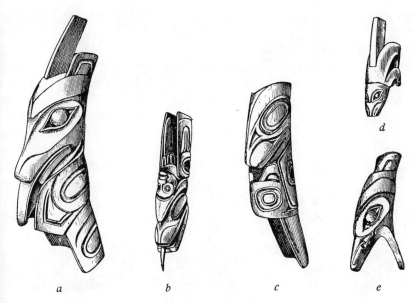

a b c d e

Fig. 176. a—e Carvings from handles of spoons of mountain-goat horn representing killer-whale, Tlingit.

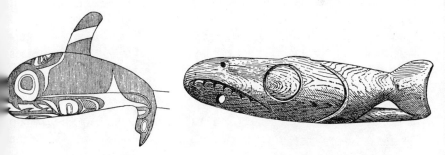

Fig. 177. Rattle representing killer-whale, Haida.

Fig. 178. Wooden float representing killer-whale, Haida.

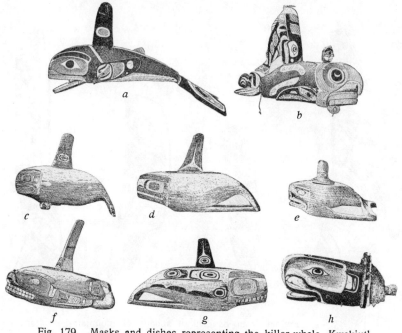

Fig. 179. Masks and dishes representing the killer-whale, Kwakiutl

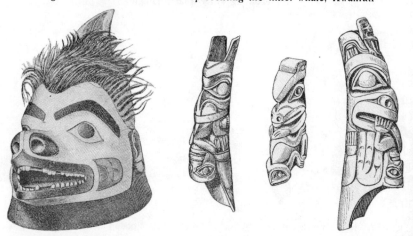

Fig. 180. Helmet representing
the killer-whale, Tlingit.

Fig. 181. Carvings from the handles of spoons of
mountain-goat horn representing the bear.

whale. It will be noticed that *b*, *c*, *d* have round eyes while in *a* and *h* the regular oblong eye is used. In *e* and *g* the fundamental form of the eye is also round. Fig. 180 is a Tlingit helmet which is characterized as the killer-whale by the large mouth set with teeth, the sudden turn of the nose towards the forehead, the fin made of hide which rises over the crown of the head, and the fin which is painted on the left cheek. Ordinarily the killer-whale has no ears. In facial

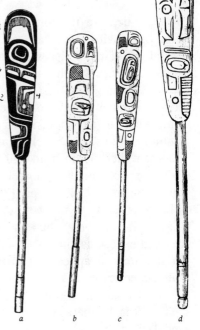

painting red under and on the lower jaw up to a line running from the angle of the jaw to a point a little below the lips, represents the throat of the killer-whale.

The bear is symbolized by a large mouth set with many teeth, often in the act of swallowing some animal. Very often the tongue protrudes. The nostrils are high and round, sometimes represented by spirals (see also figs. 157, 175). On totem poles and carved spoon handles they are similar to those of the killer-whale but do not extend quite so far backward. There is a sharp turn in the profile from the nose to the fore-head. The paws are large (fig. 181).

In fig. 182 three berry spoons are shown which, according to Charles Edensaw, represent the bear. Fig. 182 *a* is quite clear. At the end of

Fig. 182. Berry spons representing bear; *a*, *b*, Tsimshian; *c*, Tlingit; *d*, representing killer-whale.

the spoon is shown the head with an enormous ear (1), the size of which is determined by the form of the spoon. Two teeth are indicated by red curves (2). Under the mouth is a broad black

curve, the foreleg (3), and to the right of it (4) the fore-paw. The lowest part represents the hindlegs. Fig. 182 *b* is not so clear. The face in the middle is the hip joint, under it, to the right, the thigh, to the left the paw with long claws. Edensaw considered the design over the hip joint as the tail, the end as the head, but I doubt the correctness of this interpretation. The end of the spoon looks more like the head of a sea monster and the design over the hip joint like the fin. Fig. 182 *c* was also called a bear by the same informant, while 182 *d* was called a killer-whale. I place these side by side, because the formal agreement of the lower part is striking. The right half of the base of 182 *c* has the characteristic form of the dorsal fin of the killer-whale and corresponds to an analagous design in fig. 182 *d*. In both cases the inverted eye above the "fin" would be the joint. The rest of the design consists of eye and flipper elements that are not readily recognized. In 182 *d* the flat curves in the middle may be the body; in front to the left the fin, and over it eye and mouth. In 182 *c* the elements are still less clear. According to Edensaw there is no head, only a tail at the upper end of the spoon.

There are quite a number of representations of the seamonster, the form of which is partly that of a bear and partly that of a killer-whale. In a number of cases the monster has a bear's head (fig. 183) and body, but fins are attached to the elbows. In other cases the head is that of a killer-whale and the body that of a bear. In this form it appears on many horn spoon handles (fig. 184). In still other cases the characteristics of bear and killer-whale are intermingled in other ways.

The frog is characterized by a wide toothless mouth, a flat nose, and lack of a tail.

The following series (figs. 185—188) are representations of the dogfish or shark. When the whole body of this animal is represented, it is characterized by a heterocerc tail, a large mouth, the corners of which are drawn downward, a series of curved lines on each cheek which represent the gills, and a high tapering forehead imitating the inferior position of the mouth. It is often decorated with two circles (the

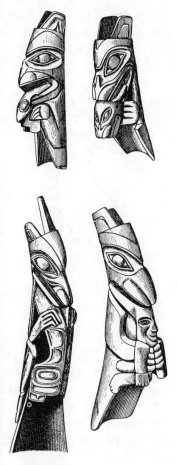

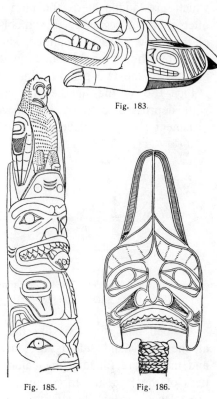

Fig. 183.

Fig. 185. Fig. 186.

Fig. 183. Carving representing a sea-
monster, Tlingit.

Fig. 185. Part of totem pole carved in
slate representing shark sourmounted by
an eagle, Haida.

Fig. 184. Carvings from handles
of spoons made of mountain-goat
horn representing a sea-monster.

Fig. 186. Handle of a dagger representing
the head of a shark, Tlingit.

nostrils), and a series of curved lines (wrinkles) similar to the gill
lines on the cheeks.

Fig. 185 represents a shark devouring a halibut, from the upper
part of a totem pole. The head has the characteristic symbols, to

which are added here the numerous sharp teeth that are found often, but not regulary, as symbols of the shark. The greater part of the body has been omitted, since the animal is sufficiently identified by the symbols found on the head; but under the chin will be noticed the two pectoral fins which identify it as a fish.

Fig. 186 is the handle of a copper dagger on which the mouth with depressed corners, the curved lines on the cheeks, and the ornament rising over the forehead, characterize the shark.

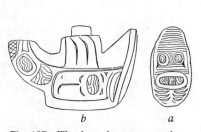

b a

Fig. 187. Wooden pipe representing
a shark, Tlingit.

Fig. 188. Tattooing representing
a shark, Haida.

A small pipe (fig. 187) has the form of a shark. The square end at the right-hand side is the face of the animal (fig. 187). Eyes and mouth are inlaid with abalone shell. On account of the narrowness of the face, the three curved lines generally found on the cheeks are placed under the mouth. The forehead has the characteristic high form described before. The opposite end of the pipe shows the tail turned upward. On the sides are carved the pectoral fins, which extend over the body of the pipe.

Fig 188 is a copy of a tattooing on the back of a Haida woman. Here we have only the outline of the head of a shark, again characterized by the peculiar, high forehead, the depressed corners of the mouth, and curved lines on each cheek.

The shark [1] (or dogfish) is found frequently on Haida carvings and paintings. It is rare among the southern tribes.

[1] See also figs. 213, 214, 217, 232, 233, 261.

The ts'um'os, the personified snag, is represented in a form similar to the bear. According to Edensaw the form of the head is analogous to that of the bear but the corners of the mouth are drawn down like those of the dog fish (fig. 189). This is contradicted by the representation of a third snag monster, in which

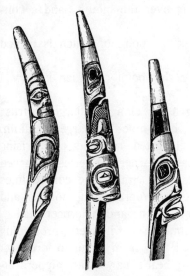

Fig. 189. Handles of spoons representing sea-monster, Haida.

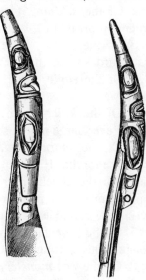

Fig. 190. Handles of spoons made of mountain goat representing snail, Tlingit.

the mouth is square like that of the bear. The region behind the mouth has, however, the characteristic curvature demanded by Edensaw. The fins of this being correspond to the concept of the sea-monster.

In fig. 190 are represented two spoon handles, representing, according to Edensaw, the snail. The characteristic feature seems to be the long snout with its sudden, angular turn. The conventional concept of the animal form with eye and nose is strikingly brought out in this instance.

Let us briefly recapitulate what we have thus far tried to show. Animals are characterized by their symbols, and the following series of symbols has been described in the preceding remarks:

1. Of the *beaver:* large incisors; large, round nose; scaly tail; and a stick held in the fore paws.

2. Of the *sculpin:* two spines rising over the mouth, and a continuous dorsal fin.

3. Of the *hawk:* large, curved beak the point of which is turned backward so that it touches the face.

4. Of the *eagle:* large, curved beak, the point of which is turned downward.

5. Of the *killer-whale*: large, long head; elongated large nostrils; round eye; large mouth set with teeth; blow-hole; and large dorsal fin.

6. Of the *shark* or *dogfish*: an elongated rounded cone rising over the forehead; mouth with depressed corners; a series of curved lines on the cheeks representing gills; two circles and curved lines on the ornament rising over the forehead representing nostrils and wrinkles; round eyes; numerous sharp teeth; and heterocerc tail.

7. Of the *bear*: large paws; and large mouth set with teeth; protruding tongue; large, round nose; and sudden turn from snout to forehead.

8. Of the *sea-monster:* bear's head; bear's paws with flippers attached; and gills and body of the killer-whale, with several dorsal fins; or other mixtures of bear and killer-whale type.

9. Of the *dragon-fly:* large head; segmented, slender body; and wings.

10. Of the *frog:* wide, toothless mouth; flat nose; and lack of tail.

11. Of the personified *snag:* like a bear with mouth depressed at the corners like that of the dogfish.

12. Of the *snail:* long snout with sudden downward turn. [1]

I have had occasion to examine the Kwakiutl in greater detail in regard to the symbols used in designating certain animals. One artist gave me a series of eye patterns together with the adjoining parts of the face and explained in what way each is characteristic of the animal in question. These are shown in figs. 191 and 192.

[1] See also characterization of wolf, p. 207.

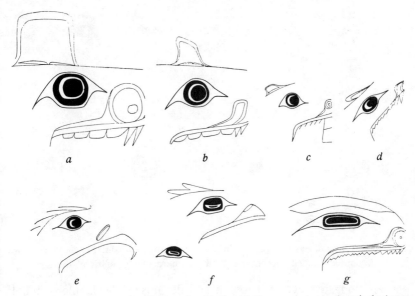

Fig. 191. Types of eyes of various animals, Kwakiutl; *a*, sea bear; *b*, grizzly bear; *c*, beaver; *d*, wolf; *e*, eagle; *f*, raven; *g*, killerwhale.

The grizzly bear of the sea *(a)* has a large eye, the form of which is not definitely determined, a very large, round nostril, large teeth and a large ear. The grizzly bear *(b)* has a round eye with white rim, smaller than that of the grizzly bear of the sea. The nose is not round, but high, the teeth large but smaller than those of the grizzly bear of the sea. The ear is small and pointed. The beaver *(c)* has, besides the large incisors, a high, round nose and a very small ear. The wolf *(d)* has a slanting, long eye; the ear is laid down backward; he has many teeth. The eye of the eagle *(e)* has a white crescent behind the eyeball, the nostril is slanting and placed high up on the beak. The eye of the raven *(f)* is white in the center. The killerwhale *(g)* has a very large eyebrow, a long eye and face, long nose and a long mouth with many teeth. The whale (fig. 192 *a*) has a round eye and nose. The sea-lion *(b)* has a round nose, large teeth, the eye near to the nose and a small ear. The frog *(c)*

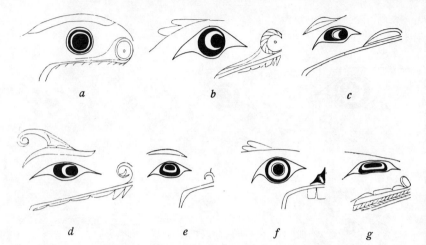

Fig. 192. Types of eyes of various brings, Kwakiutl, *a*, whale; *b*, sea lion; *c*, frog;
d, double headed serpent; *e*, man; *f*, merman; *g*, spirit of the sea.

has an elongated eye, flat mouth and flat nose. The fabulous double-headed serpent *(d)* has a small eye like that of the wolf, a spiral nose and a spiral plume. The eyes of a man, of the woodman, and of the seaspirit who gives wealth, are shown in *e*, *f*, and *g*.

The Kwakiutl also claim as the standard for the bird's tail, a joint with a single eye, although sometimes there may be two eyeballs enclosed in one eye. The rounded feathers (fig. 193) are also characteristics of the bird's tail. The tail of the whale, killer-whale, and porpoise, on the other hand, has two joints and the flukes have double curvatures on the inner side.

The Kwakiutl also claim a definite distinction between the designs representing wing feathers and those representing fins, (fig. 194). The wing feathers should be pointed; the fin, on the other hand, has no point and is cut off square.

In figs. 195 and 196 are represented the characteristic elements of the halibut and of the wolf. These elements are supposed to be used by the Kwakiutl in the representation of these animals, selected according to the requirements of the decorative field. In the

figures here reproduced they are given without any reference to the decorative field. Fig. 195 represents the halibut; (1) the mouth and over it the nose, (2) the eyes, (3) the bone of the top of the head and (4) the side of the head. In (5) are shown the gills; (6) and (8) represent the intestinal tract, and (7) is the part of the intestinal tract just under the neck; (9) is the collar bone, (10) the lateral fin, the bones of which are shown in (11). (12) is the clotted blood that is found in the dead halibut under the vertebral column; (13) represents the joint of the tail, (14) part of the bone in the tail, and (15) the tip of the tail.

Fig. 196 represents, in the same way, the wolf. The head with the elevated nose is easily recognized. (1) represents the throat. (2) The humerus connected with the forearm is shown in the lower

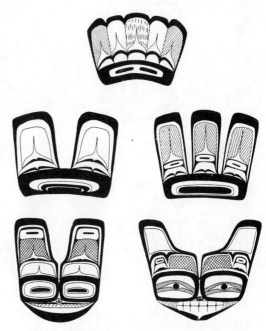

Fig. 193. Styles of tails, Kwakiutl; above bird; below sea mammals.

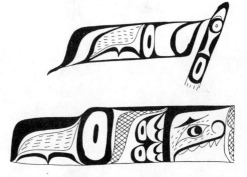

Fig. 194. Styles of wing designs and of fin designs, Kwakiutl; above, fin; below, wing.

Fig. 195. Elements used in representing the halibut, Kwakiutl.

Fig. 196. Elements used in representing the wolf, Kwakiutl.

left hand side of the pattern; (3) represents the collarbone, the four circles (4) the backbone, (5) the back with hair. The three thin slanting lines (6) are the ribs, (7) the sternum and the hooks over it the intestinal tract, (9) is the hind leg, corresponding to (2), (10) the toes, (11) the foot, (12) connects the backbone with the tail. The thin lines (13) represent the hair of the tail, (14) is supposed to be a second joint in the tail, (15) the hairy tail, and (16) the ears.

Fig. 197 represents the wolf, a painting from the bow of a canoe. Here again the elevated nose of the wolf will be recognized. The hachure (1) represents the pelvis, (2) and (3) the intestinal tract, (4) the humerus, (5) the cheek, (6) the facial bones, and (7) the ear.

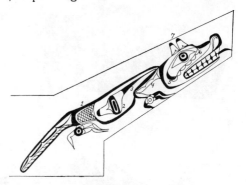

Fig. 197. Painting from bow of a canoe, representing the wolf.

An examination of carved and painted specimens shows clearly that this description of symbols is theoretical rather than rigidly normative, for in many cases considerable freedom in their use may be observed. An example of this kind is presented by the wolf masks used by the Kwakiutl in the dance „Brought-Down-From-Above" [1] (fig. 198). Most of these have the slanting eye and pointed ears. In one specimen, however, the ear is pointed forward. The snout slants backward, the nose is high. The identity of treatment of the specimen shown in figs. *d* and *f* is interesting. The former was collected by Captain Adrian Jacobsen, 1884, and the latter by Captain Cook more than a hundred years earlier. The double mask, fig. *a*, resembles them in general shape,

[1] See Social Organization and Secret Societies of the Kwakiutl Indians, Annual Report of the United States National Museum, 1895, p. 477, illustrations p. 493, Plate 37.

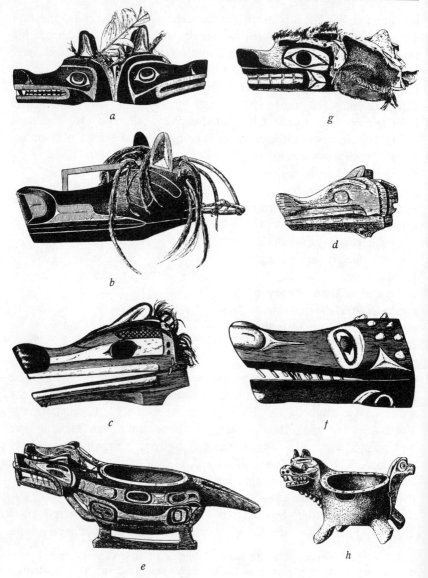

Fig. 198. Masks and dishes representing the wolf, Kwakiutl.

but the eye is treated quite differently and the ear, while narrow, is not pointed and the backward slant of the snout is not sufficiently pronounced. The double headed wolf dish *(e)*, has small reclining ears and long eyes. The ears of figs. *c, d, e,* are small and recline, but the eye of *c* and *d* is rounded.

The forms of animals used by the northern tribes vary considerably also. It is not safe to base our arguments on models or on objects made for the trade. I shall use, therefore, exclusively, older specimens which have been in use.

Swanton [1] gives two interpretations of the Haida house post fig. 199. He had two informants; both explained the top figure as an eagle but they differed as to the meaning of the rest. The one claimed that the lower part of the pole represented the story of a woman being carried away by a killer-whale. The woman's face shows just below the eagle's beak, and the whale's blow-hole is represented by a small face above the face of the killer-whale. The second informant, however, explained the large face at the bottom as that of a grizzly bear, presumably meaning thereby, the sea-grizzly bear; and the small figure over it as the „sea ghost" which usually rides upon its back. The woman's face he left unexplained. From an objective point of view, the face at the base of the pole appears as a grizzly bear's face. Attached to it on each side

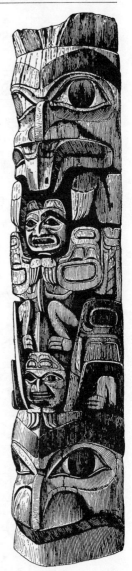

Fig. 199. House-post, Haida.

[1] John R. Swanton, The Haida, Publications of the Jesup North Pacific Expedition, Vol. V, p. 128.

14 — Kulturforskning. B. VIII.

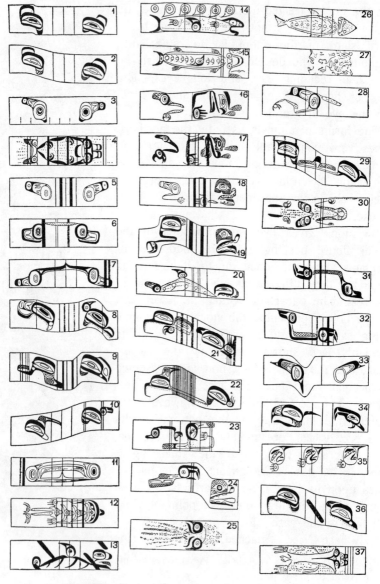

Fig. 200. Designs from a set of gambling sticks.

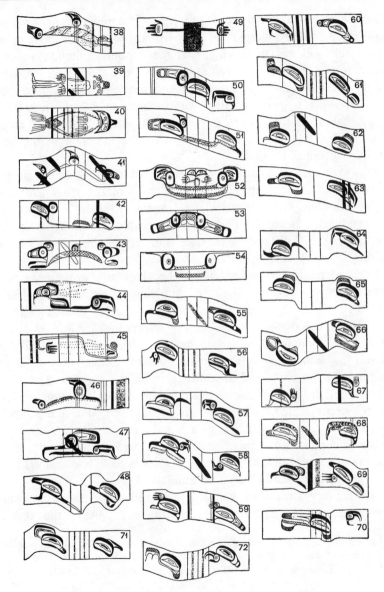

Fig. 201. Designs from a set of gambling sticks.

are the ears and above these, the flippers. Just under the talons of the eagle is found the inverted tail of a fish or aquatic mammal, which presumably belongs to the figure at the bottom, although it seems rather small. It seems doubtful whether the upper face, to which belong the two hands just under it and the legs, in squatting position below the tail, is that of a woman because there ought to be a large labret in the lower lip. Furthermore, the face has animal ears so that it does not seem likely that the intention of the artist was to represent a woman.

It is true that in some other cases in which this same story is represented,[1] the person sitting on the back of the killer-whale has no labret, while in other cases it is shown. Obviously in this case the symbolism is not clear enough to enable an Indian who does not know the artist or who does not know the meaning of the carving, to interpret it correctly.

The uncertainty of interpretation becomes the greater the more fragmentary the figure. A set of gambling sticks which in 1897 I submitted to the best carver and painter (Charles Edensaw) among the Haida, could not be satisfactorily interpreted by him (figs. 200, 201). For example: Number 35 he recognized as a series of three dorsal fins without being able to tell to what animal they belonged. Number 36 he explained as a shoulder on the right, and a tail on the left, but he was unable to identify the particular animal. Number 37 he explained, hesitatingly, as a mosquito. For the following group he felt quite unable to give any satisfactory explanation.

The uncertainty of explanation appears particularly clearly in the interpretation of Chilkat blankets. I give here a few examples according to Lieutenant George T. Emmons.[2]

The blanket shown in fig. 202 represents a bear with young. The large central figure represents the male bear; the two in-

[1] See Swanton, The Haida, pl. 15, fig. 1 where the woman is shown without labret while in the specimen pl. 14, fig. 5, she wears a large labret.

[2] George T. Emmons, The Chilkat Blanket, Memoirs of the American Museum of Natural History, Vol. 3. Part 4, N. Y. 1907, pp. 352, 369, 372, 377, and 387.

verted eyes in the middle of the lower border, with the adjoining elongated designs with round tips, the hind quarters of the bear and the legs; the three heads in the middle of the upper margin, the female and the young bears. The central head in the middle of the upper margin was also explained as the forehead of the bear. The lateral panels represent each a young bear. The design along the lower border of the lateral panel is the freshwater stream on which the bear lives. According to John R. Swanton the blanket represents the sea grizzly bear. The explanation of the principal parts is the same as that given by Lieutenant Emmons, except that the three heads in the middle along the upper border were explained, the middle one

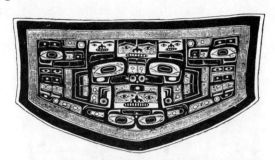

Fig. 202. Chilkat blanket.

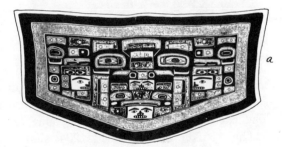

Fig. 203. Chilkat blanket.

as the top of the head, the lateral ones as ears. The wing designs which extend sideways from the border, cutting into the middle parts of the lateral panels, were explained as part of the forelegs, representing, probably, the fins which are believed to be attached to the arms of the sea grizzly bear. The two inverted eyes in the lower border, with the ornaments attached to the right and left of the eyes, were said to represent the hind legs.

The blanket shown in figure 203 represents, according to Emmons, a female wolf and young. The body of the wolf is given the form

of a hawk; the two eyes and the wing designs between them, near the lower border of the blanket, being the face of the hawk. The double feather design over these eyes represents the hawk's ears. The face in the center of the lower border of the blanket represents the body, the wing feather designs extending downward under the corners of the jaws of the wolf, the wings of the hawk. In the lateral panels the young wolf is shown sitting up. These designs represent probably at the same time, the sides and back of the wolf's body. According to Swanton the blanket represents a young raven. The body of the raven is occupied by two profiles of ravens, represented by the two large eyes near the lower border of the blanket. The face in the centre of the lower border is the raven's tail. The lateral wing designs extending downward from under the corners of the jaws of the large head, are the wings of the raven. The lateral panels represent two young ravens in profile.

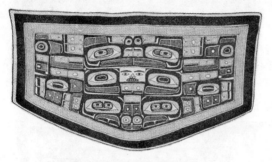

Fig. 204. Chilkat blanket.

The blanket shown in fig. 204 shows, according to Emmons, on top, a brown bear sitting up. On the body of the bear is a raven's head. The hind-quarters are treated like a whale's head. The eyes being at the same time the hip joints, the mouth the feet of the bear. He was given another explanation: the principal figure being explained as a whale, the head of which is below. The body, which is turned up, is treated as a raven's head, and the tail as a bear's head. The side panels are the sides and the back of these animals, but represent at the same time, an eagle in profile on top, and a raven in profile below. According to Swanton the design represents a halibut. The head is below. The whole large middle face represents the body; and the large face nearer the

upper border, the tail. The wing designs in the lateral panels, next to the lowest head, are the small pectoral fins and the rest of the lateral fields, the continuous border fin.

The blanket in Fig. 103 (p. 108) represents, according to Emmons, a diving whale and the lateral fields a raven sitting. The head, with nostrils and mouth, is shown below. The central face represents the body. The eyes near the upper border are the flukes of the tail. The face designs at the sides of the body represent the fins. In the lateral panels is shown a raven sitting. According to Swanton the same blanket represents a wolf with young. The head is shown below. The hind-legs and hip-joints are represented by two large eyes and the adjoining ornaments along the upper border, the two

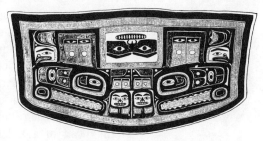

Fig. 205. Chilkat blanket.

dark segments just over the eye, being the feet. The face in the middle of the design represents, as usual, the body of the animal. The small eye design, with adjoining ear and wing feather designs, in the middle on each side of the body, are ·interpreted as fore-leg and foot. The lateral panels are explained as representing each a young wolf sitting.

There are also considerable discrepancies in the explanation of the blanket shown in fig. 205. According to Emmons it represents a killer-whale. In each lower corner is one half of the head with teeth; right in front of the teeth, the nostril; between the two halves of the head, in the lower border of the blanket, the tail. The inverted face in the middle of the upper border, represents the body. The large square designs containing the goggle design, on each side, are interpreted as water blown out from the blow-hole. One half of the dorsal fin is indicated by a small round wing feather design

in each upper corner, the human face in profile under it, representing one half of the blow-hole. According to Swanton a spirit of the sea is represented. One half of the head is shown in each lower corner, the eye design in front of the tongue being interpreted as chin. The two faces in the middle of the lower border are explained as the young ones of this sea spirit; the flicker feather designs over them, as the inner part of the body of the old animal; the inverted large face in the middle of the upper border, as its hat; the large square designs on each side of this face, containing the goggle designs, as the dorsal fin; the two human faces in profile near the upper corners, the young ones whose bodies are shown by the round feather design over the face. Still another explanation of the same pattern was given to me. In each lower corner is shown one half of the head of a killer-whale. Its food is represented by the eye design in front of the mouth. The tail is below in the middle; the two halves of the dorsal fin are just over the tail; the inverted face in the middle of the upper border is the chest; the adjoining square designs and the attached round feather design are the flippers. Accordingly the profile faces near the upper, outer corners should be the blow-holes.

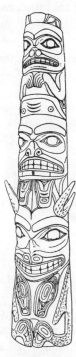

Fig. 206. Model of totem pole with three figures representing, from below upward; sculpin, dog-fish, and sea-monster; Haida.

These examples show clearly that there is ample room for the fancy of the interpreter. The symbols lend themselves to various explanations, which are presumably selected in accordance with totemic affiliations of the owner. Not all of them seem quite consistent with the best northwest coast usage; for instance, Swanton's explanation of the last named blanket seems doubtful on account of the inverted position of the hat and the explanation of a single wing design as a body.

So far I have considered the symbols only in connection with

their use in representing various animals. It now becomes necessary to inquire in what manner they are used to identify the animals. We have seen that in a number of the preceding cases entire animals were represented, and that they were identified by means of these symbols. However, the artist is allowed wide latitude in the selection of the form of the animal. Whatever its form may be, as long as the recognized symbols are present, its identity is established. We have mentioned before that the symbols are often applied to human faces, while the body of the figure has the characteristics of the animal.

We find this principle applied on the totem pole, fig. 206. Each of the three animals represented has a human face, to which are added characteristic symbols. In the

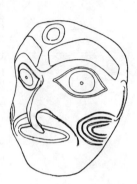

Fig. 207. Mask representing the hawk, Tlingit.

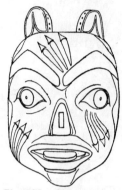

Fig. 208. Mask with painting symbolizing the flicker, Tlingit.

top figure the ears indicate an animal; the arms, to which flippers are attached, the sea-monster (see fig. 183). The next figure below represents the shark. Originally a large lip with a labret was attached to it. This would indicate that a female shark is represented. Its symbols are the peculiar high snout which rises over its forehead, and the fins, which are placed under the chin. The body of the lowest figure which is shown under the face represents a fish; and the two large spines which rise over the eyebrows specify the sculpin.

In many cases the bodies of the animals are not represented and the essential symbols are applied to a purely human face. This style is found on masks and in facial paintings.

Fig. 207 has a human face with human ears. Only the nose indicates that the mask is not intended to represent a human being.

It is strongly curved, and drawn back into the mouth, thus symbolizing the hawk.

In fig. 208 we see the face of a woman with a moderately large labret. The ears, as explained before, are those of an animal. The nose, which has been lost, had undoubtedly the form of a bird's beak. Thus the face was characterized as that of a bird. It was specified partly by the form of the beak, but principally by the ornaments painted in red and black on the cheeks and fore-head. These represent the feathers of the red-winged flicker.

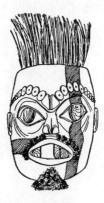
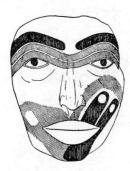

Fig. 209. Mask with eyebrows symbolizing the squid, Tlingit.

Fig. 210. Mask with painting symbolizing the killer-whale, Tlingit.

A small mask representing a human face (fig. 209) has, in place of the eyebrows, two rows of circles, the sucking-cups of the squid. By means of this symbol the face is recognized as that of the squid.

In the same manner the mask fig. 210 is identified as the killer-whale by the two black ornaments painted on the left cheek and extending down to the chin. They represent the dorsal fin of the killer-whale.

These symbols are also used as facial paintings and body paintings by dancers, who are thus recognized as personifying the animal in question, or as belonging to the social group with which the animals are associated (see figs. 264, 265, pp. 250, 251). Sometimes these symbols are attached to the garments. To this class belongs the ornament (fig. 212), which represents the dorsal fin of a killer-whale and which is worn attached to the back part of the blanket.

Having thus become acquainted with a few of the symbols of animals, we will next investigate in what manner the native artist

adapts the animal form to the object he intends to decorate. First of all, we will direct our attention to a series of specimens which show that he endeavors, whenever possible, to represent the whole animal on the object that he desires to decorate.

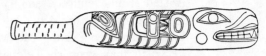

Fig. 211 is a club used for killing seals and halibut before they are landed in the canoe. The carving

Fig. 211. Wood carving representing the killer-whale, Tlingit.

represents the killer-whale. The dorsal fin, the principal symbol of the killer-whale, cannot be omitted. If placed in an upright position on the club, the implement would assume an awkward shape. Therefore the artist bent it down along the side of the body, so that it covers the flipper. The tail of the whale would have interfered with the handle, and has been turned forward and lies flat over the back.

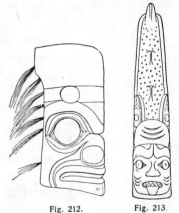

The distortion of the body has been carried still further in the handle of a spoon (fig. 176 *a*, p. 195) which represents the same animal. The large head of the whale, to which the flippers are attached is near the bowl of the spoon. The body has been twisted backward so that it is completely doubled up. Therefore, the surface pattern of the tail is carved on the back of the spoon, and the two projections just below the mouth are the two tips of the whale's tail. The dorsal fin extends upward from the head of the whale, between the legs of the man who forms the tip of the handle.

Fig. 212. Fig. 213.

Fig. 212. Wood carving representing dorsal fin of the killer-whale, Tlingit.
Fig. 213. Model of a totem pole representing a shark, Haida.

Fig. 213 is a small totem pole representing the shark. The tip of its tail forms the top of the pole, while the face is placed at its lower end. Since most of the symbols of the shark are found

on its face, it was necessary to bring the face into such a position as to be seen in front view, but the artist also desired to show the back of the fish. For this reason the head has been twisted around entirely, so that it appears in front view over the back of the fish. The flippers are made visible by having been pushed backward far beyond the place to which they properly belong.

The speaker's staff (fig. 214), which also represents the shark, has been distorted in the same manner; but here the head has been turned round entirely, so that it faces the back of the fish. The pectoral fins are shown below the chin.

On the berry spoon (fig. 215) is an eagle whose head which is turned back completely. The small wing occupies the field under the head. The upper margin with geometrical decoration represents the body under which the hip joint, leg and feet are shown.

The changes of position and of the relative sizes of parts of the body, which result from such adaptations to the form of the object to be decorated, are still more far-reaching in the following specimens.

On a halibut-hook (fig. 216) carved with a design of the beaver, the two incisors, the symbols of the beaver, have been moved to the same side of the mouth. In reality only one of the incisors is visible in profile, but being important symbols, both are shown.

Fig. 217 is a shark represented on the top of a totem pole. The head of the animal is shown in the form of a human face with the characteristic symbols. Under the chin are two flippers. The body must be considered turned upward; but it has been shortened so much that only the tail remains, which rises immediately above the face.

On a wooden dancing-hat (fig. 218) the symbols of the killer-whale are attached to its head. Since the whole body has been

Fig. 214.
Speaker's staff representing a shark, Tlingit.

omitted, the dorsal fin, the essential symbol, has been moved from the back to the head, and the flippers are attached to the head behind the eyebrows.

In all these cases the artist has taken great liberties with the form of the animal body, and has treated it so that the symbols become clearly visible. On the whole, he endeavors to represent the whole animal. When this is not possible, all its essential parts are shown. The insignificant parts are often omitted.

Farreaching distortions result from the adjustment of the animal body to the decorative field and from the necessity of preserving its symbols.

Fig. 219 is the top view of a wooden hat on which is carved the figure of a sculpin. The animal is shown in top view, as though

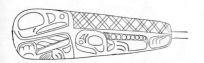

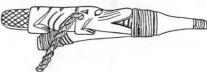

Fig. 215. Berry Spoon with design representing the eagle.

Fig. 216. Halibut hook representing a beaver, Tlingit.

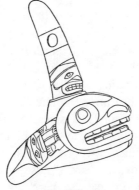

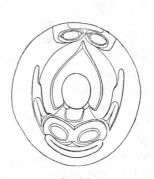

Fig. 217.

Fig. 218.

Fig. 219.

Fig. 217. Part of totem pole representing a shark, Haida.
Fig. 218. Dancing-hat representing a killer-whale, Tsimshian.
Fig. 219. Wooden hat with carving representing the sculpin.

it were lying with its lower side on the hat. The dancing-hats of these Indians have the forms of truncated cones. To the top are attached a series of rings, mostly made of basketry, which indicate the social rank of the owner, each ring symbolizing a step in the social ladder. The top of the hat, therefore, does not belong to the decorative field, which is confined to the surface of the cone. The artist found it necessary, therefore, to open the back of the sculpin far enough to make room for the gap in the decorative field. He has done so by representing the animal as seen from the top, but split and distended in the middle, so that the top of the hat is located in the opening thus secured.

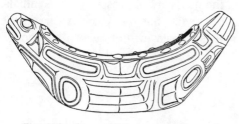

Fig. 220. Grease dish representing seal.

Fig. 220 represents a dish in the shape of a seal. The whole dish is carved in the form of the animal; but the bottom, which corresponds to the belly, is flattened, and the back is hollowed out so as to form the bowl of the dish. In order to gain a wider rim the whole back has been distended so that the animal becomes inordinately wide as compared to its length. The flippers are carved in their proper positions at the sides of the dish. The hind flippers are turned back, and join the tail closely. A similar method of representation is used in decorating small boxes. The whole box is considered as representing an animal. The front of the body is painted or carved on the box front; its sides, on the sides of the box; the hind side of the body, on the back of the box (see figs. 282 et seq., p. 270). The bottom of the box is the animal's stomach; the top, or the open upper side, its back. These boxes are bent of a single piece of wood and are represented here unbent.

In the decoration of silver bracelets a similar principle is followed, but the problem differs somewhat from that offered in the decoration of square boxes. While in the latter case the four edges make

a natural division between the four views of the animal,— front and right profile, back and left profile,—there is no such sharp line of division in the round bracelet, and there would be great difficulty in joining the four aspects artistically, twowhile profiles offer no such difficulty. This is the method of representation adopted by the native artists (figs. 221; 255—257 p. 245). The animal is imagined cut in two from head to tail, so that the two halves cohere only at the tip of the nose and at the tip of the tail. The hand is put through this hole, and the animal now surrounds the wrist. In this position it is represented on the bracelet. The method adopted is therefore identical with the one applied in the hat (fig. 219), except that the central opening is much

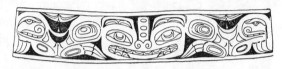

Fig. 221. Design on a bracelet representing a bear, Nass River Indians.

larger, and that the animal has been represented on a cylindrical surface, not on a conical one.

An examination of the head of the bear shown on the bracelet (fig. 221), makes it clear that this idea has been carried out rigidly. It will be noticed that there is a deep depression between the eyes, extending down to the nose. This shows that the head itself must not be considered a front view, but as consisting of two profiles which adjoin at mouth and nose, while they are not in contact with each other on a level with the eyes and forehead. The peculiar ornament rising over the nose of the bear, decorated with three rings, represents a hat with three rings which designate the rank of the bearer.

We have thus recognized that the representations of animals on dishes and bracelets (and we may include the design on the hat, fig. 219) must not be considered as perspective views, but as representing complete animals more or less distorted and split.

The transition from the bracelet to the painting or carving of animals on a flat surface is not a difficult one. The same principle

is adhered to; and either the animals are represented as split in two so that the profiles are joined in the middle, or a front view of the head is shown with two adjoining profiles of the body. In the cases considered heretofore the animal was cut through and through from the mouth to the tip of the tail. These points were allowed to cohere, and the animal was stretched over a ring, a cone,

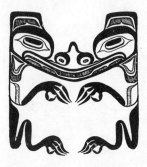

Fig. 222. Painting representing bear, Haida.

or the sides of a prism. If we imagine the bracelet opened, and flattened in the manner in which it is shown in fig. 221, we have a section of the animal from mouth to tail, cohering only at the mouth, and the two halves spread over a flat surface. This is the natural development of the method here described when applied to the decoration of flat surfaces.

It is clear that on flat surfaces this method allows of modifications by changing the method of cutting. When the body of a long animal, such as that of a fish or of a standing quadruped, is cut in this manner, a design results which forms a long narrow strip. This mode of cutting is therefore mostly applied in the decoration of long bands. When the field that is to be decorated is more nearly square, this form is not favorable. In such cases a square design is obtained by cutting quadrupeds sitting on their haunches in the same manner as before, and unfolding the animal so that the two halves remain in contact at the nose and mouth, while the median line at the back is to the extreme right and to the extreme left.

Fig. 222 (a Haida painting) shows a design which has been obtained in this manner. It represents a bear. The enormous breadth of mouth observed in these cases is brought about by the junction of the two profiles of which the head consists.

This cutting of the head is brought out most clearly in the painting

fig. 223, which also represents the bear. It is the painting on the front of a Tsimshian house, the circular hole in the middle of the design being the door of the house. The animal is cut from back to front, so that only the front part of the head coheres. The two halves of the lower jaw do not touch each other. The back is represented by the black outline on which the hair is indicated

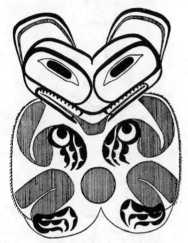 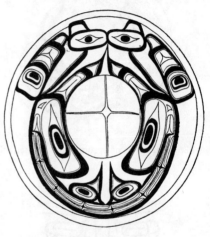

Fig. 223. Painting from a house-front representing a bear, Tsimshian.

Fig. 224. Wooden hat painted with the design of a sculpin, Haida.

by fine lines. The Tsimshian call such a design "bears meeting", as though two bears had been represented.

In a number of cases the designs painted on hats must also be explained as formed by the junction of two profiles. This is the case in the painted wooden hat (fig. 224), on which the design of a sculpin is shown. It will be noticed that only the mouth of the animal coheres, while the eyes are widely separated. The spines rise immediately over the mouth. The flippers are attached to the corners of the face, wbile the dorsal fin is split into halves, each half being joined to an eye.

The beaver (fig. 225) has been treated in the same manner. The head is split down to the mouth, over which rises the hat with four rings. The split has been carried back to the tail, which,

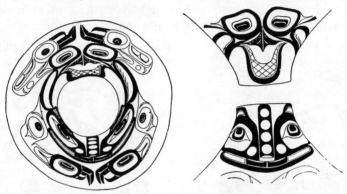

Fig. 225. Hat made of spruce roots painted with design of a beaver, Haida or Tsimshian.

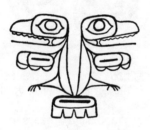

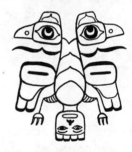

Fig. 226. Tattooing representing
a duck, Haida.

Fig. 227. Tattooing representing
a raven, Haida.

however, is left intact, and turned up towards the centre of the hat. The importance of the symbols becomes very clear in this specimen. If the two large black teeth which are seen under the four rings, and the tail with the cross-hatchings, were omitted, the figure would represent the frog.

In other designs the cut is made in the opposite direction from the one described heretofore. It passes from the chest to the back,

and the animal is unfolded so that the two halves cohere along the middle line of the back. This has been done in the Haida tattooings figs. 226 and 227, the former representing the duck, the latter the raven. In both the tail is left intact. The duck has been split along the back so that the two halves of the body do not cohere except in their lowest portions, while the two halves of the raven are left in contact up to the head.

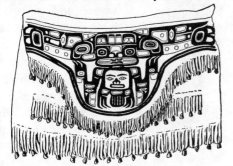

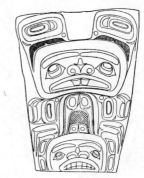

Fig. 228. Dancing-apron woven of mountain-goat wool, design representing a beaver, Tsimshian.

Fig. 229. Painted legging with design representing a beaver sitting on a man's head, Haida.

Fig. 228 is a dancing-apron woven from mountain-goat wool, and fastened to a large piece of leather, the fringes of which are set with puffin beaks. The woven design represents the beaver. Its symbols, the two pairs of incisors and the scaly tail, are clearly represented. While in most carvings and paintings the tail is turned upward in front of the body, it is hanging down here between the two feet. The meaning of the ornaments in the upper part of the apron to the right and to the left of the head is not quite clear to me, but, if they are significant at all, I believe they must be considered as the back of the body split and folded along the upper margin of the blanket. If this explanation is correct, we have to consider the animal cut into three pieces, one cut running along the sides of the body, the other one along the back.

Fig. 229 shows the design on a leather legging, a beaver squatting on a human head. In this specimen we observe that the proportions

of the body have been much distorted owing to the greater width of the legging at its upper part. The head has been much enlarged in order to fill the wider portion of the decorative field.

The gambling-leather (fig. 230) is treated in a similar manner. It represents the beaver, and must probably be explained as the animal cut in two. The symbols,— the large incisors and a scaly tail, — appear here as in all other representations of the beaver, but the lower extremities have been omitted. It might seem that this design could be explained as well as a front view of the animal, but the deep depression between the two eyes is not in favor of this assumption. The head consists undoubtedly of two profiles, which join at the nose and mouth; but the cut has not been continued to the tail, which remains intact.

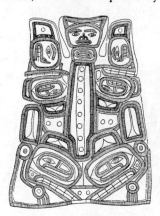

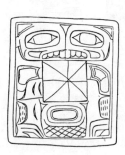

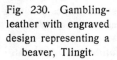

Fig. 230. Gambling-leather with engraved design representing a beaver, Tlingit.

Fig. 231. Embroidered legging representing a sea-monster with a bear's head and body of the killer, Haida.

Fig. 231 is one of a pair of leggings embroidered with quills on a piece of leather. The design, which represents the sea-monster described in fig. 183, must also be explained as a representation of the animal split along its lower side, and flattened. In the lower portion of the legging the two profiles are seen, which are joined on a level with the eyes, while the two mouths are separated. The nostrils are shown in the small triangle below the line connecting the two eyes. Owing to the shape of the legging, the arms are not attached to the body, but to the upper part of the head. They appear at the right and left borders of the legging, and are turned

inward along the lower jaws, the three-toed paws touching the lower border. The fins, which are supposed to grow out of the upper part of the arms, adjoin the elbows, and are turned upward. Another pair of fins, which do not appear in most representations of this monster, are attached to the upper part of the back, and form the two flaps to the right and left of the upper margin. On the back we see a series of circles, which probably represent the dorsal fin. The tail occupies the centre of the upper margin. The smaller ornaments in the outside corners of the head, adjoining the mouth, probably represent the gills.

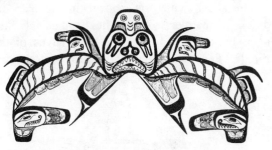

Fig. 232. Painting representing a dog-fish, Haida.

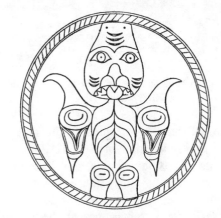

Fig. 233. Slate dish design representing a shark, Haida.

In the following figures we find a new cut applied. Figs. 232 and 233 represent the shark. I explained, when discussing the symbols of the shark, that in the front view of the animal the symbols are shown to best advantage. For this reason side views of the face of the shark are avoided, and in representing the whole animal a cut is made from the back to the lower side, and the two sides are unfolded, leaving the head in front view.

The painting (fig. 232) has been made in this manner, the two halves of the body being entirely separated from each other, and

folded to the right and to the left. The heterocerc tail is cut in halves, and is shown at each end turned downward. The pectoral fins are unduly enlarged, in order to fill the vacant space under the head.

The shark which is shown in fig. 233 is treated in a slightly different manner. Again the head is left intact. The cut is made from back to chest, but the two halves of the animal are not separated. They cohere at the chest, and are unfolded in this manner, so that the pectoral fins and dorsal fins appear to the right and left of the body. The heterocerc tail is not clearly indicated in this specimen.

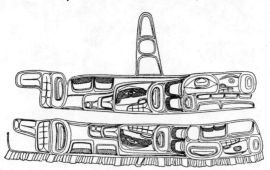

Fig. 234. Painting on edge of a blanket representing a killer-whale, Tlingit.

The method of section applied in fig. 234 is still different. The figure represents a painting on the border of a large skin blanket. The animal here represented is the killer-whale. The upper painting clearly represents the profile of the animal. The lower painting represents the other profile, so that both the right and the left halves are visible. Since there was no room for showing the dorsal fin on the lower painting, it is indicated by a curved line on one of the series of wider fringes at the lower border. It is remarkable that the tails in the two halves of the animal are not drawn symmetrically; but it is possible that this is due to a mistake on the part of the painter, because the design is repeated on the opposite border of the blanket in the same manner, but with symmetrical tails. The two halves of the body differ in details, but their main features are identical. The flipper is shown on a very large scale. It is attached immediately behind the head, and extends to a point near the tail. Its principal part is occupied by a face, in front of which an eye is shown.

Animals are represented by means of sections not only on flat surfaces, but also in round carvings in which one side cannot be shown. This is the case on all totem poles, for the rear side of the pole is not carved. Whenever all the symbols of the animal can be shown on the front of the totem pole, the animals are apparently represented in their natural position. But representations of animals, the symbols of which would be placed on the rear side of the totem pole, make it clear that the artist actually splits the animals along the rear of the totem pole, and extends this cut in such a way that the animal is spread along the curved front of the pole. This will become clear by a consideration of the following figures.

Fig. 235 represents a sea-monster with a whale's body and bear's paws. It differs from the monster discussed before in that it has a whale's head, and no fins attached to the fore paws. It has, however, one large dorsal fin. The blow-hole of the whale is shown over its eyebrows. The tail is turned up in front of the body, and the paws are raised in front of the chest. The dorsal fin will be recognized in the narrow strip, ornamented with a small ring, which slants

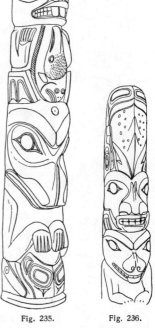

Fig. 235. Fig. 236.

Fig. 235. Model of totem pole representing a sea-monster, Haida.
Fig. 236. Model of totem pole representing a sculpin, Haida.

downward from the elbow towards the tail. An ornament of this sort is shown on both sides of the carving. We see, therefore, that the dorsal fin has been split, and is turned down along each side of the body. This shows that the right and left margins of the carved portion of the totem pole must be considered as the medial line of the back, which has been split and pulled apart.

The sculpin on the totem pole (fig. 236) is treated in the same manner, but in this case the cut is made along the lower side of the animal. The head is turned upward, so that the front view of the face is seen when looking down upon the back of the fish. The spines rise over nose and eyebrows. The pectoral fins are shown over the eyebrows on the edge of the carved portion of the pole, while the hind portion of the lower part of the body occupies the upper part of the margin of the pole.

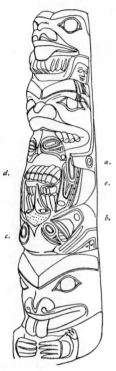

a.

d.

e.

b.

c.

Fig. 237. Model of totem pole representing a sea-monster devouring a fish, Haida.

The exceedingly intricate central figure on the pole shown in fig. 237 must be explained in the same manner as fig. 235. We see here the sea-monster described before in fig. 183. It has a bear's head. In each ear is placed a small human figure the hands of which grasp the eyelid of the monster, which they are lifting. The tail (c) is turned upward in front of the body, immediately over a beaver's head which is the next lower figure on the column. The dorsal fin (a) has been split, and one-half of it is seen under the mouth of the bear, indicated by a projection which is decorated with a double circle. The fore paws of the animal (d) are raised in front of its chest, and appear under the mouth. The fins which are attached to them (b) are shown to the right and to the left of the tail. The animal is swallowing another being, but it is not clear what animal is meant. A fish-tail and a hand are seen protruding from the mouth. The space between the fore paws and the tail of the sea-monster is occupied by an inverted bird, which will be seen clearly when the figure is reversed. Its head is shown with beak resting between the feet. The two wings (e) are extended, and reach from the fins of the fore arm of the monster to its dorsal fin. The particular point brought out by this figure is the same as

that which I tried to explain in considering fig. 235; namely, that the two edges of the carved pole must be considered as the extended medial line of the back of the animal that is represented on the pole.

These carvings make it clear that in paintings on hats, such as shown in figs. 219, 224 and 225, and in flat figures, such as fig. 163, we must consider the outer rim of the figure as the distended sides of a cut made along the lower side of the body. All of these

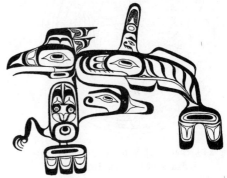

Fig. 238. Slate carving representing the sea-monster, Wasgo, Haida.

Fig. 239. Tattooing representing the fabulous sea-monster, Ts'um'a'ks, Haida.

distortions and sections of animals may be explained by the necessity the artist felt of showing in his work all the symbols of the animal.

In most cases the symbols appear clearly in profiles of animals. For this reason the artist, when representing profiles, has not endeavored to show both sides of the body. I will give here a series of figures illustrating this point.

Fig. 238 represents the top of a box on which is carved the sea-monster Wasgo. It has a wolf's head and body, and a large dorsal fin. It is able to hunt in the sea as well as on land. The artist has shown a profile of the animal with one foreleg and one hindleg, the tail curled up over the back. The dorsal fin, which in most representations of this animal stands out vertically from the body, has been laid down along the back in order to fit it into the decorative field.

Fig. 239 is a tattooing representing the sea-monster Tsum'a'ks,

which is sometimes described as having a raven's body with a whale's body attached to its head, and a fin attached to the raven's back. It is shown in profile with one leg, the dorsal fin, and the tails of raven

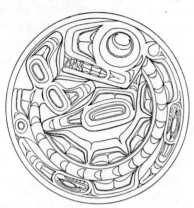

Fig. 240. Slate dish with design representing a killer-whale, Haida.

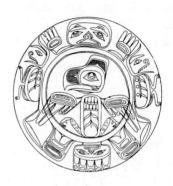

Fig. 241. Drum painted with design of an eagle, Tsimshian.

Fig. 242. Tattooing representing the moon, Haida.

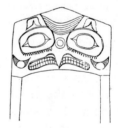

Fig. 243. Carving on the end of a food tray representing a hawk, Tlingit.

and whale, twisted around so as to be seen from the side. In other cases it is described as having a bear's head with the mouth of a shark.

In fig. 240, which represents the design on a circular slate dish, we see a good case of the adaptation of a profile to the decorative field. The design represents a killer-whale with two dorsal fins. The animal is bent around the rim of the dish so that the head

touches the tail. The two dorsal fins are laid flat along the back, while the large flipper occupies the centre of the dish.

Fig 241, which is the painting on the head of a drum, is a combination of front and side views. The head is turned sideways, while the body, the outstretched wings, and the feet are shown in front view. This method is found rarely in the art of the North Pacific coast, and, so far as I am aware, almost exclusively in representations of the eagle (see, however, fig. 239). The painting on the outer ring of the drum-head is difficult to explain. It will be noticed that the tail of the eagle occupies the lower centre of the ring. On top we see the front view of a human figure, the arms of which, of diminutive size, are placed near the lower corners of the face, while the hands are of very large size. The two sitting figures below the two hands probably represent the back of the man who is shown on top, but their connection with the peculiar fin-like figures on the lower portion of the painting is not clear.

Fig. 242 is a tattooing representing the moon. In its lower portion the crescent will be seen. In the dark portion of the moon a semi-human figure is shown in profile, with one leg. One arm is extended downward, and one backward, as though he were lifting a heavy weight.

There are very few designs which can possibly be interpreted as full-face views of animals. I explained before that the face of the shark is always shown in this manner, because its symbols appear best in this position. The only other animal which is painted or carved on flat surfaces in full front view is the hawk or thunder-bird, whose symbol is the long beak which descends to the chin. A number of carvings representing the thunder-bird were given in figs. 165—168 (p. 191).

We find full-face representations of the thunder-bird frequently used on dishes, on which the beak is indicated by a long wedge which separates the mouth into two halves. It is, however, not certain whether the artists consider this face always as a full front view, because we often find (fig. 243) a depression between the two eyes, corresponding to the depression which I described before

when referring to the joining of the profiles of animals. It may be
that the long central wedge must be considered as the two halves
of the long descending beak, which join in the middle. It might be
expected, however, that in this case the beak would, at least some-
times, be carried on outward to the right and to the left below the
chin, corresponding to one-half of the beak seen in fig. 166 p. 191).
I have not observed a single specimen in which this is the case, and

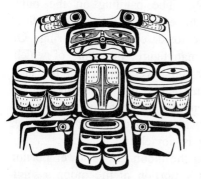

Fig. 244. Painting from a house-front
representing thunder bird, Kwakiutl.

therefore I am inclined to consider
the carvings of thunder-birds on
dishes as full front views.

This ornament may have origin-
ated in the following manner: Many
grease and food dishes have the
form of canoes. The canoe sym-
bolizes that a canoe-load of food is
presented to the guests; and that
this view is probably correct is
indicated by the fact that the host
in his speeches sometimes refers
to the canoe filled with food which

he gives to his guests. The canoe form is often modified, and a
whole series of types may be established forming the transition
between canoe dishes and ordinary trays. Dishes of this sort
always bear a conventionalized face at each short end, while the
middle part is not decorated. This is analogous to the style of the
decoration of the canoe. On the whole the decoration of the canoe
is totemic. It may, however, be that the peculiar manner in which
the beak of the hawk is represented has given rise to the preval-
ence of this decoration. The upper jaw of the hawk is always
shown so that its point reaches the lower jaw and turns back into
the mouth. When painted or carved in front view the beak is indi-
cated by a narrow wedge-shaped strip in the middle of the face,
the point of which touches the lower margin of the chin. The
sharp bow and stern of a canoe with a profile of a face on each

side, when represented on a level or slightly rounded surface, would assume the same shape. Therefore it may be that originally the middle line was not the beak of the hawk, but the foreshortened bow or stern of the canoe. This decoration is so uniform that the explanation given here seems to me probable.

In fig. 244 we see a painting representing a full front view of the thunder-bird. Its principal symbol is the long beak, which in front view appears like a long line descending from the nose over the mouth. In this case it is doubtful whether the body may be considered as being split along the back. Since the face is certainly represented in front view, it seems more likely that the animal is represented with spread wings, similar to the eagle in fig. 241.

I have described a number of dissections applied in representing various animals. Heretofore we have had cases only in which the dissections were rather simple. In many cases in which the adaptation of the animal form to the decorative field is more difficult, the sections and distortions are much more far-reaching than those described before.

The cut that has been applied in the totem pole (fig. 245) is much more intricate than the preceding ones. The upper figure represents a bird which is shown in the form of a human being, to the arms of which wings are attached. Under this figure we find a representation of the killer-whale. The hind part of its body is more easily recognized than the head. A small human figure is seen riding on the dorsal fin. The tail (*a*), which appears at the lower margin of the figure, is turned backward over the back of the animal.

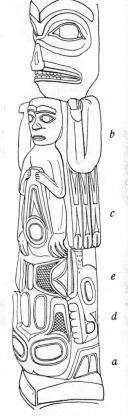

Fig. 245. Model of totem pole with design representing a killer-whale, Haida.

We must therefore imagine that the head has been turned downward behind the human figure (*b*) riding on the dorsal fin (*c*). It would, therefore, lie on the back of the totem pole, which is not carved. Consequently, according to what was stated before, the artist has split and distended it so that the middle line appears at each edge of the carved portion of the pole. Thus the right half of the head (*d*) has been brought into view on the right side of the totem pole, and the left half on the left. This is the explanation of the whale's head with its teeth, which is seen in our figure next to the tail, the lower jaw being omitted. The flipper (*e*), which adjoins the head, is laid over the back of the whale, immediately under the feet of the human being riding on the dorsal fin of the whale. The figure must therefore be explained in such a way that the animal is twisted twice, the tail being turned up over the back, and the head being first turned down under the stomach, then split and extended outward.

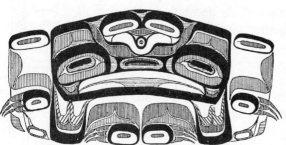

Fig. 246. Painting for a box front, design representing a frog, Haida.

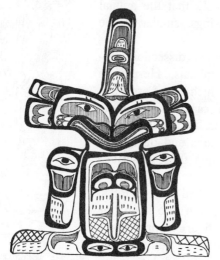

Fig. 247. Painting for a house-front, design representing a killer-whale, Kwakiutl.

Fig. 246 is a copy of a painting on the front of a box, made on paper with colored crayons by a Haida Indian named Wiha. It represents a frog. By far the greater portion of the box-front is occupied by the head of the animal, which, according to what was said before, must be considered as consisting of two adjoining profiles. The symbol of the frog's head is its toothless mouth. The two black portions extending downward from the lower corners of the face are two halves of the body. To these are joined the fore paws, which occupy the space below the mouth; the upper arm and fore arm being turned inward, the fore feet being turned outward under the arm. The hind legs occupy the lateral field on both sides of the head. They are not connected in any way with the body of the animal.

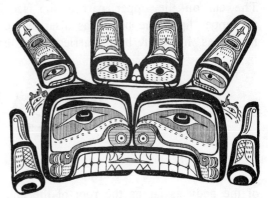

Fig. 248. Painting for a house-front with design representing a killer-whale, Kwakiutl.

In fig. 247 we find a novel representation of the killer-whale, which was given to me as illustrating the painting on a house of the Kwakiutl Indians. The sections that have been used here are quite complicated. First of all, the animal has been split along its whole back towards the front. The two profiles of the head have been joined, as described before. The painting on each side of the mouth represent gills, thus indicating that a water-animal is meant. The dorsal fin, which according to the methods described heretofore would appear on both sides of the body, has been cut off from the back before the animal was split, and appears now placed over the junction of the two profiles of the head. The flippers are laid along the two sides of the body with which they cohere only at one point each. The two halves of the tail have been twisted outward

so that the lower part of the figure forms a straight line. This is done in order to fit it over the square door of the house.

In fig. 248 the same animal has been treated in still a different manner. The figure illustrates also the painting from a house-front of the Kwakiutl Indians. The central parts of the painting are the two profiles of the head of the killer-whale. The notch in the lower jaw indicates that it also has been cut, and joined in its central part. The cut on the upper part of the face has been carried down to the upper lip. The body has disappeared entirely. The cut of the head has, however, been carried along backward the whole length

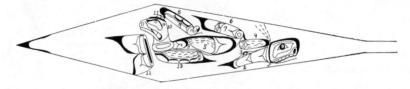

Fig. 249. Painting on a paddle representing porpoise and seal, Kwakiutl.

of the body as far as the root of the tail, which latter has been cut off, and appears over the junction of the two profiles of the head. The dorsal fin has been split, and the two halves are joined to the upper part of the head, from which they extend upward and out-ward. Immediately below them the two halves of the blow-hole are indicated by two small faces, the upper parts of which bear a semi-circle each. The flippers are attached to the lower corners of the face. The painting on the face next to the mouth represents gills.

Fig. 249 is a complicated painting on a Kwakiutl paddle. It re-presents a porpoise and a seal combined; the porpoise turning to the right, the seal to the left, and both having a common body. At the right is seen the head of the porpoise and the short lines be-hind it, upward, represent the animal spouting. (1) is the neck, (2) the flipper, (3) a joint in the flipper, (4) and (5), (9) and (13) jointly representing the body of the porpoise, (5) is the stomach, (8) the dorsal fin of the porpoise, (9) is the backbone both of the

porpoise and of the seal, (12) is the tail of the porpoise. The head of the seal is shown in (11), (10) represents the ears, although another pair of ears, like those of all animals, appear over the head. It has been stated before that (9) is the backbone of both seal and porpoise, (5) is the stomach of the seal, (13) its flippers, and (4) its tail.

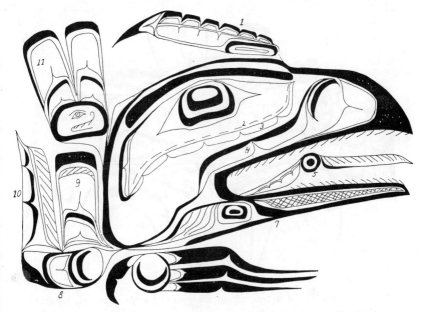

Fig. 250. Painting for a house-front representing a raven, Kwakiutl.

Fig. 250 represents the painting from a housefront showing a raven in profile. This painting appears on the right and left of the doorway; the beaks facing the door. (1) is the raised tuft on the head of the raven, (2) feathers, (3) the facial bones, (4) the skin over the beak, (5) is supposed to be a joint in the tongue, (6) the skin over the lower jaw, (7) the supposed joint at the base of the tongue, (8) represents the shoulder joint, (9) feathers, and (10) the long wing feathers. It will be noticed that the inner feathers (9) are rounded, while the wing feather has a sharp point, according

to the standard requirements referred to on p. 205. (11) represents the tail with a single face as a joint, according to standard requirements.

Fig. 251 is a design from a housefront, over the door, representing a thunder bird. The design must be considered as consisting, more or less clearly, of two profiles. (1) represents the hooked

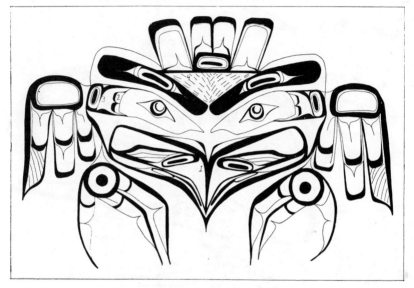

Fig. 251. Painting for a house-front representing a thunder-bird, Kwakiutl.

nose, (2) the skull, (3) the ears, (4) the feathers over the heavy eyebrows. The tail rises over the head. It has the characteristic single joint. Rounded feathers are shown on the wings, right and left; the extreme long wingfeather is sharply pointed. The feet, to the right and left of the face, are enormously enlarged. The circular eye design represents the joint to which three toes are attached.

Fig. 252 represents another painting which is placed over the door of a Kwakiutl housefront. It represents a whale. In this specimen are found a number of deviations from the supposed standard. Below is the tail (1), with the flukes (2). While the double curva-

ture on the inner side of the flukes is preserved, there is only one joint design instead of the normal two. The design (3) on each side represents the fins. According to the standard these ought to be round, but they are actually sharply pointed like wing feathers. This may be due to the prevailing tendency of showing the middle feathers as round, and letting the extreme lateral ones run into a long point which closes off the design more effectively then a round form would. Over the tail will be noticed the long mouth and the nose with its sudden turn. The line (4) indicates the strong curve which sets off the nose from the forehead. This is analogous to the treatment of the nose among the Haida. (5) represents the shoulder joint. The scallops under the eyes are the cheekbones. Over the eyes are the ears (6), over the forehead rises the dorsal fin with a single joint. Normally the eyes

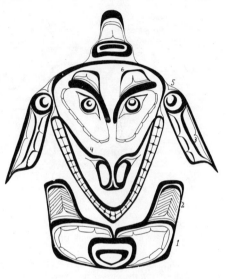

Fig. 252. Painting for a house-front representing a whale, Kwakiutl.

of the whale are round and the person who explained the design called particular attention to the fact that in this painting they had not the standard form.

Fig. 253 is another house-painting of the Kwakiutl, representing the raven. The same principle as in fig. 251 has been adhered to by the artist. The central portion of the figure is occupied by the head of the raven split from its lower side upward so that the two halves cohere along the upper edge of the beak. The two halves of the head have been folded outward, so that the two halves of the tongues (2) and the two lower jaws (1) appear on each

side of the central line. The two halves of the lower side of the body are shown extending in a curved line (3) from the corners of the mouth towards the tail, which latter has not been cut. The wings have been considerably reduced in size, and pulled upward so that they appear over each upper corner of the head. The legs (5) occupy the right and left lower parts of the painting, the feet (4) being disconnected from the thin legs.

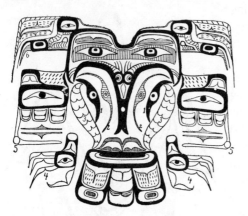

Fig. 253. Painting for a house-front representing a raven, Kwakiutl.

Fig. 254. Painting from the edge of a blanket representing a sea-monster, Northern British Columbia.

In fig. 254, which is a painting on the margin of a blanket, the sea-monster described in Fig. 183 (p. 199) is represented. The animal is shown here as split in two along its back; but all its parts, except the head, the paws, and the tail, are much reduced in size. The two enormous eyes, and between them the nose, will be readily recognized. The teeth are indicated by a series of slanting lines under each eye, but the lower jaws of both halves have been omitted. The whole body is represented by the thin line extending from the lower outer corner of the eyes upward, then along the upper margin of the painting, and downward again. The three dorsal fins are shown over this line,— one-half of each on each side of the back. The arms are indicated by two curves under the line indicating the back. The fin of the arm is shown under the fore arm. While all these are of small size, the paw which adjoins

the fore arm is shown on a large scale, the claws turned towards the face. The line representing the body runs towards both ends of the painting along the lower margin until it is merged into the tail, one-half of which is shown on each side. In this specimen the proportions of the body are much more distorted than in any previous case.

The following series of figures are designs found on a number of silver bracelets. The animals represented on these are also shown very fragmentarily.

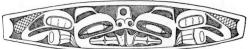

Fig. 255. Desisn on a silver bracelet representing a beaver, Haida.

In fig. 255 we see the beaver cut in two along its back. The face does not need any further explanation. The fore legs adjoin it on each side, the toes being turned inward; but the whole rest of the body has been omitted, except the two halves of the tail, which

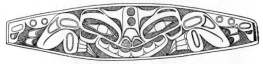

Fig. 256. Design on a silver bracelet representing a sea-monster, Haida.

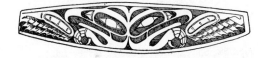

Fig. 257. Design on a silver bracelet representing a hawk, Haida.

the artist was compelled to show, because they are symbols of the animal.

In fig. 256 we recognize the sea-monster, with a bear's head and a whale's body. Here also by far the greater portion of the etching represents the head and fore arms of the monster. The fins, that are attached to the upper arms near the elbow, are shown on a rather small scale. The whole rest of the body is of small size, the two halves of the body, with the adjoining half of the tail, occupying only the outer upper margin of the bracelet. I am not quite clear whether the artist intended to represent the two halves of the dorsal fin by the curved ornament adjoining the hat which rises over the nose of the monster.

The hawk which is shown in fig. 257 has been cut in a different manner, namely, from the beak backward, the two halves being then turned outward. The centre of the design is occupied by the two halves of the head, and the two talons which adjoin it. The wings are cut off from the body, and occupy the outer corners of the design.

The designs on the following series of carvings are no less conventionalized. Fig. 258 is a sea-monster adjusted to a circular slate dish. The carving is perfectly

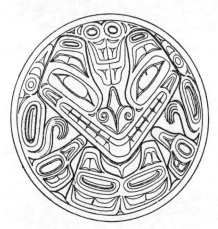

Fig. 258. Slate dish with design representing a sea-monster, Haida.

symmetrical. The drawing appears asymmetrical because it has been taken from an eccentric point of view. Here also the centre is occupied by the head of the animal. The tail is seen under the lowest part of the mouth, turned upward in front of the body. The arms are shortened considerably. They are attached to the lower corners of the mouth, the paws touching the chin. The fins are joined to the upper part of the arms, and are turned upward so that they lie close to the sides of the face and about on a level with the ears. Attention is called again to the spiral nostrils.

In fig. 259, which represents the front of a small box carved in slate, the same sea-monster is shown. Again we see the animal cut in two, the section separating the eyes and the ears, the mouth, however, being left intact. Here the whole body has been omitted, with the exception of the paws to which the fins are attached. The paws will be recognized turned inward under the mouth, while the fins extend upward along the outer margins of the slab. The dorsal fin has been bisected, and one-half is shown in each upper corner. The ornament in the centre of the upper margin probably represents

the tail turned upward over the back so that it almost touches the head. This arrangement must be considered in connection with the formal treatment of boxfronts which will be discussed later (pp. 263 et seq.).

Fig. 260 represents the carving on a slate slab. We have here a different representa-tion of the sea-monster, which is also, as we might say, much ab-breviated. The head occupies by far the larger portion of the carving. The body which is seen under-neath the head, in the centre of the slab, is indicated by a com-paratively small square with rounded edges, decorated with two fins. The rest of the decora-tion on the lower edge of the slab must be interpreted as the arms of the monster, the large face on each corner representing an elbow. The whole arm,

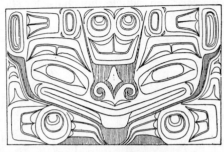

Fig. 259. Front of a slate box with design representing a sea-monster, Haida.

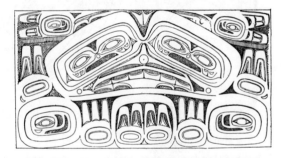

Fig. 260. Slate slab with design representing a sea-monster, Haida.

extending from the elbow to the hand, is omitted. The latter is indicated by an oval the centre of which is occupied by an eye. From it rise the three fingers or claws. The important symbols of the monster, the fins, which are attached to the fore arm, are shown adjoining the elbow, and rise along the sides of the slab, outside of the eyes. The two ornaments occupying the upper corners of the slab are undoubtedly the tail. This arrangement is

also determined by the general principles governing the decoration of boxes (see p. 263).

The shark which is shown in fig. 261 is found on one end of a small food tray. I do not need to repeat the description of the shark's face, on which the characteristic symbols will be recognized.

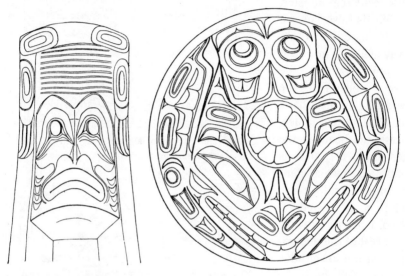

Fig. 261. Design from the end of a food tray representing a shark, Tlingit.

Fig. 262. Slate dish with design representing a sculpin, Haida.

I have introduced this figure here in order to show that the whole body of the animal has been omitted with the sole exception of its pectoral fins, which are carved on the rim of the tray on both sides of the forehead. Their position is somewhat analogous to the one found on the totem pole fig. 213 (p. 219).

In figs. 262 and 263 we find the representations of the sculpin distorted and dissected in the same manner as the sea-monster of the preceding figures.

In fig. 262 the sculpin has been adapted to a circular slate dish. The centre of the design is occupied by a rosette, which has

undoubtedly been copied from European patterns. In the drawing the outlines of the various parts of the body have been strengthened in order to make their relations somewhat clearer. It will be noticed that the head is split in two, cohering only at the nose and the upper jaw. The two spines rise immediately from the nose. The two halves of the body extend from the corners of the face upward along the rim of the dish. There they grow thinner, indicating the thin portion of the fish body near the tail. The tail has not been split, and is turned upward and backward so that it touches the central rosette. A comparison between this design and the design at the centre of the upper margin in fig. 259 will show a great similarity between the two, thus making it probable, that, as stated before, the latter design is intended to represent the tail of the monster. The

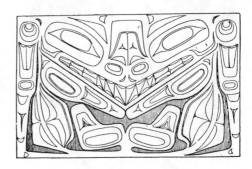

Fig. 263. Front of a slate box with design representing a fish, Haida.

pectoral fins of the sculpin are shown in a rather abnormal position. They are turned forward from the body so that they adjoin the lower jaw. They will be recognized between the jaws and the rim of the dish. The dorsal fin is indicated by the long pointed ornaments extending from the eye towards the tail.

In the design fig. 263 a fish has been dissected in a somewhat different manner. The head occupies the upper margin of the slab. It has a remarkably triangular shape. The body has been bisected from head to tail, and turned and twisted in such a manner that each half extends in a curve downward from the corners of the face to the middle of the lower margin of the slab. The pectoral fins have been left in contact with the corners of the mouth, and are placed in the same position as in the preceding figure,

namely, adjoining the lower jaw. They meet just below the chin of the animal. I believe the ornaments which are stretched along the right and left margins of the slab represent the dorsal fins.

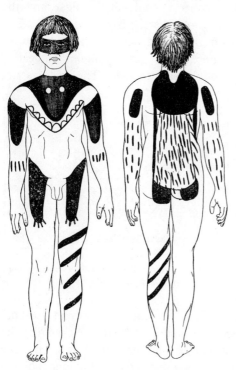

Fig. 264. Body painting representing the bear, Kwakiutl.

I have described at a previous place (p. 215) the extraordinary distortion and dissection of the killerwhale in its adaptation to a blanket, and I have given the description at that place.

Quite a unique distortion is found in body paintings used by the Kwakiutl Indians in a boy's dance. Fig. 264 is a copy of a body painting representing the bear. On the chest, the head of the bear is shown turned downward. The white spots over the collarbones are the eyes of the bear; the angular line with semicircles, the mouth and teeth. On the upper arms are shown the forelegs, the claws just under the elbow. The hind legs are shown on the front of the thighs. On the back of the person is shown the nape of the bear placed on the upper part of the back; under it, extending downward, is the back, the lines representing hair. The hip-joints are shown by dark designs on the buttocks. The spiral design on the left leg was said to represent the tail.

Still more remarkable is the frog painting shown in fig. 265. On the small of the back is shown the top of the head of the frog;

the two eyes with eyebrows above, the mouth below. Corresponding to this place we find in the front of the body the mouth set with teeth (which really do not belong to the frog). The back of

the frog is shown on the upper part of the back; the hind legs on the back of the arms. The opposite side of the hind legs is shown on the front of the arms. It seems probable that in the design which was copied for me by an Indian, the painting on the front of the left arm was accidentally omitted. The shoulder joint is shown on the front of the thighs; the forelegs in corresponding position on the back of the thighs; the ankle joints on the knees; and the foot on the calf of the legs. In other words, the frog is shown in such a way as though the body of the person were the frog. No explanation was given for the black design on the left leg.

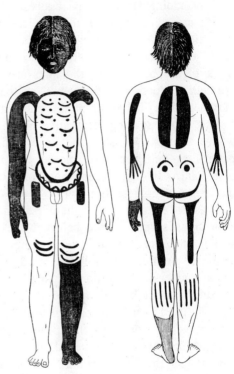

Fig. 265. Body painting representing the frog, Kwakiutl.

We will turn now to the purely formal side of the treatment of the decorative field. There is a tendency to cover the entire surface with design elements. Vacant places are avoided. When the surface of the object represented has no features that lend themselves to decorative development, the artist resorts to devices that enable him to fill the surface with patterns. On totem poles the

bodies of the animals represented occupy considerable space. The monotony of the surface is broken by placing the forelegs and hindlegs across the front of the body, by turning up the tail in front, and by adding small animal figures.

Far more important is the application of a great variety of decorative elements, all of which consist of curved lines. The Indians have a decided disinclination to apply equidistant curves. In all work of the better class the lines are so arranged that more or less crescent shaped surfaces result, or that narrow, curved areas, wide in the middle, narrower at the ends, are formed.

The most striking decorative form which is used almost everywhere, consists of a round or oval field, the "eye design". This pattern is commonly so placed that it corresponds to the location of a joint. In the present stage of the art, the oval is used particularly as shoulder, hip, wrist, and ankle joint, and as a joint at the base of the tail and of the dorsal fin of the whale. It is considered as a cross section of the ball and socket joint; the outer circle the socket, the inner the ball. Often the oval is developed in the form of a face: either as a full face or a profile.

The general disposition of this design demonstrates that the explanation is not by any means always tenable. Thus in the blanket, fig. 205 (p. 215), the eye pattern in the two lower corners has no connection with a joint. In this position, in the mouth of an animal, it is sometimes described as food. The two profile faces higher up on the side of the same blanket, are obviously fillers. They might be replaced by "eye designs". Another instance of similar kind is found on the upper part of the face of the dish fig. 168 (p. 191). The circular designs shown here might perhaps be interpreted as tail joints, but they are probably decorative elements. The design appears clearly as a filler in fig. 283 *f* (p. 272) at the inner upper corner on the long side of the box, and on the ears of the beaver, fig. 229, (p. 227). On Chilkat blankets it appears always in fixed positions (see p. 258) and in large boxes it is the constant corner design (see p. 263). Its use and interpretation as a joint is presumably

related to the frequent ornamental combination shown, for instance, in the feet on fig. 160 (p. 188) and in the tails fig. 193 (p. 205). The oval represents the joint and the elevated part the limb. These are at the same time formal elements that appear regularly on the lateral border designs on carved boxes (fig. 274, p. 263). The eye design appears in a variety of forms ranging from a large double eye to a circular pattern with black center.

Lieutenant Emmons has collected the various design elements as they appear on the blankets and has given the names by which they are designated by the Tlingit (fig. 266). These names do not fit the explanations given for the whole pattern. The "double eye" *(h)* and the "eye" *(f)* are not always eyes but occur also as joints, (fig. 269 *b*). The profile eye is called the "head of the salmon trout" *(c)*. It is used quite generally as the eye of any animal. The "black eye" *(g)*, the "nostril" *(l)* and the design called "one in another" *(o)* are practically identical. They are also used as joints. The frequent use of the circular design of light or dark color, set off against a dark or light background indicates that the tribes of the north west coast do not tolerate areas of the same color, the monotony of which is relieved by the insertion of circular designs of contrasting colors. These may be seen on many blanket and box designs (fig. 274 et seq.).

The forms called "side holes" *(p)* and "holes", "ends of gambling sticks" or "rain drops" *(q)* have

Fig. 266. Design elements from Tlingit blankets.

white circles relieving a black background. It is quite evident that these designs also, as parts of the whole design, have not the significance implied in the names, nor do the names explain the reason for their use. The frequent occurrence of the white circles, both isolated and in lines, (see figs. 269 et seq., pp. 259 et seq.) proves that they must be considered primarily as a formal element designed to break large surfaces.

It seems to me most likely that the black or white circular design has been the basis from which the eye design has developed. In the style of the north west coast art shoulders, hips, hands, and feet form large dark monotonous surfaces. These are broken by a large white circle or oval, which is again varied by a black center. This tendency would also account for the goggle design (fig. 266 *i*). The same desire to relieve the monotony of the cheek surface leads to the insertion of an oval design on the cheek *(k)*.

In carved designs these forms are not contrasted by color, but the form alone varies the monotony of the large undecorated surface.

Another characteristic pattern, the narrow crescent, has presumably also originated from the desire to break the monotony of continuous areas. It appears particularly when it is desired to set off two merging patterns against each other. Here also design names obtained by Emmons, "woman's hair ornament" *(r)* and "slit" *(s)* have nothing to do with its function and significance as part of the whole pattern.

The most characteristic filler, next to the eye, is a double curve, which is used to fill angular and round fields that rise over a strongly or gently curved line. Many fillers of this type have a dark colored band at the upper end, generally rounded in paintings or carvings, square in blankets (see fig. 202, lower lateral design on central panel; the tail patterns, fig. 193). In the blankets the angular form is perhaps due to the technique in weaving, although the frequent eye designs prove that round forms are not impossible. On blankets the heavy upper line is often drawn out into a tip

(fig. 270 *a*, over the "goggle" design on the side of the central panel). Examples of these forms have been collected by Lieutenant Emmons who states that the Tlingit call them "the wing-feather of red-winged flicker" (fig. 266 *t*). The use of the pointed form of this design for a bird feather agrees with the theoretical claim of the Kwakiutl (see p. 205), but obviously the explanation does not always fit the meaning of the pattern as a whole, as is shown by the killer-whale design fig. 205 (p. 215) or the whale design fig. 270 (p. 260).

The design is used commonly to represent quite diverse objects. Thus, the double flicker-feather (fig. 266 *t*), occurs in fig. 269 *a* as the beak of a bird, occupying the middle of the mouth design between the two large eyes. It occurs also between the ears along the upper border of the design as the single flicker-feather. Here as well as over the beak of the bird, in the lateral fields, it is used only for filling in parts of the design which otherwise would remain undecorated. In fig. 202 (p. 213) the same design occurs between the eyes, just over the nostril, and here also it obviously has nothing to do with the red-winged flicker. Many other cases of this application of the wing-feather design, simply for the purpose of filling in spaces, may be observed in practically all the blankets. A comparison of fig. 202 with the box designs fig. 274 shows that the wing-feather design may serve to express the forearm and the upper arm. In fig. 274, we have the two hands placed in a position similar to the paws in figs. 202 and 269 *b*. On the box fig. 274 *a* the parts are connected with the body by a narrow red strip, which is divided by characteristic curves into two parts. A comparison of this design with figs. 222 and 223 shows very clearly that they are meant to represent the upper arm. In the blanket design fig. 269 *b*, the two sections connecting the paw with the body may be recognized distinctly as upper arm and forearm. In the blanket designs fig. 202, the space that is available for the upper arm is much condensed; but it is quite obvious that the two wing-feather designs which lie on the outer sides of the paws must be interpreted here also as the forearm and upper arm. Judging by this

analogy, I think there can be very little doubt that the two wing-feathers placed by the sides of the body in fig. 269 *a* may be considered in the same way as the two parts of the arm of the animal represented. Since the animal here shown is a bird, these feather designs are in this way made to represent the bones of the wing.

Similar considerations have determined the distribution of ornaments in the design fig. 270 *b*. Here the two feet will be recognized at the lower edge of the design. Adjoining it, above the "eye", are two long white flicker-feather designs, which obviously represent the legs. Each of the two inverted double eyes under the jaws must be interpreted as a shoulder-joint to which is attached the lower part of the arm in the form of a flicker-feather design.

The forms here discussed are interpreted as various kinds of animals,— birds, quadrupeds, sea-monsters,— but never as the red-winged flicker, nor can the parts be interpreted as ornaments made of flicker-feathers. It is obvious that we are dealing here with a fixed form, which has a conventional name, and which is used for a variety of purposes.

It will be noticed that this design occurs in three principal forms. In one of these it is cut off square at the upper end. Most of those shown in fig. 266 are of this type. Another characteristic form of this design has the pointed wing-feather, (as the second one in the series fig. 266 *t*). A third form, which is not given in the series of named designs, seems to be quite common. It has a rounded tip, and may be observed, for instance, in the beak part in front of the upper eye in the lateral panels of figs. 203 and 269 *a*; also in the central field in fig. 273 *b*.

The wing design is applied wherever a somewhat oval or rectangular field which is situated laterally has to be filled in, particularly when the field adjoins another design which is surrounded by heavy black lines, and which forms part of an animal body. For this reason the design appears very commonly in front of, over, or under the eye design. It is used to fill in the ears; it appears at the sides of the body, as in figs. 203 and 269 *a*; and it is used

to fill in small fields which adjoin black lines, as for instance, in the lowest section of the lateral panels in fig. 269 *a*.

On blankets the light circle on a darker background with black tip and small white segment at the base, is almost ever-present. The white segment at the base is limited very often by a pointed double curve,— like a brace,— which divides the adjoining colored field more or less distinctly into two halves. These may be observed, for instance, in one of the ear designs in figs. 202 and 269 *b*, and also in the design over the nose in fig. 202.

This pattern is also used as a filler for long narrow spaces. According to Emmons this is called the "mouth design" (fig. 266 *j*) or the "eyebrow" (*e*), but it is often used on fields that cannot be interpreted as "mouth" or "eyebrow", as for instance, in the lateral parts of the lower border of fig. 202 and in the lower corner of the box, fig. 274 *b*.

Judging from the general application of this design, it is quite obvious that it is not primarily a feather design, but that it is a decorative element used throughout in certain definite positions for the purpose of filling in.

Flat black curves are used quite often for indicating the teeth. These may be observed in fig. 269 *a*, on the body of fig. 270 *a*, in the lowest face in fig. 204, in the lower faces of fig. 271.

We have discussed before the adjustment of animal form to the decorative field. The adjustment is not by any means free, but definite, stylistic forms may be recognized. These appear with great clarity on the Chilkat blankets.

The measurements of the blankets show that the central height is very nearly one half of the width. The width of the narrow border, consisting of a black and yellow stripe, is about one twelfth of the total width. The angle of the lower border is quite variable, the vertical distance from a line connecting the lower corners of the blanket to its greatest depth is generally a little less than one sixth of the width. The fundamental trait of the blanket pattern is the

Fig. 267. Schematic design showing the arrangement of the central field
of the Chilkat blanket.

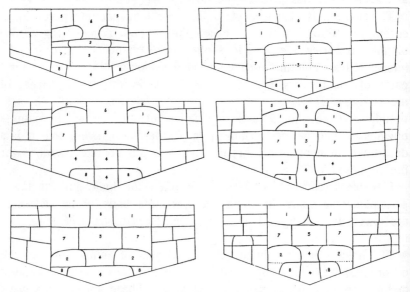

Fig. 268. General plans of Tlingit blankets.

division of the field into three panels The central one about double
the width of the lateral ones, or more. In most blankets the line
of division of these fields is quite clear and is indicated by black
and white lines. The designs on the lateral fields are symmetrical
and quite distinct from the central field.

The blankets may be divided into two large groups. Their funda-
mental patterns are indicated schematically in fig. 267. The one

design is clearly a representation of an animal with a large head which occupies the whole upper part of the field down to an almost straight cross line (fields 1, 2, 5, fig. 268). Under it are the body (field 3) and in the lower border the tail and hips (field 4) of the animal. It may be noticed that there are always two tail joints, although in other cases the use of a single tail joint for birds and a double tail joint for sea mammals is fairly consistent. Fields 6, 7, and 8 are used in various ways. They are not essential parts of the animal represented, although field 6 may be utilized for the purpose of showing parts of the back, and field 7 may be utilized for a representation of the forearms. In this style we may distinguish, in the

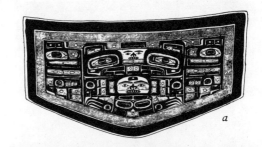

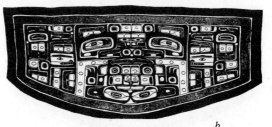

Fig. 269. Chilkat blankets.

wide center, a central stripe, consisting of the elements numbered 6, 2, 3, 4 and two lateral stripes 5, 1, 7, and 8. Generally these sections interlock. In a few specimens, the outer limits of field 3 are carried down to the lower border so that they form a continuous broad line with the outer limits of field 4.

Examples of this type are shown in figs. 202 and 269. In these the animal figure in the center appears very clearly. It will be noticed that the large eyes of the animal have always a cheek design attached to them. These appear also in fig. 203, a blanket belonging to the same class, the lower part of which is, however, much less distinctively body and tail belonging to the large head. The

reduction of field 7 and its extension to the lower margin is rare in other specimens. In fig. 202 field 7 is occupied by the raised hands of the animal, while in fig. 269 *a* it is occupied by a wing design. The rectangular frame surrounding the body in fig. 269 *b*

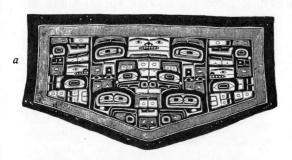

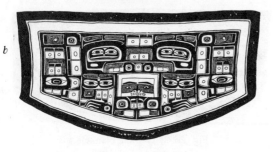

Fig. 270. Chilkat blankets.

is an exceptional feature which I have seen only in one other modern blanket.

A sub-type may be distinguished in which the lower part is treated differently (fig. 270 *a*). The two eyes of field 4 are of the same size as those of field 1. In this way a more symmetrical impression is produced, but at the expense of the unity of the animal form. This treatment lends itself to a sharper separation of the fields 5, 1, 7, 8 against the fields 6, 2, 3, 4 so that the whole central field seems to be divided into three sections (see fig. 204). Fig. 270 *a* is decidedly influenced by the second type of blanket; the four eyes being approximately of the same size and symmetrically arranged around a central face.

The fundamental feature of the second type of blankets is a central face placed a little higher than in the preceding type, so that it forms exactly the center of the whole field. In place of the large eyes on top, we find two large inverted eyes, often without the adjoining jaw design. In many cases two small circular patterns, or small eye designs, occupy the center of the lower border. These

may often be identified
with the nostril of the
head to which the two
large lower eyes belong.
This pattern is much
more symmetrical than
the former type, but its
symbolism is much more
obscure. I presume that
the inverted position of
the eye in the upper
border is essentially due
to the attempt to obtain
greater symmetry. For
an explanation it is
necessary that the upper
eyes must be viewed as
some part of the body
that is turned upside
down. Characteristic
examples of this type
are shown in figs. 103
and 271. In these, the
fields to the right and
left of the central face
are treated, in the former,
as a profile face; in the
second they are de-

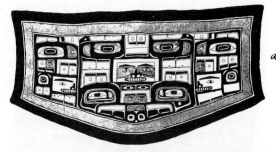

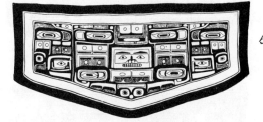

Fig. 271. Chilkat blankets.

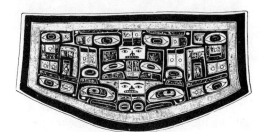

Fig. 272. Chilkat blanket.

corated with a feather-design filler. A somewhat different treatment
is given in fig. 272 which may be compared with fig. 270. In both a
large face occupies the center of the whole design, surrounded by
the four large eyes and the lateral spaces filled with feather designs.

In fig. 273 the upper eyes have been moved towards the center
and the eye design has been expanded into a profile which occupies

the whole upper margin of the central field. In fig. 273 *b* the lateral fields next to the central face are occupied by the two sides of the dorsal fin so that here the form of a whale is brought out fairly clearly.

The general scheme of the narrow lateral panels is also quite definite. We find on practically all the blankets an eye design,—

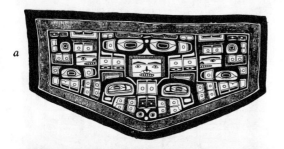

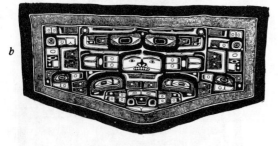

part of the profile of an animal's head,— in the upper, outer corner, another eye design near the lower border, generally approximately in the middle of the lateral field. The position of the lower eye design is much more irregular than that of the upper one. In general we are given the impression of an animal, the body of which extends along the extreme outer border of the blanket, the head occupying the centre of the panel, while the feet

Fig. 273. Chilkat blankets.

or tail are shown along the lower border. In this way a space is left in the middle, next to the central panel, which does not belong essentially to the form of the animal.

In both fundamental types the intervening spaces which are not filled by the large eye designs, the body, tail, and extremeties, are filled with a variety of patterns which depend only in part upon the selection of the animal to be represented, but are very largely determined by esthetic considerations.

The broad sides of rectangular boxes bear the same fundamental design as the first type of blankets; an animal with an enormous

head on the upper border, the body occupying the centre below. A fairly consistent difference between the blanket and box types is that the lower border of the large face is curved on the boxes; straight on the blankets. I believe this difference is due to the

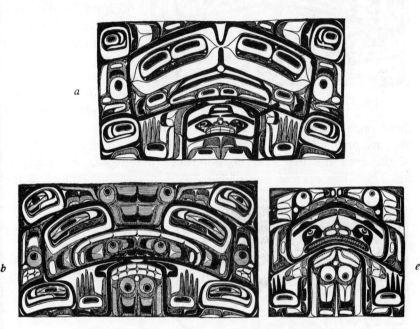

Fig. 274. Front, reverse and side of a painted box.

desire to avoid excessive parallelism. In the blanket the straight lower line of the head is set off against the curves of the upper part of the head and against the angle in the lower border of the blanket, while in the boxes a straight middle line would appear set off against the parallel upper and lower edges of the box. The lateral panels of the blanket correspond, in a way, to the narrow lateral strips in the front of the long boxes (fig. 274 a) which are characterized by a fairly large eye design in each corner. These are connected by a variety of decorative elements. At the lower

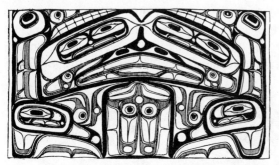

Fig. 275. Painted and carved box front.

border of the box front there originate, in this manner, five fields. The middle one being occupied by the body of the central animal; the corners being occupied by the eye designs which form the basis of the lateral strips. Between these there remain spaces which are often filled with designs representing the fore or hind feet of the central animal. On account of the shifting of the eyes the five field division does not appear as clearly in fig. 275. The reverse side of fig. 276 is treated differently; in the

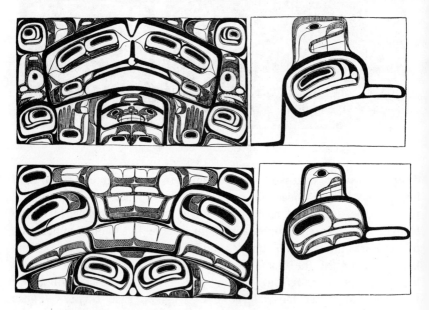

Fig. 276. Four sides of a painted box, Tlingit.

lower field the body is omitted, the two eyes placed in the middle so that a fourfold division of the whole area under the mouth originates. A similar treatment is given to a front (fig. 277 below), in which the eyes are placed in the corners while the middle is

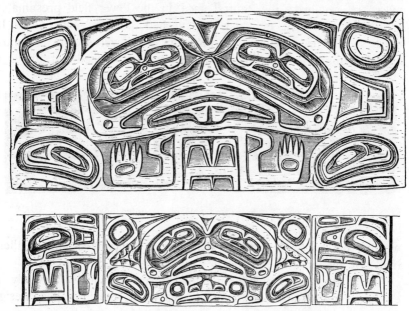

Fig. 277. Four sides of a painted box, front on a larger scale, Tlingit.

occupied by the two sides of a tail, which, however, is treated like a hawk's face. The arbitrary character of the details appears very clearly in this arrangement.

The narrow sides of the boxes are generally painted with a design analogous to the central design of the front with this difference, however, that the lateral panels are missing and that the head is more compressed. In a number of cases the short sides are treated differently, as shown in fig. 276. Very rarely the short sides contain a profile figure that does not occupy the whole width of this side (fig. 277).

There are also a number of low boxes which are treated some-
what differently. On account of the lowness of the sides the lower
rim of the head is drawn straight so that a narrow rectangular panel
originates along the lower border (fig. 278). In this specimen the
eyes are retained; the central face in the lower field presumably
represents the body, to which are attached the arms and hands. In
most specimens of this type, however, the lower section is almost
entirely suppressed; the large upper face is retained but under it

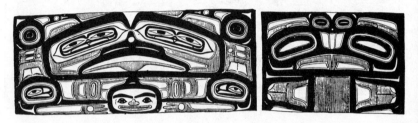

Fig. 278. Front and side of a painted box.

we find only a few ornaments that may be interpreted only as fillers
(fig. 279 above).

There are also a number of low boxes in which the body is
entirely suppressed. They contain, essentially, the large head design
with a few decorative features along the sides, and the eyes in the
upper corners. (Fig. 279 below).

The arrangement of the long boxes is such that the center of
the mouth, or a point a little below it, is the center of the decora-
tive field (figs. 274—276). A line drawn from the center of the
lower border to the upper corners passes almost always along the
corner of the mouth and often also through the sharp curve at the
upper, outer outline of the face. The line drawn from the center
of the upper border to the lower corner passes, generally, through
the corner of the mouth. When the central field along the upper
border is wide, so that it reaches down to the upper curve limiting
the mouth, the eye is shown in profile (figs. 274 *b*, 276 reverse)

When the central field consists only of a sharp short angle, there is a double eye (figs. 274 *a*, 275, 276 front, 277).

The general arrangement of lines on the box is such that the upper curves of the face are strongly curved downward. The curvature decreases downward; and in some boxes, for instance in those shown in figs. 275 and 276 reverse, there is a tendency to an arrangement of lines which are convex, upward.

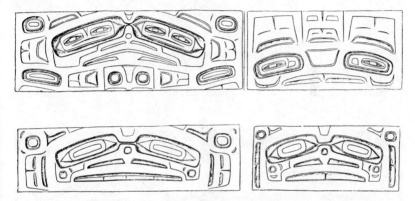

Fig. 279. Front, reverse and side of carved boxes.

The eye decorations are always so placed that they are not arranged in straight lines. It will be seen that in the best boxes they fall into curves that intersect the black lines of the design. In fig. 274 *a*, the eyes in the lower corners and those in the mouth are placed so as to form a continuous curve; in fig. 274 *b*, the arrangement of the eyes in the upper corners, the eyes of the large head, and those in the mouth form a fairly regular curve.

In the square boxes on which only one side of the face is shown on each side (fig. 280), the body is very much reduced in size. In most of these the large head is limited below by a straight line, while on the long boxes containing the full face on the front the lower line of the face is curved. In only one of these (fig. 278) do we find the face limited below by a straight line.

In fig. 280 *a*, the two sides shown on the left are occupied by a large head on top, corresponding to the blanket fields 1, 2, and 5. The ear (5) is much reduced in size. The sharp beak in the middle indicates that the hawk is meant. Under it is seen a small field corresponding to field 3 on the blankets and under it a face with

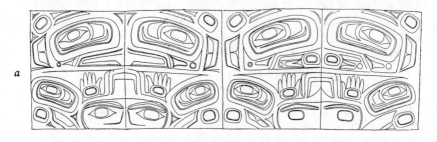

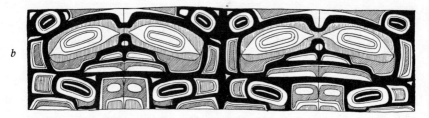

Fig. 280. Carved boxes.

its two eyes, corresponding to 4. The field 7 is occupied by the arms, indicated by the curved line running from the shoulder to the wrist of the raised hand. The whole lateral field of the blanket is condensed in the narrow strip to the right and left of the face and body. The designs on the upper corners are clearly ornamental and do not represent any particular part of the head; the eyes in the lower corners are considered as feet and toes; the large eyes over the lower corners as knee joints. The two sides of the box shown on the right hand side correspond in all details to those on the left, excepting the mouth, which is treated quite differently; the nostrils being shown in the center.

In fig. 280 *b* the lower portion of the decorated side is much reduced in size and the marginal fields are simplified. The head may represent a hawk; the eyes in the lower fields are exceptional in so far as they are not placed in the corners but near the body and they may be considered ankle joints and below them

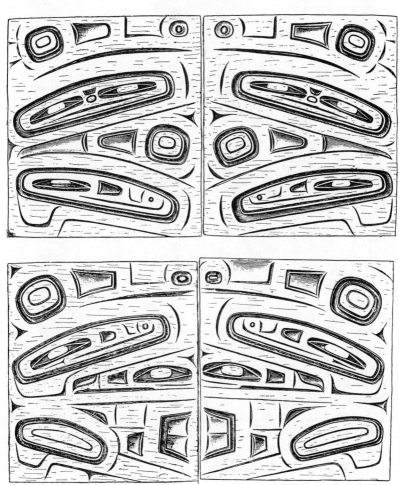

Fig. 281. Carved box, Tlingit.

the toes. The eye designs in the upper corners take the place of
the ears. The reduction of the body is even more marked in
fig. 281; here the eye designs and the adjoining curves on the
upper margin are clearly fillers; the body has been completely

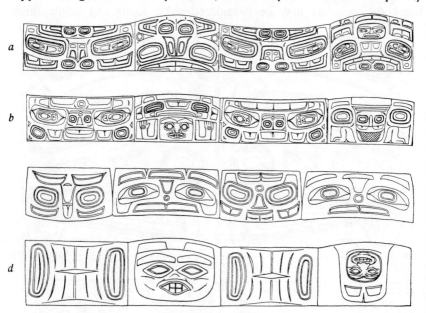

Fig. 282. Carved trays.

dissolved. The eyes in the lower corners with the attached lower
curve show an attempt to represent a flipper. The common character
of these three specimens is the horizontal dividing line under the
mouth and (excepting the one face in fig. 281) the general tendency to
the symmetrical arrangement of lines in the upper and lower fields.
The lines in the upper field point from the middle downward, and
those in the lower, from the middle upward.

There are a number of peculiar developments of the head and
body designs which are used on small food trays, the sides of which
are bent out of a single plank. In one group of these (fig. 282) the

two narrow sides represent, in front, the head of the animal; on the opposite, side the tail. This appears most clearly in figs. 282 *b* and *d*; both representing the beaver. In fig. 282 *d* the beaver's head and tail are perfectly plain. In 282 *b* there is considerable confusion; the beaver's body below is provided with two human arms and over it is indicated the large characteristic head. The tail is shown on the opposite short side, together with the hind legs and the two disconnected eyes which ordinarily would form the hip joints and would be connected with the upper end of the thighs. On all these specimens, 282 *a*, *b*, and *c*, the other sides show an inverted face. This originates evidently in such a way that the eyes represent, at one end, the shoulder joints, at the opposite end, the hip joints, but instead of developing the sides as fore and hind legs, the inverted eyes have lead to the development of a face design which has no particular relation to the animal represented. In other words, we find here, as well as in many other places that elements which are in part derived from representations of parts of animals, have assumed a purely decorative function so that an explanation of the details is, to a great extend, arbitrary. The geometrical decoration on the long side of fig. 282 *d* is also derived from the shoulder and hip joints, but instead of parts of a face, slit designs fill in the rest of the side.

The trays shown in fig. 283 are of the same make as those shown before, with the only difference that on the long sides the shoulder joints, knee and foot are shown in the ordinary way. The hind limbs are here represented on the short side, where the hip joints are shown by two large eyes in the upper part of the design. It will be observed, however, that in these cases also there is a considerable amount of arbitrary use of decorative elements that have no particular significance, but which must be considered simply as fillers. This appears most clearly in fig. 283 *e*, which represents a dish with a design of a human being. Here the arms are represented on the long sides, the shoulder joint by an eye which, however, is provided with lids. The space under the eye is filled

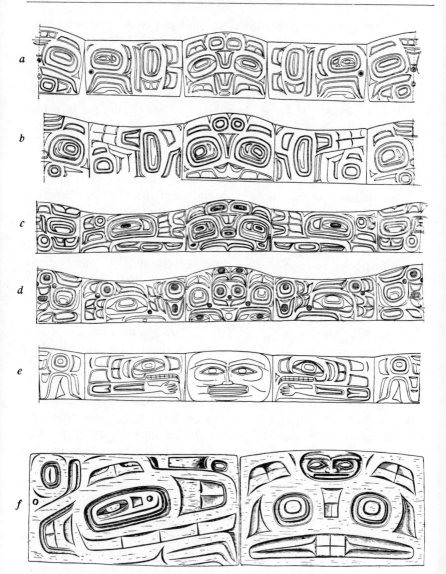

Fig. 283. Carved trays.

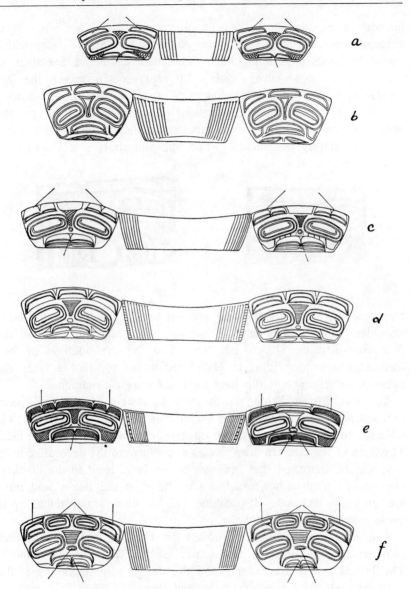

Fig. 284. Carved trays.

in with a mouth which has no function in this position. It is evidently introduced in the same way as the profile faces which serve as fillers on the blankets. The most distinctive specimen of this type is shown in fig. 283 *f*. It represents a beaver, the face indicated by disconnected eyes, mouth, and ear; the nose showing the form of one of the conventional copper plates used by the northwest coast Indians, while the face in the middle of the upper border is purely ornamental. The opposite short side shows very

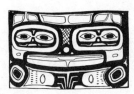 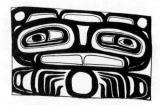

Fig. 285. Designs on Tlingit armor.

clearly a tail, hip, legs, and feet and on the long side also the large shoulder joint in the form of an eye with ear; the arm and the foot are distinctly shown but here also, by the addition of four teeth, the shoulder joint is elaborated in the form of a face; the eyes in the corners of the long field are purely ornamental.

To the same group belong also the carved trays cut out of a single piece of wood, shown in fig. 284. Here we have only the head design which is adjusted to the curvature of the upper border of the decorative field. The lines of the face are drawn so as to conform to the decorative field.

It will be observed that the eyes of the large head in the blankets are always almost horizontal while those on the boxes and trays are strongly inclined. I presume this is due to the tendency to avoid massing of parallel lines.

The large head design found on the blankets and boxes occurs also on the paintings in the center of the front of slat armour. The lateral panels are missing and the design consists simply of the head with attached shoulder, arm, and hand (fig. 285).

A number of square food trays, bent of a single piece of wood, are not decorated according to this plan. The face, consisting of two symmetrical halves, is replaced by a series of profiles (fig. 286); the short and high sides have the large eye in the left hand upper corner; the mouth in the lower right hand corner. The design on the long sides represents the sides of the body. The large eyes stand, presumably, for the shoulder joint and are placed in the center of the side; wrist and fingers are in the lower left hand corner. The significance of the design in the right hand upper

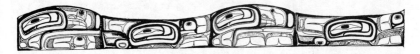

Fig. 286. Painted tray.

corner is not clear. The general distribution of the design elements is evidently determined by the central position of the large eyes.

The boxes shown in fig. 287 illustrate that still another pattern is used on square boxes. Each of the four sides of the two boxes shown in figs. 287 *a* and *b*, is divided into four rectangles of unequal size. The general plan of the two designs is almost the same, although there are considerable differences in detail. It is quite evident that in 287 *a* the lower part of the first and third sides represents legs and feet. A distinct wing design appears in the left hand upper rectangle of the fourth side, but otherwise the arrangement of the elements is so arbitrary that a safe interpretation is impossible. It seems plausible that in this case also the attempt at decoration was much more important than the attempt at interpretation. An interpretation was given to me for the box shown in fig. 287 *b*. Although obtained from Charles Edensaw, one of the best artists among the Haida, I consider it entirely fanciful. The first side to the left, corresponds to the third side, which is opposite to it on the box. The second side corresponds to the fourth side. Edensaw explained the design as showing four interpretations of the

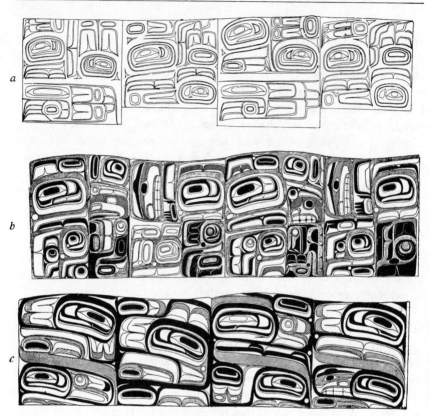

Fig. 287. Painted boxes.

raven as culture-hero. The upper right hand rectangle of the first side he claimed to represent the head of the raven surmounted by the ear; the large eye to the left of it, in the left hand upper corner, the shoulder and under it the wing and tail. The design in the right hand lower corner he interpreted as the foot; the toes are clearly visible in the lowest right hand corner of this field. He claims that the head turned upside down in the left hand upper rectangle of the second side represents the head of the raven and under it the hand; the raven being conceived as a human being. The rectangle in

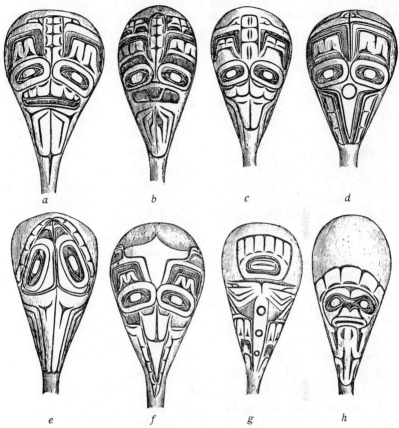

Fig. 288. Horn spoons showing carving on the back; *a*, representing sea-monster; *b*, hawk; *c*, beaver (?); *d*, raven; *e*, killer-whale; *f*, raven; *g*, dlia (?); *h*, sun.

the upper right hand corner contains the shoulder; the right hand lower corner under it, the tail; and the left hand lower corner, leg and foot.

The box shown in fig. 287 *c* is related to the general design of fig. 287 *b*. The somewhat slanting lines between the upper and lower fields occur in both cases, but the vertical division of each side, which is characteristic of the specimen just described, is lacking in the last named specimen.

A fairly fixed formal arrangement may also be observed on horn spoons moulded of a single piece (fig. 288). On the back of the spoon is a design, the center of which is a large face. In many specimens the space above the eye is filled by two ear designs which are doubled and unusually large on account of the space that they have to fill. In these specimens the space between the ears is taken up by a narrow decorated strip. In a few simpler forms parts of the bowl of the spoon remain undecorated.

Fig. 289. Dish of horn of big-horn-sheep representing the bear.

A closer examination of the decorated objects shows that even apart from the decorative use of symbolic motives, geometric elements are not by any means absent. The most striking use of geometrical forms is found on wooden trays, which bear at the ends the characteristic faces, but which are decorated on the sides by groups of short parallel lines (fig. 284, p. 273). The line and circle pattern on the dish (fig. 168, p. 191) illustrates also the use of geometrical forms for decorative purposes. On the berry spoon (fig. 215, p. 221) the space left vacant by the symbolic design is filled in with a net of crossing lines. This specimen shows that the cross hatching which occurs in many specimens,— on the beaver tail (fig. 157, p. 186), on berry spoons (fig. 182, p. 197), on spoons (fig. 189, p. 201) and often in red or black as a filler on boxes (fig. 274, p. 263) has a decorative value even when it may be given at the same time a symbolic meaning. The dish of big-horn-sheep horn (fig. 289) shows a bear's head at each end. At the same time it has a decorative border which seems to imitate the border of a basket and which is purely ornamental. It serves to close off the rim which without it would seem to end abruptly. A similar device is used on a Kwakiutl mask (fig. 290). Although the encircling ornament is explained as a ring made of twisted, shredded cedar

PLATE X.

Chilkat Blanket.

PLATE XI.

Cedarbark Blanket, British Columbia.

PLATE XII

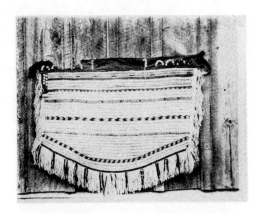

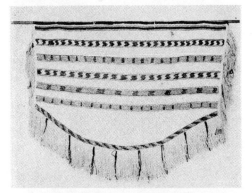

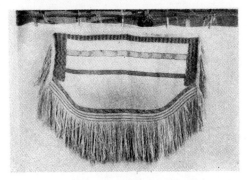

Blankets of Mountain-goat Wool.
Bella Coola, British Columbia.

Plate XI

Bracket of Rangamati Wall,
Delta Gupta, British Kingdom.

bark, it is obviously essentially ornamental. The circular and spiral designs bring out the ornamental character most clearly.

It seems not unlikely that the symbolic style and the desire to cover the whole field with ornaments have developed exuberantly only recently. In early times geometric ornaments were probably more widely used than is the case now. We shall see presently that they are in extensive use in basketry.

A number of ancient blankets show that angular geometrical ornaments played an important part in earlier weaving. Plate X represents a blanket of mountain-goat wool, in the Ethnological Museum at Copenhagen, formerly belonging to the old collections in Leningrad. It is decorated entirely with geometrical designs arranged in horizontal bands. The same zigzag pattern in short panels that occupies alternating bands in this blanket appears in a second ancient blanket (Pl. XI) which contains also curiously conventionalized faces and triangular designs. This is a cedar bark blanket in the British Museum transferred from the United Service Museum about 1868, collected at Nootka. It has a border in brown and yellow wool (?), consisting of obtuse triangles, assimilated to an eye design. A series of photographs of blankets in the hands of Dr. Newcombe of Victoria, British Columbia, shows that these types were in common use in Bella-Coola (Pl. XII, see also p. 292).

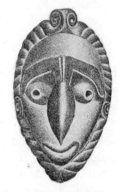

Fig. 290. Mask of Kwakiutl Indians used in winter ceremonial; according to some representing fool dancer, according to others The-One-Shining-Down.

Our consideration of the fixed formal elements found in this art prove that the principles of geometric ornamental form may be recognized even in this highly developed symbolic art; and that it is not possible to assign to each and every element that is derived from animal motives a significant function, but that many of them are employed regardless of meaning, and used for purely ornamental purposes.

The symbolic decoration is governed by rigorous formal principles. It appears that what we have called for the sake of convenience dissection and distortion of animal forms, is, in many cases, a fitting of animal motives into fixed ornamental patterns. We infer from a study of form and interpretation that there are certain purely geometric elements that have been utilized in the symbolic representation. Most important among these are the double curve which appears always as a filler in an oval field with flat base, and the slit which serves to separate distinct curves. The typical eye design is presumably related to the circle and dot and may have developed from the double tendency of associating geometrical motives with animal forms and of the other, of standardizing forms derived from animal motives as ornamental elements.

This art style can be fully understood only as an integral part of the structure of Northwest coast culture. The fundamental idea underlying the thoughts, feelings, and activities of these tribes is the value of rank which gives title to the use of privileges, most of which find expression in artistic activities or in the use of art forms. Rank and social position bestow the privilege to use certain animal figures as paintings or carvings on the house front, on totem poles, on masks and on the utensils of every day life. Rank and social position give the right to tell certain tales referring to ancestral exploits; they determine the songs which may be sung. There are other obligations and privileges related to rank and social position, but the most outstanding feature is the intimate association between social standing and art forms. A similar relation, although not quite so intimate, prevails in the relation of religious activities and manifestations of art. It is as though the heraldic idea had taken hold of the whole life and had permeated it with the feeling that social standing must be expressed at every step by heraldry which, however, is not confined to space forms alone but extends over literary, musical and dramatic expression. Who can tell whether the association between social standing and the use of certain animal forms, — that is the totemic aspect of social life, — has given the

prime impetus to the art development or whether the art impetus has developed and enriched totemic life? Our observations make it seem plausible that the particular symbolic development of art would not have occurred, if the totemic ideas had been absent and that we are dealing with the gradual intrusion of ever fuller animal motives into a well established conventionalized art. On the other

hand it seems quite certain that the exuberance of totemic form has been stimulated by the value given to the art form. We may observe among all the tribes that high chiefs claim highly specialized art forms that are built up on the general background of totemic representation. In the south, there is clear evidence of the late exuberant development of the totemic, or perhaps better, crest idea,

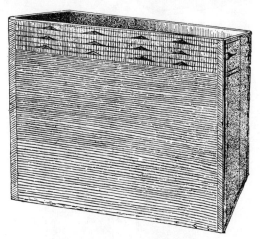

Fig. 291. Ancient type of Kwakiutl box.

owing to the strong endeavor to raise by the possession of art forms the standing of the social units to which the individual belongs. The multiplicity of forms among the numerous small divisions of the Kwakiutl and the sporadic appearance of animal forms among the adjoining Salish are ample proof of these relations.

The style has undoubtedly its home in northern British Columbia and southern Alaska. The manufactures of the tribes of Vancouver Island show a far more extended use of geometrical ornamentation than those of the northern tribes. I am under the impression that these are survivals of an older style. Trays, boxes, and baskets of the Kwakiutl Indians are still decorated with geometrical patterns. A rattle used in a ceremony performed after the birth of twins

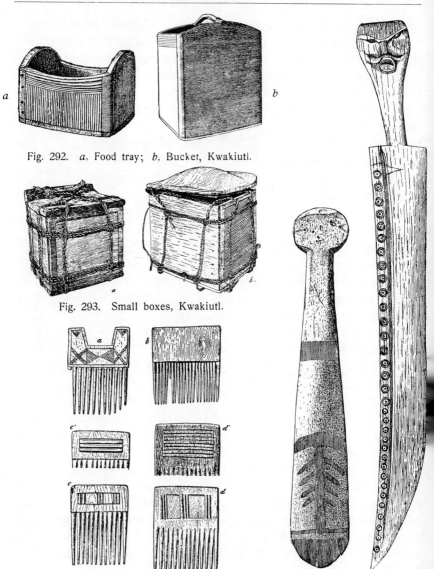

Fig. 292. *a*, Food tray; *b*, Bucket, Kwakiutl.

Fig. 293. Small boxes, Kwakiutl.

Fig. 294. Combs, Kwakiutl. Fig. 295. Bone club and sword, Kwaki

Fig. 296. Spindle whorls.

(fig. 19, p. 31) bears a pattern consisting of angular fields. Ancient boxes found in caves are ornamented with a geometrical style more elaborate than that of modern times (fig. 291).

The small food trays, the sides of which are bent out of a single board, bear on the upper end a border pattern consisting of equidistant lines following the rim, while the body of the sides is ornamented with vertical lines (fig. 292 *a*). A similar border pattern is found on buckets (fig. 292 *b*). In boxes a border design is cut in, setting off the central field (fig. 293). Combs are decorated with geometrical motives most of which consist of a central rectangular field set off from the background by parallel lines or developed by a subdivision of the field. In one case triangles and crossing lines with hachure are used (fig. 294). On a bone sword the decoration consists of circles with center, a pattern that is widely distributed

Fig. 297. Ladle made of big horn sheep horn, Columbia River.

among the western Eskimo, the plateau tribes of the interior and in California (fig. 295). It will be noticed that the head carved at the end of this specimen does not conform at all to the style of

a b c d e f g

Fig. 298. Clubs made of

art here discussed but rather agrees with the carving found in the region of the Gulf of Georgia and Puget Sound. Another specimen (fig. 295), differs still more from the style of the Northwest coast art and resembles that of the tribes of the interior.

In the art of the West coast of Vancouver Island, in a few ancient specimens of the Kwakiutl and particularly in the whole area of the Gulf of Georgia, a triangular motive analagous to the "Kerbschnitt" of northern Europe, plays an important role. It is found on the ancient Kwakiutl boxes previously referred to (fig. 291), and is a common decorative motive on clubs made of bone of whale

bone of whale, Nootka.

(fig. 298). A related motive is found on spindle whorls (fig. 296). It is also found on representative wood carvings, as on the eagle design on a house post from the Fraser River Delta (Plate XIII p. 288). In the region still farther south, this ornament becomes more and more important, as may be seen on dishes and spoons from the Columbia River area. On these the circular design and central dot also occur (fig. 297).

A number of ancient specimens prove the existence of a fixed art style in this region, representative, but differing in character from the style of the Northwest coast. This is best illustrated by a

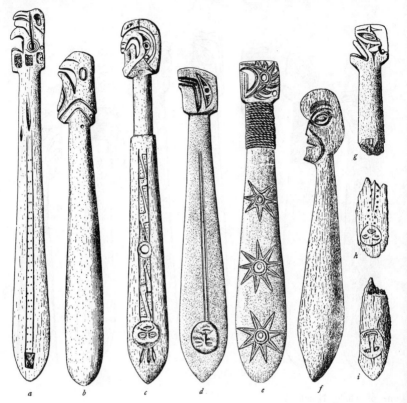

Fig. 299. Clubs made of bone of

series of war clubs. The fundamental type is a blade of a lenticular cross section surmounted by a head resembling that of an eagle, which bears on its head a bird head dress not unlike what is used by the Nootka of modern times.[1] In all the specimens represented in figures 298 and 299 this fundamental form will be recognized, although in many cases the outlines are so crude that the elements of the composition are recognized with difficulty only. It is possible

[1] See Harlan I. Smith, Archaeology of the Gulf of Georgia and Puget Sound, Publications of the Jesup North Pacific Expedition, Vol II, figs. 165—168.

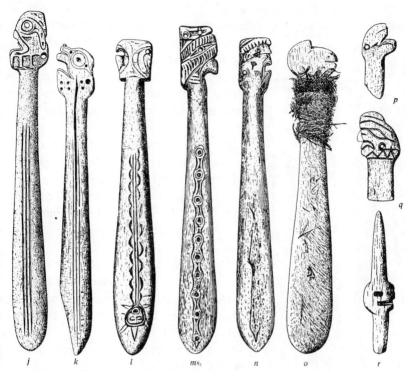

whale, Nootka and coast of Salish.

that in a number of these carvings it was not the intent to represent the eagle with bird headdress, but that the form is rather due to the compelling influence of a standardized form that determined the outlines of the subject of the representation. Common to these clubs is also the central ornamental line ending near the point in a circular ornament which is often given the form of a human head·

Representations of animals in wood carving differ also in important features from those of the northern region. The tendency to ornament the whole body, the dislike of a plain background is not

found here. If we are right in assuming that the fullest development of a rich ornamentation in the north is late, we might say that in the south the ornamentation has not yet encroached upon the whole background. The eye design, double curve, the slit design are foreign to this area. Instead of house posts carved in the round, we find heavy posts of rectangular cross section which bear on the front figures carved in the round or in high relief. Sometimes the post assumes geometrical forms. A characteristic trait of the human face in this region is the sharp angle setting off the forehead from the face. This is most pronounced in the carvings of the Puget Sound region (fig. 300 and Plate XIV).

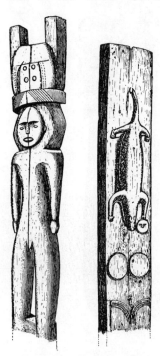

Fig. 300. House posts, Lower Fraser River.

On Puget Sound animal representations are used with great frequency in basketry, particularly as ornamental borders. In ancient times they were also applied to hats (fig. 301, see also fig. 72 p. 78). This style seems to be entirely missing in the north.

At the present time the Kwakiutl apply the symbolic style in house paintings, house posts, and masks. The skill of the artist is not inferior to that found among the northern tribes, but the subject matter differs somewhat according to the difference in mythological concepts. The distortions in painting are, if anything, more daring than those of the Haida, but I have not observed to the same degree the tendency to interlock various animal forms, as is done on spoon handles and totem poles of the northern tribes. On totem poles so far as these occur, and on house posts the single figures are placed one on top of the other, but they remain separated. The

PLATE XIII.

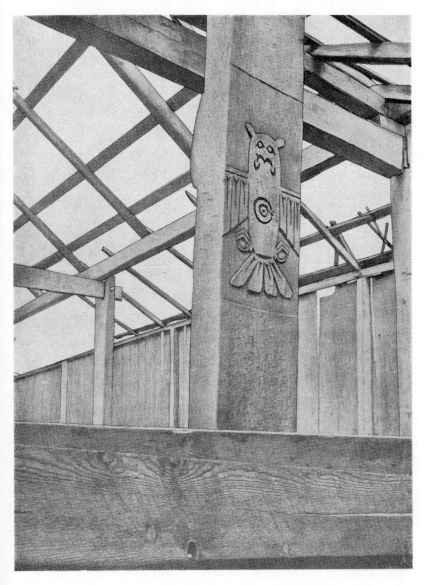

House Post near Eburne, Fraser River Delta, British Columbia.

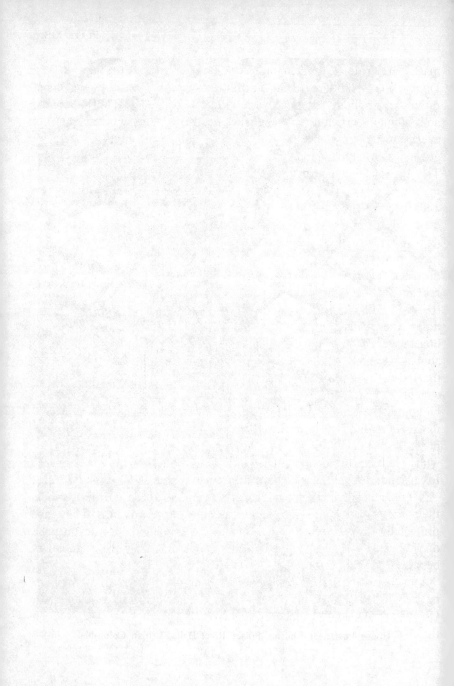

masks are painted as elaborately as those of the northern tribes. Double masks and revolving attachments occur. In short, the decorative art of those objects that are strictly related to use in totemic and similar ceremonies, have the northern type, while objects of every day life tend to have geometric ornamentation. The use of animal forms on large dishes (see fig. 198, p. 208) is a characteristic trait of this region.

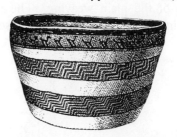

Fig. 301. Basket, Lower Chehalis.

Historical tradition confirms our view that the northern art type is of recent introduction among the Kwakiutl. In ancient times the walls of the houses were built of horizontal, overlapping boards. that did not admit painting, except on separate planks. Old Indians claim that, until about 1860, the house posts were heavy planks

Fig. 302. Designs on matting, Kwakiutl.

with relief carving or painting,— like those known to us from Fraser River, and that only masks were of the same type as those now in use.

While realistic representations are rare among the northern tribes, they are found quite frequently among the Kwakiutl. They are principally caricatures that are made and exhibited for the purpose of ridiculing a rival. A head used in a ceremonial performance has been referred to before (fig. 156 p. 185).

I have stated that in basketry and matting geometrical ornamentation is used by all the tribes. It is the style of the woman's art. On decorated mats checker designs are made in black and red on the background of natural color of cedar bark (fig. 302). More

elaborate are the patterns which occur on spruce root weaving, particularly on hats. These are made by twining, and ornamental lines are developed by the occasional skipping of two woof strands. By this device lines are produced which appear raised over the surface of the plain weaving. The most frequent designs which are made in this way consist of a series of diamonds and of zigzag lines. Sometimes these hats are also painted. In these the woven pattern disappears almost completely under the painted design (fig. 303).

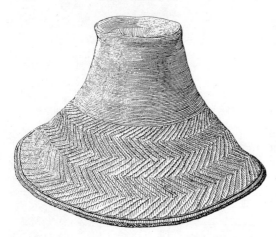

Fig. 303. Woven hat of spruce root, Kwakiutl.

On the coast of Alaska we find the highest development of the geometric style.

The patterns used on these baskets consist of angular forms, except on modern placques, and bear names.[1] From the way in which these are used we may infer that they have no symbolic significance. I give here a selection of these. Fig. 304 *a*, *b*, *c*, patterns consisting of zigzag lines, represent in this order: the woodworm or the woodworm tracks *(a)*, lightning *(b)*, the butterfly *(c)*. The rectangle divided by an oblique line, *(d)*, represents tracks of the bear; the dark part of the rectangle may be interpreted as the sole of the foot; the light part of the rectangle as the claws. The design *(e)* is called the arrow; *(f)* the rainbow; *(g)* fire weed; and *(h)* the hood of the raven. Fig. 305 *a* shows various representations of the isosceles triangle, some of which are identical with the forms occurring in

[1] G. T. Emmons, The Basketry of the Tlingit, Memoirs American Museum of Natural History. Vol. 3 (1903) pp. 229 et seq.

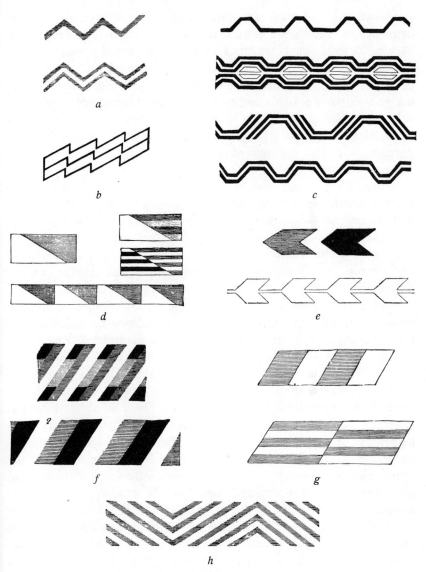

Fig. 304. Decorative designs from Tlingit basketry.

California. All of these are called head of the salmon-berry. The designs *b*, *c*, and *d*, are closely related; *(b)* is generally used on the narrow central band which separates two broad design bands; it is called "tying". Flying geese are represented in *(c)*; tracks of geese in *(d)*. The complicated design in *(e)* is called "raven tail"; the relation between this name and the form is not clear; *(f)* shows a number of representations of the wave. Designs *(g)* and *(h)* are from circular placques; *(g)* represents the fern frond; *(h)* the porpoise. In the last named case the relation between form and name is obscure.

I have little doubt that the designs are closely related to the blanket patterns previously referred to and to the porcupine quill embroidery of the tribes of the interior. The design fig. 304 *h*, for instance, is found in identical form on the lowest stripe of the Bella Coola blanket on top of Plate XII. The arrangement of patterns in blocks on these blankets is also similar to the arrangement found in this type of basketry. In fact the technique is a kind of embroidery in which the decorative material is wrapped around the woof strand when the basket is being made. The materials used are grasses and fern stems of contrasting color.

The baskets are round, mostly with almost straight walls. The diameter is very nearly equal to the height. On the majority of baskets which are used for berrying and as general receptacles, the patterns are applied in horizontal bands. The rim of the basket is generally undecorated. The rim weave which holds the warp together, is in most cases quite insignificant and does not give a decorative effect. The only specimen of decorative band at the upper rim, with which I am familiar, has no color embroidery but has only a zigzag decoration made by the process of twilling described before, similar to the pattern fig. 304 *h*. Most baskets are decorated by a broad band parallel to the rim, which consists of two wide stripes separated by a narrow one. These bands are placed at a short distance from the upper rim. (Plate XIV). The distance is often about equal to the width of the central band. The

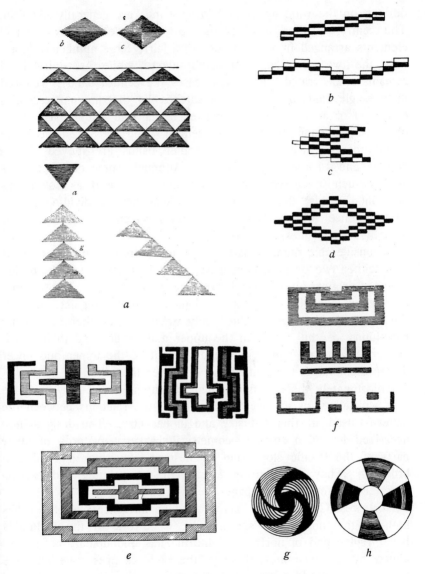

Fig. 305. Decorative designs from Tlingit basketry.

designs on the wide upper and lower bands are generally identical. The central dividing band is in most cases decorated with small elements arranged in zigzag lines. In a fairly large number of cases, only the two outer bands are embroidered, while the central band remains undecorated. In a few cases the central band is reduced to a single undecorated line of stitches wo that the impression is conveyed of a single broad band encircling the whole basket. In open work spoon baskets the central band is placed near the middle of the basket, while the outer bands are moved to the bottom and to the upper border. Although some of the designs are of such a character that they may be used as continuous horizontal bands, there is a marked tendency of dividing up the circumference into a number of panels which are separated by straight vertical lines.

A considerable number of the baskets decorated with three bands have either two or four "droppers", and in a few cases the design of the "dropper" is repeated over the upper design. The number of repetitions of the design in the bands is quite irregular, some of the large designs are repeated only twice. When there are many repetitions of the design in the upper and lower band their distribution is generally quite independent, that is, the upper and lower design elements are not fitted the one over the other.

Unfortunately there is not enough porcupine embroidery available that will allow us to investigate in detail the relations between the patterns used in this industry and in basketry. The designs here described are akin to the geometrical basketry patterns of other parts of the Pacific slope and to designs occurring in bead embroidery. They are entirely foreign to the painting and carving described in the previous pages.

Northwest Coast culture has exerted its influence over the tribes both of the north and south. The woodwork of the Columbia River region and of northern California has undoubtedly been stimulated by its example. Although the style changes materially, the technique of handling the wood and the relative abundance of wood

PLATE XIV.

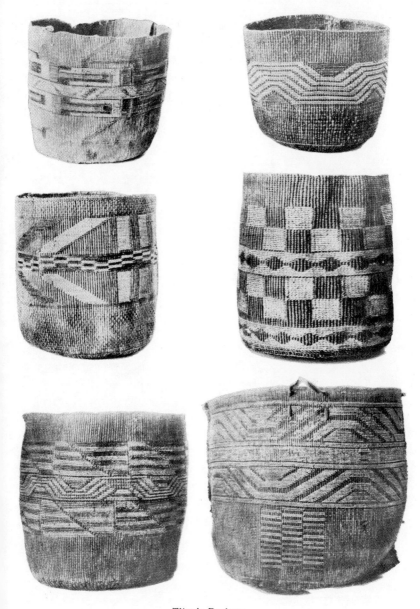

Tlingit Baskets.

carving indicates the interrelation of these cultures. Taken in conjunction with other features,— such as the peculiar type of correlation of wealth and rank and the extensive use of standards of value,— the historical relation seems firmly established. The art style of woodwork does not exhibit a close affinity to the North West Coast. We have shown that the older art of the Gulf of Georgia is quite distinct from that of the North West Coast. The further south we go the more meager become the vestiges of the symbolic style here treated.

In the north conditions are somewhat different. Even among the northern Tlingit tribes some types of masks may be observed that are conceptionally different from those found further south. They are characterized by the attachment of small animal figures to the face,— particularly on the forehead and cheeks. This usage is much more frequent among the Eskimo tribes.[1] Their masks tend to be flat and appear like plastic representations of their paintings and etchings: realistic forms of human or imaginary beings or of animals. They have adopted from the North West Coast the attachment of parts of the body to the face, while these parts,— such as hands and feet, retain their realistic character. The attachment of small animal forms to the face is quite frequent here. Its source may perhaps be found in the application of animal heads to carved objects, which is one of the principle features of the decorative art of the Alaskan Eskimo. It is exemplified in the needle cases shown in fig. 119, p. 125. The abundance of masks can hardly be understood unless we assume that the coast people of the south exerted a powerful influence over the Eskimo. The eastern Eskimo, among whom this influence is lacking, have few masks of quite a different type.

The relation of the North West Coast art to that of the adjoining plateaus of the interior deserves special consideration. The contrast

[1] Sie E. W. Nelson, The Eskimo about Bering Strait, 18th Ann. Rep. Bur. Am. Ethn. (1899) Plates 95 et seq.; also the Athapascan masks from Anvik in J. W. Chapman, Notes on the Tinneh tribe of Anvik, Congrès International des Americanistes XVe session, Vol 2, pp. 7 et seq.

between the two is striking. A few of the tribes that have adopted, partially at least, totemic ideas of the coast people, as the Lillooet, have taken over with it a moderate amount of carving. A few that have fallen more fully under the sway of the North West Coast culture, as the Bella Coola, Babine, and a few of the Alaskan tribes near the coast of southern Alaska, have also, to a great extent, adopted the art style of the coast.

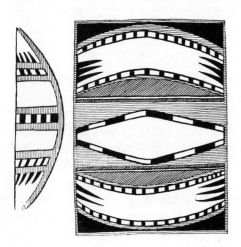
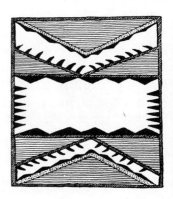

Fig. 306. *a,* Rawhide pouch, Salish or Chinook; *b,* Design from parfleche, Fort Colville, Washington.

As soon as we move farther inland we find an art that, in its essential characteristics, is subject to the Plains art. The style and decoration of the clothing are essentially those of the Plains. Rude pictography is used extensively. There is hardly any attempt to fit the pictographic representation to the decorative field that serves merely as the background on which the representative design is conveniently placed. Most of the geometric patterns that do occur are closely related to eastern forms. A rawhide pouch from the interior of British Columbia (fig. 28, p. 36) may serve as an example. On parfleches and rawhide pouches from Fort Colville and from Columbia River (fig. 306) we find the same designs that

are characteristic of eastern paintings on rawhide (see figs. 144—146 pp. 170—172). Analogous forms are found in bone carvings from the Tahltan in Alaska (fig. 307). In the southern parts of the plateaus of British Columbia, simple lines and circles with center are the most common decorative pattern on bone and on wood. Representative sculpture is rare although a few ancient specimens have been found. The archaeological remains prove that at an early time the same art type prevailed in the Delta of Fraser River. The symbolism of the patterns is very weak, but seems analogous to that found in the east.

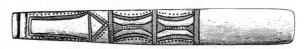

Fig. 307. Scraper of bone, Tahltan.

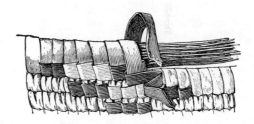

Fig. 308. Detail of imbricated basketry.

Decorative art is most highly developed in basketry. The basketry of the Coast tribes is made by twining or weaving, but the highly decorated basketry of the interior is exclusively of the coiled type. Only among the Sahaptin and other tribes to the southeast do we find elaborately decorated twined bags. The twined weaving of the interior of British Columbia is largely undecorated or bears a few lines set off in lighter color. The coiled weaving is decorated by imbrication, a method peculiar to that part of the plateaus extending from the Columbia River to Chilcotin (fig. 308). In this area a number of decorative art styles have developed. These appear most clearly on the burden baskets. The southern baskets are round and flaring, those of southern British Columbia are angular in cross section, those of the north oblong and of irregular form. The southern baskets are decorated all over with designs resembling

Californian patterns. Those of the Thompson River have design areas set off against an undecorated background. The designs are made by imbrication and extend over the whole side of the basket, evenly on all sides. The Lillooet baskets are more flaring than those of the Thompson. The coils are wider and the decorative field is arranged in a different manner. The imbrication is confined to the upper two-thirds of the basket while the lower part remains undecorated, except that there are frequently two hangers on the wide sides which may be compared to the hangers on Tlingit baskets, described before. I am doubtful whether there is an historical connection between the two, notwithstanding their striking similarity. The Indians suggest that the hangers may have developed from the earlier use of birch bark baskets. These were often wrapped at the upper part with buckskin the lower portion of which hung down freely in fringes, so that the droppers would represent the fringes. Many of the Lillooet designs are large. (Plate XV).

The Chilcotin type differs from the preceding by the small size of the coil and a distinctive form, the narrow ends being higher than the middle of the long sides. The treatment of the decorative field is similar to that used by the Tlingit. The ornamentation consists of three bands; the upper and the lower ones wide, bearing the same kind of decorative design and the central one narrower and either undecorated or showing a design of a different character. Arrangements of this kind are used so frequently that is seems hardly justifiable to consider them as proof of an historical connection between Tlingit and Chilcotin basketry. We find similar arrangements for instance in the pouches of the Woodland Indians referred to on p. 175, figs. 149, 150.

PLATE XV.

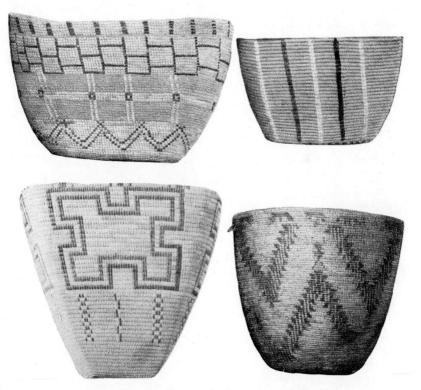

Imbricated Baskets from British Columbia and Washington.

Imbricated baskets from Wright, Columbia and Washington.

LITERATURE, MUSIC, AND DANCE.

We shall now turn to a consideration of literature, music and dance. It is a noticeable fact that a rich literary art is much more universally distributed than well developed decorative art. While among tribes like the Bushman and the eastern Eskimo very few manufactured objects of artistic value are found, these same tribes produce an abundance of literary work. Volumes of Eskimo lore have been collected and if it did not require a most intimate knowledge of the people and an endless amount of patience to collect songs and poems, their number would undoubtedly equal that of tales. The collections of Bushman lore are also quite extended. I believe the reason for this difference is not far to seek. Decorative art requires rest and quiet, a stationary abode. There must be opportunity to continue steadily the work which requires the use of tools; or at least there must be a chance to lay it aside and to take it up again. The life of hunters is not favorable to the prosecution of such work. First of all the weapons of the hunter must be kept in order. The supply of provisions is generally so scanty or the possibility of laying by stores for future use is so limited, that the hunter is compelled to spend the greater part of every day in pursuit of the game. Little time remains for domestic work. Furthermore when camp is shifted which is frequently necessary, bulky, half finished work can be carried along with difficulty only. It is, therefore, not surprising that the household goods of the hunter are few in number and easily transported. The property of a Bushman family might be carried in two hands.

Quite different are conditions under which literary work and music develop. It might be imagined that the hunter has just as little time for poetic work, as for the manufacture of decorated articles. This opinion is based on an erroneous conception of the work of the hunter. He is not all the time following strenuously

the tracks of the game, but often he resorts to trapping, or he sits still, waiting for the game to appear. The Eskimo, for instance, sits for hours by the breathing-hole of the seal. During such times his fancy is free to wander and many of his songs take shape during these moments. There are other times of enforced idleness in which manual work is impossible but when the people may give free range to their fancy. An instance of this stands out clearly in my mind: An Eskimo youth was carried away in the fall on the drifting ice. After a few days he succeeded in reaching land. During these days of danger and privation he composed a song in which he mocked his own misfortunes and the hardships he had endured, a song which appealed to the fancy of the people and which soon became popular in all the villages.[1]

> "Aya, I am joyful; this is good!
> Aya, there is nothing but ice around me, that is good!
> Aya, I am joyful; this is good!
> My country is nothing but slush, that is good!
> Aya, I am joyful; this is good!
> Aya, when, indeed, will this end? this is good!
> I am tired of watching and waking, this is good!"

We must remember that the first condition for the development of artistic handicraft is leisure. No matter how strong the art impulse may be, it cannot find expression so long as man's time is entirely taken up by procuring the barest necessities of life. The paleolithic hunter who painted on the walls of the caves must have been able to spare sufficient time from the labor of getting his food supply to devote himself to the joy of painting the animals of the chase. We recognize in a study of the art products of each people that the amount they produce is in direct relation to the amount of their leisure. Therefore tribes that procure their main food supply in one season and store it up for the rest of the year and who enjoy, therefore, seasons of leisure, will be found to be most productive in works of art as well as in ceremonial affairs and other

[1] See Journal of American Folk Lore, Vol. 7, p. 50.

manifestations of social life that do not contribute to the mere need of food and shelter.

These conditions are more easily fulfilled for those arts that do not require manual labor than for those based on industrial occupations; hence the wider distribution of literary art.

The two fundamental forms of literature, song and tale, are found universally and must be considered the primary form of literary activity. Poetry without music, that is to say forms of literary expression of fixed rhythmic form, are found only in civilized communities, except perhaps in chanted formulas. In simpler cultural forms the music of language alone does not seem to be felt as an artistic expression, while fixed rhythms that are sung occur everywhere.

We may even recognize that in all parts of the world songs are found in which the words are subordinated to music. As we sing tunes without words, either because the words are not known, — or, more significantly, on a refrain, on vocables consisting of syllables without meaning, — so songs carried along on a meaningless burden are found in all parts of the globe. They are not often recorded because the collection of material of this kind is quite novel, but the data that we have in hand prove that the connection between song and burden is universal. The Eskimo have songs carried along on the syllables *amna aya*, *iya aya*, and other similar ones. In some cases there is a certain emotional significance inherent in the burden, as on the Northwest coast of America where the songs refer to different supernatural beings, each having its own characteristic syllables: the cannibal spirit *ham ham*, the grizzly bear *hei hei* and so on. According to the usual definition of poetry we should perhaps exclude these songs, but that is impossible because the transition from songs carried along by the burden alone and others that contain significant words is quite gradual. In many cases a single word is introduced at a definite point of the tune and the verses contain each one single word. This may be the name of the supernatural being to which the song refers.

Thus we have in British Columbia

> Ham ham hamaya, He-who-travels-from-one-end-of-the-world-to-the-other
> ham ham.
> Ham ham hamaya, The-great-cannibal-of-the-north-end-of-the-world,
> ham ham.
> Ham ham hamaya, He-who-carries-corpses-to-be-his-food,
> ham ham.

In other songs the significant words are more elaborate. They are phrases fitted to the tunes, often by doing violence to the ordinary forms of the words. The words are controlled by the tunes. I might imitate this in the following way:

Instead of "I saw the great spirit travelling about". We might have

> I sawhaw the greaheat sp'rit tra'ling 'bout, ham ham.

This process is not quite unfamiliar to us in so far as we use the apostrophe for syllables that in ordinary speech are not slurred, when we expand a long vowel over several tones, when we utilise archaic pronunciations for the sake of the meter, or when wrong accents are introduced. Disregard for the words is found also in borrowed songs which are sung in a language that is not understood and in which the words (which are usually mispronounced) have only the value of a burden that may be connected with a certain emotion determined by the use of the song. All these forms are found everywhere and must therefore be considered the foundations of poetry.

Primitive poetry is primarily lyric, in many cases dithyrambic, and elements which express definite coherent ideas are, in all probability, later developments. Perhaps we may see here an analogy to the growth of language. In the animal world cries are primarily reactions to emotions and only indirectly designative. It seems likely that in human speech the spontaneous emotional cry preceded the designative and so much more the predicative expression, not by any means in the sense that the exclamation accounts for the origin of organized speech, but that it is probably the first form of articulation.

It must not be assumed that the control of the word by music is characteristic of all primitive song. On the contrary, in recitatives which are quite common, the words are often controlling and musical phrases are added or omitted whenever the words require it. Among the Sioux Indians we find often both tendencies; the words adapted to the tunes and the tune, on its part, adjusted to the words.[1]

We might express the results of our considerations in stating that song is older than poetry and that poetry has gradually emancipated itself from music.

The relation between music, words and dance are of a similar character. Primitive literary expression is often, though not by any means always, accompanied by some kind of motor activity; or certain kinds of motions may release articulations that take the form of song or of spoken words. Strong, but controlled emotion finds utterance in movements of the body and in articulation, and emotional speech releases similar movements. This may be inferred from the frequent association of song and dance, of song and games, and of that of gestures and lively speech. Dance has always remained associated with music, but with the emancipation of poetry music has lost its close association with the spoken word.

Primitive artistic prose has two important forms: narrative and oratory. The form of modern prose is largely determined by the fact that it is read, not spoken, while primitive prose is based on the art of oral delivery and is, therefore, more closely related to modern oratory than to the printed literary style. The stylistic difference between the two forms is considerable.

Unfortunately most primitive prose has been recorded in European languages only, and it is impossible to determine the accuracy of the rendering. In most of the records there is an obvious attempt to adapt it to the European literary style. Even when the material is available in the original text we may assume that, at least in the majority of cases, it does not reach the standard of excellence of

[1] Frances Densmore, Teton Sioux Music, Bull. Bur. Amer. Ethnol. 61, Washington, 1918; see, for instance No. 38, p. 162.

the art of native narrative. The difficulty of phonetic rendering of foreign languages requires such slowness of dictation that the artistic style necessarily suffers. The number of collectors who possess complete mastery of the languages of the natives is altogether too small. The best approximation to the art of narrative of primitive people is probably found in those cases in which educated natives write down the texts, or in the records taken down by missionaries who in long years of personal, intimate contact with the people have acquired complete control of their language, and who are willing to give us just what they hear.

As an example of the difference in style between the free rendering of a story told in English by an interpreter, and the translation of a native text I give part of the Twin-Hero story of Sia, as told by M. C. Stevenson, and the same story as dictated to me in Laguna. Mrs. Stevenson[1] tells as follows: Upon visiting the plaza the twins found a large gathering and the housetops were crowded with those looking at the dance. The boys who approached the plaza from a narrow street in the village, stood for a time at the entrance. The one remarked, "I guess all the people are looking at us and thinking we are very poor boys; see how they pass back and forth and do not speak to us;" but after a while he said, "We are a little hungry; let us walk around and see where we can find something to eat." They looked in all the houses facing upon the plaza and saw feasting within, but no one invited them to enter and eat, and though they inspected every house in the village, they were invited into but one. At this house the woman said, "Boys, come in and eat; I guess you are hungry." After the repast they thanked her, saying, "It was very good." Then the one said, "You, woman, and you, man," addressing her husband, "you and all your family are good. We have eaten at your house; we give you many thanks; and now listen to what I have to say. I wish you and all your children to go off a distance to another house; to a house

[1] Matilda Coxe Stevenson, The Sia, 11th Annual Report Bureau of Ethnology, Washington, 1894, pp. 54—55.

which stands alone; the round house off from the village. All of you stay there for a while."

The Laguna version is as follows:[1]

Long ago. — Eh. — Long ago in the north in Whitehouse lived the people. At that time they had a war dance. At that time, when they were dancing, Salt-Woman and her grandsons, the Twin-Heroes, were travelling in this direction searching for a town, yes, some place where nobody would make dirt, searching for good water standing on the ground; for that they were searching. At the time they reached Whitehouse the people were having a war dance. They arrived at the east end of the town, and they climbed up the ladder, entered after having climbed down, but nobody said anything to them. Then they climbed up and out again. Again they climbed down into a house on the west and again they entered, climbing downward. Here also nobody invited them in and nobody gave them to eat. Then they climbed up going out and climbed down the ladder. Then the grandmother spoke thus, "Grandchildren, are you hungry?" said she to them. Then the Twin-Heroes spoke, "Yes," they said to her. Then the grandmother, Salt-Woman, spoke thus, "Now let us go for the last time, climb up the house to the west." Thus said Salt-Woman. They went westward and climbed up, then they climbed down the ladder and entered. When they had entered the Parrot People were about to eat. They said, "How is everything?" — "It is well," said the Parrot People. "Sit down," said the Parrot People. Then they sat down and soon they were satisfied. After a while the one who was the mother of the Parrot People spoke thus, "Give them to eat," said she. Then they gave them to eat and they dipped out the deer meat with a chamber vessel. Then the one who was the mother spoke thus, "Take this; eat," said she. Then Salt-Woman put her hand into the soup that had been dipped out and she stirred it with her hand and they ate and they were satisfied. Then the one

[1] Franz Boas, Keresan Texts, Publications of the American Ethnological Society, Vol. 8, p. 17.

who was the mother of the Parrot People took it away. She spoke thus, "I wonder why this soup is so different," said she. Then she tasted it. Then the one who was the mother spoke thus, "Oh my, that soup is very sweet," said the one who was the mother. Then Salt-Woman spoke thus, "Behold, go on, dip it out and give it to them and eat," said Salt-Woman. Then she dipped out the soup and passed it about. They sat down there together. Then Salt-Woman took scabs from her body (which was salt) and she put the salt in for them. Then Salt-Woman spoke thus, "Let us continue to stir it," said Salt-Woman. Then they stirred it and ate. Now Salt-Woman spoke thus, "I tell you this," said Salt-Woman, "I am Salt-Woman, there is no sickness on my body. Is not this my body pure salt?" said Salt-Woman. "Now I also tell you this," said Salt-Woman. "How many children have you and how many families of Parrot People live here?" said Salt-Woman. "Now go ahead and come in this direction," said she, "for I am very grateful because you gave me to eat," said Salt-Woman. Now the one who was the mother of the Parrot People went to call her relatives. She brought the whole number of them. Then she took them down and Salt-Woman spoke thus, "Are these your relatives, the Parrot People?" — "Yes," said the one who was the mother. "Indeed," she said, "Go ahead, take this basket and give it to me," said Salt-Woman. Then she gave the basket to Salt-Woman and salt came off from her arms and from her feet. Then she picked it up and put it into the basket. "Take this," said Salt-Woman, "with this you will season what you eat." Then again she spoke thus, "Enough," she said, "it is good, thank you. Now we shall climb up and go out from here. You stay here," said Salt-Woman, "then, when the Twin-Heroes are ready we shall open the door after a while." Thus spoke Salt-Woman. Then they climbed up and went away and climbed down again. After they had climbed down outside the children came and looked at them for a while. The Twin-Heroes were playing thereabouts with a shuttlecock. Then the children spoke thus, "Boy," said they, "go ahead, bring me

this shuttlecock," said the children. Then the younger one of the Twin-Heroes spoke thus, "Go ahead," said he, "stand there to the south under the cotton wood tree." The children went southward. They arrived there. Then the children spoke thus, "Go ahead," they said. "Now look out," said the elder one of the Twin-Heroes, "I throw the shuttlecock southward." When it arrived at the south where they stood, the shuttlecock fell down between them. Then all were turned into chaparal jays. All flew upward. Then Salt-Woman and her grandchildren went to the south. They arrived in the south. Then the elder one of the Twin-Heroes stood up. He took up his shuttlecock in his turn. The younger one said, "Now, look out, it is my turn. Let me make the shuttlecock fly to the north." — "Go ahead," said the elder one. The younger one made the shuttlecock fly northward. In the north it reached the plaza and when the shuttlecock fell down the people were transformed into stones. Then Salt-Woman spoke thus, "Enough," said she, "Now go ahead to the house of the Parrot People and open the door."

Another example may not be amiss. Dr. Ruth Benedict recorded the following as part of the creation myth from a Zuni Indian who has a good command of English:

"The Two came to the fourth world. It was dark there; they could see nothing. They met a man; he was naked and his body was covered with green slime, he had a tail, and a horn on his forehead. He took them to his people. The Two said to them, "In the upper world there is no one to worship the sun. He has sent us down to you to take you out to the world above." They said, "We are willing. In this world we cannot see one another, we step upon one another, we urinate upon one another, we spit upon one another, we throw refuse upon one another. It is nasty here, we do not want to stay. We have been waiting for someone to lead us out. But you must go to the priest of the north; we want to know what he has to say."

They took them to the priest of the north. He said to them, "What is it that you have come to say?" — "We want you to

come out into the upper world." — "We are willing to go. In this world we cannot see, we step upon one another, we urinate upon one another, we throw refuse upon another, we spit upon one another. It is nasty here, we do not want to stay. We have been waiting for someone to lead us out. But you must go to the priest of the west; we want to know what he has to say." (This is repeated for the priests of the six directions.)

Cushing[1] has rendered the same incident as follows:

"Anon in the nethermost of the four cave-wombs of the world, the seed of men and the creatures took form and increased; even as within eggs in warm places worms speedily appear, which growing, presently burst their shells and become as may happen, birds, tadpoles, or serpents, so did men and all creatures grow manifoldly and multiply in many kinds. Thus the lowermost womb or cave-world, which was Anosin tehuli (the womb of sooty depth or of growth-germination, because it was the place of first formation and dark as a chimney at night time, foul too, as the internals of the belly) thus did it become overfilled with being. Everywhere were unfinished creatures, crawling like reptiles one over another in filth and black darkness, crowding thickly together and treading each other, one spitting on another or doing other indecency, insomuch that loud became their murmurings and lamentations, until many among them sought to escape, growing wiser and more manlike."

I think these examples demonstrate that it is not easy to discover from published material the stylistic pattern of primitive narrative. Sometimes the rendering is bald and dry owing to the difficulties of expression that the interpreter cannot overcome; sometimes elaborated in a superimposed literary style that does not belong to the original.

In free prose narrative particular stress is laid upon the completeness of the succession of events. Both Pueblo and Kwakiutl informants criticize tales from this point of view. A Pueblo will

[1] Frank H. Cushing, Zuni Creation Myths, 13th Annual Report of the Bureau of American Ethnology, p. 381.

say, "You cannot say, 'he entered the house,' for he must first climb up the ladder, then down into the house. He must greet those present properly and receive the proper courteous reply." None of these steps may be omitted. This is illustrated by the example of the Laguna tale referred to before (see p. 305). The Kwakiutl cannot say, "Then he spoke," but they would say "Then he arose, spoke and said." They do not allow a person to arrive at a place without first letting him start and travel. An epic diffusiveness, an insistence on details is characteristic of most free primitive narrative.

Besides these free elements, primitive prose contains passages of fixed form which are, to a great extent, the source of its attractiveness to the hearer. Quite often these passages consist of conversation between the actors and in these, deviations from the fixed formula, are not permitted. In other cases they are of rhythmic form and must be considered poetry, chants or songs rather than prose.

In almost all reliable collections the fixed, formal parts are of considerable importance. In a few cases, as among the Wailaki of California, the connective text disappears almost completely.

In contrast to the fullness of the free narrative these formal parts are apt to be so brief that they are obscure unless the significance of the story is known to the hearers. Examples of these are the brief tales of the Eskimo. In Cumberland Sound I recorded the following example:[1] a tale of a woman and the Spirit of the Singing-House.

> "Where is its owner? Where is its master? Has the singing-house an owner? Has the singing-house a master? It has no owner." — "Here he is, there he is." — "Where are his feet? Where are the calves of his legs? Where are his knees? Where are his thighs?" — "Here they are, there they are." — "Where is his stomach?" — "Here it is, there it is." — "Where is his chest? Where is his arm? Where is his neck? Where is his head?" — "Here it is, there it is." He had no hair.

[1] Journal of American Folk-lore, Vol. 7, (1894), p. 45.

This means that the woman felt for the supernatural owner of the singing-house. He is supposed to have bandy legs, no hair and no occipital bone. To touch his soft head is immediate death.

The same observation may be made in formulas of the Chukchee.[1]

> "I call Raven. My abdomen I make into a bay. The bay is frozen. Icebound rubbish is there. All this rubbish is frozen in the ice of the bay. It is the disease of my stomach. Oh, you my stomach, you are full of pain. I make you into a frozen bay, into an old ice floe, into a bad ice floe.
> "Oh, Oh! I call to Raven. You Raven travel around from very remote times. I want your assistance. What are you going to do with this bay that is frozen? Mischievous people made it freeze; you have a strong beak, what are you going to do?"

Sometimes these parts of tales are in an archaic form, or in a foreign language, so that they may be quite unintelligible. Their impressiveness rests on the form and the general emotional trend of the passages in which they occur.

When such passages are discourse they are probably the best material for the study of literary style.

From these remarks let us turn to a few general characteristics of literary style, first of all to a consideration of rhythm and repetition.

The investigation of primitive narrative as well as of poetry proves that repetition, particularly rhythmic repetition, is one of its fundamental, esthetic traits.

It is not easy to form a just opinion regarding the rhythmic character of formal prose; in part because the rhythmic sense of primitive people is much more highly developed than our own. The simplification of the rhythm of modern folk song, and of poetry intended to appeal to popular taste, has dulled our feeling for rhythmic form. I have referred to this question before when discussing

[1] W. Bogoras, Publications of Jesup North Pacific Expedition, Vol. VIII, Chukchee Texts, p. 133.

the complexity of rhythm in decorative art. It requires careful study to understand the structure of primitive rhythm, more so in prose than in song, because in this case the help of the melodic pattern is lacking.

Rhythmic repetition of contents and form is found commonly in primitive narrative. For example, the tales of the Chinook Indians are often so constructed that five brothers, one after another, have the same adventure. The four elder ones perish while the youngest one emerges safe and successful. The tale is repeated verbatim for all the brothers, and its length, which to our ear and to our taste is intolerable, probably gives pleasure by the repeated form. [1] Conditions are quite similar in European fairy tales relating to the fates of three brothers, two of whom perish or fail in their tasks, while the youngest one succeeds. Similar repetitions are found in the German tale of Redridinghood, in the widely spread European story of the rooster who goes to bury his mate, or in the story of the three bears. In Oriental tales the incidents of the tale are sometimes repeated verbatim being retold by one of the heroes.

A few additional examples taken from the narratives of foreign people will illustrate the general occurrence of the tendency to repetition. In the Basuto tale called Kumonngoe a man leads his daughter into the wilderness where she is to be devoured by a cannibal. On the way he meets three animals and the son of a chief. In each case the same conversation ensues. "Where are you leading your daughter?" — "Ask herself, she is grown up." She replies:

"I have given to Hlabakoane, Kumonngoe, [2]
To the herd of our cattle Kumonngoe
I thought our cattle were going to stay in the kraal, Kumonngoe,
And so I gave him my father's Kumonngoe."

[1] Franz Boas, Chinook Texts, Bull. Bur. of Ethnol. Washington D. C., (1894), pp. 9 et seq.

[2] The girl had a brother named Hlabakoane, to whom she had given a magical food, called Kumonngoe, that belonged to her father and that the girl had been forbidden to touch. E. Jacottet, The Treasury of Basuto Lore, Vol. 1, (1908), p. 114.

In an Omaha tale [1] of a Snake-Man it is related that a man flees from a serpent. Three helpers in succession give him moccasins which, on the following morning return of their own accord to their owners, and every time the same conversation is repeated. When the serpent goes in pursuit it asks every animal for information in exactly the same words. In a tradition of the Kwakiutl of Vancouver Island the same formula is repeated forty times together with the description of the same ceremonial. In the tales of the Pueblo Indians the same incident is repeated four times as happening to four sisters; the yellow, red, blue, and white girls. In a Siberian tale of the Hare we hear that a hunter hides under the branches of a fallen willow tree. One hare after another appears in order to browse, espies the hunter and runs away. In a Papua tale from New Guinea the birds come one after another and try to peck open the stomach of a drowned person so as to let run out the water that he has swallowed. Still more markedly appears this type of repetition in a tale from New Ireland. The birds try to throw the casuary off from the branch of a tree on which he is perched. In order to accomplish this, one after another alights on the same branch next to the casuary but nearer the trunk. Thus he is compelled to move out farther and farther until finally he drops down.

Much more striking are the rhythmic repetitions in songs. Polynesian genealogies offer an excellent example. Thus we find in Hawaii the following song: [2]

> Lii-ku-honua, the man,
> Ola-ku-honua, the woman,
> Kumo-honua, the man,
> Lalo-honua, the woman,

and so on through sixteen pairs.

[1] James Owen Dorsey, The Thegiha Language, Contributions to North American Ethnology, Vol. VI, (1890), Washington D. C., p. 284.

[2] Fornander Collection of Hawaiian Antiquities and Folk-lore. Mem. Bernice Pauahi Bishop Museum, Vol. VI, Honolulu, (1919), p. 365.

Or in a cradlesong of the Kwakiutl Indians:[1]

"When I am a man, then I shall be a hunter, o father! ya ha ha ha.
When I am a man, then I shall be a harpooneer, o father! ya ha ha ha.
When I am a man, then I shall be a canoe-builder, o father! ya ha ha ha.
When I am a man, then I shall be a carpenter, o father! ya ha ha ha.
When I am a man, then I shall be an artisan, o father! ya ha ha ha.
That we may not be in want, o father, ya ha ha ha."

In the Eskimo song of the raven and the geese, the raven sings:[2]

Oh, I am drowning, help me!
Oh, now the waters reach my great ankles.
Oh, I am drowning, help me!
Oh, now the waters reach my great knees,

and so on through all the parts of the body, up to the eyes.

Quite remarkable is the analogy between this song and the following Australian war song:

Spear his forehead
Spear his chest
Spear his liver
Spear his heart, etc.

Rhythmic variations of a similar type develop also in oratory when a number of persons are addressed in the same formal way: As an example may serve the following address in a Kwakiutl speech:

Now you will witness, Northerners,[3] the dance of Many-on-Fire,
 the Daughter of Giver-of-Presents.
Now you will witness, Great Kwakiutl,[3] the dance of Many-on-Fire,
 the Daughter of Giver-of-Presents,
Now you will witness, Rich Side,[3] the dance of Many-on-Fire,
 the Daughter of Giver-of-Presents,

[1] Franz Boas, Ethnology of the Kwakiutl, 35th An. Rep. Bur. Am. Ethn., Washington, 1921, p. 1310.

[2] W. Thalbitzer, The Ammassalik Eskimo, Meddelelser om Grønland, Vol. XL, p. 211. Compare before p. 309, for a similar formula from Cumberland Sound.

[3] These are names of 'tribes, Columbia Contributions to Anthropology, III, p. 140.

or:

> "I have come Northerners; I have come Great Kwakiutl,
> I have come Rich Side." [1]

The repetitions discussed so far are rhythmic in form, varied in contents. They may be compared to an orderly succession of decorative motives that agree in the plan of the unit, but vary in details. In poetry rhythmic repetitions of identical formal units are frequent. These occur in all songs without words, consisting of vocables only. An example of this is a Kwakiutl canoe song in which every syllable is sung with one stroke of the paddles:

> Aw, ha ya ha ya hä
> ha ya he ya ä
> he ya ha ya ä
> A, ha ya ha ya hä
> aw, ha ya he ya hä
> he ya ha ya hei
> ya hä
> hä hä wo wo wo.

They are also found in introductions to many songs in which the tune is carried by vocables as an introduction to the words of the song: [2]

> Mai hamama.
> Haimama hamamai hamamamai.
> Hamama hamamayamai
> Haimama hamamai hamamamai.

Rhythm is not confined to the larger units, but is applied as an artistic device in the detailed structure. In exhortative speech some tribes develop a rhythmic form by adding a strongly accented syllable to each word. The Kwakiutl use the strongly accented ending *ai* for this purpose and I may imitate the impression of their speech by saying, Welcome-ai! brothers-ai! at my feast-ai! Here

[1] Ibid. p. 142.

[2] The Social Organization and the Secret Societies of the Kwakiutl Indians; Rep. U. S. National Mus. for 1895, Washington, 1897, p. 703.

the time for each word group ending in *ai* is approximately equal, or the words leading up to the ending *ai* are at least pronounced with great rapidity when they contain a longer phrase.

In the recital of myths rhythmic structure is sometimes attained by the addition of meaningless syllables that transform the recital into a chant. Thus the Fox Indians will add in the recital of the Culture Hero legend, the syllables nootchee, nootchee. A. L. Kroeber and Leslie Spier tell us that the myths of Southern California are chanted. Edward Sapir has observed the Song recitative in Paiute mythology, each animal speaking according to a definite rhythm and tune to which the text is adjusted.[1] I have recorded an Eskimo tale from Cumberland Sound in which the travels of the hero are recorded in a chant with interspersed melodic phrases.[2] In wails the repetition of the formal cry of moaning at short intervals and the rapid, even pronunciation of the recital creates rhythmic structure.

Much stricter than in prose is the rhythmic structure of song. It is often assumed that regularity of musical rhythm, which is found in most primitive music, is due to the multiplicity of motor actions connected with the music, particularly to the close relation between music and dance. It is true that primitive song is often accompanied by movements of the body, — a swinging of the whole trunk, movements of head, feet, and arms; hand clapping and stamping; but it is an error to assume that for these the same synchronism prevails to which we are accustomed. With us the stamping and clapping of hands coincides with the accent of the song. Some tribes innervate so that the innervation for the articulation and for the movement of hands or feet coincide. This habit has the effect of letting the clapping, drumming, or stamping follow the accent of the song. It is also not a rare occurrence that the rhythmic pattern of body

[1] Song Recitative in Paiute Mythology, Journal American Folk-lore, Vol. 23, pp. 455 et seq.

[2] F. Boas, Bull. A. M. N. H., Vol. 15, pp. 335, 340, tune in Sixth Annual Report Bureau of Ethnology, p. 655, no. 13.

movements and of song are not homologous, but that they are interrelated in different ways or sometimes even seem to be quite independent. Negro music as well as that of Northwest America offers many examples of this kind.

Although the problem involved in the structure of primitive poetry is better understood now than it was a few years ago, and although many energetic efforts are being made to obtain adequate collections, the material for the study of this subject is still quite insufficient. Travellers are rarely trained in the art of recording songs and are apt to give us only the simplest forms that offer the least difficulties, or to summarize their observations in descriptions that are altogether too often misleading. Exact observations show that rhythmic complexity is quite common. Regular rhythms consist of from two to seven parts, and much longer groupings occur without recognizable regularity of rhythmic structure. Their repetition in a series of verses proves that they are fixed units.

On account of the physiologically determined emotional quality of rhythm it enters into all kinds of activities that are in any way related to emotional life. Its exciting effect manifests itself in religious songs and dances. Its compelling control may be observed in war songs; its soothing effect appears in melodies; its esthetic value is seen in song and decorative art. The origin of rhythm must not be looked for in religious and social activities but the effect of rhythm is akin to the emotional states connected with them and, therefore, arouses them and is aroused by them.

I believe the great variety of forms in which rhythmic repetition of the same or similar elements is used, in prose and in poetry as a rhythm of time, in decorative art as a rhythm of space, — shows that Bücher's theory according to which all rhythm is derived from the movements accompanying work cannot be maintained, certainly not in its totality. Wundt derives the rhythm of the songs used in ceremonies from the dance, that of the working song from the movements required in the performance of work, — a theory practically identical with that proposed by Bücher, since the movements

of the dance are quite homologous to those of work. There is no doubt that the feeling for rhythm is strengthened by dance and the movements required in the execution of work, not only in the common work of groups, of individuals who must try to keep time, but also in industrial work, such as basketry or pottery that require in their execution regularly repeated movements. The repetitions in prose narrative as well as the rhythms of decorative art, so far as they are not required by the technique, are proof of the inadequacy of the purely technical explanation. The pleasure given by regular repetition in embroidery, painting, and the stringing of beads cannot be explained as due to technically determined, regular movements, and there is no indication that would suggest that this kind of rhythm developed later than the one determined by motor habits.

It is a precarious undertaking to discuss the characteristics of primitive poetic forms, partly because so little reliable material is available, but partly also on account of the impossibility of obtaining a fair insight into the meaning and value of literary expression without an intimate knowledge of the language and culture in which they have come into being. For this reason I shall base the following remarks principally upon observations of the Kwakiutl tribe, a tribe with whose language and culture I am familiar. It would be unjustifiable to generalize and to claim that the traits that I am going to discuss are characteristic of all primitive litèrature. On the contrary, as our knowledge of primitive literature expands, individuality of style will certainly be found to prevail. Still it seems likely that features which are analogous to our own literary devices may disclose general tendencies.

Emphasis of salient points is used extensively in Kwakiutl prose and song. Stress is most frequently given by repetition. I give a few examples culled from speeches: "Indeed, indeed, true are the words of the song, of my song, sung for you, tribe."[1]

[1] Contributions to the Ethnology of the Kwakiutl, Columbia University Contributions to Anthropology, Vol. 3, p. 194, line 25.

"He is a kind chief who is kind, speaking kindly to those who have him for a chief." [1]

"Now is finished the song of my chief. Finished is the great one." [2]

"Now you will give the name Great-Inviter to Inviter who has come out of her room, her who has been made a princess, her who is all over a princess on account of this that has been done by this chief who has her for a princess." [3]

In songs repetitions are much more frequent than in speech. I give a few examples:

Wa, out of the way! Waw haw hawa, Wa, out of the way! Ah, do not in vain ask for mercy, Waw haw hawa! Ah, do not in vain ask for mercy and raise your hands." [4]

Another example is the following:

"I am the only great tree in the world, I the chief: I am the only great tree in the world, I the chief.

I am the great chief who vanquishes, Ha, ha, I am the great chief who vanquishes, Ha, ha!" [5]

Emphasis may be obtained by placing the word to be emphasized at the end of one phrase and by beginning the next phrase with the same word.

There are also many emphatic particles. The closing *ai* referred to before, used in exhortative oratory, belongs to this group. Verbal affixes meaning "really", "indeed", and the like are used in formal speech to give proper strength to the whole expression. In a wail a woman chants: "Haha, hanane, now really I do this, I remember my real past forefathers and really my great grandfathers and now really I will go on with my family-myth here, telling of this, of my beginning in the beginning of the world, of the chief who come up

[1] Ibid., p. 258, line 24.
[2] Ibid., p. 268, line 25.
[3] Ibid., p. 308, line 3.
[4] Ethnology of the Kwakiutl, Thirty-fifth Annual Report Bur. Am, Ethn., p. 1288.
[5] Ibid., p. 1290.

in this world, haha, hanane; and really this was my ancestor who really was going about spouting."[1]

In Africa the telling of a story is enlivened by affirmative exclamations of the audience. When the narrator says, "The turtle killed the leopard," the audience will repeat, clapping their hands, "The leopard, the leopard."

Emphasis is also given by an accumulation of synonyms. Alternate terms are often used in this manner and in the original they often have an added rhythmical value on account of the homology of their form. Thus the Kwakiutl sings in a laudatory chant: "I greatly fear our chief, oh tribes! I tremble on account of this great means of trying to cause fear, of this great means of trying to cause terror, of this greatest cause of terror."[2]

"I shall break, I shall let disappear the great Copper, the property of the great foolish one, the great extravagant one, the great surpassing one, the one farthest ahead, the greatest Spirit-of-the-Woods among the chiefs."[3]

The beginning or the end of a rhythmic unit is often marked by an interjection like the "haha hanane" of the wail previously quoted, or by the repetition of the same word. Both these forms occur often in love songs:

> Ye ya aye ya! You are hard hearted, you who say that you love me,
> You are hard hearted, my dear!
> Ye ya aye ya! You are cruel, you who say that you are lovesick
> for me, my dear!
> Ye ya aye ya! When are you going to talk my love? my dear![4]

or in a shaman's song:[5]

[1] Ibid., p. 836.

[2] Ibid., p. 1287.

[3] By "copper" is meant one of the valuable plates of copper that are considered the "highest" kind of property. The "Spirit-of-the-Woods" is the symbol of wealth and power, Ibid., p. 1288.

[4] Ibid., p. 1301.

[5] Ibid., p. 1296.

I have been told to continue to heal him by
 the Good Supernatural Power,
I have been told to keep on putting the hemlock ring
 over him by the Shaman-of-the-Sea,
 the Good Supernatural Power,
I have been told to put back into our friend his soul, by
 the Good Supernatural Power,
I have been told to give him long life, by the Long-Life-
 Giver-of-the-Sea, the Chief-of-High-Water,
 the Good Supernatural Power.

Symmetry in the rigid sense of the term does not exist in the
arts built on time sequences. A reversion of time sequence is not
felt as symmetry in the same way as a reversion of space sequence
where every point has its equivalent point. In time sequences we
have a feeling for symmetry only for the order of repetition and
structural phrases. The following Negro poem will illustrate this:

Ko ko re ko kom on do!
Girl gone, him no gone,
Ko ko re ko kom on do![1]

It seems, however that in primitive recitative poetry and music
this form is not as frequent as in modern folk song or in modern
poetry.

The effect of poetry and oratory depends in part on the use of
metaphor. It is hardly possible to discuss this in a generalized way,
because the appreciation of metaphor requires a most intimate knowl-
edge of the language in which it occurs. Apparent absence of
metaphor is undoubtedly more likely due to imperfect records than
to an actual absence of figures of speech. It is quite striking that it
is difficult to find metaphorical expressions in American Indian litera-
ture, although it is undoubtedly a feature of their oratory. The
whole naming system of most American Indians proves their feeling
for figurative speech.

[1] Martha Warren Beckwith, Jamaica Anansi Stories, Memoirs. Amer. Folklore
Soc., Vol. 17 (1924) p. 107.

Here also I may be permitted to confine my remarks to the use of metaphor among the Kwakiutl with whose speech forms I am fairly familiar. Metaphorical expressions are used particularly when describing the greatness of a chief or of a warrior. The chief is compared to a mountain; a precipice (from which rolls down wealth overwhelming the tribes); a rock which cannot be climbed; the post of heaven (who supports the world); the only great tree (that raises its crown over the lesser trees of the woods or that rises in lonely height on an island); a loaded canoe at anchor; the one who makes the whole world smoky (from the fire in the house in which he gives feasts); the thick tree; the thick root (of the tribe). It is said that through his great acts he burns up the tribes, a term which is primarily used for the warrior. The people follow him as the young sawbill-ducks follow the mother bird. He makes the people suffer with his short-life maker; he shoves away the tribes. His rival whom he tries to vanquish is called, he with ruffled feathers; the one whom he puts across his back (like a wolf carrying a deer); the one with lolling tongue; the one who loses his tail (like the salmon); the spider woman; old dog; mouldy face; dry face; broken piece of copper.

Greatness of a chief is called the weight of his name; when he marries a princess he lifts her weight from the floor; his wealth of blankets is a mountain that rises through our heavens; in the feast surrounded by his tribe, he stands on his fortress. Wealth that he acquires is a salmon that he catches.

When following ancient customs the people walk the road laid out for them by their ancestors.

The warrior or a person of ill temper is called "hellebore". The warrior is also called "the double-headed serpent of the world".

Metaphorical terms are an important element in the speeches accompanying public purchases, particularly the purchase of valuable "coppers". Many of these terms are accompanied by symbolic actions. The first part of the payment in the purchase of a copper is called the pillow or mattress on which the copper is to rest or

the harpoon line by which it is hauled in. The purchase itself is called "shoving," that means pushing the value of the purchase under the name of the purchaser who is thus raised in rank. At the end of the transaction the seller gives to the purchaser a certain number of blankets (which are the standard of value) as a "belt" to hold up the blankets (in which the purchase price is reckoned); as boxes in which to store these blankets; and finally he gives an amount as a dress for his dancer (that is his female relative who dances for him on festive occasions).

When a person gives a great feast for his rival he extinguishes the fire of his rival's house; his feast steps up to the fire in the middle of the house. If he surpasses his rival in liberality, his feast steps across the fire and reaches the rear of the house where the chief is seated.

Presents for a bride are a packline to carry her property; a mat on which she is to sit; and a mast for her canoe.

I do not mention here the many euphemistic terms for sickness and death, except a few that are used in speeches: the dead chief has gone to take a rest; he has disappeared from this world; he stays away; or he lies down.

Metaphorical figures in songs are not rare. Of the death of a renowned man who was drowned, it is said in his mourning song:

"It deprived me of my mind, when the moon went down at the edge of the waters".[1]

And in another mourning song[2]:

> Hana, hana, hana. It broke down, the post of the world.
> Hana, hana, hana. It fell down to the ground, the post of the world.
> Hana, hana, hana. Our great chief has taken a rest.
> Hana, hana, hana. Now our past chief has fallen down.

In a feast-song the chief is compared to the salmon[3]:

[1] Ethnology of the Kwakintl, 35th Ann. Rep. Bur Am. Ethn. p. 1292.

[2] Boas, Kwakiutl Ethnology, Columbia University Contributions to Anthropology. Vol. III, p. 77.

[3] Ibid. p. 123.

The great one will not move, the greatest one, the great Spring Salmon.
Go on, great one, hurt the young children, the humble sparrows who are being
teased by you, great Spring Salmon.

In another feast-song the rivals are compared to insects [1]:

I am a chief, I am a chief, I am your chief, yours, who you are flying about.
I am too great to be bitten by those little flies that are flying about.
I am too great to be desired as food by those little horseflies that are flying about.
I am too great to be bitten by those little mosquitoes that are flying about.

In still another song he is compared to a tree [2]:

A great cedar dancer is our chief, our tribes.
It cannot be spanned, our great chief, our tribes.
My chief here from long ago, from the beginning of the myth time, for you, tribes.

A number of sayings of the Tsimshian present also good cases of
the use of metaphor. "A deer though toothless, may accomplish
something"; "he is just sleeping on a deerskin" (i. e. not expecting
approaching hardships); "it seems you think that Nass River is al-
ways calm" (i. e. that you will always be fortunate); "he is just
enjoying the water lilies for a short time" (as a bear feeding on
water lilies and about to be killed by the hunter who lies in ambush). [3]

Examples of metaphor may be found here and there in songs
and speeches. The Osage sing:

Ho! Toward what shall they (the little ones) direct their footsteps, it has been said
in the house.
It is toward a little valley they shall direct their footsteps.
Verily, it is not a little valley that is spoken of,
It is toward the bend of a river they shall direct their footsteps.
Verily, it is not the bend of a river that is spoken of,
It is toward a little house that they shall direct their footsteps.

The valley and the bend of the river represent the path of life
which is pictured as crossing four valleys or as following the course

[1] Ibid. p. 129.
[2] Ibid. p. 197.
[3] Journal of American Folk-Lore, Vol. 2 (1889), p. 285.

of the river having four bends.[1] This concept also finds expression in the decorative art of the Indians of the Plains.[2]

Another metaphor is used in the following illustration:

Upon whom shall we slip off our moccasins? they said to one another, it has been said in this house.
Toward the setting sun,
There is an adolescent youth,
Upon whom we shall always slip off our moccasins, they said to one another, it has been said in this house.

Here the slipping off of moccasins means the crushing and killing of the enemy, here personified in the adolescent youth.[3]

In the speech containing the migration legend of the Creek, the head-chief Chekilli said: "The Cussetaws cannot yet leave their red hearts, which are, however, white on one side and red on the other".[4]

James Mooney records the following formula for success in hunting. obtained from the Cherokee.[5]

Give me the wind. Give me the breeze. Yu! O Great Terrestrial Hunter, I come to the edge of your spittle where you repose. Let your stomach cover itself; let it be covered with leaves. Let it cover itself at a single bend, and may you never be satisfied.
And you, O Ancient Red, may you hover above my breast while I sleep. Now let good (dreams?) develop; let my expressions be propitious. Ha! Now let my little trails be directed, as they lie down in various directions (?). Let the leaves be covered with the clotted blood, and may it never cease to be so. You two shall bury it in your stomachs. Yu.

[1] Francis La Flesche, The Osage Tribe, The Rite of Vigil, 39th Ann. Rep. Bur. Amer. Ethnology, Washington 1925, p. 258.

[2] A. L. Kroeber, The Arapaho, Bulletin Am. Uns. Nat. Hist. Vol. 18, Plate 16, p. 100; Clark Wissler, Decorative Art of the Sioux Indians, Ibid., p. 242, fig. 77.

[3] Francis La Flesche, Ibid. p. 84.

[4] Albert S. Gatschet, A Migration Legend of the Creek Indians, Philadelphia, 1884; p. 251.

[5] James Mooney, The Sacred Formulas of the Cherokees, Seventh Annual Report of the Bureau of American Ethnology, p. 369.

In this formula the gods of the hunt, fire and water are called upon. The Great Terrestrial Hunter is the river, its spittle the foam; the blood-stained leaves on which the game has been killed are to cover the surface of the water. The hunter asks that all the game may be assembled at one bend of the river which is supposed to long for evermore. In the second part, the Ancient Red is the fire. It hovers over the breast because the hunter rubs his chest with ashes. The blood-stained leaves are thrown into the fire and into the water which is expressed by having them buried in the stomach.

The contents of primitive narrative, poetry and song are as varied as the cultural interests of the singers. It does not seem admissible to measure their literary value by the standards of the emotions that they release in us. We ought to inquire in how far they are an adequate expression of the emotional life of the natives. To primitive man, hunger is something entirely different from what it is to us who ordinarily do not know what the pangs of hunger mean, who do not realize all the implications of starvation. If a people like the Bushmen or the Eskimo sing of their joy after a successful hunt and after a hearty meal, if the Orang Semang of the Malay Peninsula sing of the gathering of fruit and of the successful hunt, the connotation of these songs is no different from that of a harvest song. We are too easily mislead by the concreteness of the picture and assume that the emotional connotation that we require in poetry must be absent. Even among ourselves a graphic passage in a lyric poem does not by any means always release a definite, mental image but appeals rather through the feelings engendered by the descriptive terms. For this reason we must necessarily assume that the emotional setting of the picture is the essential poetic element for the singer, not the objective terms that alone appeal to us because we are not familiar with the emotions of every day native life. We feel only the graphic value of the words. The much-quoted Semang [1] song represents a good example:

[1] W. W. Skeat and C. O. Blagden, Pagan Races of the Malay Peninsula, Vol. 1 (1906), p. 627.

> Our fruit grows plump at the end of the spray.
> We climb along and cut it from the end of the spray.
> Plump, too, is the bird (?) at the end of the spray.
> And plump the young squirrel at the end of the spray.

This song which deals with plants and animals serving as food, should be compared with another one that is more readily appreciated by us:

> The stem bends as the leaves shoot up.
> The leaf-stems sway to and fro.
> To and fro they sway in diverse ways.
> We rub them and they lose their stiffness.
> On Mount Inas they are blown about.
> On Mount Inas which is our home.
> Blown about by the light breeze.
> Blown about is the fog (?).
> Blown about is the haze.
> Blown about are the young shoots.
> Blown about is the haze of the hills,
> Blown about by the light breeze.
> etc.

If we feel the latter as a more poetic type it is presumably only because we cannot share the feelings aroused in the Orang Semang by the reference to the efforts in gathering fruit and in hunting animals. The effectiveness of poetry does not depend upon the power of expressive description that releases clear mental images, but upon the energy with which words arouse the emotions.

It is misleading to compare primitive poetry that has been recorded by collectors with the literary poetry of our times. The coarse sexual songs or drinking songs that do not form part of our polite literature, are quite on a par with the songs that may be heard in primitive society in the company of lusty young men or excited young women and their prevalence in existing collections is, in all probability, merely due to the inability of the collector to approach the natives in moments of religious devotion, of tender love, or poetic exaltation. In many cases it is quite obvious that some of the songs collected were made to make fun of the collector. It is

not admissible to build on the meagre evidence that we possess, a system of development of lyrics in which the coarse forms, the exuberant spirits of every day life are mistaken for the expression of the highest poetic achievement. In all those cases in which fuller collections are available, as in America for instance from the Omaha, Eskimo, Kwakiutl, and from some of the southwestern tribes, there is ample evidence of poetic feeling that moves on higher planes.

Still, poetic susceptibility is not the same everywhere, neither in form nor in intensity. The local culture determines what kind of experiences have a poetic value and the intensity with which they act. I select as an example the difference between the descriptive style found in Polynesia and that of many Indian traditions. In the Fornander collection of Hawaiian tales we read: "They admired the beauty of his appearance. His skin was like to a ripe banana. His eyeballs were like the young buds of a banana. His body was straight and without blemish and he was without an equal." In the story of Laieikawai it is said: "I am not the mistress of this shore. I come from inland, from the top of the mountain which is clothed in a white garment." It would be a vain task to search for similar passages in the literature of many Indian tribes. The American Indians differ considerably among themselves in regard to this trait. Tsimshian tales are rich when compared to the barrenness of the descriptive tales of the Plateau tribes.

Poetic descriptions appear more frequently in songs. However even these are not found everywhere. The songs of the Indians of the Southwest suggest that the phenomena of nature have impressed the poet deeply, although it must be remembered that most of his descriptive terms are stereotyped ceremonial expressions.

As an example I give the following song of the Navaho: [1]

> "On the trail marked with pollen may I walk,
> With grasshoppers about my feet may I walk,
> With dew about my feet may I walk,

[1] Washington Matthews, Navaho Myths, Prayers and Songs. University of California Publications in Archaeology and Ethnology, Vol. 5, p. 48, lines 61—73.

With beauty may I walk,
With beauty before me, may I walk,
With beauty behind me, may I walk,
With beauty above me, may I walk,
With beauty under me, may I walk,
With beauty all around me, may I walk,
In old age wandering on a trail of beauty, lively, may I walk,
In old age wandering on a trail of beauty, living again, may I walk,
It is finished in beauty.

Of similar character is the following song of the Apache:[1]

"At the east where the black water lies, stands the large corn,
 with staying roots, its large stalk, its red silk, its long
 leaves, its tassel dark and spreading, on which there is the dew.

"At the sunset where the yellow water lies, stands the large
 pumpkin with its tendrils, its long stem, its wide leaves, its
 yellow top on which there is pollen."

The following song of the Pima has also ceremonial significance:[2]

"Wind now commences to sing;
Wind now commences to sing;
Wind now commences to sing.
The land stretches before me,
Before me it stretches away.

Wind's house now is thundering;
Wind's house now is thundering.
Came the myriad-legged wind.
The wind came running hither.

The Black Snake Wind came to me;
The Black Snake Wind came to me.
Came and wrapped itself about,
Came here running with its song.

[1] P. E. Goddard, Myths and Tales from the White Mountain Apache. Anthropological Papers of the American Museum of Natural History, Vol. 24, 1910.
[2] Frank Russell, The Pima Indians, 26th Ann. Rep. Bur. Am. Ethn., p. 324.

The following Eskimo song which describes the beauty of nature is well known: [1]

> "The great Kunak mount yonder south, I do behold it;
> The great Kunak mount yonder south, I regard it;
> The shining brightness yonder south, I contemplate.
> Outside of Kunak it is expanding,
> The same that Kunak towards the seaside doth quite encompass.
> Behold, how yonder south they shift and change.
> Behold, how yonder south they tend to beautify each other,
> While from the seaside it is enveloped in sheets still changing,
> From the seaside enveloped to mutual embellishment."

A song, provided it does not contain intelligible words, may be of purely formal esthetic value, which depends upon its melodic and rhythmic character. Even these forms may be attached to more or less different groups of ideas of emotional value. On the other hand the established significance of the song may vary materially when different sets of words are used with it. We observe this in our own culture, when diverse thoughts are expressed in the same metre or when distinct poems are sung according to the same tune, — as, for example, happened in the transfer of folksongs into religious songs. I do not know in how far this may happen in primitive poetry. Among the tribes that I know best there is a decided tendency to associate a certain rhythm with a certain set of songs. Thus the five part rhythm of the Northwest coast of America seems to be closely connected with the religious winter ceremonial; the mourning songs with slow regular beating.

The inherent relation between literary type and culture appears also clearly in narrative.

The motives of action are determined by the mode of life and the chief interests of the people, and the plots give us a picture of these.

In many typical tales of the Chukchee of Siberia the subject of the tale is the tyranny and overmastering arrogance of an athletic

[1] Henry Rink, Tales and Traditions of the Eskimos, London, 1875, p. 68.

hunter or warrior and the attempts of the villagers to free themselves. Among the Eskimo a group of brothers often take the place of the village bully. Among both groups of people who live in small settlements, without any hard and fast political organization, the fear of the strongest person plays an important role, no matter whether his power is founded on bodily strength or on supposed supernatural qualities. The story uses generally a weak, despised boy as savior of the community. Although tales of overbearing chiefs do occur among the Indians they are not by any means a predominant type.

The principal theme of the Indians of British Columbia, whose thoughts are almost entirely taken up by the wish to obtain rank and high position in the community, is the tale of a poor man who attains high position, or of the struggles between two chiefs who try to outdo each other in feats that will increase their social standing. Among the Blackfeet the principal theme is the acquisition of ceremonies, possession and practise of which is a most important element in their life.

All these differences are not entirely those of content but they influence the form of the narrative, because the incidents are tied together in different ways. The same motive recurs over and over again in the tales of primitive people, so that a large mass of material collected from the same tribe is liable to be very monotonous, and after a certain point has been reached only new variants of old themes are obtained.

However, much more fundamental are the differences which are based on the general difference of cultural outlook. The same story told by different tribes may bear an entirely different face. Not only is the setting distinct, the motivation and the main points of the tales are emphasized by different tribes in different ways and take on a local coloring that can be understood only in relation to the whole culture. An example selected from among the tales of the North American Indians will illustrate this point. I chose the story of the star husband, which is told on the prairies, in British Columbia, and on the North Atlantic coast. The prairie tribes tell

that two maidens go out to dig roots and camp out. They see two stars and wish to be married to them. The next morning they find themselves in the sky married to the stars. They are forbidden to dig certain large roots, but the young women disobey the orders of their husbands and, through a hole in the ground they see the earth below. By means of a rope they climb down. From here on, the story takes distinctive forms in different geographical areas. In one form the adventures of the women after their return are described, in the other the feats of the child born by one of them. The central view point of the same story as told by the Indians of British Columbia is completely changed. The girls of a village build a house in which they play and one day they talk about the stars, how happy they must be because they are able to see the whole world. The next morning they awake in the sky, in front of the house of a great chief. The house is beautifully carved and painted. Suddenly a number of men appear who pretend to embrace the girls but kill them by sucking out their brains. Only the chief's daughter and her younger sister are saved. The elder sister becomes the wife of the chief of the stars. Finally the chief sends them back with the promise to help them whenever they are in need. They find the village deserted and the star chief sends down his house and the masks and whistles belonging to a ceremony which becomes the hereditary property of the woman's family. The tale ends with the acquisition of the house and the ceremony, matters that are the chief interest in the life of the Indians. In this way the story becomes one of the long series of tales of similar import, although the contents belong to an entirely distinct group.

As a second example I mention the story of Amor and Psyche which has been cast into a new mould by the Pueblo Indians. Here the antelope appears in the form of a maiden. She marries a youth who is forbidden to see the girl. He transgresses this order and, by the light of a candle, looks upon her while she is asleep. Immediately the girl and house disappear and the young man finds himself in the wallow of an antelope.

Equally instructive are the transformations of biblical stories in the mouths of the natives. Dr. Benedict and Dr. Parsons have recorded a nativity story of the Zuni in which Jesus appears as a girl, the daughter of the sun. After the child is born the domestic animals lick it, only the mule refuses to do so and is punished with sterility. The whole story has been given a new aspect. It is made to account for the fertility of animals, and tells how fertility may be increased, a thought uppermost in the minds of the Pueblos.

European fairy tales differ in this respect from those of primitive tribes, for in contents and form they embrace many survivals of past times. It is quite evident that the modern European fairy tale does not reflect the conditions of the State of our times, nor the conditions of our daily life, but that they give us an imaginative picture of rural life in semifeudal times, and that, owing to the contradictions between modern intellectualism and the ancient rural tradition, conflicts of viewpoints occur that may be interpreted as survivals. In the tales of primitive people it is otherwise. A detailed analysis of the traditional tales of a number of Indian tribes shows complete agreement of the conditions of life with those that may be abstracted from the tales. Beliefs and customs in life and in tales are in full accord. This is true not only of old native material but also of imported stories that have been borrowed some time ago. They are quickly adapted to the prevailing mode of life. The analysis of tales from the Northwest coast and from the Pueblos gives the same result. Only during the period of transition to new modes of life, such as are brought about by contact with Europeans, contradictions develop. Thus it happens that in the tales of Laguna, one of the Pueblos of New Mexico, the visitor always enters through the roof of the house, although the modern houses have doors. The headman of the ceremonial organization plays an important role in many tales, although the organization itself has largely disappeared. The tales of the Plains Indians still tell of buffalo hunts although the game has disappeared and the people have become tillers of the soil and laborers.

It would be erroneous to assume that the absence of survivals of an earlier time can be explained as due to the permanence of conditions, to a lack of historical change. Primitive culture is a product of historical development no less than modern civilization. Mode of life, customs, and beliefs of primitive tribes are not stable; but the rate of change, unless disturbances from the outside occur, is slower than among ourselves. What is lacking is the pronounced social stratification of our times that brings it about that the various groups represent, as it were, different periods of development. So far as my knowledge goes we find the cultural, formal background of the art of narrative of primitive people almost entirely determined by its present cultural state. The only exceptions are found in periods of an unusually rapid change or of disintegration. However, in this case also a readjustment occurs. Thus the stories of the modern negroes of Angola reflect the mixed culture of the west African coast. In the cultural background of the narrative, survivals do not play an important role, at least not under normal conditions. The plot may be old and taken from foreign sources, but in its adoption it undergoes radical changes.

These remarks relating to literature do not mean, of course, that in other aspects of life ancient customs and beliefs may not persist over long periods.

We have spoken so far of the structure of the elements of prose tales and songs. Important characteristics are found also in the manner of their composition. In the narratives of some people the episodes are anecdotically short, among others the wish for a more complex structure is felt. Often this is accomplished by the meagre device of concentrating all the anecdotes around one personage.

In many cases the craftiness, strength, voracity or amorousness of the hero gives a more or less definite character to the whole cycle. The Raven tale of Alaska consists entirely of unrelated episodes. The only connecting element, besides the identity of the hero, is the voracity of the Raven; but even this disappears in many cases. Quite similar are the Coyote tales of the Plateaus,

the Spider tales of the Sioux, the Rabbit tales of the Algonquin, the Spider tales of the Guinea coast, the Rabbit and Turtle tales of South Africa, and the Fox tales of Europe. There is no inner connection between the specific character of the hero and the contents in the anecdote of the hoodwinked dancers (birds are induced to dance with closed eyes so as to give the hero a chance to wring their necks without being observed); in the tale of the eye juggler (the hero who is induced to throw up his eyes which are then caught in the branches of a tree so that he becomes blind); or in the incident of the bungling host (the hero is invited to partake of magically obtained food and he reciprocates the invitation but is ignominiously defeated in his attempt to repeat the magical procedure).

Sometimes the tales are strung on the slight thread of an Odyssey, of a tale of adventure and travel. To this class belongs the Eskimo tale of a hero who escaped a storm created by magic, and who encountered dangers of the sea which are described in some detail. He reaches a foreign coast and encounters cannibals and other dangerous creatures. Finally he reaches home again. Another case of this kind is a newly developed legend of the Tlingit of Alaska. In the early days of Russian colonization of Alaska the Tlingit attacked the fort at Sitka and the Russian governor, Baranoff, had to flee. After a few years he returned to reestablish the fort. This interval is filled by the Tlingit with a marvellous journey, telling how he goes in search of his son. He encounters fabulous beings that are known from other tales, visits the entrance to the lower world and communicates with the ghosts who give him instructions. Among the Pueblo Indians a large number of incidents are connected in a tale of migration in which the whole tribe participates.

In other cases there is an effort to establish an inner connection between the single elements. Thus the disconnected Raven tale of Alaska has been remodelled in southern British Columbia in such a manner that some of the elements of the tale have been brought into an inner connection: The thunderbird steals a woman. In order to recover her the raven makes a whale of wood and kills

the gum because he needs it to caulk the whale. In another tale the killing of the gum is the introduction to a visit to the sky. The sons of the murdered gum ascend the sky to take revenge.

Other tales are so developed that they form a complex, novelistic plot. The creation legends of the Polynesians are of this character. Even among those tribes that enjoy the brief, etiological anecdote, tales occur that contain the elements of an epic poem. The bare outlines of a family story of the Kwakiutl may serve as an example: The Thunderbird and his wife live in heaven, they descend to our earth and become the ancestors of a family. The Transformer meets them and in a series of contests the two prove to be of equal power. Finally the transformer puts frogs into the stomach of the Thunderbird-ancestor who takes them out again and deposits them on a rock. The sons of one of his friends go and then the frogs enter their stomachs, but they are cured by the Thunderbird-ancestor. In return he receives a magic canoe. The tale goes on to relate the birth, magic growth, and exploits of his four children. His wife is ravished by a spirit and gives birth to a boy who is washed in the slime of a double-headed serpent. Thus his skin becomes stone. The tale continues with a long series of warlike exploits of this son. Finally he woes a princess for one of his brothers. On a visit to her home the son of this princess is made fun of by the children in the village of her father. This results in a war in which the village of her father is destroyed. One of the wives of her father escapes and gives birth to a boy. The second wife of her father is enslaved by Stone-Body, the young man whose skin had been transformed into stone. She gives birth to a boy and by a ruse succeeds in making her escape with her son. The two brothers grow up and, in a series of adventures and exploits, both obtain supernatural power. They meet and travel towards the village of their father, killing and transforming on the way danger-ous monsters. Meanwhile Stone-Body has obtained a ceremonial from a southern tribe and goes to Feather-Mountain in the north to obtain bird's down, needed for this dance. On his way back he

meets the ancestors of another tribe and they have a contest of magical powers. In this he is overcome and killed with his whole crew. In the main story this incident is omitted. He goes on and the two brothers, the daughters of the escaped woman overturn his canoe and kill him. On a visit to her father the woman married to Stone-Body's brother sees the head of Stone-Body and her child reports this after their return. Then her husband's people set out to take revenge but all are killed by the two brothers, who give a feasts in their house and maltreat their guests.

So far we have considered only the reflection of cultural life in the form of the narrative. Its influence is also expressed in another manner. When the narrative is thoroughly integrated in the life of the people a process occurs quite similar to the one we observed in decorative art. As a geometric form often receives a secondary meaning that is read into it, so the narrative is given an interpretative significance that is quite foreign to the original tale; and as in decorative art the adventitious meaning varies in character according to the culture of the people, thus the style of the interpretation of a tale depends upon the cultural interests of the people telling it and, accordingly, assumes distinctive forms We have found that art styles are apt to be disseminated over wide areas while the explanatory meaning of art forms shows much greater individuality. Precisely in the same manner, tales are apt to travel over enormous areas but their significance changes according to the various cultural interests of the tribes. As an example I refer to the story of the girl who married a dog, a tale widely spread in North America. It is used to explain the origin of the milky way (Alaska); the origin of the culture hero (British Columbia); the origin of the tribal ancestor (Southern British Columbia); the origin of a constellation (interior of British Columbia); the origin of a red cliff (interior of Alaska); the origin of the Dog Society (Blackfoot); and the reason why dogs are the friends of man (Arapaho). [1]

[1] Waterman, The Explanatory Element in the Folk-tales of the North American Indians, Journal of American Folk-lore, Vol. 27 (1914), pp. 28 et seq.

The view of the historical development of explanatory tales here expressed is analogous to that regarding the relation of symbolism and design. The general type of interpretation of symbolism exists in the tribe and the tale is made to conform to it. In many cases the symbolic or interpretative explanation is a foreign element added on to the design or to the tale in agreement with a stylistic pattern controlling the imagination of the people. This process may lead indirectly also to a conformable stylistic development of other representations, or to attempts to give explanations for the phenomena of nature. Only on the basis of a pre-existing style which has its origin in non-symbolic and non-interpretative sources can the resultant form develop.

It must not be assumed that the literary style of a people is uniform, on the contrary the forms are quite varied. I have pointed out before that unity of style is not found in decorative art either, that many cases may be adduced in which different styles are used in different industries or among different groups of the population. Just so we find in a tribe complex tales that have definite structural cohesion, and brief anecdotes; some told with an evident enjoyment of diffuse detail, others almost reduced to a formula. An example of this are the long stories and the animal fables of the Eskimo. The former treat of events happening in human society, of adventurous travel, of encounters with monsters and supernatural beings, of deeds of shamans. They are novelistic tales. On the other hand many of the animal fables are mere formulas. Similar contrasts are found in the tales and fables of the negroes.

The styles of songs vary also considerably according to the occasion for which they are composed. Among the Kwakiutl we find long songs in which the greatness of the ancestors is described in the form of recitatives. In religious festivals songs are used of rigid rhythmic structure, accompanying dances. In these the same words or syllables are repeated over and over again, except that another appellation for the supernatural being in whose honor they are sung is introduced in each new stanza. Again of a different type are the love songs which are not by any means rare.

It is striking that certain literary forms are found among all the races of the old world while they are unknown in America. Here belongs particularly the proverb. The important position held by the proverb in the literature of Africa, Asia, and also of Europe until quite recent times, is well known. In Africa particularly do we find the proverb in constant use. It is even the basis of court decisions. The importance of the proverb in Europe is illustrated by the way in which Sancho Panza applies it. Equally rich is Asiatic literature in proverbial sayings. On the contrary, hardly any proverbial sayings are known from American Indians. I have referred before to a few metaphorical sayings of the Tsimshian, the only proverbial sayings known to me north of Mexico. [1]

The same conditions are found in regard to the riddle, one of the favorite pass-times of the Old World, which is almost entirely absent in America. Riddles are known from the Yukon River, a region in which Asiatic influences may be discovered in several cultural traits, and also in Labrador. In other parts of the continent careful questioning has failed to reveal their occurrence. It is striking that even in New Mexico and Arizona, where Indians and Spaniards have been living side by side for several centuries and where Indian literature is full of Spanish elements, the riddle, nevertheless, has not been adopted, although the Spaniards of this region are as fond of riddles as those of other parts of the country. Sahagun, however, records a number of riddles from Mexico. [2]

As a third example I mention the peculiar development of the animal tale. Common to mankind the world over is the animal fable by means of which form and habits of animals, or the existence of natural phenomena are explained. The moralising fable, on the other hand, belongs to the Old World.

The distribution of epic poetry is also wide, but nevertheless

[1] I collected one saying among the Eskimo of Cumberland Sound: "If I should go to get them I should be like one who goes to buy the backside of a salmon (i. e. something without value)."

[2] B. Sahagun (see note p. 132), Vol. 2, pp. 236, 237.

limited to a fairly definitely circumscribed area, namely Europe and a considerable part of Central Asia. We have mentioned that in America long, connected tribal traditions occur, but up to this time no trace of a composition that might be called a romance or a true epic poem has ever been discovered. Neither can the Polynesian legends telling of the descent and deeds of their chiefs be designated as epic poetry. The distribution of this form can be understood only on the basis of the existence of ancient cultural relations. For this reason Wundt's analysis of the origin of the epic poem does not seem adequate. It has a meaning only in so far as the inclination existed to express in song tribal history and the deeds of heroes, a pattern that developed locally, but that is not of universal occurrence.

On the ground of the distribution of these types two conclusions may be established: the one that these forms are not necessary steps in the development of literary form, but that they occur only under certain conditions; the other that the forms are not determined by race, but depend upon historical happenings.

If at the time when Europeans first came to the New World the literature of the Americans did not possess the three types of literature which we mentioned, it does not follow that they would have appeared at a later time. We have no reason whatever to assume that American literature was less developed than that of Africa. On the contrary, the art of narrative and poetry are highly developed in many parts of America. We must rather assume that the historical conditions have led to a form different from that of the Old World.

The wide distribution of most of these forms among Europeans, Mongols, Malay, and Negro proves the independence of literary development from racial descent. It shows that it is one of the characteristics of the enormously extended cultural area, which embraces almost the whole of the Old World, and which in other features also appears in distinct contrast to the New World. I mention here only the development of a formal judicial procedure,

founded on the taking of evidence, the oath and the ordeal and the absence of this complex in America; and the absence in America of the belief in obsession and of the evil eye which are widely known in the Old World.

The characteristics of poetry lead us to a consideration of the forms of music. The only kind of music that is of universal occurrence is song; and the source of music must therefore be sought here. Universally valid characteristics of song will also be general principles of music. Two elements are common to all song: rhythm and fixed intervals. We have shown before that rhythm must not be conceived on the basis of our modern regularity as a sequence of measures of equal duration and somewhat free subdivision, but its form is much more general. Apparent irregularity must not be misinterpreted as a lack of rhythm, for in each repetition of a song the same order is preserved without change. Precisely as the rhythmic order in primitive decorative art is more complex than our own, so also is the rhythm of music liable to be more complex. Regular measures do occur, but they are not so rigidly confined to 2, 3 or 4 part time, as our own, but 5 and 7 part sequences frequently occur, in fact predominate in some types of music: five part rhythms are common in northwestern America, 7 part rhythms in southern Asia. Alterations of rhythms that seem unfamiliar to us are found, as well as very complex sequences that cannot be reduced to measures at all. We may best describe the rhythm of many types of primitive music as consisting of a regular sequence of musical phrases of irregular structure. Sometimes the phrases expand into long rhythmic units without recognisable subdivision.

A second and all-important element of all music is the use of fixed intervals which may be transposed from one point of the tone series to another and which are always recognized as equivalent. In singing, these intervals are naturally inaccurate, for intonation is uncertain and wavering and depends upon the intensity of emotional excitement. Intervals are liable to increase, as the emotions of the

singers are raised to a higher pitch. It is, therefore, difficult if not impossible to say what the singers intend to sing. The musical interval may be compared with the melody of language. Most languages do not use pitch in such a way that it is an important, significant part of articulation. The use of pitch in language is more widely distributed than is generally known. It is not by any means the exclusive feature of Chinese, but it occurs in Africa as well as in America, not to speak of its familiar use in the Scandinavian languages and in ancient Greek. Theoretically it is conceivable that early human speech might have used fixed intervals and musical phrasing of vowels and voiced consonants just as well as different timber of vowels (that is our *a, e, i, o, u,* and other vowel values), to express different ideas, but it cannot be proved that such was done. It is much more likely, according to available linguistic evidence that musical tone in language is a secondary development due to the disappearance of formative elements. We must also consider that in languages with tone, glides are of great importance and that these are not typical parts of the melodic sequence, although they occur as endings of phrases. Furthermore the intervals of speech are not fixed and vary considerably according to the position of the word in the phrase. It does not seem likely, therefore, that the melody can be derived directly from speech, as Herbert Spencer tried to do. I rather adhere to the opinion of Stumpf who demands a different origin for the fixed interval. The sustained cry is much more likely to use fixed intervals and stable tones.

Whatever their origin may have been, we must recognize the existence of fixed intervals and their transponability as the fundamental requirements of all music. It is true that in some languages the value of the fixed interval is keenly felt. This is demonstrated by the so-called drum language of West Africa in which the speech melody and rhythm is repeated on drums of definite tones and where these tone sequences are understood.

Further investigation of primitive music requires a study of the intervals themselves. Notwithstanding the great differences of

systems we find that all intervals may be interpreted as subdivisions of the octave. To the untrained ear the octave appears very commonly as a single tone; in other words, no distinction is made between a tone and its octave. To a lesser extent this is true of the fifth and even of the fourth. The majority of intervals that have been found must be considered as subdivisions of the octave. However, the subdivision does not always proceed according to harmonic principles as in our music, but by equidistant tones. The development of harmony in modern music has had the effect that we have lost all feeling for equidistance in a harmonic series and that the recent music in which non-harmonic equidistant tones are applied require a difficult break with the pattern of musical form to which we are accustomed. After a long struggle, we have reached a compromise between the two systems, the harmonic and the equidistant, by dividing the octave into twelve equal parts which give a fairly close agreement to the natural harmonic intervals, although the differences are audible to a trained ear. The Javanese divide the octave into seven equidistant steps, the Siamese into five, systems that are in fundamental conflict with those of our music. In short, a great variety of scales exist and serve as foundation for the musical systems of different people. All seem to have in common as foundation the octave.

I will not enter into this intricate subject any further, because a safe method has not yet been found that would enable us to tell definitely what people *want* to sing among whom there is no theory of music, as it exists among ourselves or the civilized people of Asia, and who have no exactly constructed instruments.

Among musical instruments one type is of universal distribution: the percussion instruments, or perhaps better instruments for producing noises that carry the rhythm of the song. In the simplest cases these are sticks with which boards or other resounding objects are struck. But besides these we find everywhere the use of some kind of a drum: wooden, hollow boxes, hollow cylinders or hoops covered with a drum head of skin. Rattles, and locally other

devices for producing noises occur. Not so general, for musical purposes, is the use of wind instruments. Whistles used as calls are perhaps universal, but the flute or pipe is not used everywhere as a musical instrument. Still more restricted is the use of stringed instruments. At the time of the discovery they were entirely unknown in America. Among primitive tribes, including the whole of America, song was accompanied only by rhythmic beating on instruments of percussion. It is interesting to note that the beats did not always coincide with the accent of the song, but had often an independent, though coordinated rhythm (see p. 315). Singing in several parts is also unknown in primitive music. In Africa solo singing and response of a chorus occurs, and a kind of polyphony due to the overlapping of these. Sometimes true singing in parts has been observed in Africa.

Music is always expressionistic and we are apt to associate with a tune and rhythm a definite mood, but these associations vary considerably with local styles. I have referred, in another place, to the feelings associated among ourselves with the major and minor keys. These are not by any means shared by people who have grown up under the influence of another musical style. It is likely that the symbolic meaning of music alone is vaguer than that of song; but it is difficult to reach a definite decision in regard to this question, for there is very little music without song or without association with symbolic or representative actions. The condition is perhaps comparable to that found in the symbolic significance of graphic and plastic arts, the connotations of which are, as we have seen, certain only when a definite relation between form and implied content exist. It is intelligible that a type of tune that is always applied in mourning ceremonies will produce the proper emotional effect, while the same type of tune without such definite setting might have quite a different effect.

The present state of our knowledge of primitive music does not permit us to establish definite musical areas, but enough is known to prove that as all other cultural features, we may recognize a

series of musical areas, each characterized by common fundamental traits. The narrow compass of tunes of east Siberian songs, the falling cadence with repetition of motives on a falling series of fundamental tones among the Plains Indians, the antiphony of Negro songs are examples of this kind. The varying systems of tonality, the use of purely instrumental music, the kind of accompaniment of song, are others. It seems quite certain that it will be possible to determine large areas in which, by diffusion, similar types of musical art have developed and in which, by subdivision, local types may be segregated similar in character to those found in decorative art. Even in the modern folk music of Europe a definite character of the folkmusic of each nation may be recognized. Borrowed melodies adapted to local forms illustrate this type of individuality. As an example of such adaptation I give on the next page a German song which has been adopted by the Mexicans. It was probably carried there by the army of Maximilian.

On account of the interrelation between body movements and articulations it seems likely that rhythmic body movements release rhythmic articulations, that is song; and that in this sense, songs that consist of meaningless syllables may have their origin in movement. On the other hand the excitement engendered by song leads to movements that are related to the rhythm of the song, so that in this sense, a dance is conditioned by the song. We mean here by dance, the rhythmic movements of any part of the body, swinging of the arms, movement of the trunk or head, or movements of the legs and feet. The two forms of expression are mutually determined.

We have to remember here the general remarks which we made in the beginning in regard to all art. We saw that without a formal element art does not exist. Technical work without fixed form does not create artistic enjoyment. In the same way violent, expressive movement born of the passion of the moment is not art. Art as an expression of feeling requires form as much as art born of the control of technical processes. If it were not selfevident we might

have pointed out also that the passionate cry is neither poetry nor music. It is, therefore, not appropriate to call dance all the violent movements that occur in the lives of primitive people. We must reserve the term to movements of fixed form, although it may be recognized that in the height of excitement dance may turn into a formless tumult of motion, as music may change to formless cries of wildest excitement.

We observe among all primitive tribes that emotions finding vent in motor activities adopt a definite form. In this sense dance as an art form may be purely formal, that is, devoid of symbolic meaning. Its esthetic effect may be founded on the enjoyment of body movement, often reinforced by that emotional excitement that is released by the dance movement. The more formal the dance, the stronger will be the purely esthetic enjoyment, as against the emotional element.

We are not well informed in regard to the local distribution of dance types among primitive people but enough is known to allow us to state that, as in decorative art and in music, areas of similar dance forms occur. The joint dances of the Pueblo Indians in which participate a large number of dancers dressed alike and in formation, are quite foreign to the North Pacific coast where the single dance prevails. In the formal woman's dance of the Northwest Coast, the dancer stays in the same place with hands raised to the height of the face, palms forward and trembling. The body movements are carried on by gentle bending of the knees and slight swaying of the body. The Koryak dancer who holds the drum, moves in quite another way, swinging his body from the hips and beating the drum (see fig. 73, p. 79). Joint dances of the two sexes are rare and the dancers do not often so move that their bodies are in intimate contact. We find more frequently either single dances or a number of performers who repeat the same movements. The effectiveness of the dance is increased by the order in which the dancers stand and move.

Symbolic movements are perhaps even more frequent than purely formal dance. They are used not only in accompanying song but

also in oratory, and the muscular play accompanying lively conversation of both the speaker and the hearer is a manifestation of the relation between language and symbolic movements. These are also standardized in each cultural area. The number of organically determined gestures is very small. Most of them are culturally patterned. Many are so automatic that they are called forth immediately by the form of thought. In other cases the speaker enhances the effect of his words by appropriate gestures and the meaning of song is often brought out more vividly by significant movements. Thus the chorus of the Indians of the Pueblo of Laguna sing:

> "In the east rises the sun youth,
> Here westward he moves with life and vegetation.
> Carrying them in his basket while he is walking along."

When this song is sung the singer faces westward and moves forward. The word "vegetation" is expressed by pushing the hands alternately upward; "basket" by describing a wide circle with both hands and bringing them together in front of the body. The gesture expresses the act of carrying in a basket. The word "walking" is indicated by stretching the hands out forward in front of the body and waving them up and up.

The Kwakiutl sing as follows:[1]

> "I am going around the world eating everywhere with
> Cannibal-at-the-North-End-of-the-World.
> I went to the center of the world; Cannibal-at-the-
> North-End-of-the-World is crying "food".

The dancer accompanies this song which is sung by a chorus, with movements. His arms tremble from right to left. To the words, "I am going" the arms are stretched out to one side; "All around the world", they swing around in a round circle; "I," the shoulders are alternately brought forward and backward; "eating everywhere",

[1] F. Boas, Social Organization and Secret Societies of the Kwakiutl Indians, Annual Report of the United States National Museum, 1895, p. 457.

the right hand stretches far out as though it was taking food, and is then brought to the mouth, while the left describes a wide circle, indicating "everywhere"; "Cannibal-at-the-North-End-of-the-World", both hands are bent inward and the finger tips moved toward the mouth, meaning "the eater"; "I went" is expressed as before; "Cannibal-at-North-End-of-the-World is crying 'food' for me", the sign of the cannibal spirit is made; then the arms are stretched far backward, the palms turned downward, and the head is lowered, this being the cannibal spirit's attitude when crying "food". "At the center of the world", when these words are sung the dancer is in front of the fire and looks up to the rear of the house in the characteristic attitude of the cannibal, the rear of the house being the center of the world.

The further development of movement accompanying the song leads to true pantomimic and ultimately to dramatic performances.

CONCLUSION

We have now completed our review of the forms of primitive art and we shall try to sum up the results of our inquiry.

We have seen that art arises from two sources, from technical pursuits and from the expression of emotions and thought, as soon as these take fixed forms. The more energetic the control of form over uncoordinated movement, the more esthetic the result. Artistic enjoyment is, therefore, based essentially upon the reaction of our minds to form. The same kind of enjoyment may be released by impressions received from forms that are not the handiwork of man, but they may not be considered as art, although the esthetic reaction is not different from the one we receive from the contemplation or the hearing of a work of art. When speaking of artistic production they must be excluded. When considering only esthetic reactions they must be included.

The esthetic effect of artistic work developing from the control of technique alone is based on the joy engendered by the mastery of technique and also by the pleasure produced by the perfection of form. The enjoyment of form may have an elevating effect upon the mind, but this is not its primary effect. Its source is in part the pleasure of the virtuoso who overcomes technical difficulties that baffle his cleverness. As long as no deeper meaning is felt in the significance of form, its effect is for most individuals, pleasurable, not elevating.

We have seen that in the various arts definite formal principles manifest themselves, the origin of which we did not try to explain, but which we accepted as present in the art of man the world over, and which for this reason we considered as the most ancient, the most fundamental characteristics of all art. In the graphic and plastic arts these elements are symmetry, rhythm and emphasis of form. We found symmetry to be very generally right and left and

suggested that this may be due to the symmetry of manual movements as well as to the observation of right and left symmetry in animals and in man. We also observed that rhythmic repetition runs ordinarily in horizontal bands and pointed out the general experience that natural objects of the same or similar kind are arranged in horizontal strata, such as woods, mountains, and clouds; legs, body and limbs. Rhythmic form seems to be closely related to technical processes, although other causes of rhythmic repetition are revealed in poetry. The simplest technical processes produce a simple repetition of the same motives, while with increasing virtuosity more complex orders become the rule. The more virtuosity is developed, the more complex are the rhythms that are liable to make their appearance. The ability of primitive artists to appreciate rhythm seems to be much greater than our own.

The desire to emphasize form made itself felt in the application of lines to the rim. We also observed the tendency of the rim designs to become exuberant and to encroach upon the decorative field. No less important is the tendency to attach ornament to prominent places of the decorated object and to divide the decorative field according to fixed principles.

While the features so far considered are common characteristics of art the world over, they do not explain the style of separate areas. We considered this problem in some detail in the field of decorative art. Here our attention was first arrested by the fact that purely formal art, or perhaps better, art that is apparently purely formal, is given a meaning endowing it with an emotional value that does not belong to the beauty of form alone. It is an expressionistic element that is common to many forms of primitive art. It is effective because in the mind of the tribes certain forms are symbols of a limited range of ideas. The firmer the association between a form and a definite idea, the more clearly stands out the expressionistic character of the art. This is true in the graphic and plastic arts as well as in music. In the former a geometrical form, in the latter a sound cluster, a particular type of musical phrasing,

if associated with a definite meaning, evokes definite emotions or even concepts. A study of these conditions shows also that a uniform reaction to form is indispensable for the effectiveness of an expressionistic art, a condition which is not fulfilled in our own modern society, so that an expressionistic art can appeal only to a circle of adepts who follow the lines of thought and feeling developed by a master. Symbolic art can still be applied successfully in the case of a few symbols that have fixed associations which are valid for all of us.

The wide distribution of symbolic forms and the remoteness of their resemblance to the objects they symbolize led us to a consideration of the question of their history. We examined particularly the theory that all artistic reproduction is by origin naturalistic and that geometrization grows up only when the artist tries to introduce ideas that are not inherent in the object itself. We saw that this theory cannot be maintained, because realistic representation and geometrization spring from distinctive sources. In plastic art the contrast between the two tendencies does not appear as clearly as in graphic art. In the former it is found more in surface treatment than in general outline. In graphic art the matter is complicated by the difficulties involved in representing a three-dimensional object on a two-dimensional surface, a problem which the artist has to solve. This may be done in one of two ways. Either a perspective representation of the object as it appears at a given moment may be attempted, or the artist may decide that the essential point is to show all its characteristic parts, no matter whether they are visible in a single view or not. The former method lays stress upon the accidental features, it is impressionistic; the latter stresses those elements that are felt to constitute the fundamental qualities of the object, it is expressionistic. The two methods which we called the symbolic and the perspective are absolutely distinct and the one cannot be developed from the other. We have also seen that the consistent application of the perspective method is reached only when we introduce also the principle of indistinctness of those points

that are removed from the center of the field of vision and that of dependence of color upon environment. Both of these have been tried in our day, without having found general acceptance. The symbolic method is always more or less wavering in the application of its principle. Sometimes perspective correctness of outline is attempted with a considerable degree of freedom in regard to the detailed treatment of those symbols that are considered important. Of this character are the Egyptian paintings with their vacillation between front and side views. In other cases the realism of outline is entirely sacrificed and the form may be reduced to a mere assembly of symbols.

The theory has been advanced that geometric ornament developed through the degeneration of perspective designs; in part perhaps also through that of symbolic designs. It is assumed that the symbol, or the object represented was misunderstood and that in course of time through a process of slurring, by careless and inaccurate representation the forms became fragmentary and finally lost all semblance to the original. It is not possible to accept this theory, because the conditions under which the supposed slurring occurs are seldom realized. Slovenly work does not occur in an untouched primitive culture. Misunderstandings may happen in cases of borrowing of designs or in that of a gradual transformation of those concepts that find expression in decorative art. Actual slurring is found in factory production. By an examination of a few cases of this kind we were able to show that it does not lead to geometrization, but to the growth of an individualism akin to that of our handwriting. It cannot be denied that in such cases occasion for re-interpretation with consequent changes of form occur, but these are not frequent. On the other hand we were able to show that reading-in of realistic meanings into geometric forms is quite common. We proved this by means of a detailed comparison of the style of painting and embroidery of the North American Plains Indians which we found to be practically identical everywhere, while the interpretations varied from tribe to tribe. This phenomenon agrees

with the general tendency to keep intact the form, but to endow it with new meaning according to the chief cultural interests of the people. We pointed out the prevalence of the same tendency in folktales and ritual. As a general explanation the geometrization of realistic patterns is, therefore, unacceptable. In the majority of cases it seems to be rather due to the inclination of man to give a meaning to geometric form, as we enjoy reading meanings into the forms of clouds and mountains. We were also able to describe a few cases in which the process of reading-in has actually been observed.

Another fact prevents us from considering geometrization as a general historical process. It is very seldom only that the steps are found so distributed that they can be proved to follow one another in time. Much oftener all are found at the same time among the same people.

Considering all these points we reached the conclusion that the stylistic form which contains to a greater or lesser extent constant geometrical elements, is decisive in determining the manner in which representations are rendered. We were thus led to the attempt to find the principles underlying art styles.

We approached this subject by the study of a few art forms. We compared a number of art styles that make use of the spiral and found in each characteristic traits, as well regarding the form of the spiral as in the handling of the decorative field. In the same way we observed that in the art of the North American Indians the same kind of triangles and rectangles are used by all the tribes, but that there exist typical differences in the treatment of the decorative field. The problem was carried through in some detail by means of a study of the decorative art of the North Pacific coast which is highly symbolic in character. This example taught us an additional point, namely that in symbolic art the selection of symbols is of decisive importance in defining the style and that the arrangement of the symbols is subject to the same formal treatment of the decorative field which control the arrangement of geometrical motives.

On the basis of this study we conclude that the particular types of geometrical motives that enter into the representative form, as well as the treatment of the decorative field determine the character of the design and that the degree of realism depends upon the relative importance of the geometric and representative elements. When the purely decorative tendency prevails we have essentially geometrical, highly conventionalized forms, when the idea of representation prevails, we have, on the contrary, more realistic forms. In every case, however, the formal element that characterizes the style, is older than the particular type of representation. This does not signify that early representations do not occur, it means that the method of representation was always controlled by formal elements of distinctive origin.

The pattern of artistic expression that emerges from a long, cumulative process determined by a multiplicity of causes fashions the form of the art work. We recognize the permanence of pattern in those cases in which a useful form that has lost its function persists as a decorative element; in the imitation in new materials of natural forms used at one time as utensils, and in the transfer of forms from one technique to another. The fixity of the pattern does not permit the artist to apply natural forms unmodified to decorative purposes. His imagination is limited by the pattern. In cases of greater freedom the representative value may not be seriously encroached upon. Such is the case for instance, with the oriental palmetto and the ear ornaments of the Marquesas Islands, on which in olden times two deities were represented, back to back, while nowadays two girls in a swing are carved, in exactly the same spacial arrangement. When the pattern is highly formal and not adapted to representation, an apparent geometrization may be the result. The distinction between these two aspects appears clearly in those cases in which pictography and symbolic geometric art appear side by side.

The art of the North Pacific coast proved also that we must not assume that the style of a tribe must always be uniform, but that

it is quite possible that in different industries, particularly when carried along by different parts of the population, quite distinctive styles may prevail. The excellence and consistency of a style as well as the multiplicity of forms depend upon the perfection of technique. We found, therefore, that in those cases in which technical work is done by the men alone, they are the creative artists, that when the women do a great deal of technical work they are no less productive, and that when the two sexes carry on different industries they may develop distinctive styles. It is, however, more frequent that the style of a dominant industry may be imposed upon work made by other processes. Weaving in coarse material seemed to be a most fertile source of patterns that are imitated in paintings, carvings, and pottery.

A comparison of the fundamental elements that are found in the graphic and plastic arts,— in the arts of space,— as contrasted with those of poetry, music, and dance,— the arts of time,— brings out certain differences and similarities. Common to both are rhythm, and it seems likely that the rhythm of technique is merely a spacial expression of the rhythm of time, in so far as the rhythmic movements result in rhythmic forms when applied to technical pursuits. We may perhaps also speak in both types of art of attempts to emphasize closed forms, for often we find musical phrases, and single ideas in poetry closed by what might be called a decorative end, consisting of burdens or of codas. Similar elements may also appear as introductions in the beginning. Completely lacking in the pure arts of time is symmetry, because an inverted time order does not convey the impression of symmetry, as is the case in the arts of space. It occurs only in a symmetrical arrangement of phrases. Dance contains elements of both the spacial and time arts. Therefore, the principles of the former may be clearly observed in dance forms. Rhythmic movements and rhythmic spacial order, symmetry of position and of movement, and emphasis and balance of form are essential in esthetic dance forms.

The graphic and plastic arts owe much of their emotional value

to the representative and symbolic values of form. This is no less true in literature, music and dance. Narrative and poetry so far as they contain intelligible words, always have a meaning which may have a deep significance because they touch upon those aspects of life that stir the emotions. Frequently there is an added meaning, when the words have a symbolic, ulterior significance related to religious beliefs or philosophical ideas. In music and dance also symbolic significance is often attached to form.

We are at the end of our considerations, but one question remains to be answered. We have seen that the desire for artistic expression is universal. We may even say that the mass of the population in primitive society feels the need of beautifying their lives more keenly than civilized man, at least more than those whose lives are spent under the urgent necessity of acquiring the meagre means of sustenance. But among others also the desire for comfort has often superseded the desire for beauty. Among primitive people the καλόν κ'αγαθόν coincide. Goodness and beauty are the same. Do they then possess the same keenness of esthetic appreciation that is found at least in part of our population? I believe we may safely say that in the narrow field of art that is characteristic of each people the enjoyment of beauty is quite the same as among ourselves: intense among a few, slight among the mass. The readiness to abandon one's self to the exaltation induced by art, is probably greater, because the conventional restraint of our times does not exist in the same forms in their lives. What distinguishes modern esthetic feeling from that of primitive people is the manifold character of its manifestations. We are not so much bound by a fixed style. The complexity of our social structure and our more varied interests allow us to see beauties that are closed to the senses of people living in a narrower culture. It is the quality of their experience, not a difference in mental make-up that determines the difference between modern and primitive art production and art appreciation.

TEXT FIGURES

EXPLANATION OF PLATES

NAME INDEX

A CATALOGUE OF SELECTED DOVER BOOKS
IN ALL FIELDS OF INTEREST

A CATALOGUE OF SELECTED DOVER BOOKS
IN ALL FIELDS OF INTEREST

AMERICA'S OLD MASTERS, James T. Flexner. Four men emerged unexpectedly from provincial 18th century America to leadership in European art: Benjamin West, J. S. Copley, C. R. Peale, Gilbert Stuart. Brilliant coverage of lives and contributions. Revised, 1967 edition. 69 plates. 365pp. of text.

21806-6 Paperbound $3.00

FIRST FLOWERS OF OUR WILDERNESS: AMERICAN PAINTING, THE COLONIAL PERIOD, James T. Flexner. Painters, and regional painting traditions from earliest Colonial times up to the emergence of Copley, West and Peale Sr., Foster, Gustavus Hesselius, Feke, John Smibert and many anonymous painters in the primitive manner. Engaging presentation, with 162 illustrations. xxii + 368pp.

22180-6 Paperbound $3.50

THE LIGHT OF DISTANT SKIES: AMERICAN PAINTING, 1760-1835, James T. Flexner. The great generation of early American painters goes to Europe to learn and to teach: West, Copley, Gilbert Stuart and others. Allston, Trumbull, Morse; also contemporary American painters—primitives, derivatives, academics—who remained in America. 102 illustrations. xiii + 306pp. 22179-2 Paperbound $3.50

A HISTORY OF THE RISE AND PROGRESS OF THE ARTS OF DESIGN IN THE UNITED STATES, William Dunlap. Much the richest mine of information on early American painters, sculptors, architects, engravers, miniaturists, etc. The only source of information for scores of artists, the major primary source for many others. Unabridged reprint of rare original 1834 edition, with new introduction by James T. Flexner, and 394 new illustrations. Edited by Rita Weiss. 6⅝ x 9⅝.

21695-0, 21696-9, 21697-7 Three volumes, Paperbound $13.50

EPOCHS OF CHINESE AND JAPANESE ART, Ernest F. Fenollosa. From primitive Chinese art to the 20th century, thorough history, explanation of every important art period and form, including Japanese woodcuts; main stress on China and Japan, but Tibet, Korea also included. Still unexcelled for its detailed, rich coverage of cultural background, aesthetic elements, diffusion studies, particularly of the historical period. 2nd, 1913 edition. 242 illustrations. lii + 439pp. of text.

20364-6, 20365-4 Two volumes, Paperbound $6.00

THE GENTLE ART OF MAKING ENEMIES, James A. M. Whistler. Greatest wit of his day deflates Oscar Wilde, Ruskin, Swinburne; strikes back at inane critics, exhibitions, art journalism; aesthetics of impressionist revolution in most striking form. Highly readable classic by great painter. Reproduction of edition designed by Whistler. Introduction by Alfred Werner. xxxvi + 334pp.

21875-9 Paperbound $3.00

VISUAL ILLUSIONS: THEIR CAUSES, CHARACTERISTICS, AND APPLICATIONS, Matthew Luckiesh. Thorough description and discussion of optical illusion, geometric and perspective, particularly; size and shape distortions, illusions of color, of motion; natural illusions; use of illusion in art and magic, industry, etc. Most useful today with op art, also for classical art. Scores of effects illustrated. Introduction by William H. Ittleson. 100 illustrations. xxi + 252pp.

21530-X Paperbound $2.00

A HANDBOOK OF ANATOMY FOR ART STUDENTS, Arthur Thomson. Thorough, virtually exhaustive coverage of skeletal structure, musculature, etc. Full text, supplemented by anatomical diagrams and drawings and by photographs of undraped figures. Unique in its comparison of male and female forms, pointing out differences of contour, texture, form. 211 figures, 40 drawings, 86 photographs. xx + 459pp. 5⅜ x 8⅜. 21163-0 Paperbound $3.50

150 MASTERPIECES OF DRAWING, Selected by Anthony Toney. Full page reproductions of drawings from the early 16th to the end of the 18th century, all beautifully reproduced: Rembrandt, Michelangelo, Dürer, Fragonard, Urs, Graf, Wouwerman, many others. First-rate browsing book, model book for artists. xviii + 150pp. 8⅜ x 11¼. 21032-4 Paperbound' $2.50

THE LATER WORK OF AUBREY BEARDSLEY, Aubrey Beardsley. Exotic, erotic, ironic masterpieces in full maturity: Comedy Ballet, Venus and Tannhauser, Pierrot, Lysistrata, Rape of the Lock, Savoy material, Ali Baba, Volpone, etc. This material revolutionized the art world, and is still powerful, fresh, brilliant. With *The Early Work,* all Beardsley's finest work. 174 plates, 2 in color. xiv + 176pp. 8⅛ x 11. 21817-1 Paperbound $3.00

DRAWINGS OF REMBRANDT, Rembrandt van Rijn. Complete reproduction of fabulously rare edition by Lippmann and Hofstede de Groot, completely reedited, updated, improved by Prof. Seymour Slive, Fogg Museum. Portraits, Biblical sketches, landscapes, Oriental types, nudes, episodes from classical mythology—All Rembrandt's fertile genius. Also selection of drawings by his pupils and followers. "Stunning volumes," *Saturday Review.* 550 illustrations. lxxviii + 552pp. 9⅛ x 12¼. 21485-0, 21486-9 Two volumes, Paperbound $10.00

THE DISASTERS OF WAR, Francisco Goya. One of the masterpieces of Western civilization—83 etchings that record Goya's shattering, bitter reaction to the Napoleonic war that swept through Spain after the insurrection of 1808 and to war in general. Reprint of the first edition, with three additional plates from Boston's Museum of Fine Arts. All plates facsimile size. Introduction by Philip Hofer, Fogg Museum. v + 97pp. 9⅜ x 8¼. 21872-4 Paperbound $2.00

GRAPHIC WORKS OF ODILON REDON. Largest collection of Redon's graphic works ever assembled: 172 lithographs, 28 etchings and engravings, 9 drawings. These include some of his most famous works. All the plates from *Odilon Redon: oeuvre graphique complet,* plus additional plates. New introduction and caption translations by Alfred Werner. 209 illustrations. xxvii + 209pp. 9⅛ x 12¼. 21966-8 Paperbound $4.00

DESIGN BY ACCIDENT; A BOOK OF "ACCIDENTAL EFFECTS" FOR ARTISTS AND DESIGNERS, James F. O'Brien. Create your own unique, striking, imaginative effects by "controlled accident" interaction of materials: paints and lacquers, oil and water based paints, splatter, crackling materials, shatter, similar items. Everything you do will be different; first book on this limitless art, so useful to both fine artist and commercial artist. Full instructions. 192 plates showing "accidents," 8 in color. viii + 215pp. 8⅜ x 11¼. 21942-9 Paperbound $3.50

THE BOOK OF SIGNS, Rudolf Koch. Famed German type designer draws 493 beautiful symbols: religious, mystical, alchemical, imperial, property marks, runes, etc. Remarkable fusion of traditional and modern. Good for suggestions of timelessness, smartness, modernity. Text. vi + 104pp. 6⅛ x 9¼. 20162-7 Paperbound $1.25

HISTORY OF INDIAN AND INDONESIAN ART, Ananda K. Coomaraswamy. An unabridged republication of one of the finest books by a great scholar in Eastern art. Rich in descriptive material, history, social backgrounds; Sunga reliefs, Rajput paintings, Gupta temples, Burmese frescoes, textiles, jewelry, sculpture, etc. 400 photos. viii + 423pp. 6⅜ x 9¾. 21436-2 Paperbound $5.00

PRIMITIVE ART, Franz Boas. America's foremost anthropologist surveys textiles, ceramics, woodcarving, basketry, metalwork, etc.; patterns, technology, creation of symbols, style origins. All areas of world, but very full on Northwest Coast Indians. More than 350 illustrations of baskets, boxes, totem poles, weapons, etc. 378 pp. 20025-6 Paperbound $3.00

THE GENTLEMAN AND CABINET MAKER'S DIRECTOR, Thomas Chippendale. Full reprint (third edition, 1762) of most influential furniture book of all time, by master cabinetmaker. 200 plates, illustrating chairs, sofas, mirrors, tables, cabinets, plus 24 photographs of surviving pieces. Biographical introduction by N. Bienenstock. vi + 249pp. 9⅞ x 12¾. 21601-2 Paperbound $4.00

AMERICAN ANTIQUE FURNITURE, Edgar G. Miller, Jr. The basic coverage of all American furniture before 1840. Individual chapters cover type of furniture— clocks, tables, sideboards, etc.—chronologically, with inexhaustible wealth of data. More than 2100 photographs, all identified, commented on. Essential to all early American collectors. Introduction by H. E. Keyes. vi + 1106pp. 7⅞ x 10¾. 21599-7, 21600-4 Two volumes, Paperbound $11.00

PENNSYLVANIA DUTCH AMERICAN FOLK ART, Henry J. Kauffman. 279 photos, 28 drawings of tulipware, Fraktur script, painted tinware, toys, flowered furniture, quilts, samplers, hex signs, house interiors, etc. Full descriptive text. Excellent for tourist, rewarding for designer, collector. Map. 146pp. 7⅞ x 10¾. 21205-X Paperbound $2.50

EARLY NEW ENGLAND GRAVESTONE RUBBINGS, Edmund V. Gillon, Jr. 43 photographs, 226 carefully reproduced rubbings show heavily symbolic, sometimes macabre early gravestones, up to early 19th century. Remarkable early American primitive art, occasionally strikingly beautiful; always powerful. Text. xxvi + 207pp. 8⅜ x 11¼. 21380-3 Paperbound $3.50

ALPHABETS AND ORNAMENTS, Ernst Lehner. Well-known pictorial source for decorative alphabets, script examples, cartouches, frames, decorative title pages, calligraphic initials, borders, similar material. 14th to 19th century, mostly European. Useful in almost any graphic arts designing, varied styles. 750 illustrations. 256pp. 7 x 10. 21905-4 Paperbound $4.00

PAINTING: A CREATIVE APPROACH, Norman Colquhoun. For the beginner simple guide provides an instructive approach to painting: major stumbling blocks for beginner; overcoming them, technical points; paints and pigments; oil painting; watercolor and other media and color. New section on "plastic" paints. Glossary. Formerly *Paint Your Own Pictures.* 221pp. 22000-1 Paperbound $1.75

THE ENJOYMENT AND USE OF COLOR, Walter Sargent. Explanation of the relations between colors themselves and between colors in nature and art, including hundreds of little-known facts about color values, intensities, effects of high and low illumination, complementary colors. Many practical hints for painters, references to great masters. 7 color plates, 29 illustrations. x + 274pp.
20944-X Paperbound $2.75

THE NOTEBOOKS OF LEONARDO DA VINCI, compiled and edited by Jean Paul Richter. 1566 extracts from original manuscripts reveal the full range of Leonardo's versatile genius: all his writings on painting, sculpture, architecture, anatomy, astronomy, geography, topography, physiology, mining, music, etc., in both Italian and English, with 186 plates of manuscript pages and more than 500 additional drawings. Includes studies for the Last Supper, the lost Sforza monument, and other works. Total of xlvii + 866pp. 7⅞ x 10¾.
22572-0, 22573-9 Two volumes, Paperbound $10.00

MONTGOMERY WARD CATALOGUE OF 1895. Tea gowns, yards of flannel and pillow-case lace, stereoscopes, books of gospel hymns, the New Improved Singer Sewing Machine, side saddles, milk skimmers, straight-edged razors, high-button shoes, spittoons, and on and on . . . listing some 25,000 items, practically all illustrated. Essential to the shoppers of the 1890's, it is our truest record of the spirit of the period. Unaltered reprint of Issue No. 57, Spring and Summer 1895. Introduction by Boris Emmet. Innumerable illustrations. xiii + 624pp. 8½ x 11⅝.
22377-9 Paperbound $6.95

THE CRYSTAL PALACE EXHIBITION ILLUSTRATED CATALOGUE (LONDON, 1851). One of the wonders of the modern world—the Crystal Palace Exhibition in which all the nations of the civilized world exhibited their achievements in the arts and sciences—presented in an equally important illustrated catalogue. More than 1700 items pictured with accompanying text—ceramics, textiles, cast-iron work, carpets, pianos, sleds, razors, wall-papers, billiard tables, beehives, silverware and hundreds of other artifacts—represent the focal point of Victorian culture in the Western World. Probably the largest collection of Victorian decorative art ever assembled—indispensable for antiquarians and designers. Unabridged republication of the Art-Journal Catalogue of the Great Exhibition of 1851, with all terminal essays. New introduction by John Gloag, F.S.A. xxxiv + 426pp. 9 x 12.
22503-8 Paperbound $5.00

A History of Costume, Carl Köhler. Definitive history, based on surviving pieces of clothing primarily, and paintings, statues, etc. secondarily. Highly readable text, supplemented by 594 illustrations of costumes of the ancient Mediterranean peoples, Greece and Rome, the Teutonic prehistoric period; costumes of the Middle Ages, Renaissance, Baroque, 18th and 19th centuries. Clear, measured patterns are provided for many clothing articles. Approach is practical throughout. Enlarged by Emma von Sichart. 464pp. 21030-8 Paperbound $3.50.

Oriental Rugs, Antique and Modern, Walter A. Hawley. A complete and authoritative treatise on the Oriental rug—where they are made, by whom and how, designs and symbols, characteristics in detail of the six major groups, how to distinguish them and how to buy them. Detailed technical data is provided on periods, weaves, warps, wefts, textures, sides, ends and knots, although no technical background is required for an understanding. 11 color plates, 80 halftones, 4 maps. vi + 320pp. 6⅛ x 9⅛. 22366-3 Paperbound $5.00

Ten Books on Architecture, Vitruvius. By any standards the most important book on architecture ever written. Early Roman discussion of aesthetics of building, construction methods, orders, sites, and every other aspect of architecture has inspired, instructed architecture for about 2,000 years. Stands behind Palladio, Michelangelo, Bramante, Wren, countless others. Definitive Morris H. Morgan translation. 68 illustrations. xii + 331pp. 20645-9 Paperbound $3.00

The Four Books of Architecture, Andrea Palladio. Translated into every major Western European language in the two centuries following its publication in 1570, this has been one of the most influential books in the history of architecture. Complete reprint of the 1738 Isaac Ware edition. New introduction by Adolf Placzek, Columbia Univ. 216 plates. xxii + 110pp. of text. 9½ x 12¾. 21308-0 Clothbound $10.00

Sticks and Stones: A Study of American Architecture and Civilization, Lewis Mumford.One of the great classics of American cultural history. American architecture from the medieval-inspired earliest forms to the early 20th century; evolution of structure and style, and reciprocal influences on environment. 21 photographic illustrations. 238pp. 20202-X Paperbound $2.00

The American Builder's Companion, Asher Benjamin. The most widely used early 19th century architectural style and source book, for colonial up into Greek Revival periods. Extensive development of geometry of carpentering, construction of sashes, frames, doors, stairs; plans and elevations of domestic and other buildings. Hundreds of thousands of houses were built according to this book, now invaluable to historians, architects, restorers, etc. 1827 edition. 59 plates. 114pp. 7⅞ x 10¾. 22236-5 Paperbound $3.50

Dutch Houses in the Hudson Valley Before 1776, Helen Wilkinson Reynolds. The standard survey of the Dutch colonial house and outbuildings, with constructional features, decoration, and local history associated with individual homesteads. Introduction by Franklin D. Roosevelt. Map. 150 illustrations. 469pp. 6⅝ x 9¼. 21469-9 Paperbound

THE ARCHITECTURE OF COUNTRY HOUSES, Andrew J. Downing. Together with Vaux's *Villas and Cottages* this is the basic book for Hudson River Gothic architecture of the middle Victorian period. Full, sound discussions of general aspects of housing, architecture, style, decoration, furnishing, together with scores of detailed house plans, illustrations of specific buildings, accompanied by full text. Perhaps the most influential single American architectural book. 1850 edition. Introduction by J. Stewart Johnson. 321 figures, 34 architectural designs. xvi + 560pp.
22003-6 Paperbound $4.00

LOST EXAMPLES OF COLONIAL ARCHITECTURE, John Mead Howells. Full-page photographs of buildings that have disappeared or been so altered as to be denatured, including many designed by major early American architects. 245 plates. xvii + 248pp. 7⅞ x 10¾. 21143-6 Paperbound $3.50

DOMESTIC ARCHITECTURE OF THE AMERICAN COLONIES AND OF THE EARLY REPUBLIC, Fiske Kimball. Foremost architect and restorer of Williamsburg and Monticello covers nearly 200 homes between 1620-1825. Architectural details, construction, style features, special fixtures, floor plans, etc. Generally considered finest work in its area. 219 illustrations of houses, doorways, windows, capital mantels. xx + 314pp. 7⅞ x 10¾. 21743-4 Paperbound $4.00

EARLY AMERICAN ROOMS: 1650-1858, edited by Russell Hawes Kettell. Tour of 12 rooms, each representative of a different era in American history and each furnished, decorated, designed and occupied in the style of the era. 72 plans and elevations, 8-page color section, etc., show fabrics, wall papers, arrangements, etc. Full descriptive text. xvii + 200pp. of text. 8⅜ x 11¼.
21633-0 Paperbound $5.00

THE FITZWILLIAM VIRGINAL BOOK, edited by J. Fuller Maitland and W. B. Squire. Full modern printing of famous early 17th-century ms. volume of 300 works by Morley, Byrd, Bull, Gibbons, etc. For piano or other modern keyboard instrument; easy to read format. xxxvi + 938pp. 8⅜ x 11.
21068-5, 21069-3 Two volumes, Paperbound $10.00

KEYBOARD MUSIC, Johann Sebastian Bach. Bach Gesellschaft edition. A rich selection of Bach's masterpieces for the harpsichord: the six English Suites, six French Suites, the six Partitas (Clavierübung part I), the Goldberg Variations (Clavierübung part IV), the fifteen Two-Part Inventions and the fifteen Three-Part Sinfonias. Clearly reproduced on large sheets with ample margins; eminently playable. vi + 312pp. 8⅛ x 11. 22360-4 Paperbound $5.00

THE MUSIC OF BACH: AN INTRODUCTION, Charles Sanford Terry. A fine, nontechnical introduction to Bach's music, both instrumental and vocal. Covers organ music, chamber music, passion music, other types. Analyzes themes, developments, innovations. x + 114pp. 21075-8 Paperbound $1.50

BEETHOVEN AND HIS NINE SYMPHONIES, Sir George Grove. Noted British musicologist provides best history, analysis, commentary on symphonies. Very thorough, rigorously accurate; necessary to both advanced student and amateur music lover. 436 musical passages. vii + 407 pp. 20334-4 Paperbound $2.75

JOHANN SEBASTIAN BACH, Philipp Spitta. One of the great classics of musicology, this definitive analysis of Bach's music (and life) has never been surpassed. Lucid, nontechnical analyses of hundreds of pieces (30 pages devoted to St. Matthew Passion, 26 to B Minor Mass). Also includes major analysis of 18th-century music. 450 musical examples. 40-page musical supplement. Total of xx + 1799pp.

(EUK) 22278-0, 22279-9 Two volumes, Clothbound $17.50

MOZART AND HIS PIANO CONCERTOS, Cuthbert Girdlestone. The only full-length study of an important area of Mozart's creativity. Provides detailed analyses of all 23 concertos, traces inspirational sources. 417 musical examples. Second edition. 509pp. 21271-8 Paperbound $3.50

THE PERFECT WAGNERITE: A COMMENTARY ON THE NIBLUNG'S RING, George Bernard Shaw. Brilliant and still relevant criticism in remarkable essays on Wagner's Ring cycle, Shaw's ideas on political and social ideology behind the plots, role of Leitmotifs, vocal requisites, etc. Prefaces. xxi + 136pp.

(USO) 21707-8 Paperbound $1.50

DON GIOVANNI, W. A. Mozart. Complete libretto, modern English translation; biographies of composer and librettist; accounts of early performances and critical reaction. Lavishly illustrated. All the material you need to understand and appreciate this great work. Dover Opera Guide and Libretto Series; translated and introduced by Ellen Bleiler. 92 illustrations. 209pp.

21134-7 Paperbound $2.00

BASIC ELECTRICITY, U. S. Bureau of Naval Personel. Originally a training course, best non-technical coverage of basic theory of electricity and its applications. Fundamental concepts, batteries, circuits, conductors and wiring techniques, AC and DC, inductance and capacitance, generators, motors, transformers, magnetic amplifiers, synchros, servomechanisms, etc. Also covers blue-prints, electrical diagrams, etc. Many questions, with answers. 349 illustrations. x + 448pp. 6½ x 9¼.

20973-3 Paperbound $3.50

REPRODUCTION OF SOUND, Edgar Villchur. Thorough coverage for laymen of high fidelity systems, reproducing systems in general, needles, amplifiers, preamps, loudspeakers, feedback, explaining physical background. "A rare talent for making technicalities vividly comprehensible," R. Darrell, *High Fidelity*. 69 figures. iv + 92pp. 21515-6 Paperbound $1.25

HEAR ME TALKIN' TO YA: THE STORY OF JAZZ AS TOLD BY THE MEN WHO MADE IT, Nat Shapiro and Nat Hentoff. Louis Armstrong, Fats Waller, Jo Jones, Clarence Williams, Billy Holiday, Duke Ellington, Jelly Roll Morton and dozens of other jazz greats tell how it was in Chicago's South Side, New Orleans, depression Harlem and the modern West Coast as jazz was born and grew. xvi + 429pp.

21726-4 Paperbound $3.00

FABLES OF AESOP, translated by Sir Roger L'Estrange. A reproduction of the very rare 1931 Paris edition; a selection of the most interesting fables, together with 50 imaginative drawings by Alexander Calder. v + 128pp. 6½x9¼.

21780-9 Paperbound $1.50

AGAINST THE GRAIN (A REBOURS), Joris K. Huysmans. Filled with weird images, evidences of a bizarre imagination, exotic experiments with hallucinatory drugs, rich tastes and smells and the diversions of its sybarite hero Duc Jean des Esseintes, this classic novel pushed 19th-century literary decadence to its limits. Full unabridged edition. Do not confuse this with abridged editions generally sold. Introduction by Havelock Ellis. xlix + 206pp. 22190-3 Paperbound $2.00

VARIORUM SHAKESPEARE: HAMLET. Edited by Horace H. Furness; a landmark of American scholarship. Exhaustive footnotes and appendices treat all doubtful words and phrases, as well as suggested critical emendations throughout the play's history. First volume contains editor's own text, collated with all Quartos and Folios. Second volume contains full first Quarto, translations of Shakespeare's sources (Belleforest, and Saxo Grammaticus), Der Bestrafte Brudermord, and many essays on critical and historical points of interest by major authorities of past and present. Includes details of staging and costuming over the years. By far the best edition available for serious students of Shakespeare. Total of xx + 905pp. 21004-9, 21005-7, 2 volumes, Paperbound $7.00

A LIFE OF WILLIAM SHAKESPEARE, Sir Sidney Lee. This is the standard life of Shakespeare, summarizing everything known about Shakespeare and his plays. Incredibly rich in material, broad in coverage, clear and judicious, it has served thousands as the best introduction to Shakespeare. 1931 edition. 9 plates. xxix + 792pp. (USO) 21967-4 Paperbound $3.75

MASTERS OF THE DRAMA, John Gassner. Most comprehensive history of the drama in print, covering every tradition from Greeks to modern Europe and America, including India, Far East, etc. Covers more than 800 dramatists, 2000 plays, with biographical material, plot summaries, theatre history, criticism, etc. "Best of its kind in English," *New Republic*. 77 illustrations. xxii + 890pp. 20100-7 Clothbound $8.50

THE EVOLUTION OF THE ENGLISH LANGUAGE, George McKnight. The growth of English, from the 14th century to the present. Unusual, non-technical account presents basic information in very interesting form: sound shifts, change in grammar and syntax, vocabulary growth, similar topics. Abundantly illustrated with quotations. Formerly *Modern English in the Making*. xii + 590pp. 21932-1 Paperbound $3.50

AN ETYMOLOGICAL DICTIONARY OF MODERN ENGLISH, Ernest Weekley. Fullest, richest work of its sort, by foremost British lexicographer. Detailed word histories, including many colloquial and archaic words; extensive quotations. Do not confuse this with the Concise Etymological Dictionary, which is much abridged. Total of xxvii + 830pp. $6\frac{1}{2}$ x $9\frac{1}{4}$. 21873-2, 21874-0 Two volumes, Paperbound $7.90

FLATLAND: A ROMANCE OF MANY DIMENSIONS, E. A. Abbott. Classic of science-fiction explores ramifications of life in a two-dimensional world, and what happens when a three-dimensional being intrudes. Amusing reading, but also useful as introduction to thought about hyperspace. Introduction by Banesh Hoffmann. 16 illustrations. xx + 103pp. 20001-9 Paperbound $1.00

POEMS OF ANNE BRADSTREET, edited with an introduction by Robert Hutchinson. A new selection of poems by America's first poet and perhaps the first significant woman poet in the English language. 48 poems display her development in works of considerable variety—love poems, domestic poems, religious meditations, formal elegies, "quaternions," etc. Notes, bibliography. viii + 222pp.
22160-1 Paperbound $2.50

THREE GOTHIC NOVELS: THE CASTLE OF OTRANTO BY HORACE WALPOLE; VATHEK BY WILLIAM BECKFORD; THE VAMPYRE BY JOHN POLIDORI, WITH FRAGMENT OF A NOVEL BY LORD BYRON, edited by E. F. Bleiler. The first Gothic novel, by Walpole; the finest Oriental tale in English, by Beckford; powerful Romantic supernatural story in versions by Polidori and Byron. All extremely important in history of literature; all still exciting, packed with supernatural thrills, ghosts, haunted castles, magic, etc. xl + 291pp.
21232-7 Paperbound· $2.50

THE BEST TALES OF HOFFMANN, E. T. A. Hoffmann. 10 of Hoffmann's most important stories, in modern re-editings of standard translations: Nutcracker and the King of Mice, Signor Formica, Automata, The Sandman, Rath Krespel, The Golden Flowerpot, Master Martin the Cooper, The Mines of Falun, The King's Betrothed, A New Year's Eve Adventure. 7 illustrations by Hoffmann. Edited by E. F. Bleiler. xxxix + 419pp.
21793-0 Paperbound $3.00

GHOST AND HORROR STORIES OF AMBROSE BIERCE, Ambrose Bierce. 23 strikingly modern stories of the horrors latent in the human mind: The Eyes of the Panther, The Damned Thing, An Occurrence at Owl Creek Bridge, An Inhabitant of Carcosa, etc., plus the dream-essay, Visions of the Night. Edited by E. F. Bleiler. xxii + 199pp.
20767-6 Paperbound $1.50

BEST GHOST STORIES OF J. S. LEFANU, J. Sheridan LeFanu. Finest stories by Victorian master often considered greatest supernatural writer of all. Carmilla, Green Tea, The Haunted Baronet, The Familiar, and 12 others. Most never before available in the U. S. A. Edited by E. F. Bleiler. 8 illustrations from Victorian publications. xvii + 467pp.
20415-4 Paperbound $3.00

MATHEMATICAL FOUNDATIONS OF INFORMATION THEORY, A. I. Khinchin. Comprehensive introduction to work of Shannon, McMillan, Feinstein and Khinchin, placing these investigations on a rigorous mathematical basis. Covers entropy concept in probability theory, uniqueness theorem, Shannon's inequality, ergodic sources, the E property, martingale concept, noise, Feinstein's fundamental lemma, Shanon's first and second theorems. Translated by R. A. Silverman and M. D. Friedman. iii + 120pp.
60434-9 Paperbound $1.75

SEVEN SCIENCE FICTION NOVELS, H. G. Wells. The standard collection of the great novels. Complete, unabridged. *First Men in the Moon, Island of Dr. Moreau, War of the Worlds, Food of the Gods, Invisible Man, Time Machine, In the Days of the Comet.* Not only science fiction fans, but every educated person owes it to himself to read these novels. 1015pp.
(USO) 20264-X Clothbound $6.00

LAST AND FIRST MEN AND STAR MAKER, TWO SCIENCE FICTION NOVELS, Olaf Stapledon. Greatest future histories in science fiction. In the first, human intelligence is the "hero," through strange paths of evolution, interplanetary invasions, incredible technologies, near extinctions and reemergences. Star Maker describes the quest of a band of star rovers for intelligence itself, through time and space: weird inhuman civilizations, crustacean minds, symbiotic worlds, etc. Complete, unabridged. v + 438pp. (USO) 21962-3 Paperbound $2.50

THREE PROPHETIC NOVELS, H. G. WELLS. Stages of a consistently planned future for mankind. *When the Sleeper Wakes,* and *A Story of the Days to Come,* anticipate *Brave New World* and *1984,* in the 21st Century; *The Time Machine,* only complete version in print, shows farther future and the end of mankind. All show Wells's greatest gifts as storyteller and novelist. Edited by E. F. Bleiler. x + 335pp. (USO) 20605-X Paperbound $2.50

THE DEVIL'S DICTIONARY, Ambrose Bierce. America's own Oscar Wilde—Ambrose Bierce—offers his barbed iconoclastic wisdom in over 1,000 definitions hailed by H. L. Mencken as "some of the most gorgeous witticisms in the English language." 145pp. 20487-1 Paperbound $1.25

MAX AND MORITZ, Wilhelm Busch. Great children's classic, father of comic strip, of two bad boys, Max and Moritz. Also Ker and Plunk (Plisch und Plumm), Cat and Mouse, Deceitful Henry, Ice-Peter, The Boy and the Pipe, and five other pieces. Original German, with English translation. Edited by H. Arthur Klein; translations by various hands and H. Arthur Klein. vi + 216pp. 20181-3 Paperbound $2.00

PIGS IS PIGS AND OTHER FAVORITES, Ellis Parker Butler. The title story is one of the best humor short stories, as Mike Flannery obfuscates biology and English. Also included, That Pup of Murchison's, The Great American Pie Company, and Perkins of Portland. 14 illustrations. v + 109pp. 21532-6 Paperbound $1.25

THE PETERKIN PAPERS, Lucretia P. Hale. It takes genius to be as stupidly mad as the Peterkins, as they decide to become wise, celebrate the "Fourth," keep a cow, and otherwise strain the resources of the Lady from Philadelphia. Basic book of American humor. 153 illustrations. 219pp. 20794-3 Paperbound $1.50

PERRAULT'S FAIRY TALES, translated by A. E. Johnson and S. R. Littlewood, with 34 full-page illustrations by Gustave Doré. All the original Perrault stories—Cinderella, Sleeping Beauty, Bluebeard, Little Red Riding Hood, Puss in Boots, Tom Thumb, etc.—with their witty verse morals and the magnificent illustrations of Doré. One of the five or six great books of European fairy tales. viii + 117pp. 8⅛ x 11. 22311-6 Paperbound $2.00

OLD HUNGARIAN FAIRY TALES, Baroness Orczy. Favorites translated and adapted by author of the *Scarlet Pimpernel.* Eight fairy tales include "The Suitors of Princess Fire-Fly," "The Twin Hunchbacks," "Mr. Cuttlefish's Love Story," and "The Enchanted Cat." This little volume of magic and adventure will captivate children as it has for generations. 90 drawings by Montagu Barstow. 96pp. 22293-4 Paperbound $1.95

THE RED FAIRY BOOK, Andrew Lang. Lang's color fairy books have long been children's favorites. This volume includes Rapunzel, Jack and the Bean-stalk and 35 other stories, familiar and unfamiliar. 4 plates, 93 illustrations x + 367pp.
21673-X Paperbound $2.50

THE BLUE FAIRY BOOK, Andrew Lang. Lang's tales come from all countries and all times. Here are 37 tales from Grimm, the Arabian Nights, Greek Mythology, and other fascinating sources. 8 plates, 130 illustrations. xi + 390pp.
21437-0 Paperbound $2.50

HOUSEHOLD STORIES BY THE BROTHERS GRIMM. Classic English-language edition of the well-known tales — Rumpelstiltskin, Snow White, Hansel and Gretel, The Twelve Brothers, Faithful John, Rapunzel, Tom Thumb (52 stories in all). Translated into simple, straightforward English by Lucy Crane. Ornamented with head-pieces, vignettes, elaborate decorative initials and a dozen full-page illustrations by Walter Crane. x + 269pp. 21080-4 Paperbound $2.00

THE MERRY ADVENTURES OF ROBIN HOOD, Howard Pyle. The finest modern versions of the traditional ballads and tales about the great English outlaw. Howard Pyle's complete prose version, with every word, every illustration of the first edition. Do not confuse this facsimile of the original (1883) with modern editions that change text or illustrations. 23 plates plus many page decorations. xxii + 296pp.
22043-5 Paperbound $2.50

THE STORY OF KING ARTHUR AND HIS KNIGHTS, Howard Pyle. The finest children's version of the life of King Arthur; brilliantly retold by Pyle, with 48 of his most imaginative illustrations. xviii + 313pp. 6⅛ x 9¼.
21445-1 Paperbound $2.50

THE WONDERFUL WIZARD OF OZ, L. Frank Baum. America's finest children's book in facsimile of first edition with all Denslow illustrations in full color. The edition a child should have. Introduction by Martin Gardner. 23 color plates, scores of drawings. iv + 267pp. 20691-2 Paperbound $2.50

THE MARVELOUS LAND OF OZ, L. Frank Baum. The second Oz book, every bit as imaginative as the Wizard. The hero is a boy named Tip, but the Scarecrow and the Tin Woodman are back, as is the Oz magic. 16 color plates, 120 drawings by John R. Neill. 287pp. 20692-0 Paperbound $2.50

THE MAGICAL MONARCH OF MO, L. Frank Baum. Remarkable adventures in a land even stranger than Oz. The best of Baum's books not in the Oz series. 15 color plates and dozens of drawings by Frank Verbeck. xviii + 237pp.
21892-9 Paperbound $2.25

THE BAD CHILD'S BOOK OF BEASTS, MORE BEASTS FOR WORSE CHILDREN, A MORAL ALPHABET, Hilaire Belloc. Three complete humor classics in one volume. Be kind to the frog, and do not call him names . . . and 28 other whimsical animals. Familiar favorites and some not so well known. Illustrated by Basil Blackwell. 156pp. (USO) 20749-8 Paperbound $1.50

EAST O' THE SUN AND WEST O' THE MOON, George W. Dasent. Considered the best of all translations of these Norwegian folk tales, this collection has been enjoyed by generations of children (and folklorists too). Includes True and Untrue, Why the Sea is Salt, East O' the Sun and West O' the Moon, Why the Bear is Stumpy-Tailed, Boots and the Troll, The Cock and the Hen, Rich Peter the Pedlar, and 52 more. The only edition with all 59 tales. 77 illustrations by Erik Werenskiold and Theodor Kittelsen. xv + 418pp. 22521-6 Paperbound $3.50

GOOPS AND HOW TO BE THEM, Gelett Burgess. Classic of tongue-in-cheek humor, masquerading as etiquette book. 87 verses, twice as many cartoons, show mischievous Goops as they demonstrate to children virtues of table manners, neatness, courtesy, etc. Favorite for generations. viii + 88pp. 6½ x 9¼.
22233-0 Paperbound $1.25

ALICE'S ADVENTURES UNDER GROUND, Lewis Carroll. The first version, quite different from the final *Alice in Wonderland,* printed out by Carroll himself with his own illustrations. Complete facsimile of the "million dollar" manuscript Carroll gave to Alice Liddell in 1864. Introduction by Martin Gardner. viii + 96pp. Title and dedication pages in color. 21482-6 Paperbound $1.25

THE BROWNIES, THEIR BOOK, Palmer Cox. Small as mice, cunning as foxes, exuberant and full of mischief, the Brownies go to the zoo, toy shop, seashore, circus, etc., in 24 verse adventures and 266 illustrations. Long a favorite, since their first appearance in St. Nicholas Magazine. xi + 144pp. 6⅝ x 9¼.
21265-3 Paperbound $1.75

SONGS OF CHILDHOOD, Walter De La Mare. Published (under the pseudonym Walter Ramal) when De La Mare was only 29, this charming collection has long been a favorite children's book. A facsimile of the first edition in paper, the 47 poems capture the simplicity of the nursery rhyme and the ballad, including such lyrics as I Met Eve, Tartary, The Silver Penny. vii + 106pp. (USO) 21972-0 Paperbound $1.25

THE COMPLETE NONSENSE OF EDWARD LEAR, Edward Lear. The finest 19th-century humorist-cartoonist in full: all nonsense limericks, zany alphabets, Owl and Pussycat, songs, nonsense botany, and more than 500 illustrations by Lear himself. Edited by Holbrook Jackson. xxix + 287pp. (USO) 20167-8 Paperbound $2.00

BILLY WHISKERS: THE AUTOBIOGRAPHY OF A GOAT, Frances Trego Montgomery. A favorite of children since the early 20th century, here are the escapades of that rambunctious, irresistible and mischievous goat—Billy Whiskers. Much in the spirit of *Peck's Bad Boy,* this is a book that children never tire of reading or hearing. All the original familiar illustrations by W. H. Fry are included: 6 color plates, 18 black and white drawings. 159pp. 22345-0 Paperbound $2.00

MOTHER GOOSE MELODIES. Faithful republication of the fabulously rare Munroe and Francis "copyright 1833" Boston edition—the most important Mother Goose collection, usually referred to as the "original." Familiar rhymes plus many rare ones, with wonderful old woodcut illustrations. Edited by E. F. Bleiler. 128pp. 4½ x 6⅜. 22577-1 Paperbound $1.00

TWO LITTLE SAVAGES; BEING THE ADVENTURES OF TWO BOYS WHO LIVED AS INDIANS AND WHAT THEY LEARNED, Ernest Thompson Seton. Great classic of nature and boyhood provides a vast range of woodlore in most palatable form, a genuinely entertaining story. Two farm boys build a teepee in woods and live in it for a month, working out Indian solutions to living problems, star lore, birds and animals, plants, etc. 293 illustrations. vii + 286pp.

20985-7 Paperbound $2.50

PETER PIPER'S PRACTICAL PRINCIPLES OF PLAIN & PERFECT PRONUNCIATION. Alliterative jingles and tongue-twisters of surprising charm, that made their first appearance in America about 1830. Republished in full with the spirited woodcut illustrations from this earliest American edition. 32pp. 4½ x 6⅜.

22560-7 Paperbound $1.00

SCIENCE EXPERIMENTS AND AMUSEMENTS FOR CHILDREN, Charles Vivian. 73 easy experiments, requiring only materials found at home or easily available, such as candles, coins, steel wool, etc.; illustrate basic phenomena like vacuum, simple chemical reaction, etc. All safe. Modern, well-planned. Formerly *Science Games for Children*. 102 photos, numerous drawings. 96pp. 6⅛ x 9¼.

21856-2 Paperbound $1.25

AN INTRODUCTION TO CHESS MOVES AND TACTICS SIMPLY EXPLAINED, Leonard Barden. Informal intermediate introduction, quite strong in explaining reasons for moves. Covers basic material, tactics, important openings, traps, positional play in middle game, end game. Attempts to isolate patterns and recurrent configurations. Formerly *Chess*. 58 figures. 102pp. (USO) 21210-6 Paperbound $1.25

LASKER'S MANUAL OF CHESS, Dr. Emanuel Lasker. Lasker was not only one of the five great World Champions, he was also one of the ablest expositors, theorists, and analysts. In many ways, his Manual, permeated with his philosophy of battle, filled with keen insights, is one of the greatest works ever written on chess. Filled with analyzed games by the great players. A single-volume library that will profit almost any chess player, beginner or master. 308 diagrams. xli x 349pp.

20640-8 Paperbound $2.75

THE MASTER BOOK OF MATHEMATICAL RECREATIONS, Fred Schuh. In opinion of many the finest work ever prepared on mathematical puzzles, stunts, recreations; exhaustively thorough explanations of mathematics involved, analysis of effects, citation of puzzles and games. Mathematics involved is elementary. Translated bv F. Göbel. 194 figures. xxiv + 430pp. 22134-2 Paperbound $3.50

MATHEMATICS, MAGIC AND MYSTERY, Martin Gardner. Puzzle editor for Scientific American explains mathematics behind various mystifying tricks: card tricks, stage "mind reading," coin and match tricks, counting out games, geometric dissections, etc. Probability sets, theory of numbers clearly explained. Also provides more than 400 tricks, guaranteed to work, that you can do. 135 illustrations. xii + 176pp.

20335-2 Paperbound $1.75

MATHEMATICAL PUZZLES FOR BEGINNERS AND ENTHUSIASTS, Geoffrey Mott-Smith. 189 puzzles from easy to difficult—involving arithmetic, logic, algebra, properties of digits, probability, etc.—for enjoyment and mental stimulus. Explanation of mathematical principles behind the puzzles. 135 illustrations. viii + 248pp.

20198-8 Paperbound $1.75

PAPER FOLDING FOR BEGINNERS, William D. Murray and Francis J. Rigney. Easiest book on the market, clearest instructions on making interesting, beautiful origami. Sail boats, cups, roosters, frogs that move legs, bonbon boxes, standing birds, etc. 40 projects; more than 275 diagrams and photographs. 94pp.

20713-7 Paperbound $1.00

TRICKS AND GAMES ON THE POOL TABLE, Fred Herrmann. 79 tricks and games— some solitaires, some for two or more players, some competitive games—to entertain you between formal games. Mystifying shots and throws, unusual caroms, tricks involving such props as cork, coins, a hat, etc. Formerly *Fun on the Pool Table*. 77 figures. 95pp.

21814-7 Paperbound $1.00

HAND SHADOWS TO BE THROWN UPON THE WALL: A SERIES OF NOVEL AND AMUSING FIGURES FORMED BY THE HAND, Henry Bursill. Delightful picturebook from great-grandfather's day shows how to make 18 different hand shadows: a bird that flies, duck that quacks, dog that wags his tail, camel, goose, deer, boy, turtle, etc. Only book of its sort. vi + 33pp. 6½ x 9¼. 21779-5 Paperbound $1.00

WHITTLING AND WOODCARVING, E. J. Tangerman. 18th printing of best book on market. "If you can cut a potato you can carve" toys and puzzles, chains, chessmen, caricatures, masks, frames, woodcut blocks, surface patterns, much more. Information on tools, woods, techniques. Also goes into serious wood sculpture from Middle Ages to present, East and West. 464 photos, figures. x + 293pp.

20965-2 Paperbound $2.00

HISTORY OF PHILOSOPHY, Julián Marias. Possibly the clearest, most easily followed, best planned, most useful one-volume history of philosophy on the market; neither skimpy nor overfull. Full details on system of every major philosopher and dozens of less important thinkers from pre-Socratics up to Existentialism and later. Strong on many European figures usually omitted. Has gone through dozens of editions in Europe. 1966 edition, translated by Stanley Appelbaum and Clarence Strowbridge. xviii + 505pp.

21739-6 Paperbound $3.50

YOGA: A SCIENTIFIC EVALUATION, Kovoor T. Behanan. Scientific but non-technical study of physiological results of yoga exercises; done under auspices of Yale U. Relations to Indian thought, to psychoanalysis, etc. 16 photos. xxiii + 270pp.

20505-3 Paperbound $2.50

Prices subject to change without notice.
Available at your book dealer or write for free catalogue to Dept. GI, Dover Publications, Inc., 180 Varick St., N. Y., N. Y. 10014. Dover publishes more than 150 books each year on science, elementary and advanced mathematics, biology, music, art, literary history, social sciences and other areas.